# NFL

## 100

### A CENTURY *of* PRO FOOTBALL

**MUD PACK**
Jim Taylor did the dirty
work in Green Bay's
bruising ground game,
as he so often did,
during a 1960 matchup
against the 49ers
in San Francisco.

EDITOR: **Rob Fleder**
DESIGN DIRECTOR: **Michael Goesele**
PHOTO DIRECTOR: **Dot McMahon**
DESIGNER: **Michael Bessire**
PHOTO EDITOR: **Mark Rykoff**
RIGHTS AND PERMISSIONS: **Carolyn Davis**

**ABRAMS**
EDITOR: **Garrett McGrath**
DESIGN MANAGERS: **Deb Wood & Eli Mock**
PRODUCTION MANAGER: **Anet Sirna-Bruder**

Library of Congress Control Number: 2018958784

ISBN: 978-1-4197-3859-3
EISBN: 978-1-68335-656-1
B&N AND INDIGO EXCLUSIVE
EDITION ISBN: 978-1-4197-4395-5

COVER PHOTOGRAPH: **Michael Kraus**
COVER DESIGN: **Michael Goesele**
Jacket © 2019 Abrams

Printed and bound in the United States
10 9 8 7 6 5 4 3 2 1

Abrams books are available at special discounts
when purchased in quantity for premiums
and promotions as well as fundraising or
educational use. Special editions can also be
created to specification. For details, contact
specialsales@abramsbooks.com or the address below.

Abrams® is a registered trademark
of Harry N. Abrams, Inc.

ABRAMS The Art of Books
195 Broadway, New York, NY 10007
abramsbooks.com

# NFL
# 100

## A CENTURY *of* PRO FOOTBALL

FOREWORD BY
## PEYTON MANNING

DECADES BY
## MICHAEL MacCAMBRIDGE

—

EDITED BY
## ROB FLEDER

ABRAMS, NEW YORK

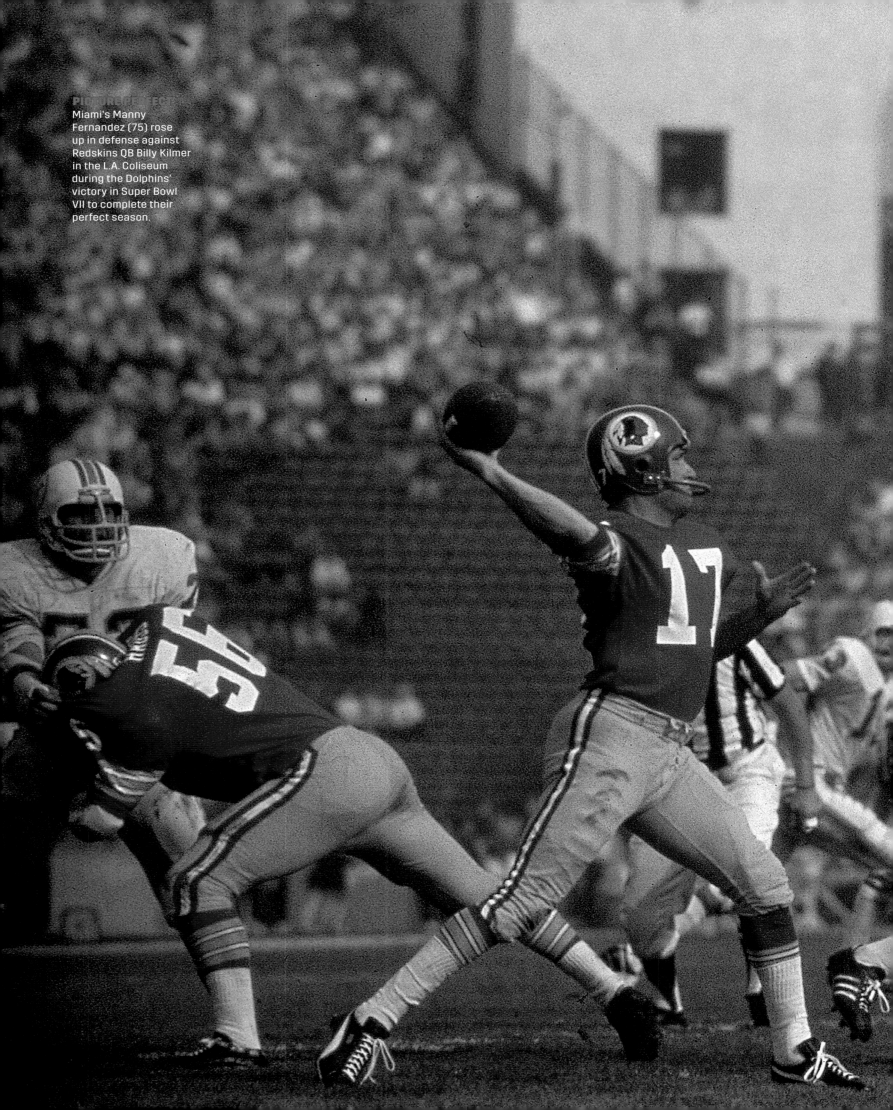

Miami's Manny Fernandez (75) rose up in defense against Redskins QB Billy Kilmer in the L.A. Coliseum during the Dolphins' victory in Super Bowl VII to complete their perfect season.

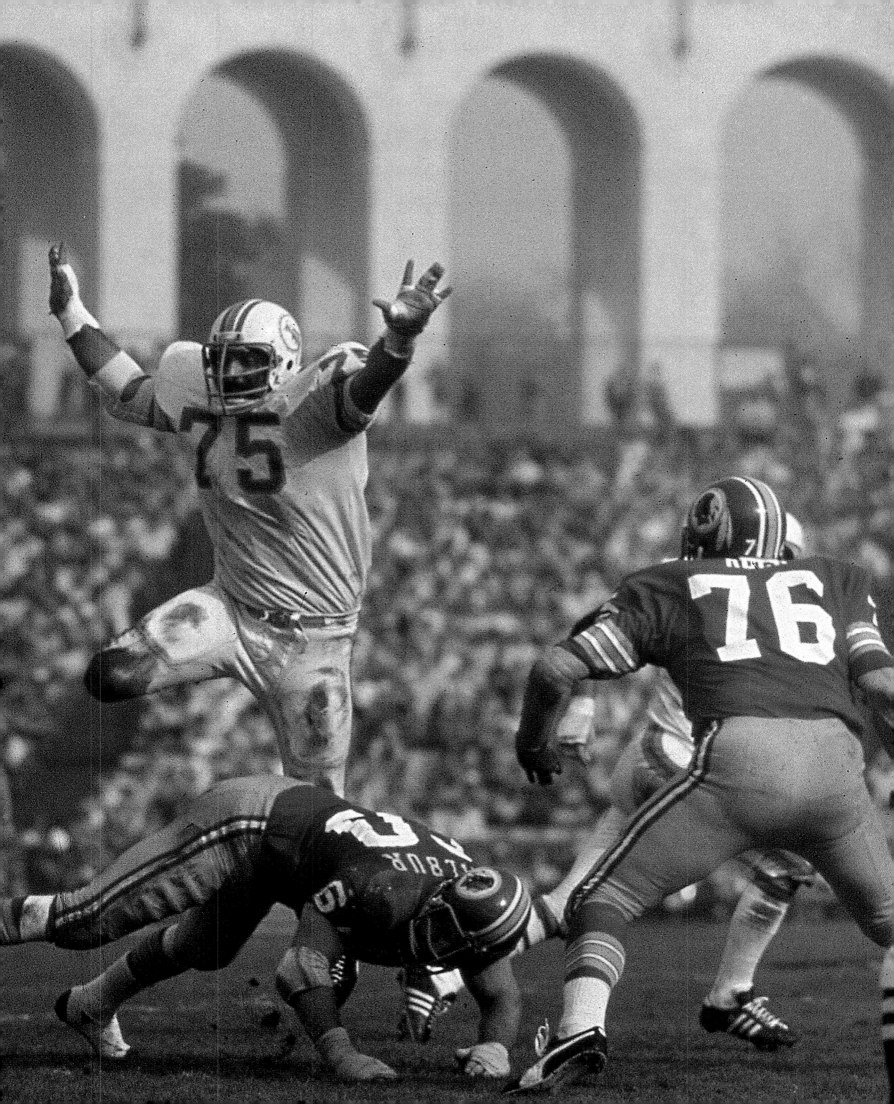

# CONTENTS

**OBSTRUCTED VIEW**
The Chicago weather
was a factor, as it so
often is, when the
Eagles (here attempting
a field goal) lost to
the Bears in an NFC
Playoff game forever
known as the Fog Bowl.

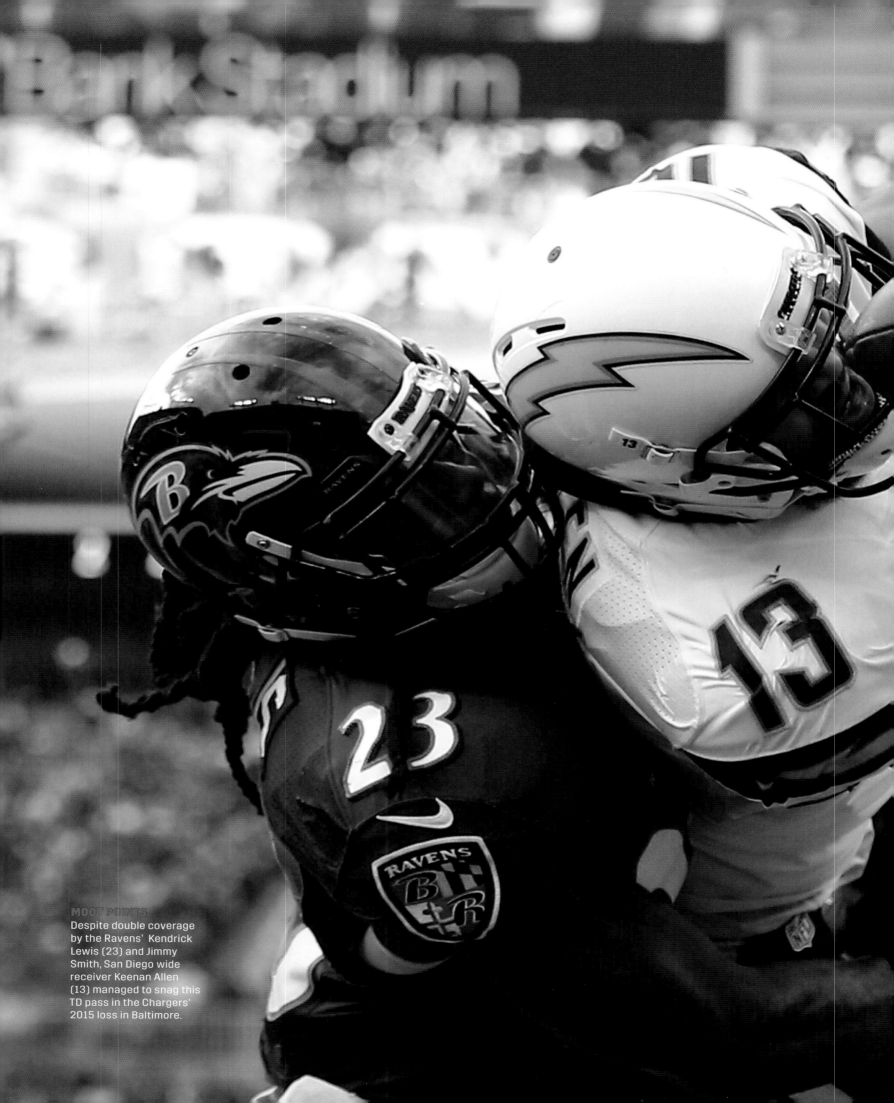

Despite double coverage by the Ravens' Kendrick Lewis (23) and Jimmy Smith, San Diego wide receiver Keenan Allen (13) managed to snag this TD pass in the Chargers' 2015 loss in Baltimore.

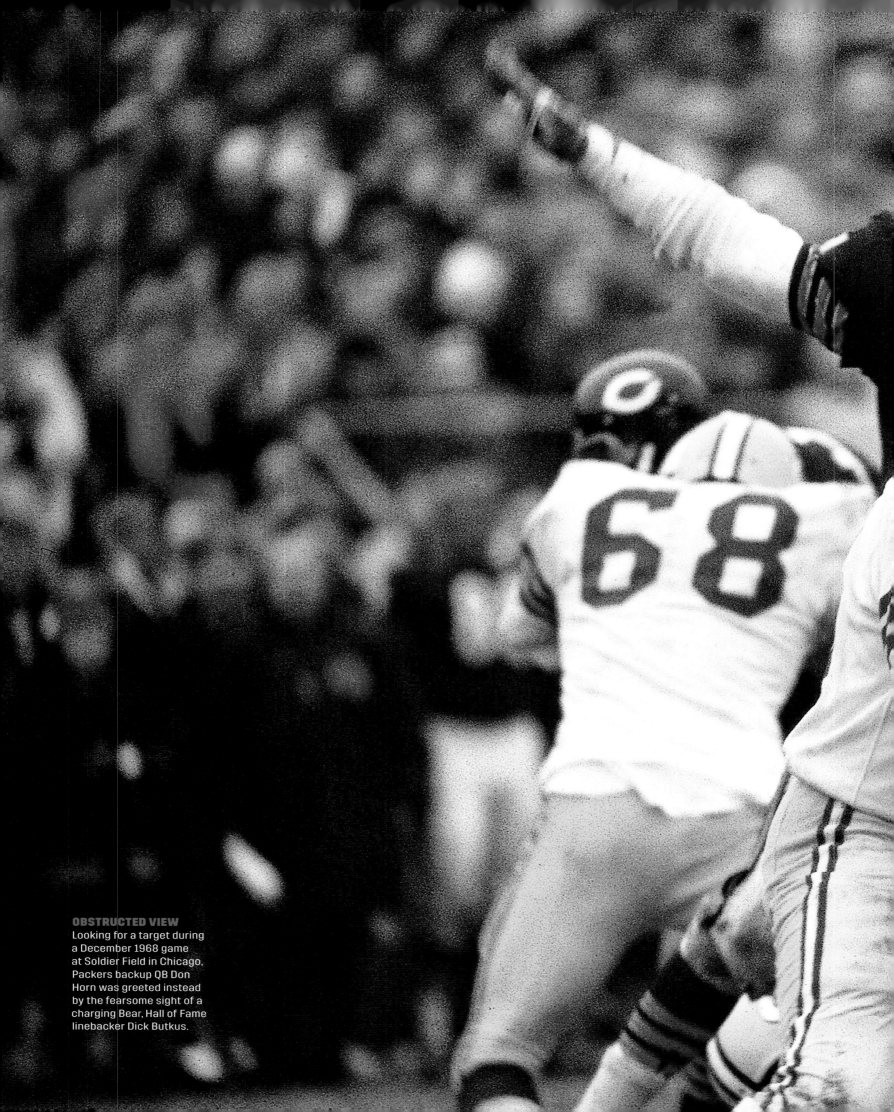

**OBSTRUCTED VIEW**
Looking for a target during a December 1968 game at Soldier Field in Chicago, Packers backup QB Don Horn was greeted instead by the fearsome sight of a charging Bear, Hall of Fame linebacker Dick Butkus.

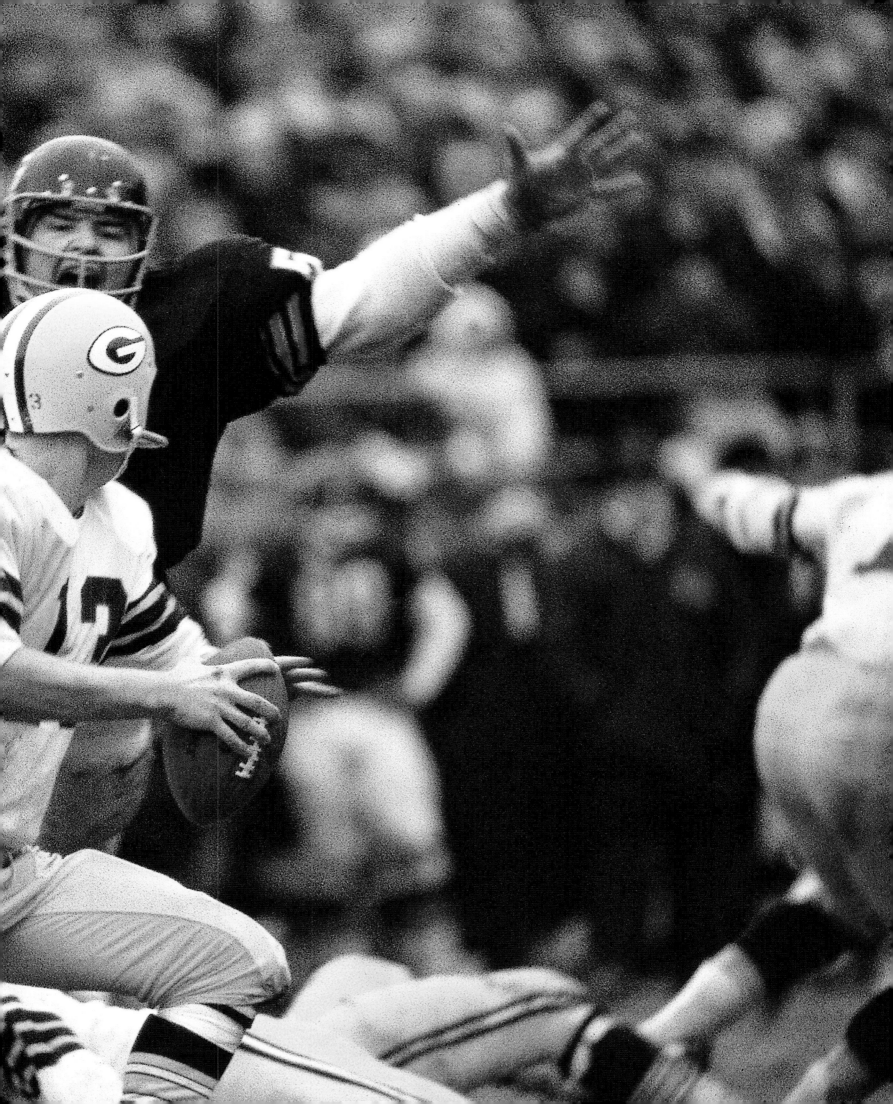

# FOREWORD

## By Peyton Manning

IF YOU GREW UP LIKE I DID—WITH AN ALL-AMERICAN QUARTERBACK WHO went on to play pro football as a father and a football-loving homecoming queen for a mother—the game is in your DNA. I've been around it as long as I can remember.

I wasn't yet four years old when my dad made the Pro Bowl after the 1979 season—the first time the game was played in Hawaii. Our whole family came along, and one day that week, my mom and dad realized they hadn't seen me for a while. They looked up and down the beach, with no sign. I'd been missing for more than an hour, and they were growing legitimately concerned. At that moment, they finally spotted me—coming ashore with Walter Payton, who'd taken me out for a ride on his catamaran.

My dad and Walter were tight because both of them had played college ball in Mississippi—my dad at Ole Miss and Walter at Jackson State. Walter was always convinced that my parents had named me after him. My dad would politely try to explain, "Well, Walter, I love you, but it's actually a family name, after my uncle Peyton, who used to drive me to my games. And our Peyton is spelled differently—it's 'P-e-y' rather than 'P-a-y.'"

"Yeah, yeah, Archie," Walter would say, smiling. "I know you named him after me."

Now, as the NFL plays its one-hundredth season, it's clear that the things around the game have changed even more than the game itself.

When my dad was drafted, second overall in 1971, the NFL draft was seventeen rounds long and began on a Thursday morning. My dad was still in school, so that morning he stopped by the Ole Miss SID's office and had his picture taken by an AP photographer, then went to his first class. That was the draft-day "scene" back then. It's even changed since I was drafted, 21 years ago. I did get to go to New York then, but there were only three other players in the "green room."

My rookie season was full of lessons. We opened against the Miami Dolphins and Dan Marino, my favorite player throughout my teenage years. I remember our defense had the Dolphins 3rd-and-11 on their opening drive. I'd already buckled up my chin strap, eager to go in, when Marino made one of the damnedest throws I've ever seen, to Lamar Thomas for a first down. I unsnapped my chin strap and waited some more. It was a long wait; Marino took the Dolphins the length of the field, on a 16-play drive. The first quarter was nearly over by the time we got the ball.

That opener was not an auspicious debut, but one play sticks out. I threw a pass to tight end Marcus Pollard on a seam route, just as I was getting clobbered by the Dolphins' 6'6", 300-pound defensive tackle Daryl Gardener, who hit me right under my chin. Pollard caught the pass in stride, for a first down, and as I got up, I remember thinking, *Well, I can take a hit; I can play in this league.*

I threw three interceptions that first game, well on my way to setting the dubious record of most interceptions thrown in a season by a rookie quarterback, which still stands. It's one record I'm eager to have broken. But a lot of things have to fall in place to throw 26 interceptions in your rookie season. You need to get off to a hot start, of course—I managed to throw 10 interceptions before the end of September. At that point, rookies usually get lifted for the wily veteran, but to Jim Mora's credit, he stuck with me. "You're the starter," he said. "You're staying in."

I remember complaining to my dad early

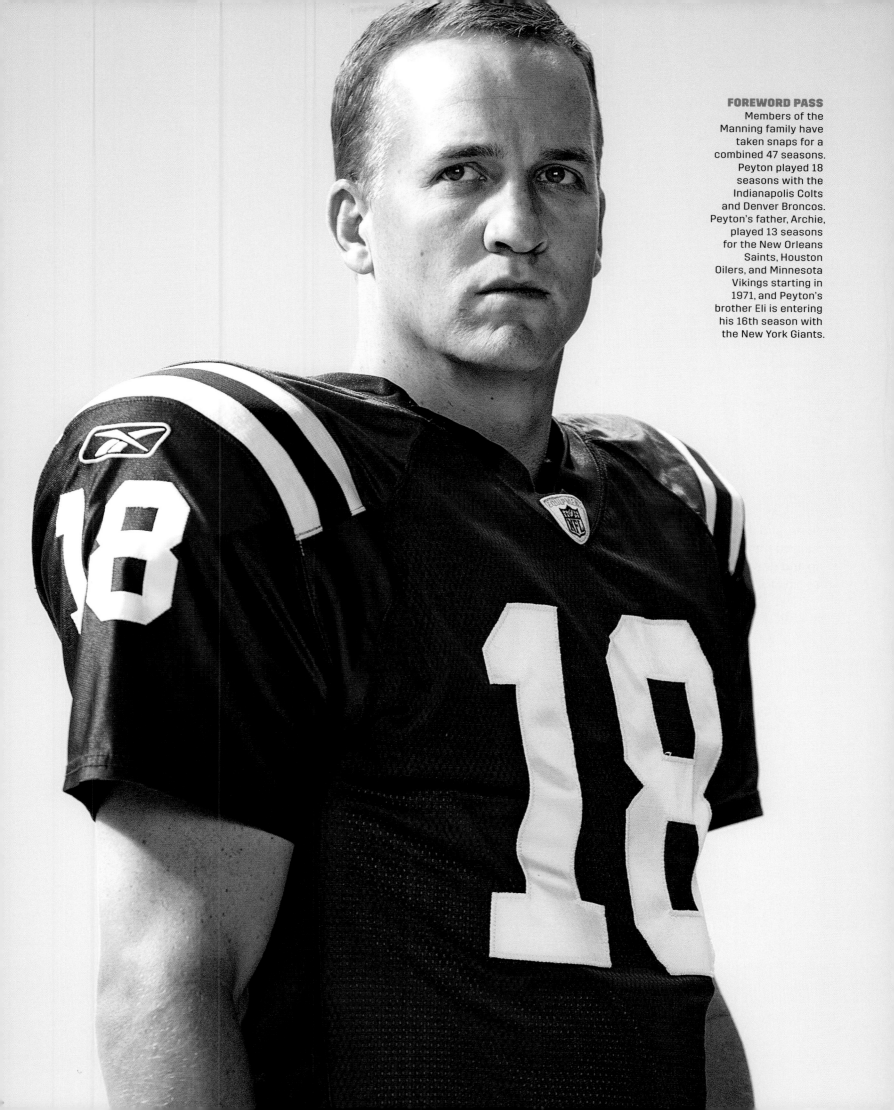

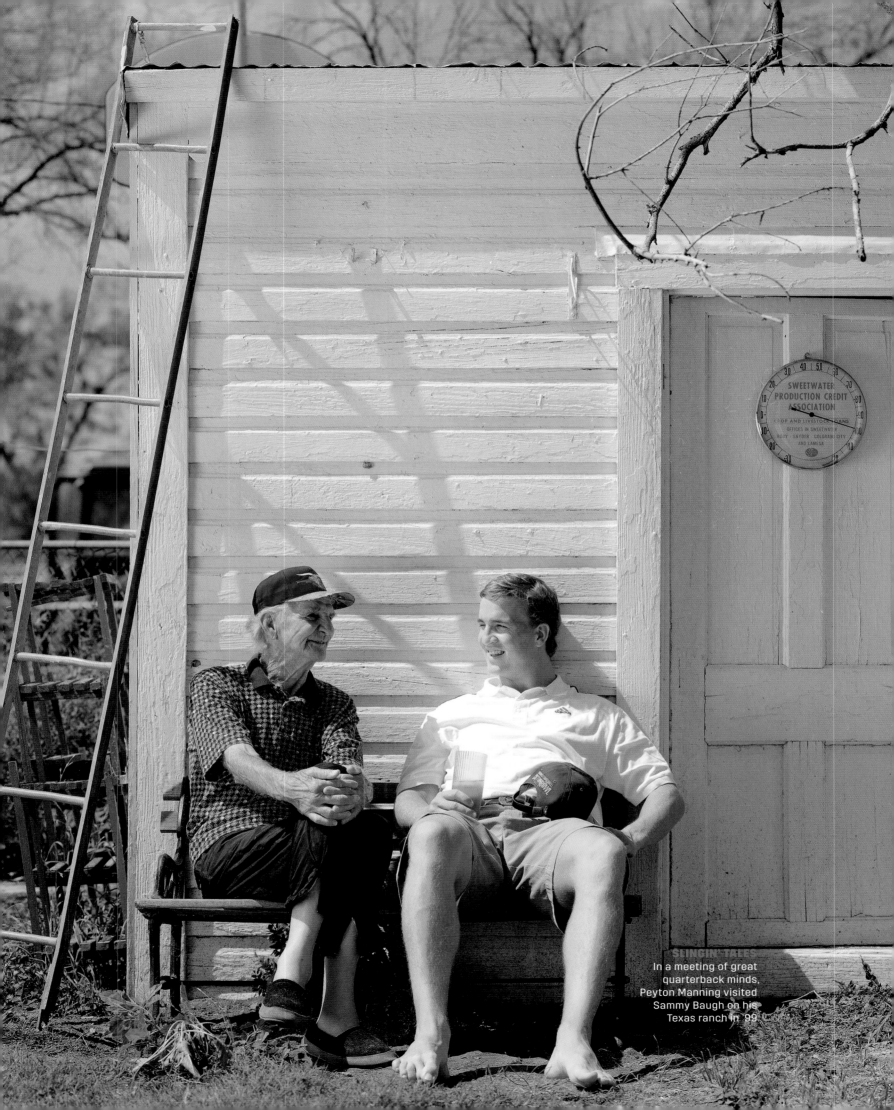

**SLINGIN' TALES**
In a meeting of great
quarterback minds,
Peyton Manning visited
Sammy Baugh on his
Texas ranch in '99

that season, "Nobody's open." It felt like every play I'd fade back and everybody was covered. On one third down early in the season, I went back to pass, couldn't find anyone, and finally just threw it out of bounds to avoid a sack.

The next day, I was going over film with my quarterbacks coach, Bruce Arians, and he asked me, "Why didn't you throw it to someone?"

"Nobody's open," I protested. "The window was like that," and then I held my hands a couple of inches apart to show how little daylight there was between my primary receiver and the defender.

Arians looked at me patiently.

"Peyton," he explained. "That is open in the NFL. That's what 'getting open' looks like here."

I had a lot to learn.

Play in the league long enough, and you get to participate in games you know will be remembered a long time. Those games still stand out: the late comeback the Colts made against Tampa Bay on *Monday Night Football* in 2003, or

## The best fans understand that, after a loss, if they're mad, the players on their favorite team are even madder. As I used to tell people, "Remember, we're all robbing the same train here."

rallying from a 21–3 deficit against the Patriots at home in the 2006 AFC championship game.

Then there's the Super Bowl. I got to play in four of them and was on the winning team twice. I still remember nearly every play in the rain in Miami (where we were the only ones who *didn't* get to watch Prince's halftime show), and my last game, in Super Bowl 50 in Santa Clara.

After both of those games, amid the euphoria, I kept looking at the Vince Lombardi Trophy, the physical manifestation of all we'd been working for. First the owner gets the trophy, then the coach, then it gets handed to the MVP, who hands it off to one of his teammates. Then the trophy gets passed around and every player puts his own personal mark

on it. Some people hug it, some guys kiss it, some just stare at it. But in the sharing, there is a validation of something monumental that the team has accomplished together. And the gratitude you feel at those moments—to your teammates, your coaches, the fans—is immense. I know my brother Eli had the same feeling when he won his two Super Bowls.

I played in the NFL for eighteen years and got to be a small part of the league's epic story. It may well be that, in another ten years, all people will remember about me is "Omaha!" But that's something.

Today, I'm still a fan. I like the throwbacks. I like games played outdoors, on natural grass. I like the true believers, the fans who remain loyal to their team. The best fans understand that after a loss, if they're mad, the players on their favorite team are even madder. As I used to tell people, "Remember, we're all robbing the same train here."

I've had a chance to spend the last year retracing the history of the league for NFL Films. I watched the 1958 NFL Championship Game with Raymond Berry; I ran "The Hill" with Jerry Rice; shot pool with Joe Namath; and I visited Graceland, to play on the same field where Elvis once played football. (I may or may not have even worn a '70s-era Elvis jumpsuit.)

The whole experience deepened my sense of appreciation for the game's rich history. In 2000, *Sports Illustrated* did a feature matching contemporary players with past NFL greats. I went to Rotan, Texas, and visited Sammy Baugh. During that day, I was struck by all that *hadn't* changed. We threw pretty much the same football, and he still loved talking about the game. He was still an all-pro cusser.

So while some things around the game have undoubtedly changed—I'm pretty sure Sammy Baugh never had his own catamaran—many of the elements that made football great a century ago are still in the game today. It's still 11 a side over 100 yards, it's still a battle of wills and a battle of wits.

As you'll see in the pages ahead, the NFL hasn't always been center stage and prime time, but it has always been compelling. As it reaches its centennial, it remains a great game to play, and to watch. ●

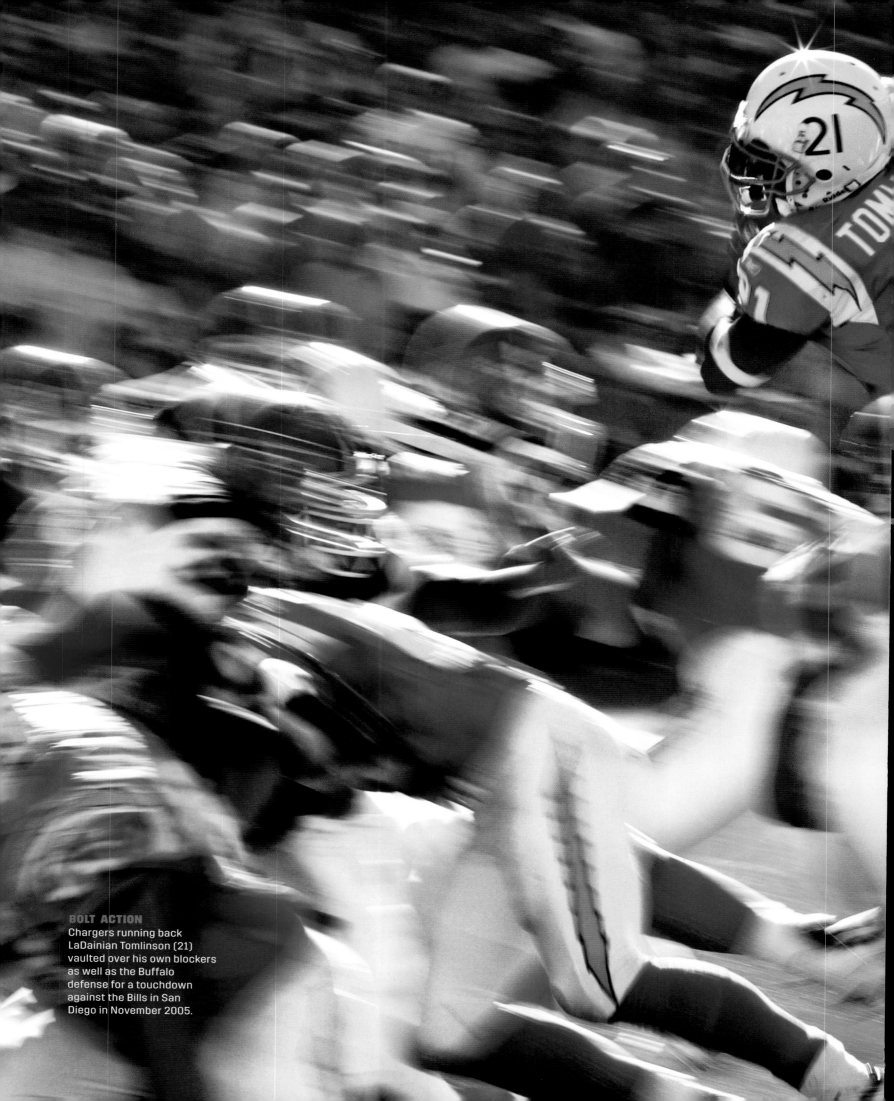

**BOLT ACTION**
Chargers running back LaDainian Tomlinson (21) vaulted over his own blockers as well as the Buffalo defense for a touchdown against the Bills in San Diego in November 2005.

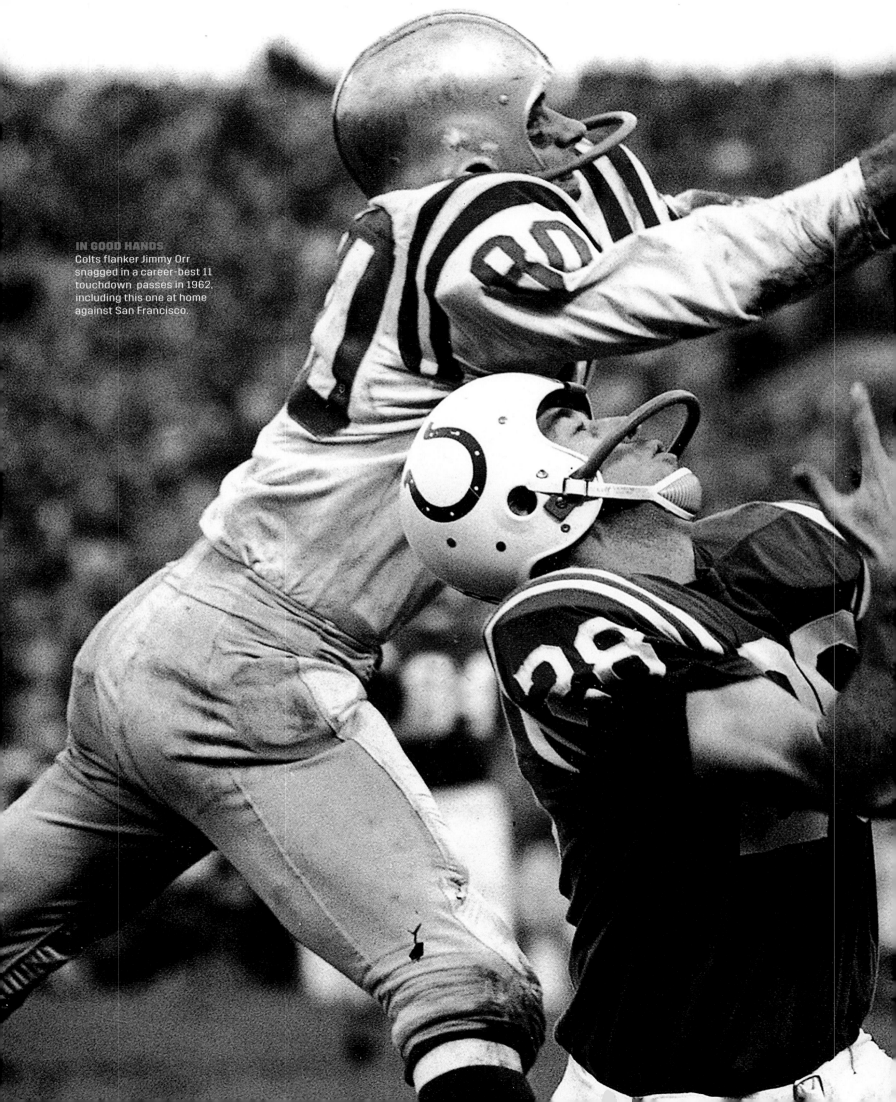

**IN GOOD HANDS**
Colts flanker Jimmy Orr snagged in a career-best 11 touchdown passes in 1962, including this one at home against San Francisco.

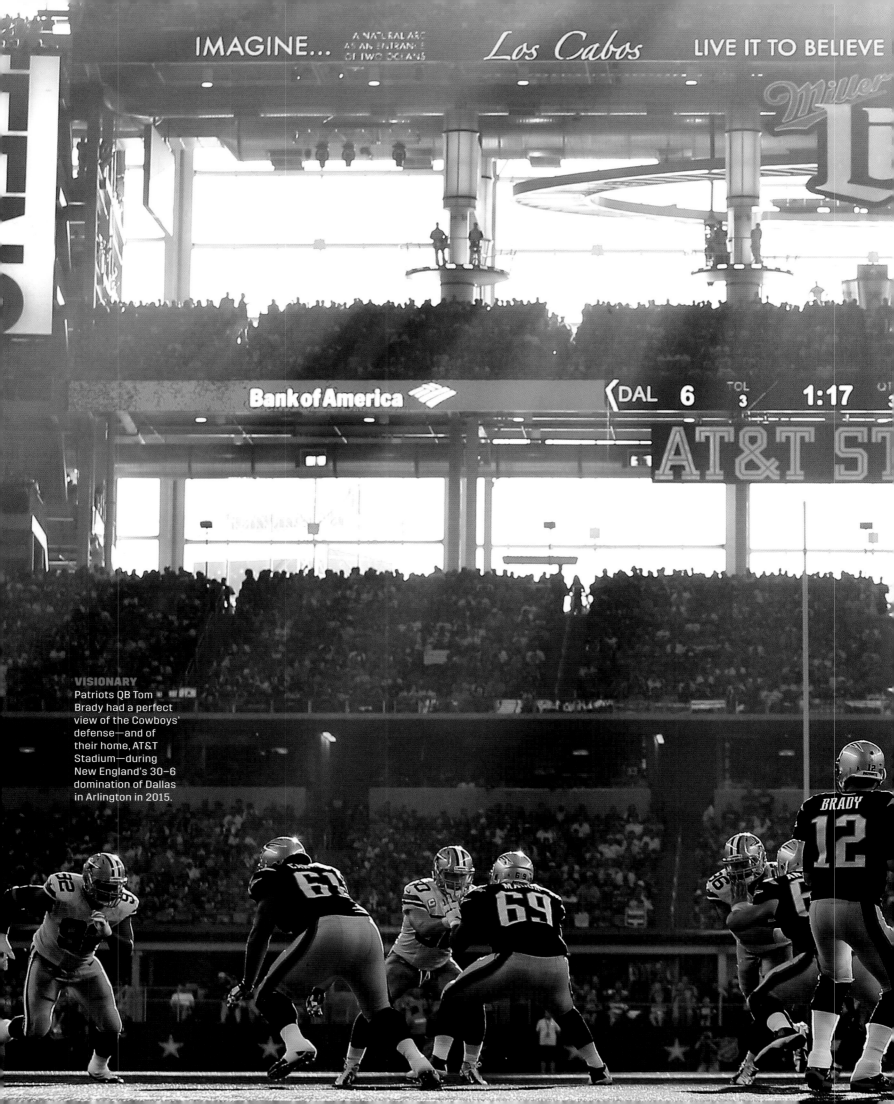

IMAGINE... A NATURAL ARC AS AN ENTRANCE OF TWO OCEANS   Los Cabos   LIVE IT TO BELIEVE

Bank of America

DAL 6 | TOL 3 | 1:17

AT&T ST

**VISIONARY**
Patriots QB Tom
Brady had a perfect
view of the Cowboys'
defense—and of
their home, AT&T
Stadium—during
New England's 30–6
domination of Dallas
in Arlington in 2015.

BRADY
12

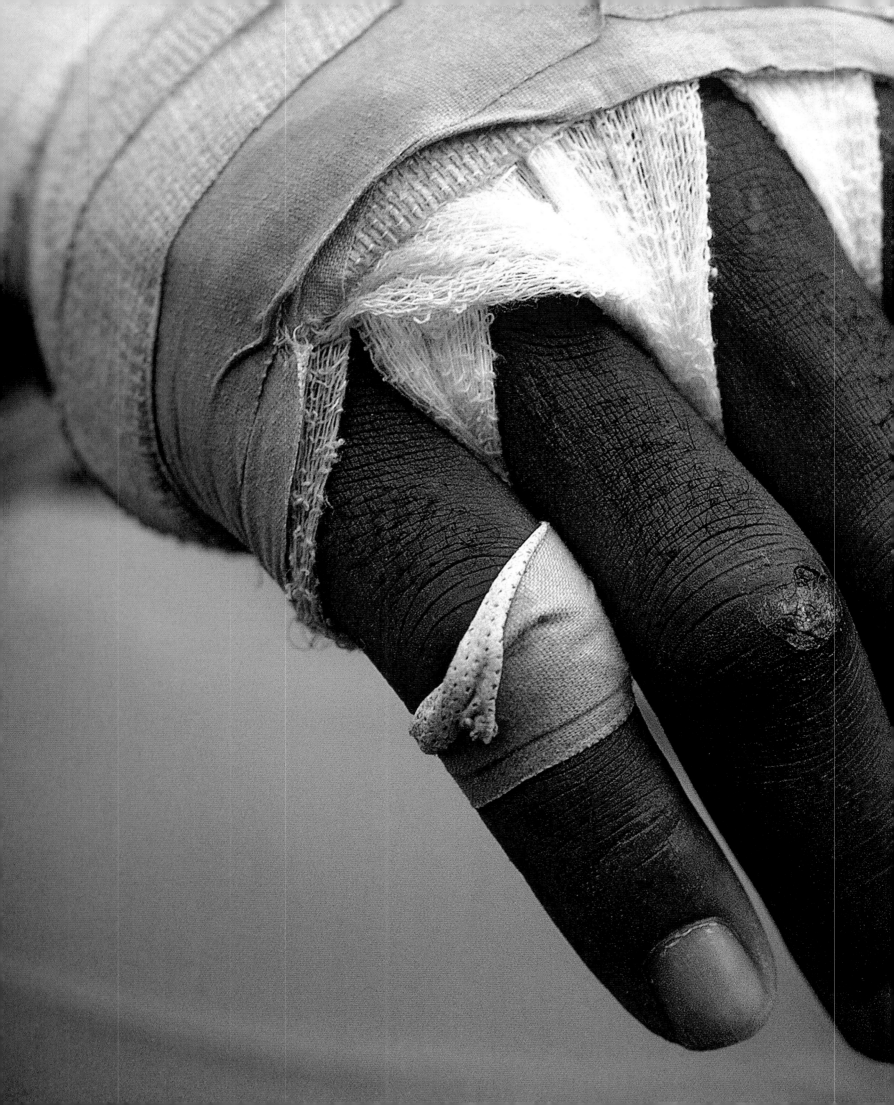

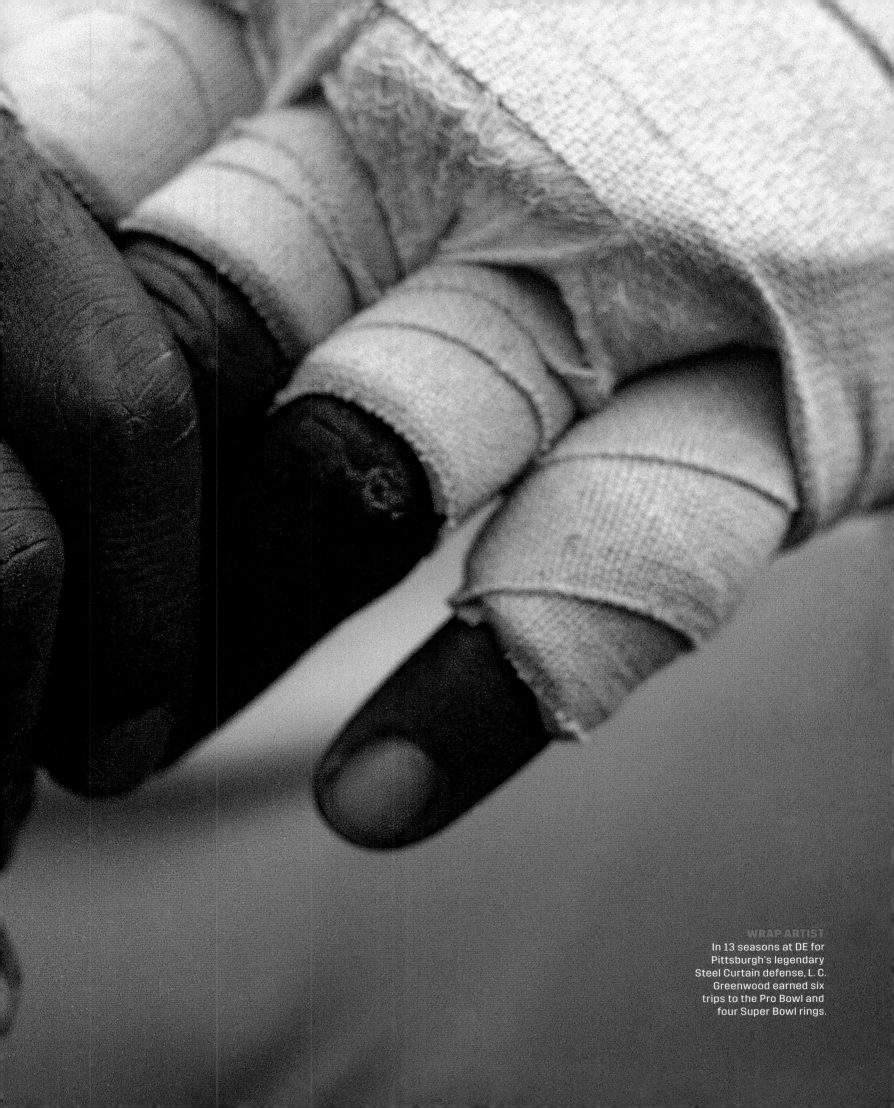

# THE DE

# CADES

**LEFT COAST OFFENSE**
Raiders tight end Rickey Dudley was in exactly the right place at the right time (and in the right October light) to make a catch against the Niners in San Francisco in 2000.

**RUNNING TO DAYLIGHT**
Pro football had a hard time drawing fans in the 1920s, but as the quality of play improved, more and more fans came to watch stars like Red Grange, Jim Thorpe and Bronko Nagurski.

# 1 9

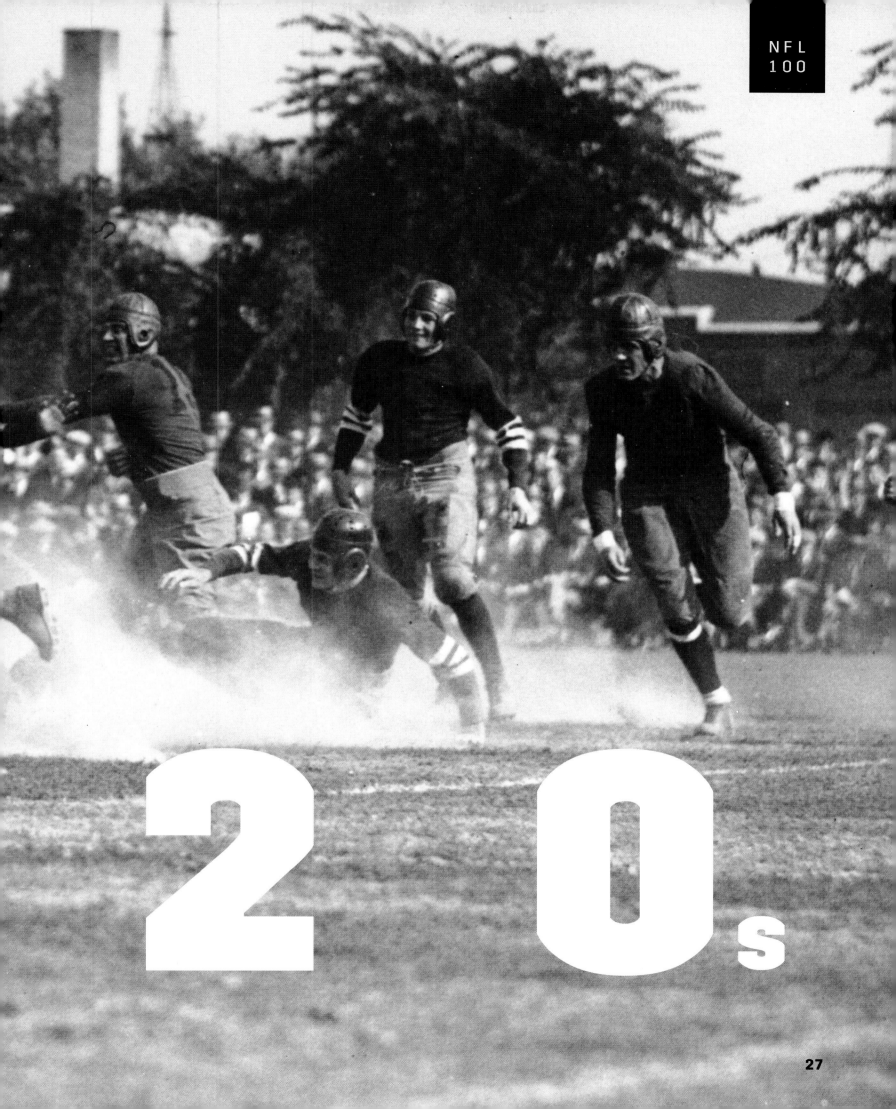

2 0s

THERE WERE MORE THAN A dozen men, too many to fit in Ralph Hay's cramped office. So when they gathered that Friday evening, September 17, 1920, the owner of the Canton Bulldogs moved the group into the showroom of his Hupmobile dealership, where they sat on the running boards and fenders of the cars and formed the American Professional Football Association, whose express purpose, according to one newspaper article, was "to raise the standard of professional football in every way possible." Among the men was a young University of Illinois grad named George Halas, representing the A.E. Staley starch company of Decatur, Illinois. Halas and the others in the group deferred to the legend in their midst, Jim Thorpe, and voted him the league's first president.

Within two years, Thorpe had been replaced by Joe Carr; Halas had bought the Decatur Staleys, moved them to Chicago and renamed them the Bears; and the APFA had changed its name to the National Football League. Fall weekends in America would never be the same.

Yet the sport was virtually unrecognizable a century ago. Thirty-six of the forty league games in that first season were shutouts, as teams averaged fewer than 10 points per game. The field's dimensions were the same as they are now, but there were no hash marks, so when a play went out-of-bounds, the next snap was just a yard inside the sideline, with all the other linemen positioned on the field side of the center. The nearly egg-shaped ball was hard to grip, and all passes had to be made from at least five yards behind the line of scrimmage.

The men, wearing leather helmets and rudimentary padding—mostly factory workers and former college stars traveling for weekend pay—routinely wound up in a monotonous series of monster scrums. The jerseys were often dark, to conceal the accumulated dirt, as teams sometimes played games on consecutive days. As for the mud-caked game pants, "all we could do was let the mud dry and use a wire brush to make the pants lighter in weight," recalled Hall of Fame tackle Steve Owen.

The Akron Pros, the inaugural season's champions, were led by Frederick Douglass "Fritz" Pollard, the Brown grad who'd been the first African-American to play in the Rose Bowl. Akron went undefeated in 1920, but there was no provision for a championship game, so the Pros weren't officially awarded the title until a vote of league owners the following spring.

**HATS ENTERTAINMENT!**
The Frankford Yellow Jackets joined the NFL in 1924. Their fans came out on Saturdays because Philadelphia's blue laws prohibited games on Sunday.

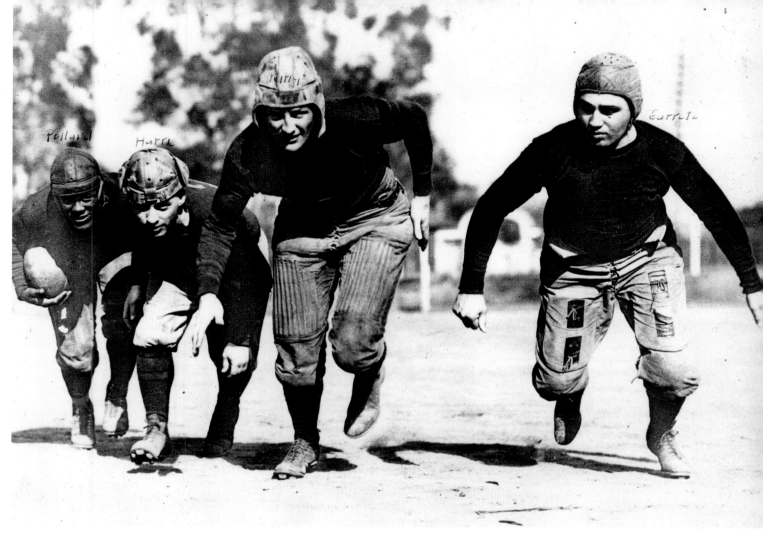

**A DEEP BENCH** The 1921 Akron Pros were co-coached by Fritz Pollard (far left). Paul Robeson also played for them.

The pivotal moment for pro football came in November 1925, when Halas and the Bears signed Red Grange, the famed Galloping Ghost, to a contract one day after his final game at Illinois. In the mythic age of Knute Rockne and the Four Horsemen, when college football was second only to baseball in sporting popularity, the Bears had acquired their own legend. After finishing out the last games of their regular-season schedule, Grange and the Bears began a barnstorming tour during which they played 17 games in two months before 302,000 people— including a crowd of 70,000 at the Polo Grounds and 75,000 at the Los Angeles Memorial Coliseum. The tour left Grange and many of his teammates hobbled, battered and lame, but it helped put pro football on the map, despite the widespread criticism from college coaches and administrators, who deemed it unseemly to play the game for money. "I see nothing wrong in playing football," said Grange. "It's the same as playing professional baseball, it seems to me. I have to get the money now because people will forget all about me in a few years."

Though the decade would see 35 franchises fail, pro football weathered the continued criticism from the college ranks and challenges from an upstart league. By the mid-'20s, there were four franchises that have survived to the present day—the Chicago Cardinals, the Chicago Bears, the Green Bay Packers and the New York Giants. Beyond the first blush of Grange's tour, the crowds tended to be woefully small. Halas would recall Tim Mara, the Giants' owner, surveying the Polo Grounds through a pair of binoculars and saying, "No, there's no one over there, either."

Still, by 1929, when the Packers won their first title, the NFL had survived its first decade. It would not be the last in the league's history when survival itself would feel like an accomplishment.

—**Michael MacCambridge**

**Within two years, the American Professional Football Association had changed its name to the National Football League. Fall weekends in America would never be the same.**

# Leaders

<table>
<tr><td rowspan="9">PASSING YARDS ▲</td><td>1920</td><td>Al Mahrt</td><td>Triangles</td><td>591*</td></tr>
<tr><td>1921</td><td>Rip King</td><td>Pros</td><td>533</td></tr>
<tr><td>1922</td><td>Jimmy Conzelman</td><td>Independents</td><td>474</td></tr>
<tr><td>1923</td><td>John Armstrong</td><td>Independents</td><td>778</td></tr>
<tr><td>1924</td><td>Curly Lambeau</td><td>Packers</td><td>1,094</td></tr>
<tr><td>1925</td><td>Hust Stockton</td><td>Yellow Jackets</td><td>886</td></tr>
<tr><td>1926</td><td>Ernie Nevers</td><td>Eskimos</td><td>885</td></tr>
<tr><td>1927</td><td>Bennie Friedman</td><td>Bulldogs</td><td>1,721</td></tr>
<tr><td>1928</td><td>Bennie Friedman</td><td>Wolverines</td><td>1,140</td></tr>
<tr><td>1929</td><td>Bennie Friedman</td><td>Giants</td><td>1,677</td></tr>
<tr><td rowspan="10">RUSHING YARDS ▲</td><td>1920</td><td>Dutch Stemaman</td><td>Staleys</td><td>274</td></tr>
<tr><td>1921</td><td>Fritz Pollard</td><td>Pros</td><td>265</td></tr>
<tr><td>1922</td><td>Jimmy Conzelman</td><td>Independents</td><td>400</td></tr>
<tr><td>1923</td><td>Tex Grigg</td><td>Bulldogs</td><td>439</td></tr>
<tr><td>1924</td><td>Tex Hamer</td><td>Yellow Jackets</td><td>789</td></tr>
<tr><td>1925</td><td>Barney Wentz</td><td>Maroons</td><td>656</td></tr>
<tr><td>1926</td><td>Barney Wentz</td><td>Maroons</td><td>727</td></tr>
<tr><td>1927</td><td>Charley Rogers</td><td>Yellow Jackets</td><td>508</td></tr>
<tr><td>1928</td><td>Bennie Friedman</td><td>Wolverines</td><td>564</td></tr>
<tr><td>1929</td><td>Red Grange</td><td>Bears</td><td>552</td></tr>
<tr><td rowspan="10">RECEIVING YARDS ▲</td><td>1920</td><td>Dutch Thiele</td><td>Triangles</td><td>181</td></tr>
<tr><td>1921</td><td>Scotty Bierce</td><td>Pros</td><td>285</td></tr>
<tr><td>1922</td><td>Guy Chamberlin</td><td>Bulldogs</td><td>258</td></tr>
<tr><td>1923</td><td>Charlie Mathys</td><td>Packers</td><td>494</td></tr>
<tr><td>1924</td><td>Charlie Mathys</td><td>Packers</td><td>579</td></tr>
<tr><td>1925</td><td>Charlie Berry</td><td>Maroons</td><td>364</td></tr>
<tr><td>1926</td><td>Charlie Berry</td><td>Maroons</td><td>330</td></tr>
<tr><td>1927</td><td>Charley Rogers</td><td>Yellow Jackets</td><td>541</td></tr>
<tr><td>1928</td><td>Eddie Kotal</td><td>Packers</td><td>508</td></tr>
<tr><td>1929</td><td>Ray Flaherty</td><td>Giants</td><td>449</td></tr>
</table>

# CHAMPIONS ▼

**1920**
**AKRON PROS**
—
**1921**
**CHICAGO STALEYS**
—
**1922**
**CANTON BULLDOGS**
—
**1923**
**CANTON BULLDOGS**
—
**1924**
**CLEVELAND BULLDOGS**
—
**1925**
**CHICAGO CARDINALS**
—
**1926**
**FRANKFORD YELLOW JACKETS**
—
**1927**
**NEW YORK GIANTS**
—
**1928**
**PROVIDENCE STEAM ROLLER**
—
**1929**
**GREEN BAY PACKERS**

# Pick Six

## $100

Original fee for an APFA franchise agreed upon by owners in their first meeting, on Sept. 17, 1920, at a Hupmobile dealership in Canton, Ohio. None of the 14 teams that played during the inaugural season actually paid the franchise fee.

## 6

Brothers who played in the early days of the NFL: Fred, Ted, Phil, John Frank, and Al Nesser. In 1921, Ted and his son Charles played together for the Columbus Panhandles, the only father-son playing duo in league history.

## 1,355

The closest (in miles) that the Los Angeles Buccaneers ever came to playing a game in their namesake city. The team, made up of Californians but based in Chicago, played only road games in its one season, 1927, and never played west of Kansas City.

## 1.000

Home winning percentage of Jim Thorpe's Oorang Indians. The short-lived team played twenty games over the 1922 and 1923 seasons, only one of which—a win over the Columbus Panhandles—was played at home. Unfortunately, they were 2–17 on the road.

## 40

Points scored in one game by Cardinals fullback Ernie Nevers, including six touchdowns and four extra point conversions. That was all of the Cardinals' scoring in a 40–6 win over the rival Bears at Comiskey Park on Thanksgiving Day, 1929. Nevers's point and touchdown totals have endured for nine decades.

## 1

Number of men enshrined in both the Pro Football and Baseball Halls of Fame. Cal Hubbard was a pioneer of the linebacker position for the Green Bay Packers, New York Giants, and, briefly, Pittsburgh Pirates, from 1927 to 1936. He then served as an American League umpire from 1936 to 1951.

*  ► *Leaders for this period are unofficial and in many cases incomplete. Compiled by David Neft and organized by the Professional Football Researchers Association*

# Innovations

**1921:** Replaceable cleats are introduced.

**1925:** Roster size is standardized, allowing 16 players per team per game.

**1926:** Players whose college class has not yet graduated are barred.

**1929:** Providence Steam Roller hosts Chicago Cardinals in first NFL night game.

## HELLO

► The Dayton Triangles defeat the Columbus Panhandles 14–0 in the first APFA game, (1920).

► George Halas moves the Decatur Staleys to Chicago (1921), then changes the team name to the Bears (1922).

► Fritz Pollard becomes pro football's first African-American coach (1921).

► APFA changes its name to National Football League (1922).

► The New York Giants are formed (1925).

► A Thanksgiving Day crowd of 36,000 fans watches Red Grange debut for the Bears (1925).

## GOODBYE

► Jim Thorpe is replaced as the league's first president by Joe Carr after one season (1921).

► The first American Football League folds after just one season (1926).

# In the Beginning . . .

## ORIGINAL 14 TEAMS (1920)

| | | |
|---|---|---|
| 1. | **Cardinals** | CHICAGO, IL |
| 2. | **Tigers** | CHICAGO, IL |
| 3. | **Staleys** | DECATUR, IL |
| 4. | **Independents** | ROCK ISLAND, IL |
| 5. | **Hammond Pros** | HAMMOND, IN |
| 6. | **Flyers** | MUNCIE, IN |
| 7. | **Heralds** | DETROIT, MI |
| 8. | **Akron Pros** | AKRON, OH |
| 9. | **Bulldogs** | CANTON, OH |
| 10. | **Tigers** | CLEVELAND, OH |
| 11. | **Panhandles** | COLUMBUS, OH |
| 12. | **Triangles** | DAYTON, OH |
| 13. | **All-Americans** | BUFFALO, NY |
| 14. | **Jeffersons** | ROCHESTER, NY |

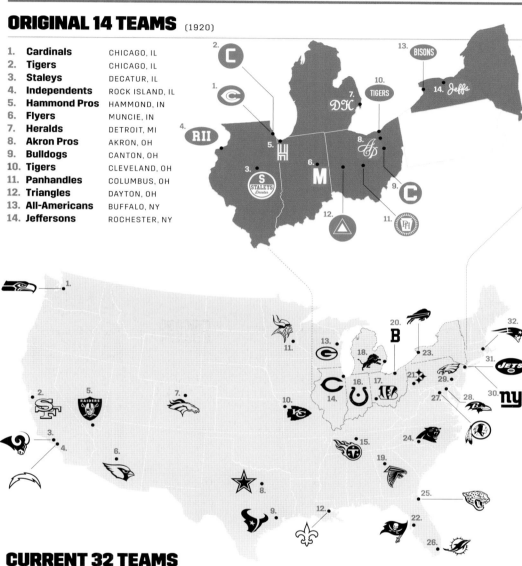

## CURRENT 32 TEAMS

| | | | | | | |
|---|---|---|---|---|---|---|
| 1. | **Seahawks** | SEATTLE, WA | | 17. | **Bengals** | CINCINNATI, OH |
| 2. | **49ers** | SANTA CLARA, CA | | 18. | **Lions** | DETROIT, MI |
| 3. | **Rams** | LOS ANGELES, CA | | 19. | **Falcons** | ATLANTA, GA |
| 4. | **Chargers** | LOS ANGELES, CA | | 20. | **Browns** | CLEVELAND, OH |
| 5. | **Raiders** | LAS VEGAS, NV (BEGINNING IN 2020) | | 21. | **Steelers** | PITTSBURGH, PA |
| 6. | **Cardinals** | GLENDALE, AZ | | 22. | **Buccaneers** | TAMPA, FL |
| 7. | **Broncos** | DENVER, CO | | 23. | **Bills** | ORCHARD PARK, NY |
| 8. | **Cowboys** | ARLINGTON, TX | | 24. | **Panthers** | CHARLOTTE, NC |
| 9. | **Texans** | HOUSTON, TX | | 25. | **Jaguars** | JACKSONVILLE, FL |
| 10. | **Chiefs** | KANSAS CITY, MO | | 26. | **Dolphins** | MIAMI GARDENS, FL |
| 11. | **Vikings** | MINNEAPOLIS, MN | | 27. | **Redskins** | LANDOVER, MD |
| 12. | **Saints** | NEW ORLEANS, LA | | 28. | **Ravens** | BALTIMORE, MD |
| 13. | **Packers** | GREEN BAY, WI | | 29. | **Eagles** | PHILADELPHIA, PA |
| 14. | **Bears** | CHICAGO, IL | | 30. | **Giants** | EAST RUTHERFORD, NJ |
| 15. | **Titans** | NASHVILLE, TN | | 31. | **Jets** | EAST RUTHERFORD, NJ |
| 16. | **Colts** | INDIANAPOLIS, IN | | 32. | **Patriots** | FOXBOROUGH, MA |

# THE PROS

**By Dan Jenkins,** FROM *FOOTBALL*, 1986

Now and then I like to remind people that pro football was a blue-collar sport for 50 years, a game mostly played by fat guys in the baseball parks of industrial cities. It didn't become chic until television.

For the most part, it came from factory workers.

In the beginning, there was rarely ever any talk about upside potential or downside risks when a man hired a bunch of meat packers to go out and play a bunch of guys from the brewery, the mill or the mines.

It gave the guys a diversion, anyhow. They were hulkish sportsmen who weren't nimble enough to make it in baseball, the only professional sport that paid a living wage. In the factories, the hours were long and exhausting and the take-home pay small, so why not release your frustrations in a game of football?

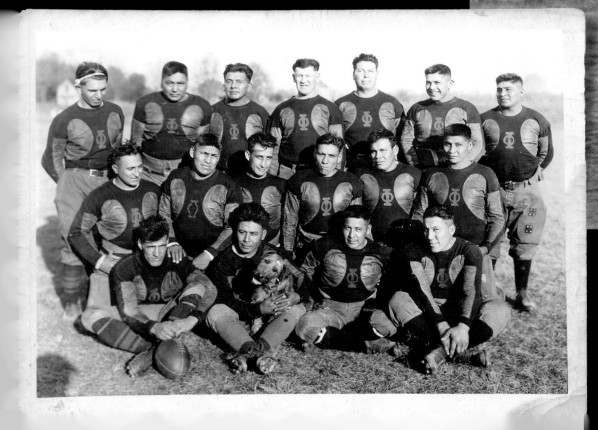

**THE DOG YEARS**
The owner of the Oorang Indians put the team together to promote his dog kennels, so they were a traveling squad with no real home field. They did, however, have Jim Thorpe (back row middle)

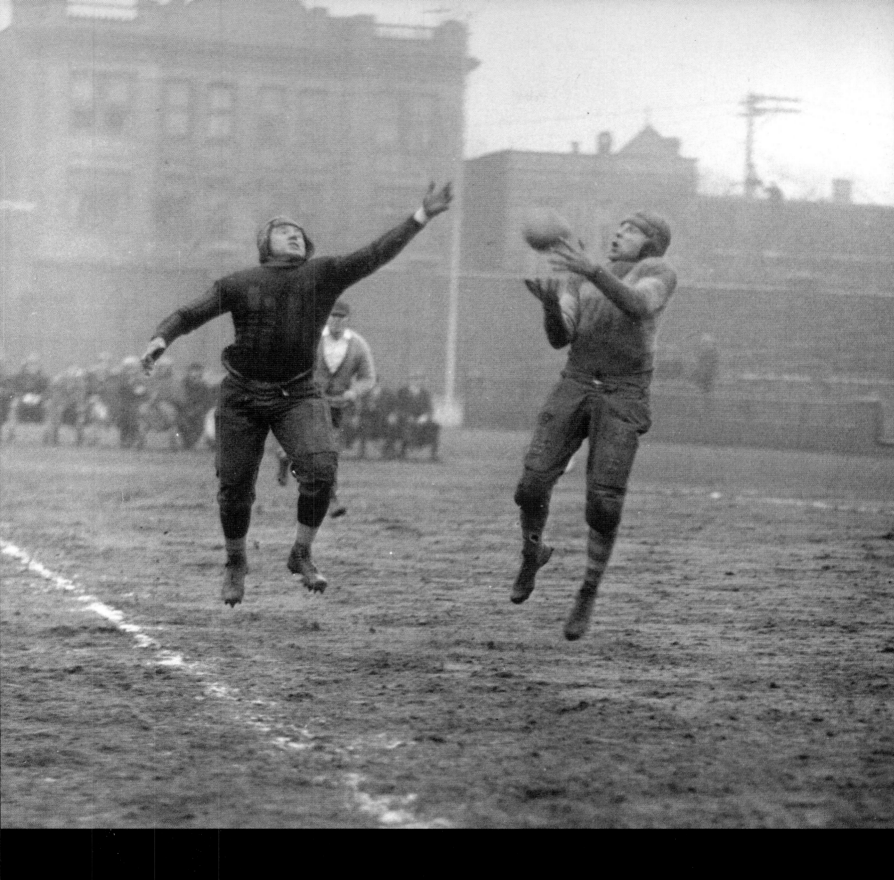

**Men understand football. It's war without death.
It's my school against your school, my town
against your town, my state against your state.**

DAN JENKINS

► FROM *YOU CALL IT SPORTS, BUT I SAY IT'S A JUNGLE OUT THERE*, 1989

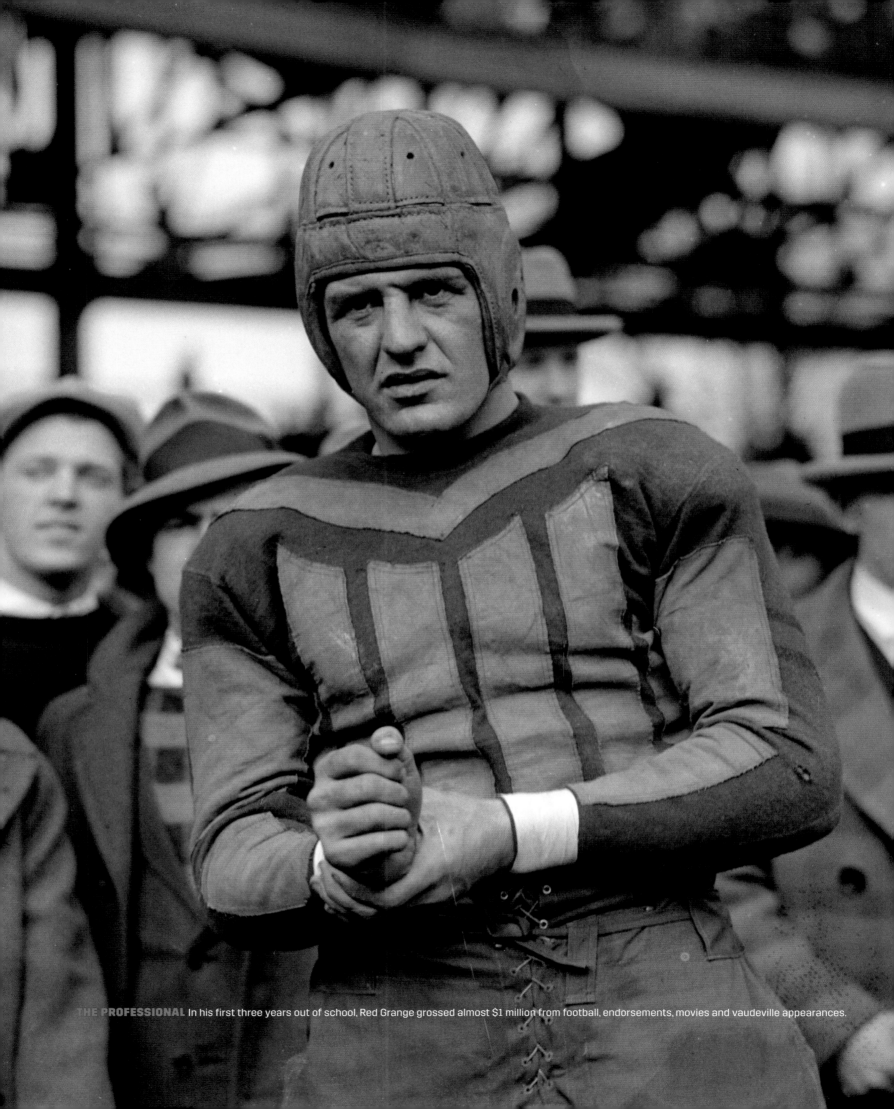

THE **PROFESSIONAL** In his first three years out of school, Red Grange grossed almost $1 million from football, endorsements, movies and vaudeville appearances.

# THE GHOST OF THE GRIDIRON

► **By W. C. Heinz,** FROM *WHAT A TIME IT WAS*, 2001

RED GRANGE HAD HIS LUCK, BUT IT WAS COMING to him, because he did more to popularize professional football than any other player before or since. In his first three years out of school he grossed almost $1,000,000 from football, motion pictures, vaudeville appearances and endorsements, and he could afford to turn down a Florida real estate firm that wanted to pay him $120,000 a year.

I have read what many of those sportswriters wrote, and they had as much trouble trying to corner Grange on paper as his opponents had trying to tackle him on the field. . . . Grange had blinding speed, amazing lateral mobility and exceptional change of pace and a powerful

> ## What made him great was his instinctive ability to plot a run the way a great general can map not only the battle but a whole campaign.

straight arm. He moved with high knee action but seemed to glide, rather than run, and he was a master at using his blockers. What made him great, however, was his instinctive ability to size up a field and plot a run the way a great general can map not only the battle but a whole campaign.

"The sportswriters wrote that I had peripheral vision," Grange was saying. "I didn't even know what the word meant. I had to look it up. They asked me about my change of pace, and I didn't even know that I ran at different speeds. I had a crossover step, but I couldn't spin. Some ballcarriers can spin but

if I ever tried that, I would have broken a leg."

What the statistics do not show . . . is what Grange, more than any other player, did to focus public attention and approval on the professional game. In 1925, when he signed with the Bears, professional football attracted little notice on the sports pages and few paying customers. There was so little interest that the American Professional Football Association did not even hold a championship playoff at the end of the season.

In 10 days after he left college, Grange played five games as a pro and changed all that. After only three practice sessions with the Bears, he made his pro debut against the Chicago Cardinals on Thanksgiving Day, Nov. 26. The game ended 0–0, but 36,000 people crowded into Wrigley Field to see Grange. Three days later, on a Sunday, 28,000 defied a snowstorm to watch him perform at the same field. On the next Wednesday, freezing weather in St. Louis held the attendance down to 8,000, but on Saturday 40,000 Philadelphians watched him in the rain at Shibe Park. The next day, the Bears played in the Polo Grounds against the New York Giants.

It had been raining for almost a week, and although advance sales were almost unknown in pro football in those days, the Giants sold almost 60,000 before Sunday dawned. It turned out to be a beautiful day. Cautious fans who had not bought seats in advance stormed the ticket booths. Thousands of people were turned away, but 73,651 crammed into the park. Grange did not score, but the Bears won 19–7. That was the beginning of professional football's rise.

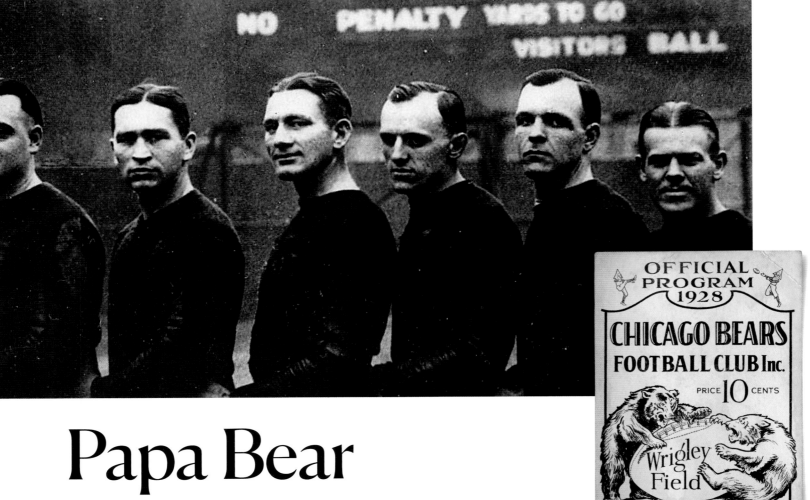

# Papa Bear

► **By Red Smith,** FROM *THE RED SMITH READER*, 1982

**George Stanley Halas** is the last survivor of that little group of willful men who sat on the running boards in Ralph Hays' Hupmobile showroom in Canton, Ohio, on Sept. 17, 1920, and laid the foundation of the NFL. Eleven teams were represented when the league was formed in that Canton auto agency, and after the meeting it was announced that the franchise fee was $100 each. Actually, George says, nobody paid anything. "I doubt if there was a hundred bucks in the whole room."

Papa Bear is a flaming wonder. As the team he founded winds up its 60th season, he still functions as owner, chairman of the board and chief executive officer. In 40 of those seasons he was also the coach, and the Bears have not won a championship since he fired himself for the fourth and final time. In bad weather he has twinges in the hip he injured as an outfielder in the 1919 training camp of the New York Yankees (that was a year before they got Babe Ruth), but he is still tough as a boot.

**WEARING MANY HATS** Halas was a founder of the league, the original owner of the Bears, a coach, a GM and even a player (third from right).

# JOE GUYON

► **By Myron Cope,** FROM *THE GAME THAT WAS*, 1969

**JOE GUYON, IN HIS OWN WORDS:**
"I played halfback on offense, and on defense I played sideback, which I suppose is what they later started calling defensive halfback. I had more damn tricks and, brother, I could hit you. Elbows, knees or whatchamacallit—boy, I could use 'em. And it's true that I used to laugh like the dickens when I saw other players get injured. Self-protection is the first thing they should have learned. You take care of yourself, you know. I think it's a sin if you don't. It's a rough game, so you've got to equip yourself and know what to do.

The games that were real scraps were the ones in Chicago. George Halas was a brawler. There'd be a fight every time we met those sons of biscuits. Halas knew that I was the key man. He knew that getting me out of there would make a difference. I was playing offense one time, and I saw him coming after me from a long ways off; I was always alert. But I pretended I didn't see him. When I got close, I wheeled around and nailed him, goddam. Broke three of his ribs. And as they carried him off, I said to him, "What the hell, Halas. Don't you know you can't sneak up on an Indian?""

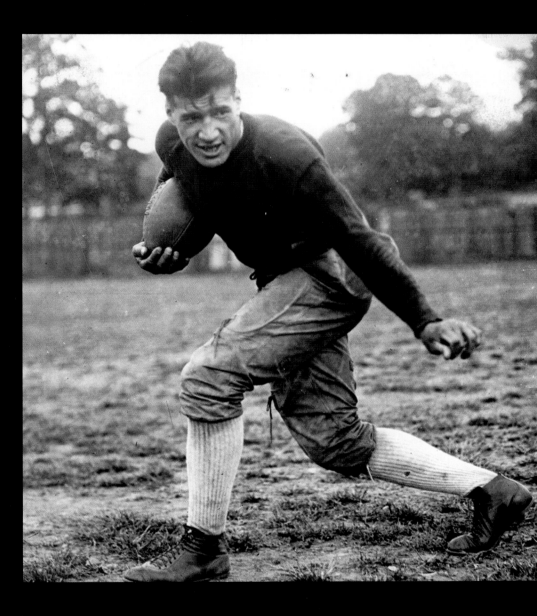

There is no argument about the identity of the greatest football player who ever performed in Dixie. There is a grand argument about second place, but for first place there is Joe Guyon, the Chippewa brave.

**RALPH MCGILL**
► ATLANTA NEWSPAPER PUBLISHER AND AUTHOR

"I think it's because I kept my sense of humor. I just got along. I took it—and bounced back for more. And scoring touchdowns won a lot of the Southern players over to my side."

—

**FRITZ POLLARD**
► DURING A 1970s INTERVIEW

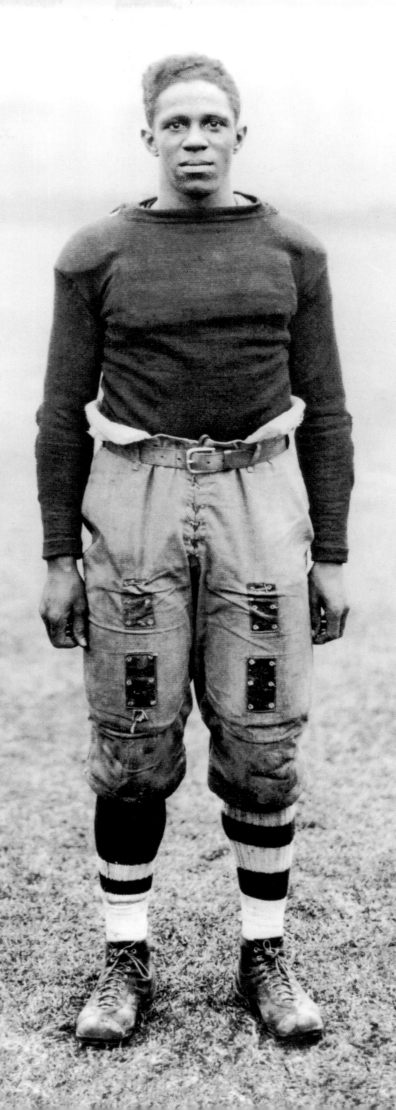

**AKRON PROS' PRO**
Pollard was a pioneer—one of the NFL's first black players and its first black coach—and, according to Walter Camp, "one of the finest runners these eyes have ever seen."

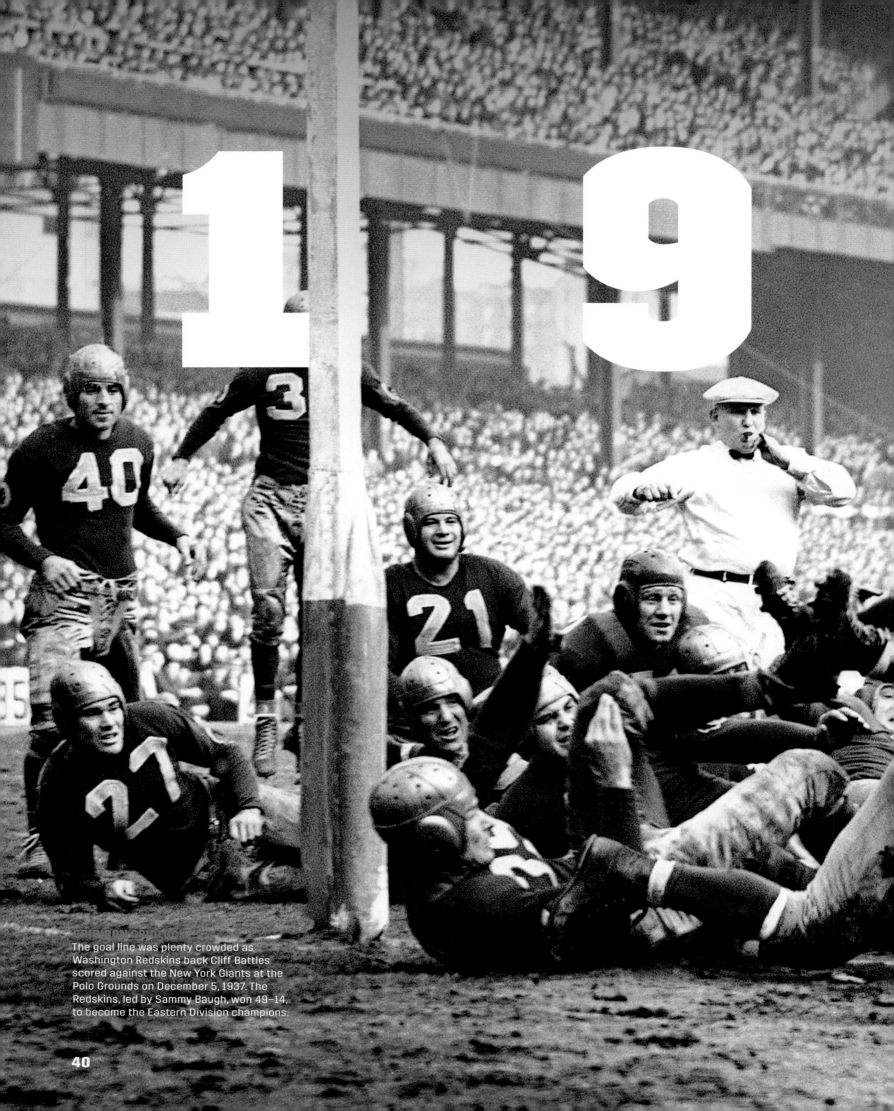

# 19

The goal line was plenty crowded as Washington Redskins back Cliff Battles scored against the New York Giants at the Polo Grounds on December 5, 1937. The Redskins, led by Sammy Baugh, won 49–14, to become the Eastern Division champions.

# 3 0s

## The Decade

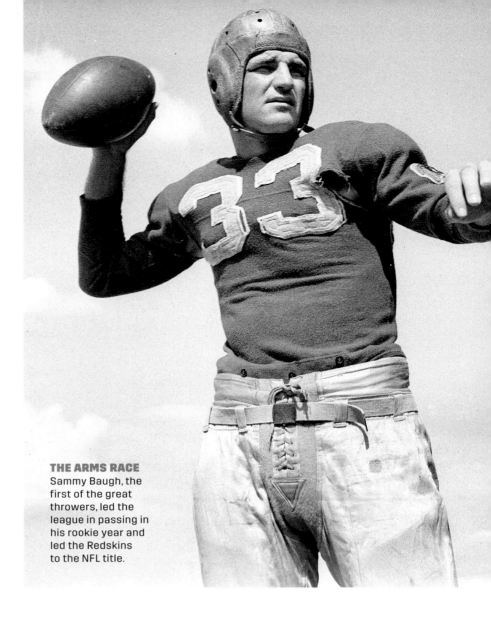

**THE ARMS RACE**
Sammy Baugh, the first of the great throwers, led the league in passing in his rookie year and led the Redskins to the NFL title.

THE HISTORIAN JOHN THORN, assessing pro football at the beginning of the '30s, described it as "a morass of low-scoring thumb-twiddlers, played largely by fly-by-night franchises in second-tier cities." Much of that would change during the course of the decade, as the maturing NFL gravitated to big cities, better competition, and the novelty of the forward pass. Though the league felt the burden of the Depression, it was during this decade that pro football began to define itself as something more than a rough imitation of the college game.

In 1932, when NFL teams averaged just 8.2 points per game, the league standings ended in a tie between Portsmouth and Chicago. The Spartans and Bears added an extra league game to the schedule to decide a champion but had to move it indoors to Chicago Stadium due to the paralyzing snow and cold in the Windy City. The Bears, led by a touchdown pass from the fierce fullback Bronko Nagurski—there has still never been a better football name—won 9–0, though there was controversy over whether Nagurski was the requisite five yards behind the line of scrimmage when he made the pass.

That controversy ushered in sweeping changes: In 1933, forward passes were allowed from anywhere behind the line of scrimmage, goal posts were moved to the goal line, and hash marks were added, 10 yards from the boundary, meaning fewer plays had to begin with the ball at the very edge of the field.

But the biggest structural change was separating the 10-team league into Western and Eastern Divisions and instituting an annual championship game between the division winners. The inaugural NFL Championship Game—a showdown between the Giants and Bears in front of 26,000 at Wrigley Field in Chicago in 1933—was one of the best, with six lead changes and a thrilling finish, as Red Grange, back with the Bears to finish his pro career, made a game-saving tackle around the arms of Morris "Red" Badgro, preventing him from lateraling to a teammate in the open field. The Bears prevailed 23–21.

The decade saw the demise of the Providence Steam Roller and the Staten Island Stapletons and the dawn of the Philadelphia Eagles and the Pittsburgh Steelers (who were called the Pirates during the '30s), and the Detroit Lions, who moved from Portsmouth in 1934, and inaugurated annual home games on Thanksgiving Day that same year.

In 1934, a new rule dictated that the football

## "In 1934, a new rule made the football slimmer. The impact soon became apparent. The tapered football made the forward pass more effective and hastened the end of drop-kicking."

couldn't be more than 21½ inches around, making it slimmer, by a full inch and a half, than it had been in the '20s. The impact on the game soon became apparent. The tapered football made the forward pass more effective and hastened the end of drop-kicking; Dutch Clark's drop-kick field goal in 1937, in fact, would prove to be the last in league history.

In 1935, on his first play from scrimmage, Packers end Don Hutson—then a rookie from Alabama—caught an 83-yard post pattern and quickly served notice that he would revolutionize the art of receiving. Hutson wasn't merely fast, he was also a master at route-running, with an unprecedented arsenal of precise cuts and deft feints.

The league's other structural change, designed to equalize competition, was conceived by the Eagles owner Bert Bell, approved by owners in 1935 and instituted in 1936. This was in the league's "annual selection meeting," which soon became known as the NFL draft, with teams drafting each round in inverse order of the previous season's standings. The first No. 1 pick, Heisman winner Jay Berwanger, from the University of Chicago, never signed with the NFL, but a year later, in 1937, the impact of the draft became clear. With the sixth pick in the first round, the Washington Redskins (newly relocated from Boston) drafted Slingin' Sammy Baugh out of TCU. Baugh would lead the league in passing in his rookie season and lead the Redskins to the NFL title.

In 1939, the league's longtime president, Joe Carr, passed away. He had presided over the maturation of the NFL, and as the decade drew to a close, the league even enjoyed a glimpse of the future: the first pro football game telecast, on October 22, 1939, matching the Brooklyn Dodgers against the Philadelphia Eagles. There were fewer than 1,000 television sets in the New York area at the time, but a crowd gathered to watch on a screen at the RCA Pavilion at the New York World's Fair. Both TV and pro football were on the rise. —**Michael MacCambridge**

**TWO-WAY TRAFFIC** Like most players in the NFL's early days, Giants running back Tuffy Leemans went both ways, playing offense and defense.

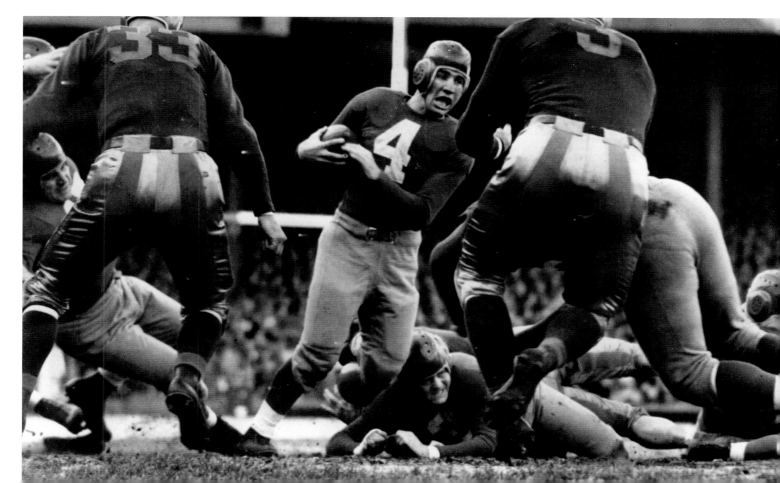

## Leaders

### PASSING YARDS

| | | | |
|---|---|---|---|
| 1930 | Bennie Friedman | Giants | 1,246* |
| 1931 | Bennie Friedman | Giants | 729* |
| 1932 | Arnie Herber | Packers | 639 |
| 1933 | Harry Newman | Giants | 973 |
| 1934 | Arnie Herber | Packers | 799 |
| 1935 | Ed Danowski | Giants | 794 |
| 1936 | Arnie Herber | Packers | 1,239 |
| 1937 | Sammy Baugh | Redskins | 1,127 |
| 1938 | Ace Parker | Dodgers | 865 |
| 1939 | Davey O'Brien | Eagles | 1,324 |

### RUSHING YARDS

| | | | |
|---|---|---|---|
| 1930 | Chuck Bennett | Spartans | 744* |
| 1931 | Red Grange | Bears | 599* |
| 1932 | Cliff Battles | Braves | 576 |
| 1933 | Jim Musick | Redskins | 809 |
| 1934 | Beattie Feathers | Bears | 1,004 |
| 1935 | Doug Russell | Cardinals | 499 |
| 1936 | Tuffy Leemans | Giants | 830 |
| 1937 | Cliff Battles | Redskins | 874 |
| 1938 | Byron White | Pirates | 567 |
| 1939 | Bill Osmanski | Bears | 699 |

### RECEIVING YARDS

| | | | |
|---|---|---|---|
| 1930 | Johnny Blood | Packers | 491* |
| 1931 | Johnny Blood | Packers | 490* |
| 1932 | Ray Flaherty | Giants | 350 |
| 1933 | Paul Moss | Pirates | 283 |
| 1934 | Harry Ebding | Lions | 264 |
| 1935 | Charley Malone | Redskins | 433 |
| 1936 | Don Hutson | Packers | 536 |
| 1937 | Gaynell Tinsley | Cardinals | 675 |
| 1938 | Don Hutson | Packers | 548 |
| 1939 | Don Hutson | Packers | 846 |

## CHAMPIONS

▼

**1930**
**GREEN BAY PACKERS**
—
**1931**
**GREEN BAY PACKERS**
—
**1932**
**CHICAGO BEARS**
—
**1933**
**CHICAGO BEARS**
—
**1934**
**NEW YORK GIANTS**
—
**1935**
**DETROIT LIONS**
—
**1936**
**GREEN BAY PACKERS**
—
**1937**
**WASHINGTON REDSKINS**
—
**1938**
**NEW YORK GIANTS**
—
**1939**
**GREEN BAY PACKERS**

## Pick Six

**31**

Years spent as an associate justice of the United States Supreme Court by Byron "Whizzer" White. White played just three NFL seasons, for the Pirates and the Lions, but led the league in rushing twice—which is more rushing titles won than by Hall of Famers Walter Payton, Marcus Allen or Terrell Davis.

**24**

Seasons that Steve Owen coached the New York Giants, beginning in 1930 and ending with his death in 1954. Under Owen the Giants won two championships and 153 games, which remains the franchise record for any coach. However, never in his coaching career did Owen sign a contract.

**53**

Of 81 players selected in the first NFL draft, the number who never played in the league. Among them was the fourth-round pick of the Brooklyn Dodgers, Paul "Bear" Bryant, who would later become the winningest coach in college football history.

**6**

Months from October 1935 to April 1936 in which Detroit won every major pro sports league title, earning the nickname City of Champions. Detroit is still the only city to hold three major professional sports championships concurrently.

**1**

Uniform number retired by the New York Giants to honor Ray Flaherty at the end of the 1935 season. The end, who led the league in receiving yards in 1932, became the first player in any major professional sports league to have his number retired.

**600**

Shares of the Green Bay Packers sold in 1935 with hopes of raising $15,000 to bail out the financially strapped team. No shares could ever be cashed out, and if the team were to fail, proceeds would be donated for a military memorial.

*  ► *Leaders for this period are unofficial and in many cases incomplete. Compiled by David Neft and organized by the Professional Football Researchers Association*

# Innovations

## 1932: Official individual statistics for passing, rushing, and receiving are kept for all games.

## 1933: The forward pass from anywhere behind the line of scrimmage is legalized.

## 1933: Hash marks are added 10 yards from the sidelines, and all plays begin on or between the hash marks.

## HELLO

▶ NFL playoffs are scheduled between the champions of the newly created East and West Divisions (1933).

▶ The Detroit Lions host a Thanksgiving Day game, now a tradition, for the first time (1934).

▶ Stability: The first year in which no team joins the NFL, moves, or folds (1936).

▶ The first NFL draft is held in Chicago (1936).

▶ The NFL presents its first official MVP Award to Mel Hein of the New York Giants (1938).

## GOODBYE

▶ George Halas is replaced as coach of the Bears by Ralph Jones and introduces the T Formation with a man in motion (1930).

▶ Red Grange, pro football's first national superstar, retires as a player (1934).

▶ Boston begins more than two decades without pro football as the Redskins relocate to Washington, D.C. (1937).

# The Talent Pool

Established in 1936, the draft is to the NFL as spring is to nature. But the annual selection of talent to replenish NFL rosters remains an inexact science, with eventual legends occasionally slipping through the cracks and can't-miss prospects descending into obscurity. Here are some notable bits of history from the NFL's yearly rite of rebirth.

## FIRST PICK ▶ JAY BERWANGER

The first selection in the NFL's inaugural draft, in 1936, was from the University of Chicago, which gave up football after 1939.

Winner of the first 1935 Downtown Athletic Club Trophy (renamed the Heisman Trophy in '36)

Drafted by the Philadelphia Eagles, his rights were traded to the Bears. He never played for Chicago because George Halas refused his contract request of $25,000 for two seasons.

## BEST PICK ▶ TOM BRADY

Tom Brady was selected in 2000 with the 199th pick. Six quarterbacks were drafted before him. Here's how Brady's production stacks up against theirs after the 2018 season.

**6 QBS PICKED BEFORE BRADY (COMBINED)**
Chad Pennington, Giovanni Carmazzi, Chris Redman, Tee Martin, Marc Bulger, Spergon Wynn

| 6 QBs Combined | | TOM BRADY |
|---|---|---|
| 229 | GAMES | 269 |
| 3,963 | COMPLETIONS | 6,004 |
| 6,310 | ATTEMPTS | 9,375 |
| 44,470 | PASS YARDS | 70,514 |
| 246 | PASS TD | 517 |
| 9 | POSTSEASON STARTS | 40 |
| 0 | SUPER BOWL STARTS | 10 |
| 0 | SUPER BOWL WINS | 6 |

## BEST DRAFT CLASS ▶ '74 STEELERS

On January 29, 1974, just 37 days after the Steelers were ousted by the Raiders in the AFC Division Playoff, Pittsburgh GM Dan Rooney, owner Art Rooney, and coach Chuck Noll transformed their team by drafting an unprecedented four Hall of Famers with their first five picks.

| | Hall of Famers Drafted | Round | Pick |
|---|---|---|---|
| WR | LYNN SWANN | 1 | 21 |
| LB | JACK LAMBERT | 2 | 46 |
| WR | JOHN STALLWORTH | 4 | 82 |
| C | MIKE WEBSTER | 5 | 125 |

## DRAFTED NO. 1 OVERALL MOST OFTEN

| COLTS | RAMS | BUCS | BROWNS |
|---|---|---|---|
| 卌 卌 || | 卌 卌 || | 卌 卌 | 卌 卌 |

## DECISIONS, DECISIONS

From 1961 through '66, when the AFL and NFL held separate drafts, players were often selected by both leagues. These icons likely altered the fate of the team they signed with—and the team they didn't.

| | NFL | AFL |
|---|---|---|
| 1965 **Joe Namath** | ⊘ | (Jets) |
| 1965 **Gale Sayers** | (Bears) | ⊘ |
| 1965 **Dick Butkus** | (Bears) | ⊘ |
| 1964 **Carl Eller** | (Vikings) | ⊘ |
| 1964 **Paul Warfield** | (Browns) | ⊘ |
| 1963 **Buck Buchanan** | ⊘ | (Chiefs) |
| 1963 **Bobby Bell** | ⊘ | (Chiefs) |
| 1963 **John Mackey** | (Colts) | ⊘ |
| 1962 **Merlin Olsen** | (Rams) | ⊘ |
| 1961 **Mike Ditka** | (Bears) | ⊘ |
| 1961 **Bob Lilly** | (Cowboys) | ⊘ |
| 1961 **Fran Tarkenton** | (Vikings) | ⊘ |
| 1961 **Fred Biletnikoff** | ⊘ | (Raiders) |

# MONEY BALL

**By Oliver E. Kuechle**
FROM *THE MILWAUKEE JOURNAL*,
DECEMBER 18, 1933

**The Chicago Bears beat the New York Giants for the** professional football championship of the world at Cubs Park in a point a minute football game that left 25,000 raving fans limp. The score was 23 to 21. If ever a greater football game was played, none of the 25,000 here today saw it. It was a game that dripped with drama, dripped with sensational passing, dripped with sensational kicking, dripped, in fact, with the superlative of everything that goes to make up football. It was better than a whole season of college football. The lead changed hands no less than six times.... You've seen two ambitious boys slug away at each other and take turns knocking each other down in the ring. That's the kind of game this was. Passing, such as nobody here ever saw before, figured directly or indirectly in all five touchdowns.

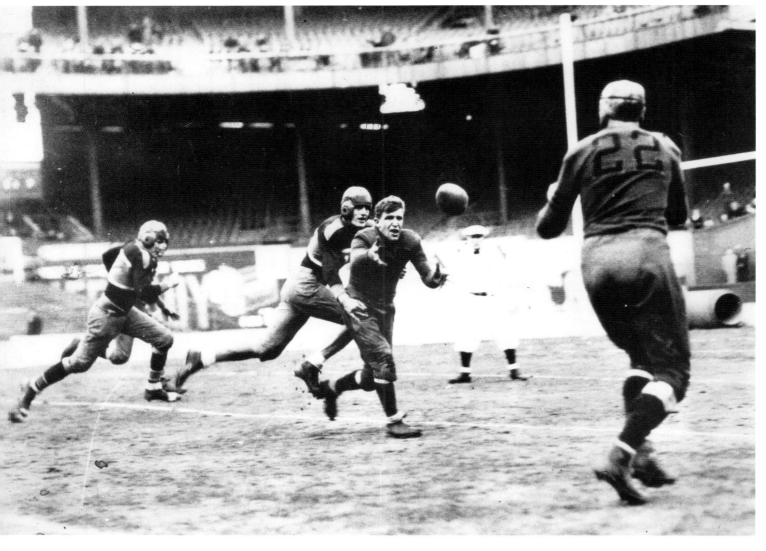

**ALL THE MARBLES** Beating the Giants in the NFL's inaugural title game earned each member of the Bears a check for $210.34.

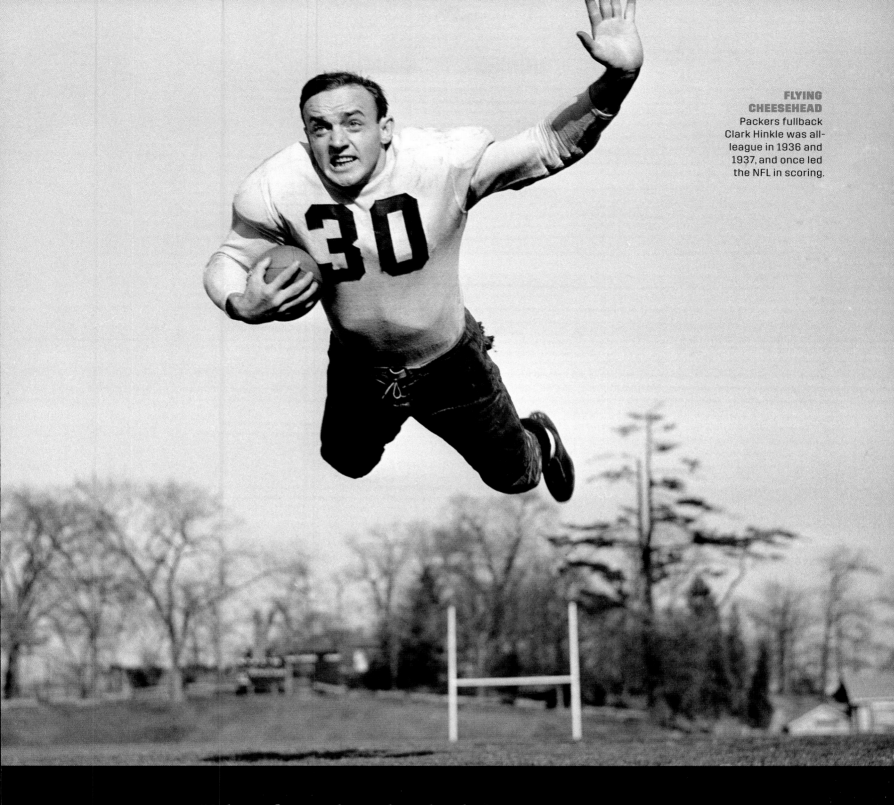

"A lot of people today think Green Bay was never a great football town until Vince Lombardi built all those winners in the 1960s. This kind of annoys me. They talk like we were a bunch of guys that got together on weekends. Listen, Curly Lambeau . . . won six championships, and in his early days he was just as tough and mean as anyone else. You think Lombardi was tough? Lambeau was tougher."

**CLARKE HINKLE**

➤ FROM *THE GAME THAT WAS*, 1970, **by Myron Cope**

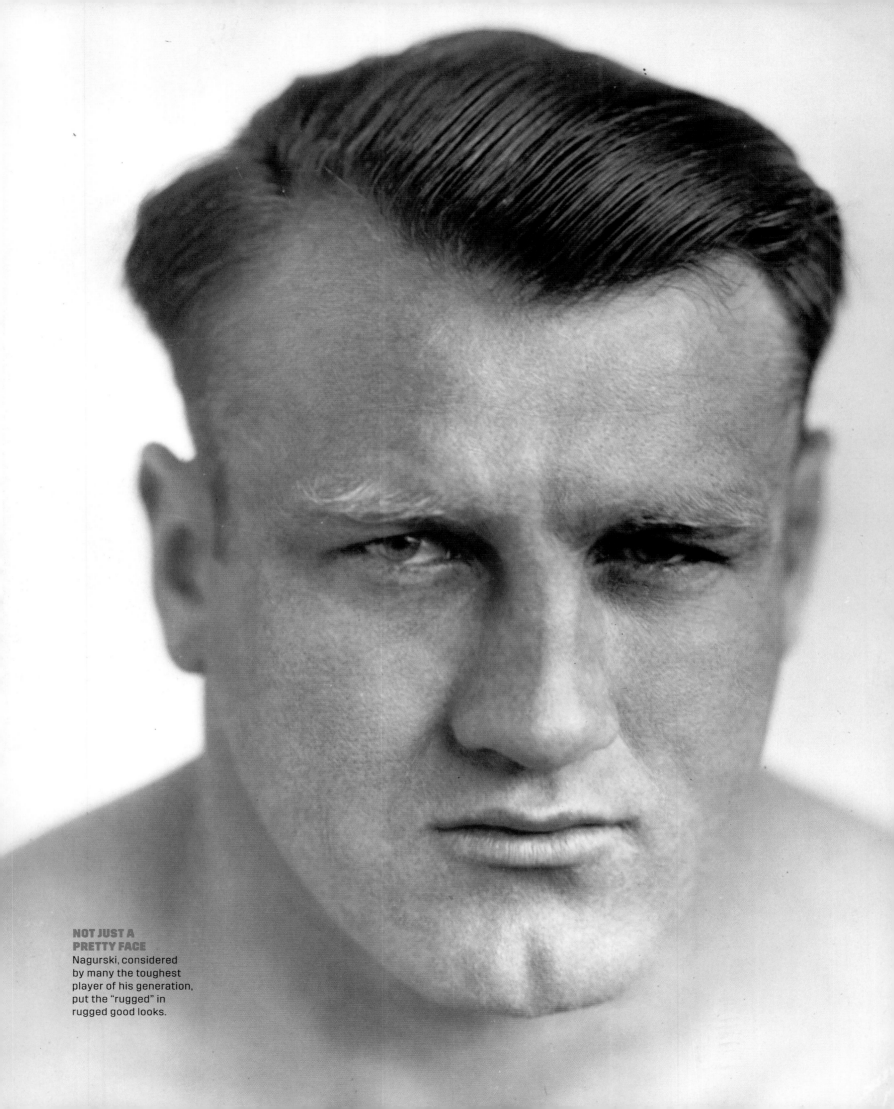

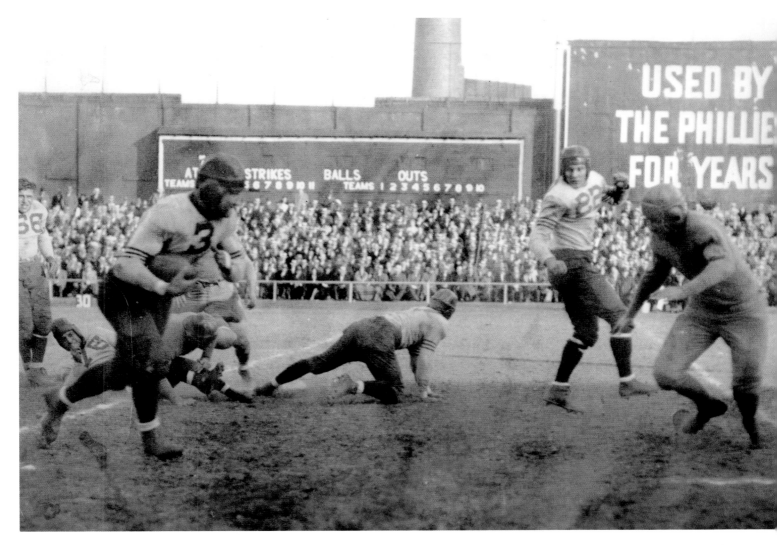

**ROLLING THUNDER** Red Grange, an expert on such accolades, called Nagurski (3) the greatest player he'd ever seen.

# BRONKO NAGURSKI

➤ **By Charles P. Pierce**
FROM *ESQUIRE*, OCTOBER 1998

THERE'S AN OLD STORY THEY TELL ABOUT Bronko Nagurski, a man of heedless simplicity who knocked people over on behalf of the Chicago Bears in the waxing half of this century. One afternoon, while playing at Wrigley Field, Nagurski lowered his head—which, in his case, could be said to include everything down to his knees—blew through two tacklers for a touchdown and then kept going, right into the famous ivy-drenched walls of the ballpark. He returned to the sidelines and greeted George Halas, the coach of the Bears. "Jeez," Nagurski told the stricken coach. "That last guy gave me a hell of a lick."

# Johnny "Blood" McNally

► **By Gerald Holland,** FROM *SPORTS ILLUSTRATED*, SEPTEMBER 2, 1963

**Candidate John F. Kennedy** met him for the first time in Green Bay, during the Wisconsin primary campaign.

"Your name," said Senator Kennedy, "was a household word in our home." After the election, President Kennedy greeted McNally again at a White House reception, which he attended in the company of his friend Byron White, then deputy attorney general, now a Justice of the Supreme Court.

His full name, as entered in the record at Canton, is John Victor McNally. If it rings no bell, then for John Victor McNally read Johnny Blood—the name he used when he was a household word with the teenage Kennedy boys, the name of the legendary halfback who scored 37 touchdowns and 224 points during his career with the Green Bay Packers and helped them win four NFL championships. As Johnny Blood, he played all around the pro circuit and served three seasons as player-coach of the Pittsburgh Steelers, the team for which he once signed his friend Whizzer White.

"He was a great teammate," said White. "Nothing fazed him. Sometimes, although he was player-coach, he might miss a practice and explain the next day that he had been to the library. He was a fine defense man. He was fast. I tried all season to beat him at 100 yards and couldn't. He was a great receiver. He thought there wasn't a ball in the air he couldn't catch."

**BLOODY WELL** McNally taught college history and economics after football and began studying for his master's degree when he was fifty. He ran for sheriff of St. Croix County, Wisconsin, on a platform promising honest wrestling.

# "In 1933 I paid $2,500 for a National Football League franchise, which I named the Pirates because the Pittsburgh baseball team was called the Pirates. It wasn't until 1940, when we had a contest for a new name, that we became the Steelers. Joe Carr's girlfriend won the contest. There were some people who said, 'That contest doesn't look like it was on the level.'"

## ART ROONEY

► FROM *THE GAME THAT WAS*, 1970, **by Myron Cope**

**ART OF THE DEAL** Rooney's Pirates never finished above .500 in the 1930s. In 1940, he renamed the team the Steelers.

**DON OF A NEW AGE** Hutson's 488 career receptions in 11 seasons were 200 more than anyone else's in that era. His number 14 was the first jersey retired by the Packers.

# DON HUTSON

► **By Peter King,** FROM *SPORTS ILLUSTRATED*, NOVEMBER 29, 1999

YOU'RE THE GUY WHO NAMED DON HUTSON THE BEST player of all time," a West Coast talk show host said to me on the air a few years ago. "Did people take that seriously?"

That's the kind of reaction I got when, in a 1993 pro football history book, I called the Green Bay Packers wide receiver the best ever. Hutson had never played a game on TV. He hadn't suited up in 48 years. But when he left the game in 1945 after 11 seasons, his 99 touchdown receptions were three times as many as any other player's in NFL history. Naturally, as I told Hutson a few years back (he died

in 1997), I wish I could have seen him in action.

Hutson was football's DiMaggio, a graceful runner who never looked as if he was trying hard. He also had some sprinter in him. At Alabama he had run the 100-yard dash in 9.8 seconds. The grainy, fluttering film I've seen of Hutson shows a 6' 1" man, much taller than most of the defensive backs who covered him. But his leather helmet rode high on his head, making him appear a little nerdy. You'd never know by listening to Hutson how good he was. He hated talking about himself.

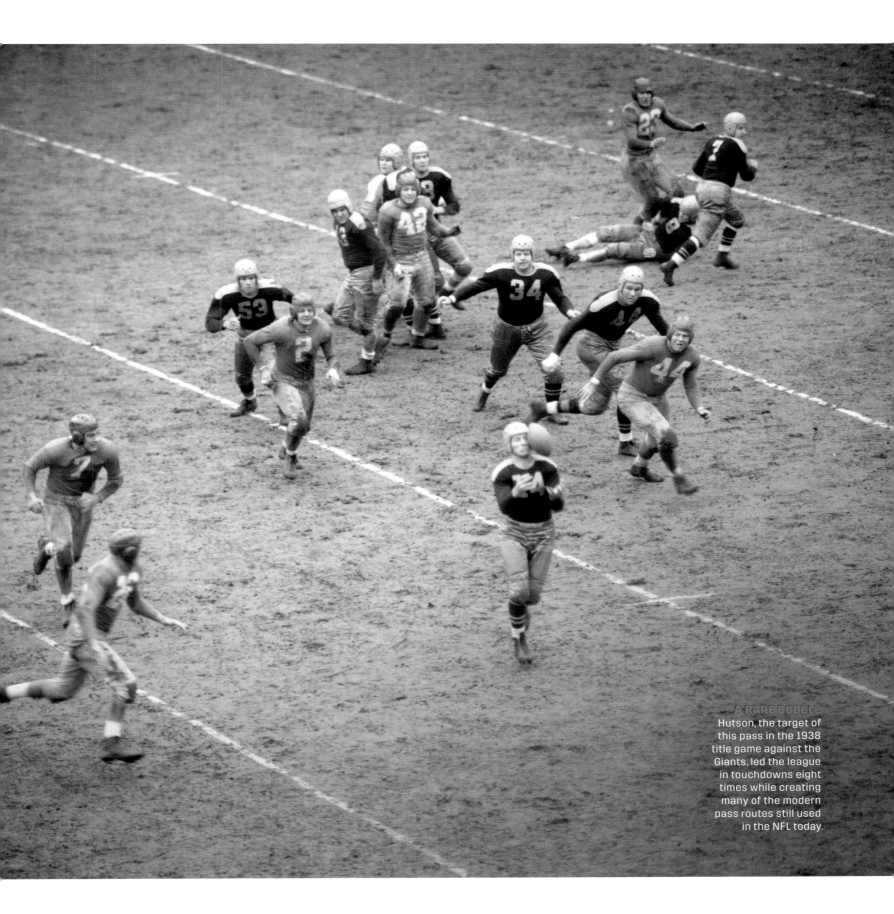

**A RARE BOBBLE**
Hutson, the target of
this pass in the 1938
title game against the
Giants, led the league
in touchdowns eight
times while creating
many of the modern
pass routes still used
in the NFL today.

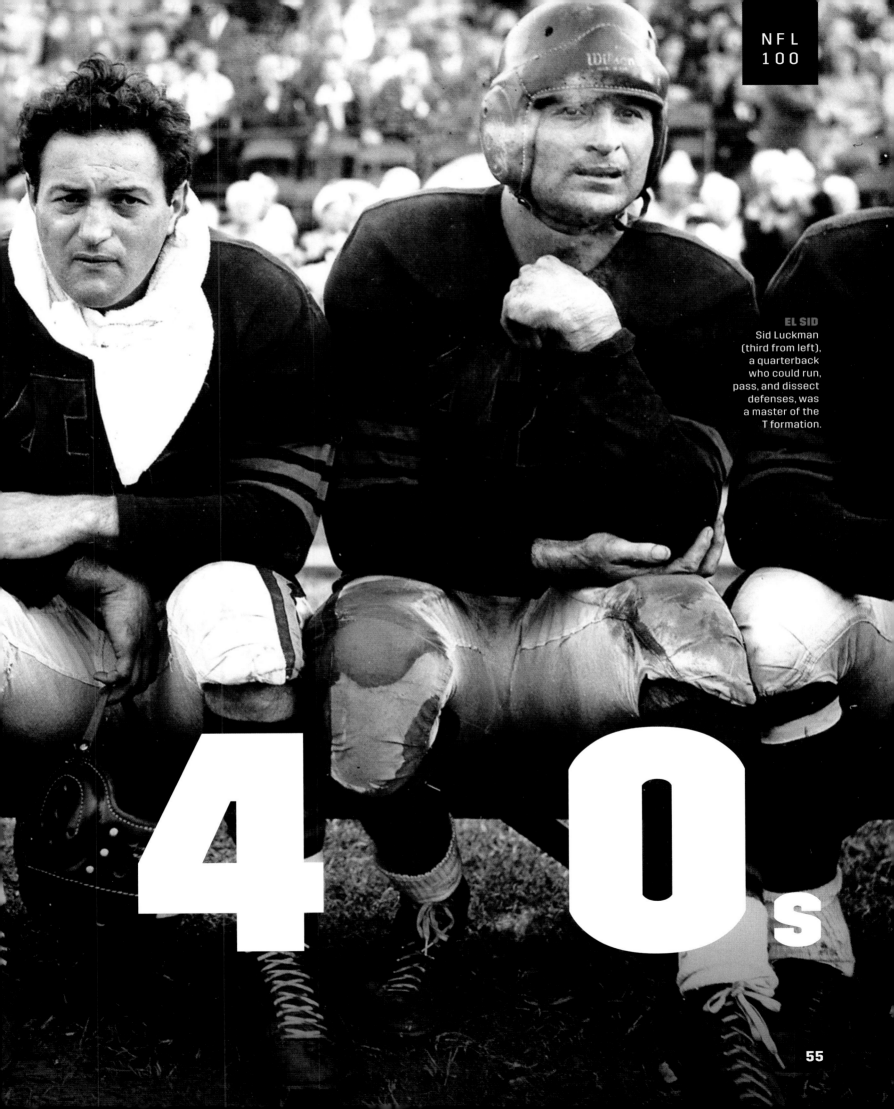

**EL SID**
Sid Luckman
(third from left),
a quarterback
who could run,
pass, and dissect
defenses, was
a master of the
T formation.

# 4  0s

I T WAS LATE IN THE FIRST HALF OF THE Washington Redskins' final game of the 1941 season, against the Eagles in front of 27,102 at Griffith Stadium, when an announcement went out over the public address loudspeakers asking for all government and military personnel to report to their bases at once. The attack on Pearl Harbor had begun just minutes before the games, and as word spread, it was clear that it would affect the NFL just as it would the rest of the country. When the United States entered the war, sweeping changes mobilized the nation but in the process nearly extinguished the NFL. Over the next four years, 638 active players served in the armed forces, and 19 players died in combat. During the manpower shortage in 1943, the Cleveland Rams suspended operations for a

year, while the Pittsburgh Steelers and Philadelphia Eagles merged to become, for one season, the "Steagles." Yet the league remained intact, and by 1944, attendance had bounced back to prewar levels.

On the field, the decade had begun with an emphatic strategic statement. In the 1940 NFL Championship Game between Chicago and Washington, the Bears—the only team in the NFL regularly using the T formation—scored on the third play of the game, took a 21–0 first-quarter lead and went on to demolish the Redskins 73–0. The Bears kicked so many extra points into the stands that the supply of footballs ran out, and the game ended with the teams using an old practice ball. (Chicago had to run or pass instead of kicking their final three conversion attempts.) The rout—the NFL's first title game broadcast nationally on radio—was the pivotal moment in the NFL's move away from

**RIFLE, ARMS** With war roiling Europe, the New York Giants posed for this training camp picture in 1940 to show support for the troops.

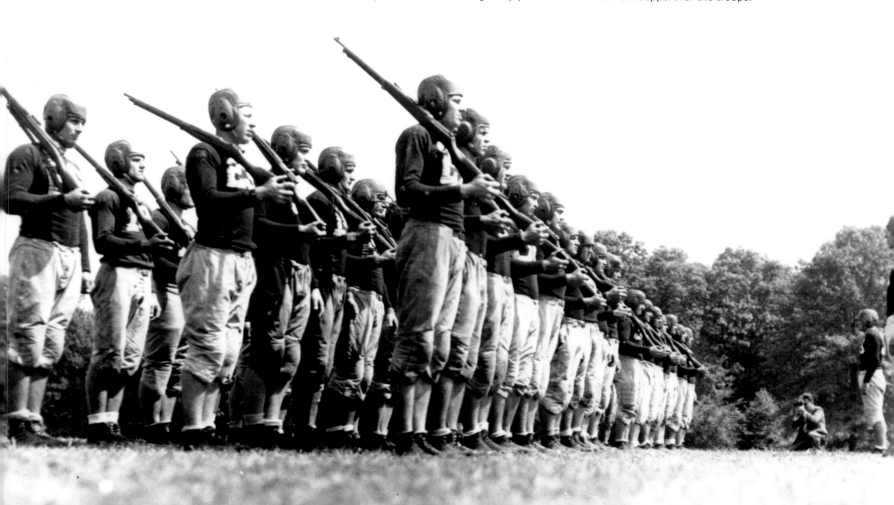

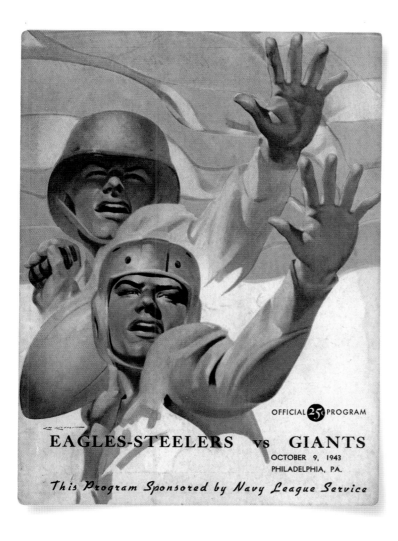

**EAGLES-STEELERS vs GIANTS**

OFFICIAL 25¢ PROGRAM

OCTOBER 9, 1943
PHILADELPHIA, PA.

*This Program Sponsored by Navy League Service*

**OVER THERE**
So many players enlisted in the service during WWII that some NFL teams had to combine forces. The Eagles-Steelers squad was sometimes called the Steagles.

the Rams' owner, Daniel F. Reeves, petitioned to move his league champions to the West Coast, making the NFL a truly national league more than a decade before Major League Baseball's Dodgers and Giants moved west. That offseason, the Rams signed Kenny Washington and Woody Strode, the first African-Americans to play in the NFL since 1933.

Back in Cleveland, former Ohio State coach Paul Brown had agreed to lead the Cleveland Browns in the upstart All-America Football Conference, which began play in 1946. In August, Brown signed future Hall of Famers Bill Willis and Marion Motely, effectively integrating the AAFC. Brown's Browns aimed to be, in the coach's words, "the New York Yankees of football," and succeeded immediately, winning four consecutive AAFC titles before the league folded, with Cleveland, San Francisco, and Baltimore agreeing to join the NFL in 1950.

Taken together, the Bears' early-decade dominance and Brown's late-decade innovations helped to transform the way the game was played. "Football became a game of brains," said Halas. Brown's cerebral approach to the game—from his dedicated film study to his relentless parsing of tactics—treated the game with the seriousness of an academic pursuit. "He brought a system into pro football," said Sid Gillman. "He's an organizational genius. I always felt that, before Paul Brown, coaches just rolled the ball out on the practice field."

The decade also brought a stylistic innovation. In 1948, the Rams' Fred Gehrke painted a dark-blue background and a stylized gold Rams horn onto the sides of the team's drab leather helmets. Soon, nearly every team would follow suit, though Gehrke had set a high standard. Decades later, Leroy Neiman would describe the design as "the most effective pop art symbol in all of sports." **—Michael MacCambridge**

the single wing and toward the T formation. Bears coach George Halas had refined the Bears' attack with the help of Clark Shaughnessy, who coached Stanford to an undefeated season in 1940.

When the troops returned home at the end of the war, the Cleveland Rams won the 1945 NFL title behind rookie quarterback Bob Waterfield, beating Washington 15–14 in zero-degree weather in Cleveland. It would be their last home game on the shores of Lake Erie.

What followed that '45 title game was one of the most eventful months in league history. At the NFL's annual meetings in January 1946, Eagles owner Bert Bell was named the new commissioner, replacing the deposed Elmer Layden. A day later,

## Paul Brown's approach— from his dedicated film study to his relentless parsing of tactics— treated the game with the seriousness of an academic pursuit.

# Leaders

| | | | |
|---|---|---|---|
| **PASSING YARDS** ▲ | 1940 | Sammy Baugh | Redskins | 1,367 |
| | 1941 | Cecil Isbell | Packers | 1,479 |
| | 1942 | Cecil Isbell | Packers | 2,021 |
| | 1943 | Sid Luckman | Bears | 2,194 |
| | 1944 | Irv Comp | Packers | 1,159 |
| | 1945 | Sid Luckman | Bears | 1,727 |
| | 1946 | Sid Luckman | Bears | 1,826 |
| | 1947 | Sammy Baugh | Redskins | 2,938 |
| | 1948 | Sammy Baugh | Redskins | 2,599 |
| | 1949 | Johnny Lujack | Bears | 2,658 |

| | | | |
|---|---|---|---|
| **RUSHING YARDS** ▲ | 1940 | Byron White | Lions | 514 |
| | 1941 | Pug Manders | Dodgers | 486 |
| | 1942 | Bill Dudley | Steelers | 696 |
| | 1943 | Bill Paschal | Giants | 572 |
| | 1944 | Bill Paschal | Giants | 737 |
| | 1945 | Steve Van Buren | Eagles | 832 |
| | 1946 | Bill Dudley | Steelers | 604 |
| | 1947 | Steve Van Buren | Eagles | 1,008 |
| | 1948 | Steve Van Buren | Eagles | 945 |
| | 1949 | Steve Van Buren | Eagles | 1,146 |

| | | | |
|---|---|---|---|
| **RECEIVING YARDS** ▲ | 1940 | Don Looney | Eagles | 707 |
| | 1941 | Don Hutson | Packers | 738 |
| | 1942 | Don Hutson | Packers | 1,211 |
| | 1943 | Don Hutson | Packers | 776 |
| | 1944 | Don Hutson | Packers | 866 |
| | 1945 | Jim Benton | Rams | 1,067 |
| | 1946 | Jim Benton | Rams | 981 |
| | 1947 | Mal Kutner | Cardinals | 944 |
| | 1948 | Mal Kutner | Cardinals | 943 |
| | 1949 | Bob Mann | Lions | 1,014 |

## CHAMPIONS
▼

1940
**CHICAGO BEARS**
—
1941
**CHICAGO BEARS**
—
1942
**WASHINGTON REDSKINS**
—
1943
**CHICAGO BEARS**
—
1944
**GREEN BAY PACKERS**
—
1945
**CLEVELAND RAMS**
—
1946
**CHICAGO BEARS**
—
1947
**CHICAGO CARDINALS**
—
1948
**PHILADELPHIA EAGLES**
—
1949
**PHILADELPHIA EAGLES**

# Pick Six

## 9

Takeaways for the Bears in their 73–0 win over the Redskins in the 1940 championship game. Eight decades later that total of eight interceptions and one fumble during the most lopsided game in NFL history remains tied for the most takeaways in any postseason game.

## 6

Months before Jackie Robinson broke baseball's color barrier with the Brooklyn Dodgers that Robinson's former UCLA teammates Kenny Washington and Woody Strode broke the NFL's color barrier in their debut for the Los Angeles Rams.

## −53

Rushing yards by the Lions against the Cardinals on October 17, 1943, the worst performance on the ground for any team in NFL history. The Cardinals managed to pick up 38 yards, but that only brought the combined total to −15 rushing yards, which also remains the lowest in NFL history.

## 3,500

Dollars allegedly offered by a known gambler to Giants players Merle Hapes and Frank Filchock to throw the 1946 championship game against the Bears. Hapes was suspended and never again played in the NFL. Filchock played and threw two touchdown passes in a 24–14 loss.

## 0

Points scored by field goal by the 1944 Bears out of a total of 238. No team in the 75 years since has completed an NFL season without the benefit of a single field goal. Pete Gudauskas, who didn't even attempt a field goal during the season, successfully kicked 36 of 37 point-after attempts.

## 51.4

Yards per punt for Slingin' Sammy Baugh in 1940, a record that has endured for nearly eighty years. A member of the inaugural Hall of Fame class, Baugh was a three-way star who led the league in passing yards four times, in punting five times, and in interceptions in 1943, with 11 in 10 games.

# The Legacy of Other Leagues

|  |  |  |  |  |  |
|---|---|---|---|---|---|
| **AAFC**<br>1946–1949 | **AFL**<br>1960–1969 | **WFL**<br>1974–1975 | **USFL**<br>1983–1985 | **XFL**<br>2001 | **CFL**<br>1958–present |
| **LEGACY**<br>The Cleveland Browns, Baltimore Colts, and San Francisco 49ers, who would survive to play in the NFL. | **LEGACY**<br>The Super Bowl and 10 teams: Patriots, Bills, Jets, Dolphins, Bengals, Raiders, Chargers, Broncos, Titans, Chiefs. | **LEGACY**<br>Established Jacksonville and Charlotte as potential NFL markets. | **LEGACY**<br>Blockbuster player contracts, instant replay challenges, two-point conversions. | **LEGACY**<br>Skycam, *Sunday Night Football*, OT with each side getting the ball at least once. | **LEGACY**<br>Showcased eventual NFL stars such as Doug Flutie, Cookie Gilchrist, Warren Moon, and Joe Theismann. |
| **EXTRA POINT**<br>When the merger of the AAFC and NFL was completed on Dec. 9, 1949, the new league was called the National-American Football League. That name lasted just 84 days until owners unanimously decided to revert to NFL. | **EXTRA POINT**<br>Bills guard Billy Shaw is the only player to be inducted into the Pro Football Hall of Fame who never played in the NFL. He spent his entire 10-year career in the AFL. | **EXTRA POINT**<br>Jim Fassel, who coached the New York Giants to an appearance in Super Bowl XXXV, threw the final pass in the history of the WFL while playing quarterback for the Hawaiians. | **EXTRA POINT**<br>The Chicago Blitz employed two Hall of Fame head coaches. George Allen was the inaugural coach for 1983. He was replaced by Marv Levy, who would go on to lead the Buffalo Bills to four Super Bowls. | **EXTRA POINT**<br>Saints safety Steve Gleason, whose blocked punt in the first game at the Superdome after Hurricane Katrina is immortalized by a statue, was the 191st pick of the Birmingham Thunderbolts in the only XFL draft. | **EXTRA POINT**<br>In 1991 the Toronto Argonauts signed Raghib "Rocket" Ismail to a four-year, $26.2 million contract, at the time the richest in pro football history. He was named 1991 Grey Cup MVP but left for the NFL in '93. |

# Innovations

**1941:** Elmer Layden elected as NFL's first commissioner.

**1943:** Helmets are required for all players.

**1944:** Coaching from the bench is legalized.

**1949:** Free substitution is legalized.

**1949:** The AAFC and NFL announce plans to merge.

## HELLO

- ► The All-American Football Conference begins play with eight teams in 1946.

- ► Mile High Stadium, home to the Denver Broncos from 1960 through 2000, opens (as Bears Stadium) in 1948.

- ► Archie Manning, father of two multiple-winning Super Bowl QBs, is born on May 19, 1949, in Cleveland, Mississippi.

- ► Twenty-two-year-old quarterback George Blanda debuts with the Bears. He'd go on to play a record 26 seasons in the NFL and AFL.

- ► Rams halfback Fred Gehrke paints horns on his helmet in 1948, creating the league's first helmet logo.

## GOODBYE

- ► Rookie quarterback Bob Waterfield leads the Rams to the 1945 championship over the Redskins in his team's last-ever home game in Cleveland.

- ► In April 1947, Cardinals owner and former vice president of the Bears Charles Bidwill, Sr., dies at age fifty-one. The Cards would go on to win the 1947 championship in his honor.

- ► The NFL's first great pass-catch duo, Arnie Herber and Don Hutson of the Packers, both retire in 1945.

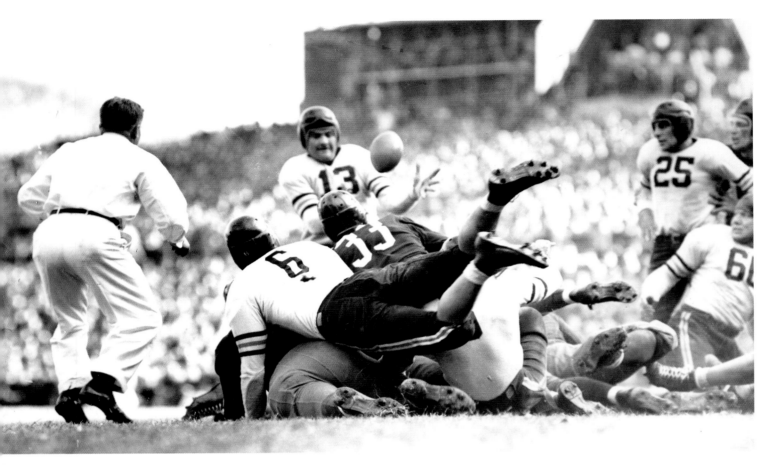

**PILING ON** Joe Stydahar grabs a fumble by Redskins QB Sammy Baugh (33) during the Bears' 73–0 win in the 1940 title game.

# BEARLY LEGAL

➤ **By George Ratterman with Robert G. Deindorfer,** FROM *CONFESSIONS OF A GYPSY QUARTERBACK*, 1962

NOBODY EVER DISSECTED A LOST CAUSE WITH QUITE the honest stoicism as Sammy Baugh after his Washington Redskins lost the 1940 National [Football] League title to the Chicago Bears by a rather conclusive 73 to 0 count. The game has since passed into the realm of legend as the Typographical Error Championship, not only because the Bears beat the Redskins 73 to 0 but also because the Redskins had beaten the Bears 7 to 3 only two weeks earlier.

Down in the locker room after the game a highly partisan Washington sportswriter in search of an alibi he could exaggerate to explain the calamity stood talking with Baugh. Doggedly he recalled the tragic moment early in the first quarter when end Charley Malone had dropped a sure touchdown pass from Baugh in the Bear end zone.

"Until Malone missed the pass it was still anyone's ball game," the writer said reassuringly. "Now if he had caught the ball and we had scored that early, how do think the game would have turned out, Sammy?"

"Seventy-three to seven," Baugh softly replied, knotting his tie.

# SID LUCKMAN

**➤ By Robert W. Peterson**

*FROM PIGSKIN: THE EARLY YEARS OF PRO FOOTBALL*, 1997

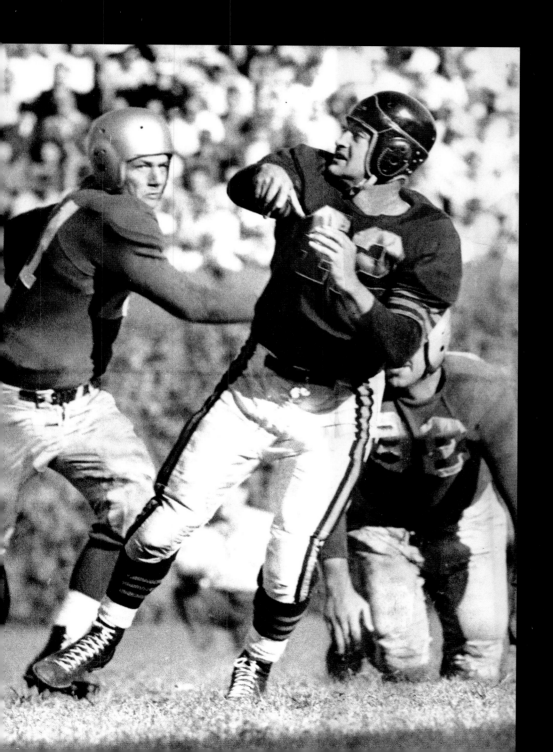

**The overall purpose of the T formation with** man in motion was to emphasize speed and deception rather than power. As [George] Halas put it, "Football became a game of brains. . . ." T formation quarterbacks had to be excellent ball handlers, since they got the ball on every play except punts, as well as good passers. They no longer were blocking backs. Most were former tailbacks in the single or double wing. A prime example was Sid Luckman, the Bears' quarterback from 1939 to 1950. A 6-foot, 195-pound tailback, he had earned All-American honors at Columbia University in 1938, but was not sure that he was good enough to play with the pros. Halas thought differently and talked him into giving it a try. Halas's judgment proved to be gilt-edged, as Luckman forged a Hall of Fame career with the Bears.

While Sammy Baugh threw bullets on a football field, Sid Luckman's passes were less spectacular but got the job done. One of his receivers, Ken Kavanaugh, recalled: "He didn't throw a real long ball, but every ball he threw was so catchable and it was soft. He threw on target. And he was a good leader and smart player."

**PASSING GRADES** Luckman led the Bears to four NFL championships in the 1940s.

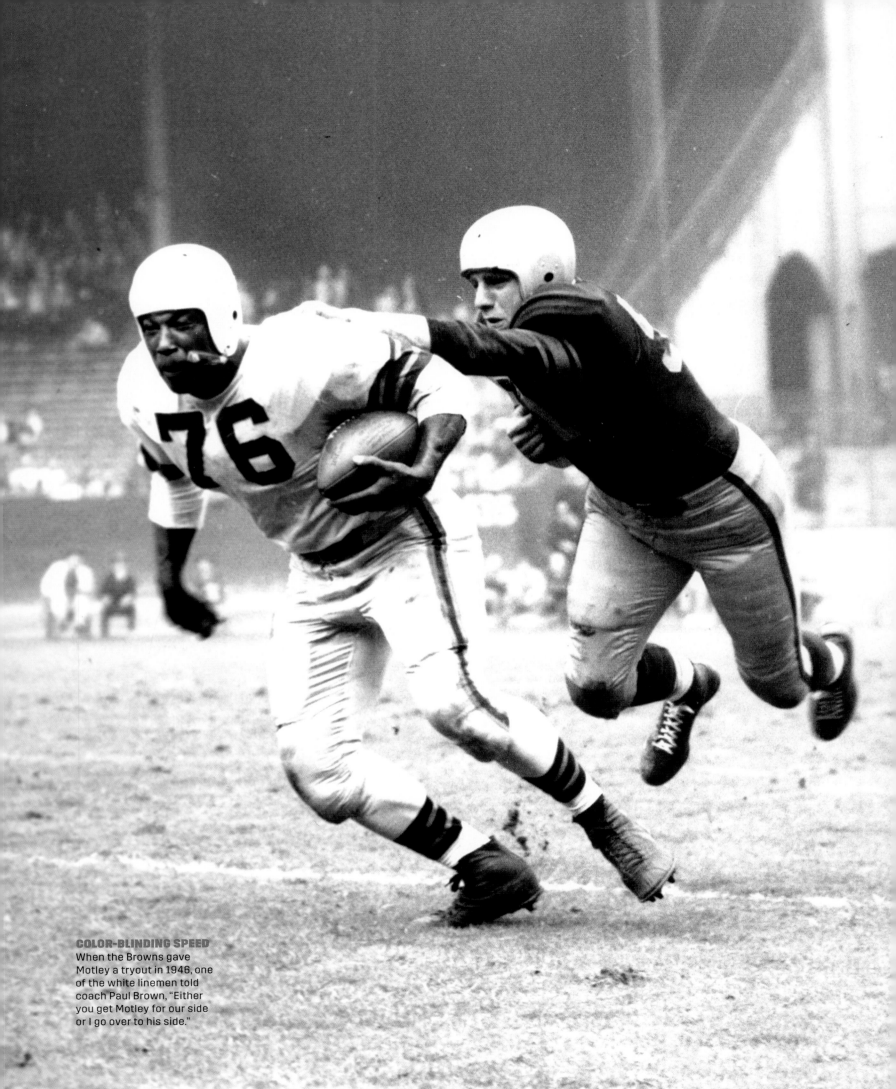

**COLOR-BLINDING SPEED**
When the Browns gave Motley a tryout in 1946, one of the white linemen told coach Paul Brown, "Either you get Motley for our side or I go over to his side."

Marion Motley had more to
deal with than blitzing linebackers
and big defensive linemen. At 6'1"
and 240 pounds, he could handle
them. But as one of the first black
players in modern pro football,
Motley was subjected to brutal
tactics and cheap shots. It was
a rare pileup in which someone
didn't "accidentally" stomp on his
hand or fling an elbow at his head.

► FROM *THE NFL CENTURY*, 1999

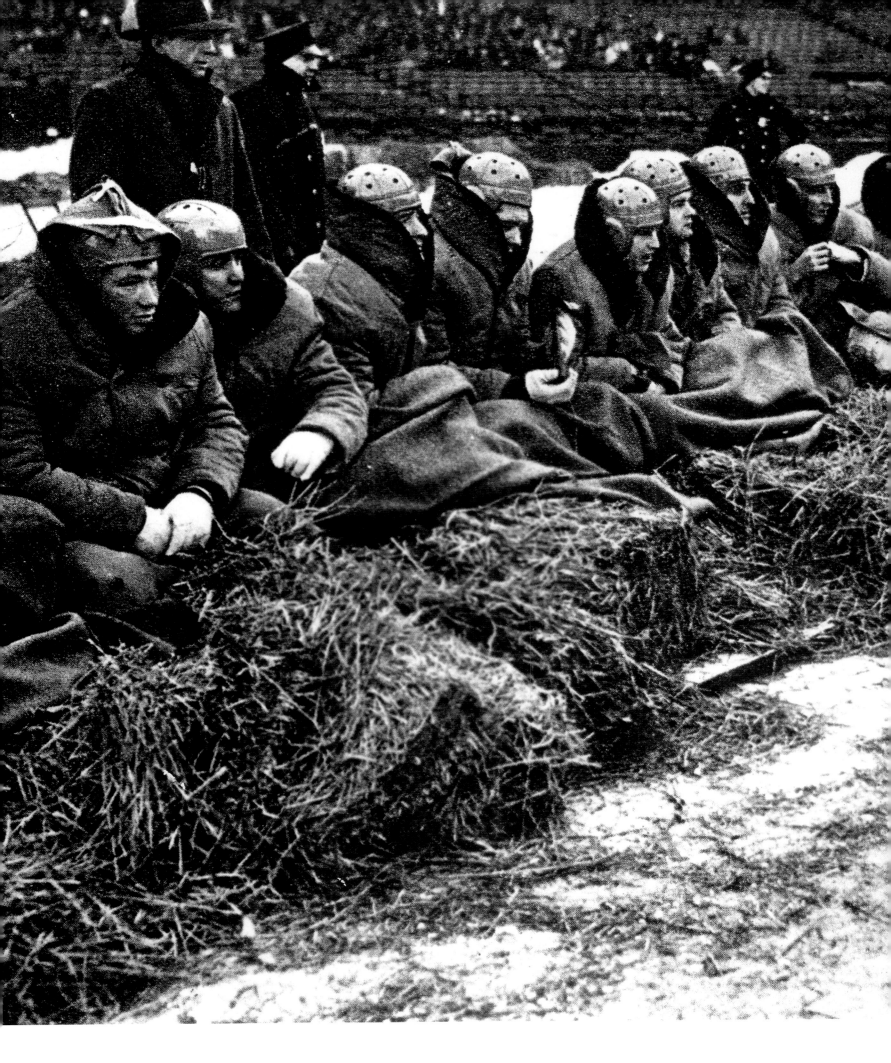

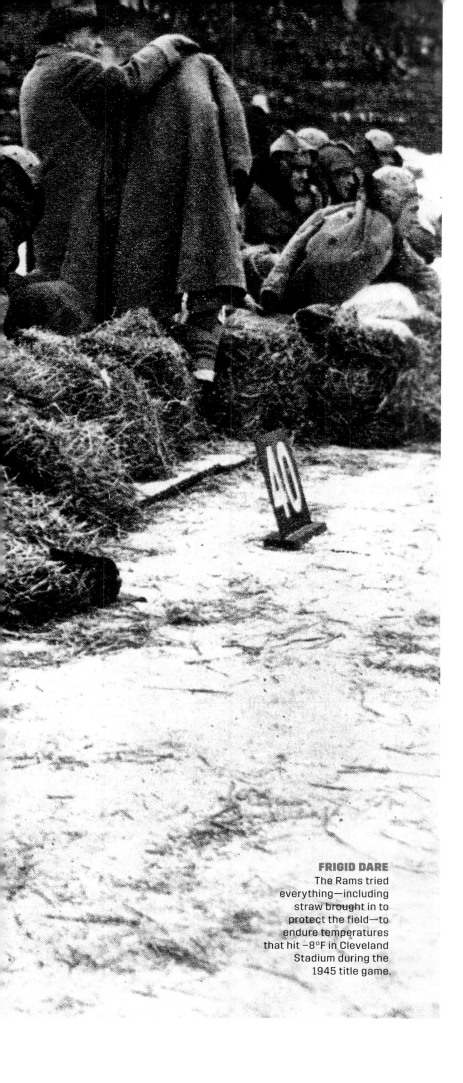

# STRAW MEN

▶ **By Michael MacCambridge**
FROM *AMERICA'S GAME*, 2004

**Bundled in a heavy winter coat and sporting a beaverskin** hat, Daniel Farrell Reeves dug his hands into his pockets and marched from the gate bordering the stands out onto the field in the cavernous Cleveland Stadium. In a matter of hours, his Cleveland Rams would take the field to play the Washington Redskins for the championship of the National Football League. But as he surveyed the field in the numbing chill of this overcast morning two days before Christmas, Reeves could see nothing on the gridiron but thousands of bales of straw and a small army of men laboring to move them. This was pro football in 1945.

In four seasons Reeves had grown accustomed to the perennial financial losses—"Irish dividends," as he called them—common to owning a pro football team.

Six days before the game, the National Weather Service had forecast a major winter storm hitting the Cleveland area in midweek, so the Rams had spent the early part of the week searching for enough bales of straw to cover the tarpaulin, to prevent the field from freezing. By 10:30 that morning most of the 9,000 bales had been cleared off the field. But the trucks that were to transport them away had trouble gaining purchase on the still clogged city streets, leaving workers no choice but to place the straw against the walls surrounding the playing field. Behind the benches, just in back of the end zones and stacked more than 10 bales high at the walls, the sea of straw was parted so the game could be played.

Cleveland Stadium had rarely looked so empty as on this day, when only 32,178 turned out. In financial terms, Reeves had already resigned himself to the realization that his share of the gate wouldn't even pay for the cost of buying, transporting, and removing the bales of straw. But as the kickoff neared, none of that mattered. It was time for football.

**FRIGID DARE**
The Rams tried everything—including straw brought in to protect the field—to endure temperatures that hit −8°F in Cleveland Stadium during the 1945 title game.

# SAMMY BAUGH

**By Dan Jenkins,** FROM *FOOTBALL*, 1986

[PRO FOOTBALL] DIDN'T HAVE THE LEAGUE AS WE KNOW it until 1933. And it didn't have the forward pass as we know it until TCU's Sam Baugh went to the Washington Redskins in 1937 and quickly convinced the pros that the pass was a weapon to be used on any play, from anywhere on the field. Baugh passed the Redskins to the NFL championship in his rookie season, and no rookie quarterback has done it since.

Largely because of Baugh, college football had already realized the forward pass was an offensive staple. Sam had thrown on just about every other down in 1935, when he pitched TCU to the national title and then a Sugar Bowl victory. With a weaker team in '36, he had thrown even more as he became a two-time All-American, but TCU had to settle for a win over Marquette in the inaugural Cotton Bowl.

Sam was more than a passer; far more. He was also the best punter anybody ever saw, and he generally led the Redskins in interceptions. Uh-huh. They played both ways then. Those were the days. Sixty-minute men like Baugh, no face masks, muddy fields, wet footballs, long train rides, no business managers, very few stock options.

After the Slinger had become a contented rancher in West Texas, I had an occasion to ask him about the hardship days of pro football.

"We thought it beat workin'" is essentially what he said about it.

**SLINGIN' HASH** In his rookie season, Baugh led the Redskins to the 1937 championship with a passing attack that was a game-changer.

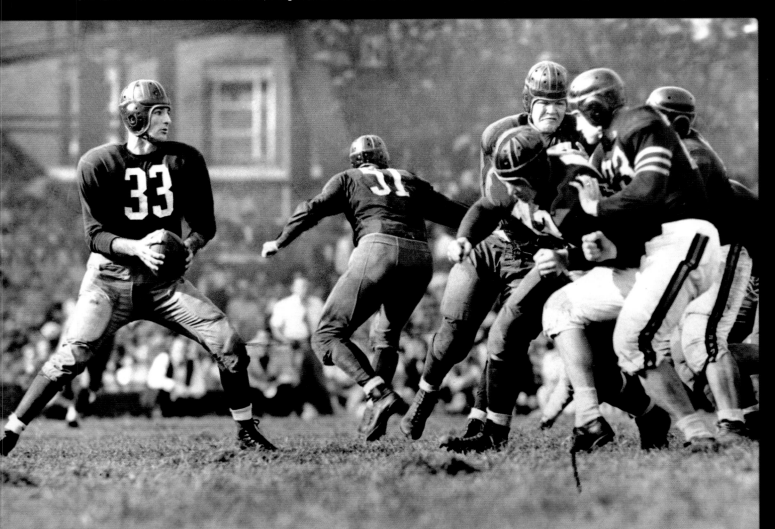

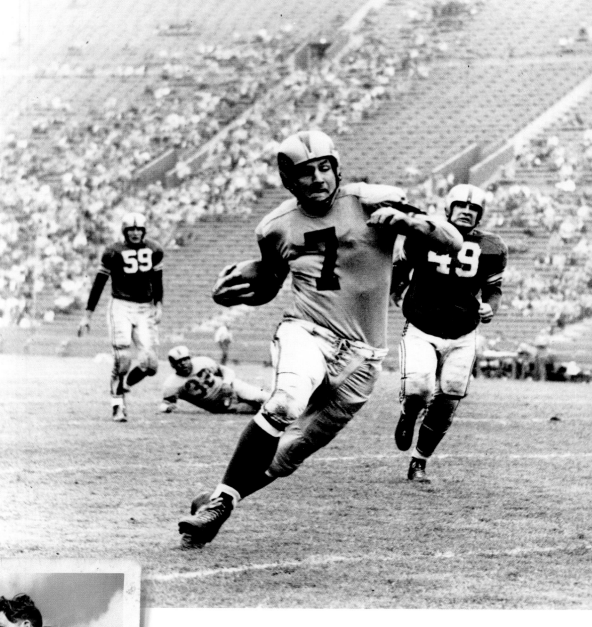

# BOB WATERFIELD

➤ **By Mickey Herskowitz**

FROM *THE GOLDEN AGE OF PRO FOOTBALL*, 1974

**In Los Angeles, a quiet genius named Bob Waterfield was at** work. Waterfield was an emotional opposite of [Bobby] Layne—slow to temper, serious, low-keyed, reserved. There was a romantic quality about him, a California campus hero who married a movie star—Jane Russell.

He had it all going for him, the looks, the manners, the wife, but none of it would have counted, of course, if he had not performed. He was the ultimate triple threat, a storybook player who was the last quarterback in history to win the NFL title and the most valuable player award in his rookie season. That was 1945, when the world was young (and the Rams were still playing football in Cleveland).

**67**

# Bulldog Turner

► **By Myron Cope,** FROM *THE GAME THAT WAS*, 1970

*Clyde "Bulldog" Turner recalls 1941, only a year after he had turned pro with the Chicago Bears, when he became the first man in nine years to unseat the great Mel Hein of the New York Giants as the National Football League's all-league center.*

HERE WAS GEORGE HALAS'S METHOD OF OPERATION in practice. First he'd say, "Give me a center!" Then he'd say, "Bausch!" He'd say, "Give me two guards!" Then he'd say, "Fortmann and Musso!" Well, the first time I heard Halas say, "Give me a center!" I didn't wait for nothing more and ran out there and got over the ball. I noticed he looked kind of funny at me, but I didn't think anything of it. I found out later that Pete Bausch was the center—a big, mean ol' ballplayer, a real

nice German from Kansas. But all I knew was George had drafted me No. 1 and I had signed a contract to play center, and I thought when it come time to line up I should be at center. From the beginning I was overendowed with self-confidence. I feared no man. So I just went out there and got over that ball, and I was there ever since. They didn't need Pete no more.

I was such a good blocker that the men they put in front of me—and some of them were stars that were supposed to be making a lot of tackles—they would have their coaches saying, "Why ain't you making any tackles?" They'd say, "That bum Turner is holding!" Well, that wasn't true. I held a few, but I was blocking them too. I used to think I could handle anybody that they'd put in front of me.

# OTTO GRAHAM

➤ **By Mickey Herskowitz,** FROM *THE GOLDEN AGE OF PRO FOOTBALL*, 1974

**OTTO-MATIC** In college, Graham finished third in Heisman Trophy voting and was first-team All-America in basketball. As a rookie pro, he was on championship teams in both sports.

**Which brings us to Otto Graham, whose** career may be said to have defined greatness for pro quarterbacks. He was the finest mechanic of his time. He led his team to the championship game every season he played, which doesn't sound quite legal. He wasn't flamboyant, but he had style, a quality that is beyond ability.

Otto didn't smoke or drink—that made him 0 and 2, somebody said—and his values were right out of the Eagle Scout Handbook. One of the rival coaches he most admired was Buck Shaw, then of the 49ers, for reasons that involved an order Shaw once gave his team.

Graham started against the 49ers one day despite a heavily taped knee that should have kept him on the bench. On Cleveland's first series he threw a touchdown pass to Lavelli, and the Browns won easily. The 49ers sacked him at times during the day— he couldn't maneuver—but no one hit him unnecessarily hard. Later he learned that Shaw had warned his team in the locker room, "The first guy who roughs up Graham gets fired."

His decent instincts did not prevent Shaw himself from being fired at the end of the 1954 season. But Graham recalls the incident warmly, because it suggests that there was still room in the game for the gentlemanly gesture. From his somewhat mellow viewpoint, Otto Graham remembers the '50s, which means, mostly, remembering Paul Brown.

"The old Browns had two things going for them: We had one of the greatest coaches who ever lived, Paul Brown, and we had something else, an esprit de corps you find very seldom on a football team today. We didn't have the petty jealousies. It didn't matter who got the credit . . . who made the headlines . . . who scored. The important thing was, did you do a good job?

# 50s

I N THE 1950S, PRO FOOTBALL embraced the forward pass and differentiated itself more clearly from the college game, providing a bridge between what the NFL had been and what it would soon become. It was an era of heroes and legends—field generals like Johnny Unitas and Bobby Layne, and near-mythic figures like Eugene "Big Daddy" Lipscomb and Hardy Brown on defense. While attendance increased every year in the '50s, the game remained, in the words of Colts Hall of Famer Art Donovan, "a localized sport based on gate receipts and played by oversized coal miners and West Texas psychopaths." It was the last decade in which anyone might describe pro football as simple.

The 1950 season began with a long-awaited reckoning. Paul Brown's Cleveland Browns, the only champion the defunct All-America Football Conference had known, joined the NFL (along with two other AAFC teams). Cleveland opened its first NFL season at Philadelphia against the NFL's two-time defending champion Eagles in a game dubbed by some as the World Series of Pro Football.

As Brown prepared to lead his team out of the visitors' locker room to try to prove they belonged in the NFL, he turned to his players. "Just think," he said, "tonight you're going to get to touch Steve Van Buren."

Van Buren was a late scratch, but the Browns routed the rest of the Eagles 35–10 and served notice that they would be a power in the NFL as well. Cleveland capped its inaugural season in the 1950 NFL Championship Game, against the Los Angeles Rams. That epic showdown—Paul Brown called it the greatest game he'd ever seen—ended with Otto Graham leading the Browns into Rams territory, where Lou Groza's field goal with 16 seconds left lifted Cleveland to a 30–28 win. "Automatic Otto" led the Browns to five more title games and two more championships before retiring after the 1955 season; he'd quarterbacked

Cleveland to 10 championship games in 10 years.

The Detroit Lions got the better of the Browns later in the decade, as Buddy Parker's charges—led by quarterback Bobby Layne and halfback Doak Walker—beat Cleveland in the '52 and '53 title games (and again in '57, after Parker left). Along the way, Parker and Layne refined the two-minute offense that would become one of the game's staples.

In 1956, the New York football Giants moved from the Polo Grounds into Yankee Stadium and found a new level of success and prominence as they won their first league title in ei seasons. The Yankee Stadium rafters shook to sounds of "*Dee*-fense! *Dee*-fense!" Middle linebacker Sam Huff became a star, and halfback Frank Gifford turned into an outright celebrity.

**LION IN WAIT**
Doak Walker was drafted by Detroit in 1949 and reunited with high school teammate Bobby Layne the following year.

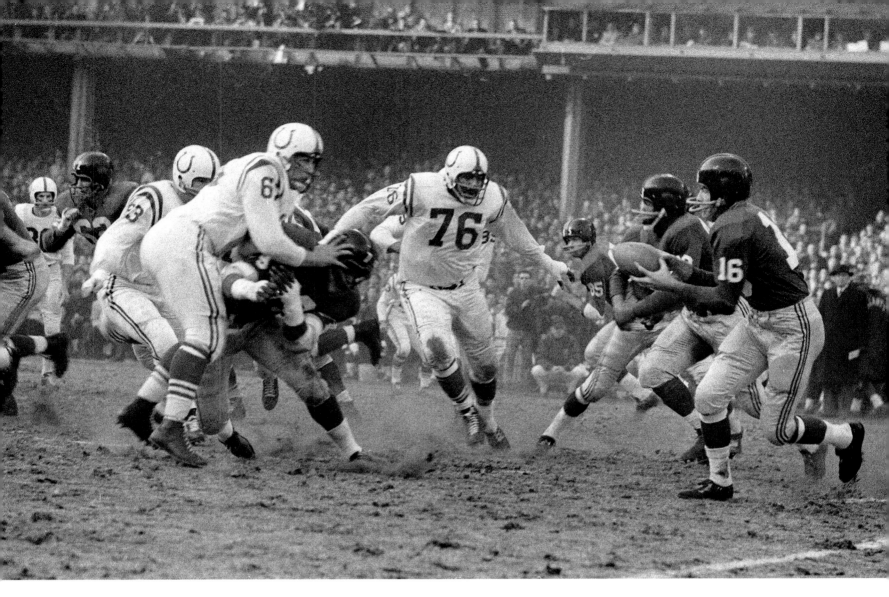

**FATHER FIGURE** Giants back Frank Gifford had extra incentive to flee when being chased by Colts lineman Big Daddy Lipscomb (76).

Pro football was clearly on the upswing, and all the elements came together on December 28, 1958, when the Giants played host to the Baltimore Colts in the 1958 NFL Championship Game. What happened that day may not have been—as it was later billed—The Greatest Game Ever Played, but it was certainly one of the most important. With his team trailing by three points in the last two minutes, the Colts' Johnny Unitas led the tense drive toward the tying field goal, sending the game into sudden-death overtime. Then, in front of a television audience estimated at 40 million, Unitas engineered another long drive to win the title. Unitas would become a laconic hero for the Cold War era, and on the strength of that game, the glamorous Giants and the charismatic Colts became nationally renowned.

Yet for all its successes, the NFL remained in many ways a small-time operation. Writers who covered pro football in the period recalled phoning the league office and having conversations like the following:

"National Football League."

"Hello, could I speak to Commissioner Bell please?"

"Speaking."

Because, indeed, Commissioner Bert Bell often answered the phones in the five-man league office in Bala Cynwyd, in suburban Philadelphia. Bell died of a heart attack during an Eagles-Steelers game in October 1959. As the decade ended with the Colts' second world championship and protracted infighting over Bell's successor, it was clear that change was coming. Pro football was on the brink of going big time. —**Michael MacCambridge**

## Commissioner Bert Bell often answered the phones in the five-man league office in suburban Philadelphia.

# Leaders

| | | | | |
|---|---|---|---|---|
| **PASSING YARDS** | 1950 | Bobby Layne | Lions | 2,323 |
| | 1951 | Bobby Layne | Lions | 2,403 |
| | 1952 | Otto Graham | Browns | 2,816 |
| | 1953 | Otto Graham | Browns | 2,722 |
| | 1954 | Norm Van Brocklin | Rams | 2,637 |
| | 1955 | Jim Finks | Steelers | 2,270 |
| | 1956 | Tobin Rote | Giants | 2,203 |
| | 1957 | Johnny Unitas | Colts | 2,550 |
| | 1958 | Billy Wade | Rams | 2,875 |
| | 1959 | Johnny Unitas | Colts | 2,899 |
| **RUSHING YARDS** | 1950 | Marion Motley | Browns | 810 |
| | 1951 | Eddie Price | Giants | 971 |
| | 1952 | Dan Towler | Rams | 894 |
| | 1953 | Joe Perry | 49ers | 1,018 |
| | 1954 | Joe Perry | 49ers | 1,049 |
| | 1955 | Alan Ameche | Colts | 961 |
| | 1956 | Rick Casares | Bears | 1,126 |
| | 1957 | Jim Brown | Browns | 942 |
| | 1958 | Jim Brown | Browns | 1,527 |
| | 1959 | Jim Brown | Browns | 1,329 |
| **RECEIVING YARDS** | 1950 | Tom Fears | Rams | 1,116 |
| | 1951 | Elroy Hirsch | Rams | 1,495 |
| | 1952 | Billy Howton | Packers | 1,231 |
| | 1953 | Pete Pihos | Eagles | 1,049 |
| | 1954 | Bob Boyd | Rams | 1,212 |
| | 1955 | Pete Pihos | Eagles | 864 |
| | 1956 | Billy Howton | Packers | 1,188 |
| | 1957 | Raymond Berry | Colts | 800 |
| | 1958 | Del Shofner | Rams | 1,097 |
| | 1959 | Raymond Berry | Colts | 959 |

# CHAMPIONS

▼

1950
**CLEVELAND BROWNS**
—
1951
**LOS ANGELES RAMS**
—
1952
**DETROIT LIONS**
—
1953
**DETROIT LIONS**
—
1954
**CLEVELAND BROWNS**
—
1955
**CLEVELAND BROWNS**
—
1956
**NEW YORK GIANTS**
—
1957
**DETROIT LIONS**
—
1958
**BALTIMORE COLTS**
—
1959
**BALTIMORE COLTS**

# Pick Six

## 4

Punt return touchdowns during the 1951 season by Lions safety Jack Christiansen. He led the league that season, and nearly seven decades later, nobody has surpassed his single-season total. Christiansen's eight career punt returns for touchdowns are the fourth-most ever.

## 8

Interceptions thrown by Cardinals QB Jim Hardy on September 24, 1950, against the Eagles, a single-game record. The following week Hardy tied the single-game touchdown pass record with six against the Baltimore Colts. Hardy, whose 24 INTs led the league, was selected to represent the American Division in the Pro Bowl.

## 5

Seasons Vince Lombardi and Tom Landry were both coordinators under Giants head coach Jim Lee Howell. From 1954 through 1958, Lombardi guided the Giants' offense and Landry the defense. Once becoming head coaches, they combined to win 375 games.

## 529

Professional touchdown passes thrown by Steelers draft picks Len Dawson (first round in 1957) and Johnny Unitas (ninth round in 1955). Both men won league championships. Both won Super Bowls. Both are in the Hall of Fame. Neither won a single game for Pittsburgh.

## 9

Consecutive seasons that Cleveland Browns fullback Jim Brown scored nine or more touchdowns. From 1957 until his retirement in 1965, Brown amassed 126 touchdowns, also an NFL record. Both the season streak and total touchdowns would endure more than thirty years until both marks were surpassed by Jerry Rice.

## 14

Interceptions during the 12-game 1952 season for Los Angeles Rams defensive back Dick "Night Train" Lane. Since then, even with a 33% increase in the number of regular-season games by each team, the Hall of Famer's total remains the single-season record.

# Tight Coverage: The NFL and the Media

**01 ▶ NOV 29, 1934**
The Bears and Lions play in the first NFL game broadcast nationally on radio.

**02 ▶ OCT 22, 1939**
In the first network telecast of pro football, the Dodgers beat the Eagles at Ebbets Field.

**03 ▶ DEC 8, 1940**
The Mutual Broadcasting System pays $2,500 to broadcast the NFL Championship Game

**04 ▶ 1950**
The Los Angeles Rams become the first NFL team to have all of its home and away games televised.

**05 ▶ 1956**
CBS first broadcasts NFL regular-season games across the nation.

**06 ▶ SEP 21, 1970**
The Browns defeat the Jets 31–21 in the first ever *Monday Night Football* game.

**07 ▶ NOV 17, 1968**
NBC cuts away from a 32–29 Jets-Raiders game with seconds left to air the children's movie *Heidi.* Oakland scores two TDs as irate fans flood the network's phone lines.

**08 ▶ JAN 15, 1967**
The AFL's network (NBC) and the NFL's (CBS) both televise Super Bowl I.

**09 ▶ 1962**
Ed Sabol pays $5,000 for film rights to the 1962 NFL Championship Game, effectively launching NFL Films.

**10 ▶ DEC 28, 1958**
The Colts's sudden-death defeat of the Giants in the NFL title game is viewed by a TV audience of 45 million.

**11 ▶ SEP 14, 1977**
*Inside the NFL*, now cable television's longest-running series, debuts on HBO.

**12 ▶ APR 29, 1980**
ESPN airs the first-ever telecast of the NFL Draft.

**13 ▶ NOV 8, 1987**
*Sunday Night Football* debuts on ESPN, the first regularly scheduled Sunday night games in league history.

**14 ▶ JUN 1, 1988**
Electronics Arts releases the first edition of the video game John Madden Football.

**15 ▶ SEP 4, 1994**
NFL Sunday Ticket launches on DirecTV and other satellite services, bringing out-of-market games to homes and public spaces.

DIRECTV

**16 ▶ NOV 4, 2003**
NFL Network, a league-owned cable channel, is launched with Rich Eisen as its lead anchor.

**17 ▶ SEP 4, 2008**
For the first time, an NFL game streams live in its entirety on the Internet.

**18 ▶ SEP 13, 2009**
NFL Network's RedZone debuts, offering viewers "Every touchdown from every game."

**19 ▶ FEB 1, 2015**
An estimated 114.4 million viewers, the most in U.S. broadcast history, see the Patriots beat the Seahawks in Super Bowl XLIX.

**20 ▶ SEP 27, 2018**
Hannah Storm and Andrea Kremer of Amazon Prime Video become the first all-female team to call an NFL game.

# Innovations

**1950:** Free substitution is permanently adopted.

**1951:** O-linemen can't catch or touch a forward pass.

**1955:** Play ends when a ballcarrier in a defender's grasp touches the ground with anything but his hands or feet.

**1956:** Grabbing the face mask of anyone except the ballcarrier is outlawed.

## HELLO

▶ The Pro Bowl (1951).

▶ The "new" Baltimore Colts join the NFL (1953).

▶ Face masks become mandatory (1955).

▶ NFL Players Association formed (1956).

▶ Green Bay's City Stadium (now Lambeau Field) opens (1957).

▶ Vince Lombardi named Packers head coach (1959).

▶ The American Football League formed (1959).

## GOODBYE

▶ Single Wing formation (1952).

▶ Dallas Texans fold, the last NFL team to go out of business (1952).

▶ Jim Thorpe, first president of the league, dies (1953).

▶ After reaching 10 title games in 10 years, Otto Graham retires (1955).

▶ Eagles leave Connie Mack Stadium (1957).

▶ Commissioner Bert Bell suffers a fatal heart attack during an Eagles-Steelers game at Franklin Field (1959).

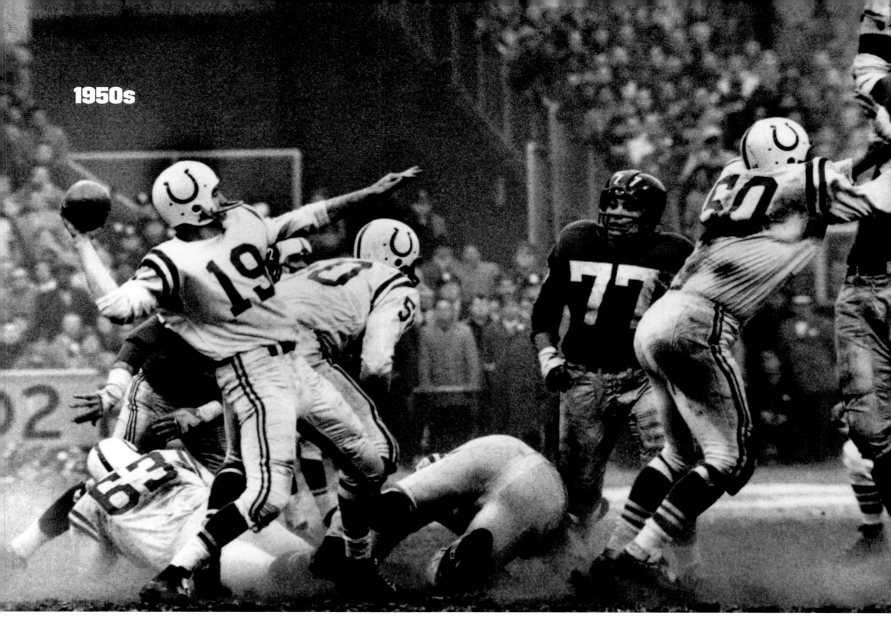

**BERRY GOOD** Colts QB Johnny Unitas hooked up with Raymond Berry 12 times for 178 yards in the 1958 title game.

# THE BEST FOOTBALL GAME EVER PLAYED

➤ **By Tex Maule**

FROM *SPORTS ILLUSTRATED*,
JANUARY 5, 1959

NEVER HAS THERE BEEN A GAME LIKE THIS ONE. WHEN there are so many high points, it is not easy to pick the highest. But for the 60,000 and more fans who packed Yankee Stadium last Sunday for the third week in a row, the moment they will never forget—the moment with which they will eternally bore their grandchildren—came with less than 10 seconds to play and the clock remorselessly moving, when the Baltimore Colts kicked a field goal that put the professional football championship in a 17–17 tie and necessitated a historic sudden-death overtime period. Although it was far from apparent at the time, this was the end of the line for the fabulous New York Giants, Eastern titleholders . . . and the heroes of one of the most courageous comebacks in the memory of the oldest fans.

This was also a game in which a seemingly irretrievable loss was twice defied. It was a game that had everything. And when it was all over, the best football team in the world had won the world's championship.

# CABINS ON THE *TITANIC*

► **By Bob Carroll**

FROM *WHEN THE GRASS WAS REAL*, 1993

**SUDDEN LIFE** Colts fullback Alan Ameche dived into the end zone to beat the Giants in sudden-death overtime.

**The national telecast [of the 1958 championship game]** put the NFL in more living rooms than ever before—an estimated 10,820,000 homes across the country. Ironically, New York, the nation's biggest market, was blacked out (and New Yorkers couldn't even read about the game the next morning because of a newspaper strike), but pro football had been established in New York for years. The critical audience was the rest of the country, places without local NFL teams. Pro football had grown in importance during the 1950s, but it still lagged behind baseball and college football in national interest. The country—certainly three-quarters of it—needed a good kick in the pants to make it aware of pro football.

[And] NBC nearly missed the winning play. Fans had inadvertently kicked a cable connection apart, plunging TV screens into darkness. Fortunately, a drunk staggered out onto the field and reeled around just long enough to allow the network to get the cable reconnected. Only later was it discovered that the fortuitous drunk was a cold sober NBC vice president. Television had controlled what happened on an NFL field for the first time.

**CAMP COUNSELOR** Paul Brown with QBs Otto Graham (14) and George Ratterman.

# Paul Brown

### ► By Larry Merchant

FROM *... AND EVERY DAY YOU TAKE ANOTHER BITE*, 1971

PAUL BROWN REVOLUTIONIZED FOOTBALL, DRAGGING IT KICKING and screaming into the second half of the 20th century with modern business techniques, meticulous scouting and planning, play-by-play film breakdowns, innovations in strategy and tactics and on and on. He created the Cleveland Himselfs, who won 11 division and seven league championships in their first 12 seasons. He ruled with a ruthlessly fair business ethic, frowning on cheap sentiment and juvenile rah-rah. If a player did his job he was rewarded, and if he didn't he became a former Himself. Brown didn't relate football to God's game plan or America's destiny; he was a coach trying to win games. He didn't lecture on love and hate; team goals and individual drive generated emotion naturally. But he ran the Himselfs with absolute, glacial, imperious authority, and when he didn't win a championship for five years, there was a rebellion led by Jim Brown, and he was ousted.

# THE LAST RESORT

### ► By George Ratterman with Robert G. Deindorfer

FROM *CONFESSIONS OF A GYPSY QUARTERBACK*, 1962

**One of the memories I relish the** least still crawls in my mind every so often. On a bitter November day my second year with the Browns, I lined up for opening kickoff in my usual position, sprawled on the bench along the sidelines, a canvas hood pulled down over my head to ward off the biting weather. After the first few plays my rump comfortably adjusted itself to the familiar old grooves of the bench.

Meanwhile, the game was not unfolding according to partisan plans. Graham, who played so many incredible games I can't possibly catalog them all, let alone envy them, was suffering one of his rare mediocre afternoons. Late in the third quarter San Francisco intercepted a Graham forward pass, which set a few wolves to howling up in the seats.

"We want Ratterman!" That nagging bawl was audible but not deafening. As the only reserve quarterback available, I knew the malcontents had no other choice. "We want Ratterman!"

Down the bench a few feet, [coach] Brown beckoned to me. I slowly stripped off the hood, reached for my shiny, unmarked helmet and approached the coach for an earful of wisdom. Any moment I'd be in the midst of the bloodletting out on the field.

"George, your friends are calling for you," Brown said, pausing for dramatic effect. "Maybe you'd better go up there in the stands and sit with them awhile."

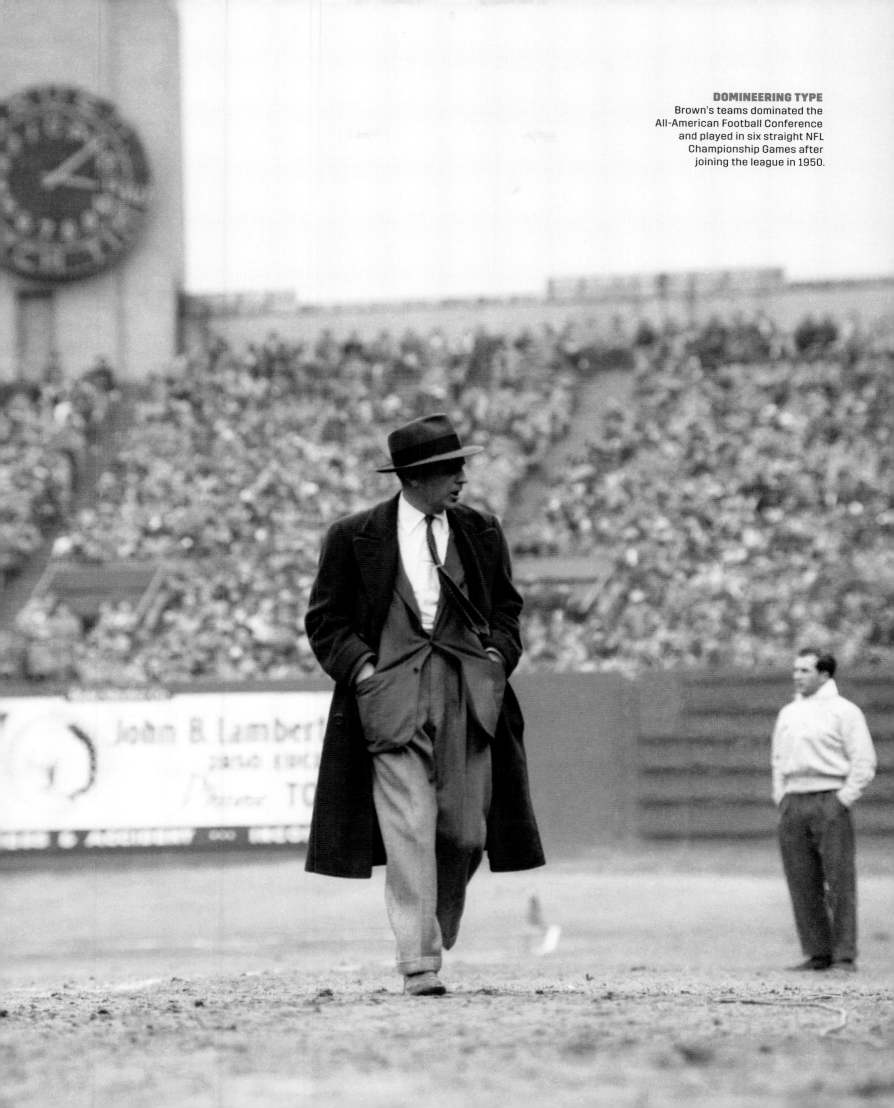

# FRANK GIFFORD

► **By Mickey Herskowitz,** FROM *THE GOLDEN AGE OF PRO FOOTBALL*, 1974

**PERFECTLY FRANK**  Gifford was the NFL MVP in 1956 and made the Pro Bowl eight times.

**Although the casualty toll was high,** the supply of great backs in the '50s seemed inexhaustible. They kept coming out of college as though machine-stamped, like link sausages: Alan Ameche, Rick Casares, Frank Gifford, Lenny Moore, Ollie Matson. Most of them lasted longer, but they came along when a running back hoped to make five or six good years, if he was lucky, and then out.

Frank Gifford claims that when he returned to California after his rookie season, with the New York Giants in 1952, his friends were startled to see him. "Where have you been all winter?" they asked. That may be a slight exaggeration, but it makes a point. Pro football was not yet our new national hysteria. Coast-to-coast flights still took all day, and network television was years in the future. A fellow could come out of Southern California, as Gifford did, handsome and celebrated, go east and still get lost. But not for long. Few backs ever did as much, with consistent skill, as Gifford. The Giants used him to carry the ball, to block, receive and, on occasional option plays, to throw. He had speed, and he had class, and he looked good just standing for the national anthem.

"Lombardi perfected the power sweep," Landry says, "with the two guards pulling and the fullback blocking. And he had the guy to make it go, Frank Gifford, because of the run-pass option—the same as he had a guy later on to work it at Green Bay, Paul Hornung."

► FROM *THE GOLDEN AGE OF PRO FOOTBALL*

Donovan controlled the defensive line for the Colts despite his love of food and disdain for exercise. In his autobiography (*Fatso*) he claimed that in his 13 NFL training camps he did just 13 push-ups.

# ART DONOVAN

► **By Mickey Herskowitz,** FROM *THE GOLDEN AGE OF PRO FOOTBALL*, 1974

ART WAS A STRONG, GUTSY TACKLE WITH AN instinct for which direction a play was going. He had a round, almost cherubic face that contradicted his toughness; a face hardened not at all by the 39 stitches needed to mend it after two 1951 accidents—a slash across the cheek from the spikes of an unidentified shoe and a cut over one eye (nine stitches) from a Deacon Dan Towler elbow.

Donovan's weakness was food. He could gain weight by breathing in the fumes from a distant bakery. In 1954 he ballooned to 309 pounds, after which the Colts inserted in his contract a clause providing that he would be fined $560 for every

five pounds he weighed over 265. Never again did the Colts have to weigh him on a freight scale. Obediently, Art held his weight at 265 or below.

Donovan was one of the symbolic players of the '50s, a lovable rogue with an Irish zest for life and cold drink. He was the team's dispenser of sunshine, and in his view all the players were great, all brothers valiant. On the bus to a game he would mentally fix the temperature outside and determine how much beer he would need, after the game, to resupply his body fluids. Then he would turn to his seatmate, usually Bill Pellington, and announce, "Well, Bill, it looks like a six-canner today."

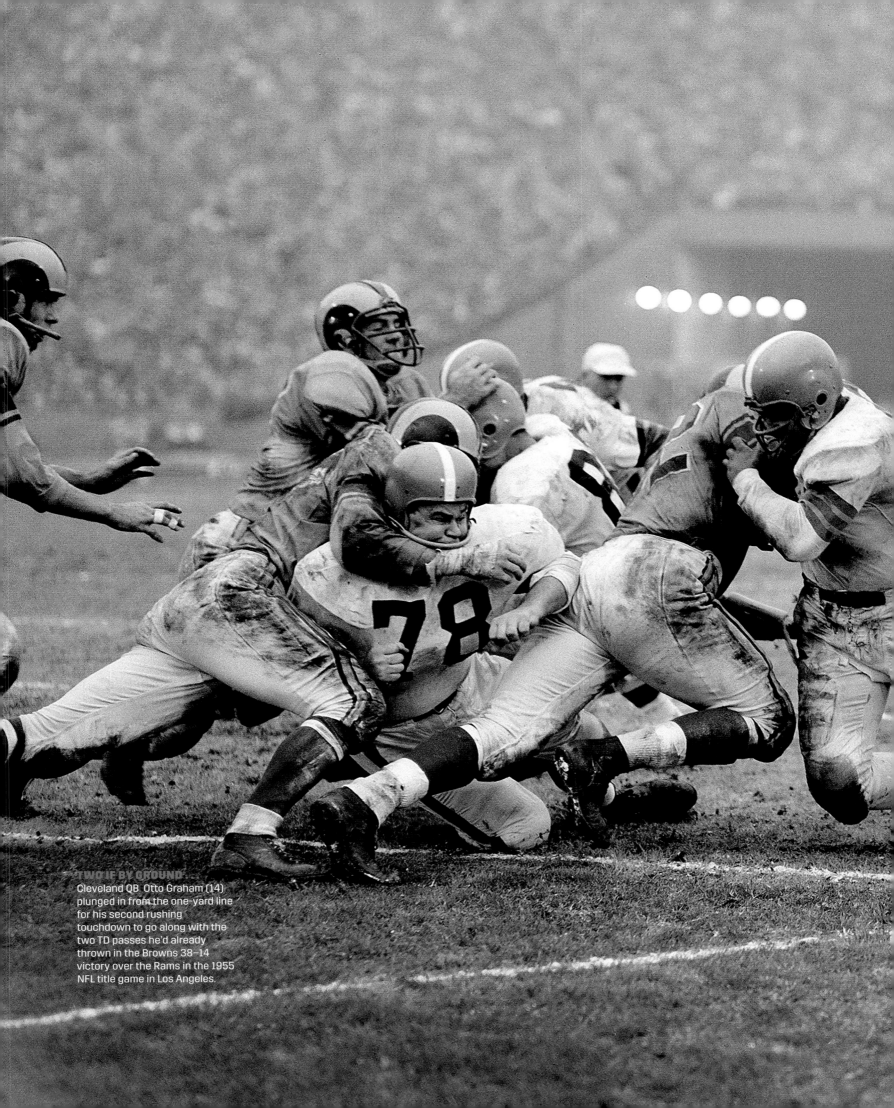

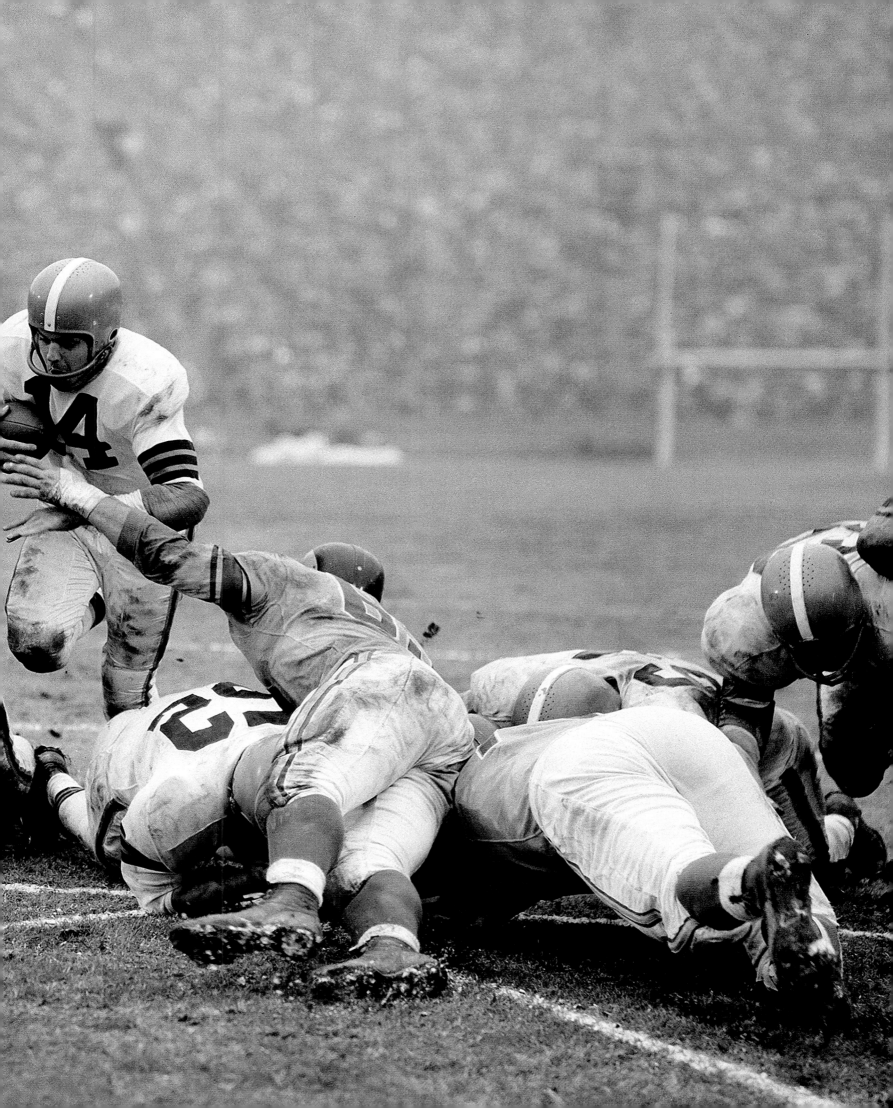

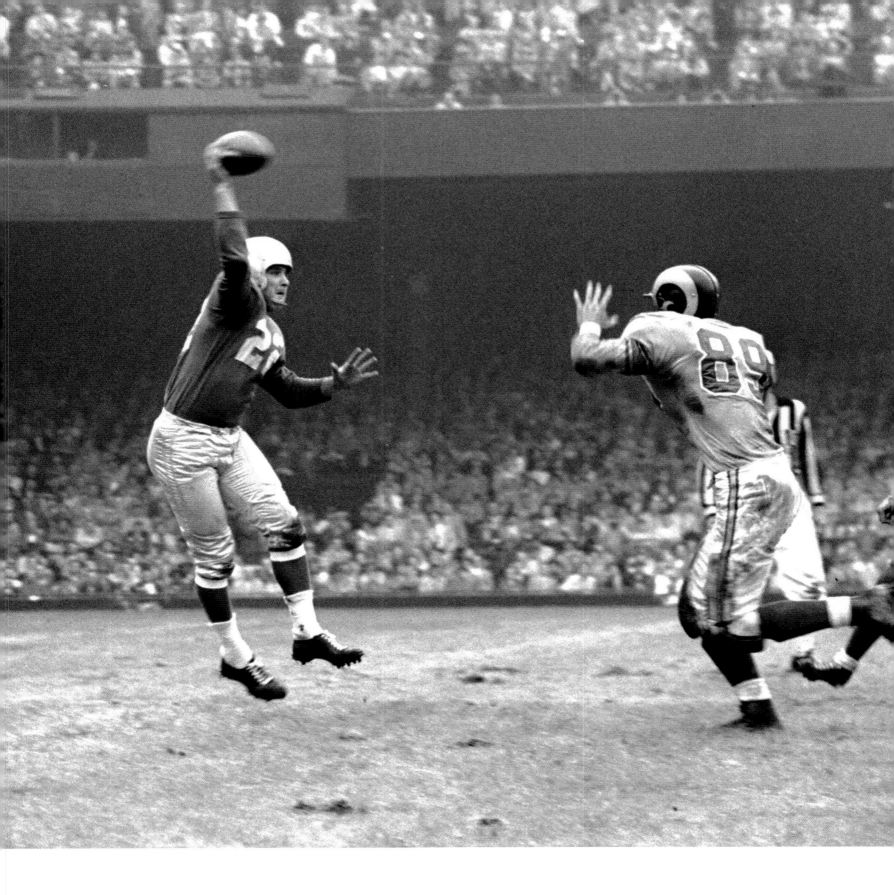

**The Detroit Lions of the Layne era were
the best team in football on Sunday afternoon
and the best party in town Sunday night.**

PETER BONVENTRE
► FROM *NEIL LEIFER'S SPORTS STARS*, 1985

# BOBBY LAYNE

► **By Myron Cope,** FROM *THE GAME THAT WAS*, 1970

**It was Bobby Layne, more than any** other man, who made the city of Detroit one of America's hotbeds of pro football enthusiasm. Television riches as yet had not begun to engulf the game when, in 1950, Layne arrived in Detroit, his third stop in the National Football League. Briefly in the mid-1930s, the great tailback Dutch Clark had attracted huge crowds in Detroit, even leading the Lions to a championship in 1935, but the club lost its momentum and did not really establish itself as a major spectacle until Bobby Layne had taken a foothold in the city.

Blond and blue-eyed, a fast-living young Texan with an infectious grin and rasping drawl, Layne not only quarterbacked the Lions to four first-place finishes and three league championships but also brought to the drab, industrial metropolis a flamboyant presence. He was flamboyant not in the sense that he strove to attract attention but in the sense that he was constitutionally propelled toward it. He never required more than five hours' sleep to be at his best. "I sleep fast" was the way he once put it. A jazz buff oversupplied with nervous energy, he loved to lead forth his teammates to a night on the town, and so he became a night figure, fair game for gossip columnists and hecklers. His temper complicated matters. He could not abide intruders. He experienced run-ins with fans, and although some of his best friends were cops, he occasionally clashed with the law. The combination of his good looks, his love of a good time and his combustibility made him the most glamorous football figure of his day.

**THE FAST LAYNE**
Revered for his play off the field as well as for what he did between the lines, Layne led the Lions to three straight title games, winning in 1952 and '53.

# Raymond Berry

► **By Mickey Herskowitz**

FROM *THE GOLDEN AGE OF PRO FOOTBALL*, 1974

IT WAS, AS GEORGE HALAS HAD suggested, the hour of the pass-catching end. And at mid-decade, onto the scene came a young fellow who looked so unlike a pro football player that he turned a popular joke into reality. His name was Raymond Berry and he actually did something that sounded like a comic's one-liner. He went on *What's My Line*, the television quiz show, and stumped the panel!

He was gangling, a spindly 185-pounder (at 6'2"), who, without glasses or contact lenses, could read nothing larger than the E on an eye chart. He was a 20th-round draft choice who became the foremost pass receiver of his time, an artist without temperament.

Berry came along on the heels of half a dozen great receivers: Hirsch, Fears, Howton, Box, et al. But he accomplished something that endeared him to a new generation of fans. He proved that endless work and sheer strength of will could lead to greatness, to machinelike near perfection, and that God-given talent wasn't always an absolute requirement. He was so human, so conventional looking, not at all your popular stereotype of the athlete-god; he was, in fact, every man's Walter Mitty. And it was always Raymond, among his teammates and friends, never the more casual Ray.

**EVERYBODY
LOVED RAYMOND**
Berry took the long way to the Pro Football Hall of Fame: He was drafted in the 20th round by the Colts after catching just 33 passes in three seasons at SMU.

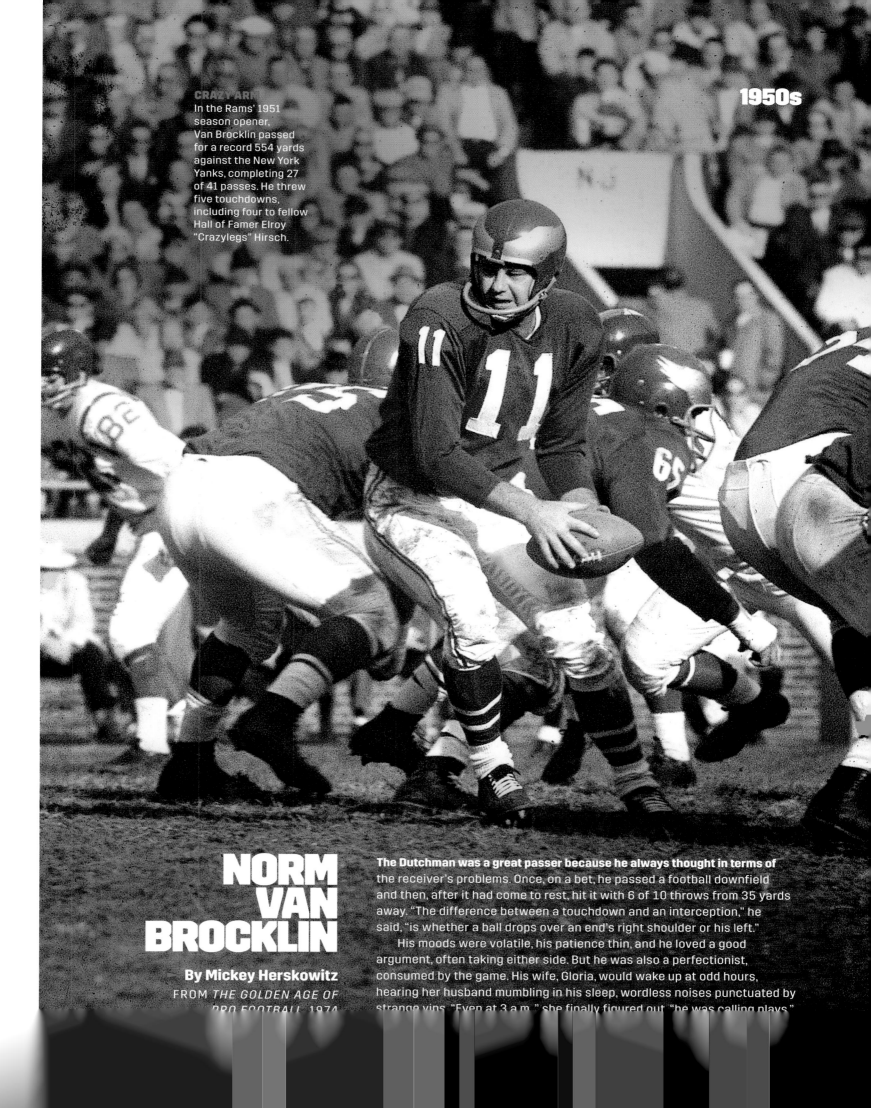

**CRAZY ARM**
In the Rams' 1951 season opener, Van Brocklin passed for a record 554 yards against the New York Yanks, completing 27 of 41 passes. He threw five touchdowns, including four to fellow Hall of Famer Elroy "Crazylegs" Hirsch.

# NORM VAN BROCKLIN

### By Mickey Herskowitz

FROM *THE GOLDEN AGE OF PRO FOOTBALL, 1974*

**The Dutchman was a great passer because he always thought in terms of** the receiver's problems. Once, on a bet, he passed a football downfield and then, after it had come to rest, hit it with 6 of 10 throws from 35 yards away. "The difference between a touchdown and an interception," he said, "is whether a ball drops over an end's right shoulder or his left."

His moods were volatile, his patience thin, and he loved a good argument, often taking either side. But he was also a perfectionist, consumed by the game. His wife, Gloria, would wake up at odd hours, hearing her husband mumbling in his sleep, wordless noises punctuated by strange yips. "Even at 3 a.m.," she finally figured out, "he was calling plays."

# Hugh McElhenny

► **By Mickey Herskowitz**

FROM *THE GOLDEN AGE OF PRO FOOTBALL*, 1974

**Our man with the sixth sense, with the kind of wide-angle vision that told** him at a glance where every tackler was staked out, was Hugh McElhenny. They called him the King. He ran with the ball the way little boys do in their wildest dreams. He had speed and power and guts and the complete repertory of moves: the pivot, the sidestep, the change of pace, the sudden bursts, the spinning, the faking and an uncanny gift for breaking a tackle. Perhaps more than any back who ever played the game he was blessed with instinct—the kind that tells you when a stranger is lurking in a doorway.

Those who were close to the San Francisco 49ers—including the bankers who held the team's notes—insist that Hugh McElhenny saved the franchise. He was never able to convert his immense talents into a title for San Francisco, not in nine seasons of trying, but he became the dominant running back of the 1950s.

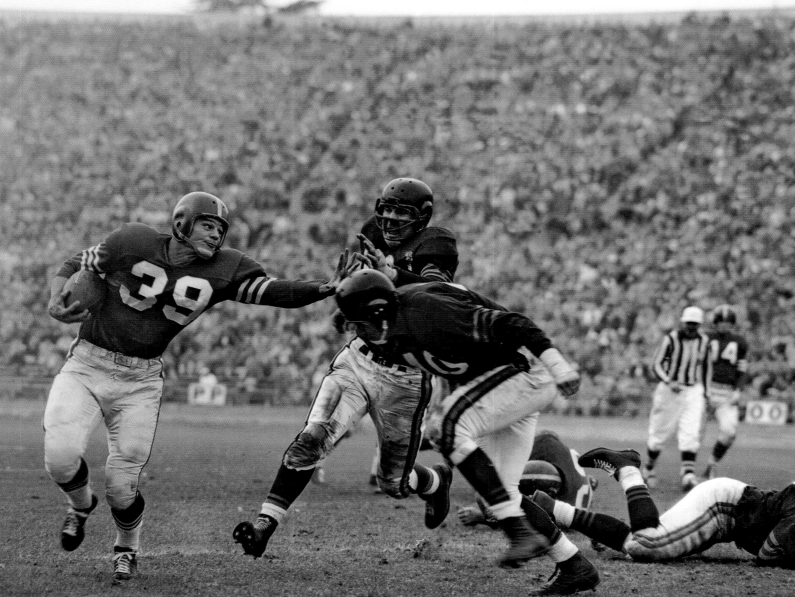

Part of the 49ers' Million-Dollar Backfield, McElhenny was a force on the field and one of the most popular players in team history.

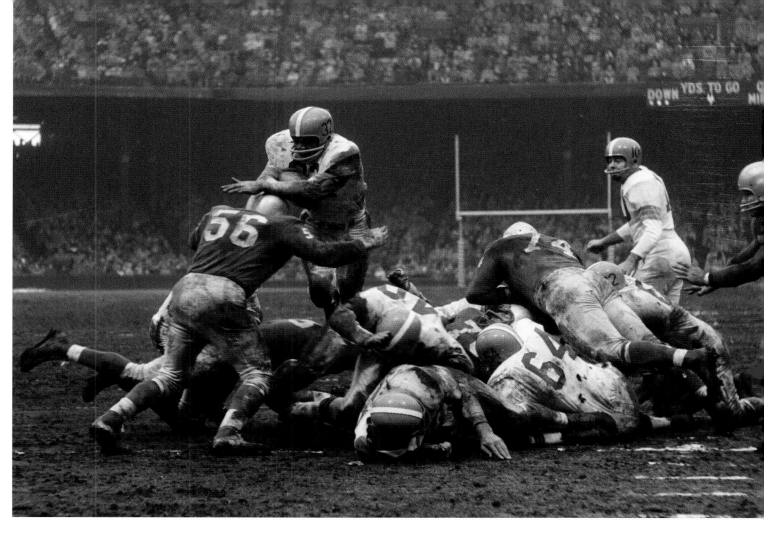

**NO ORDINARY JOE** Schmidt, who played linebacker for 13 years in Detroit, was first-team All-Pro for 10 consecutive seasons (1954–63).

# JOE SCHMIDT

► **By Myron Cope,** FROM *THE SATURDAY EVENING POST*, 1958

FOUR BROAD RUMPS, FAIRLY BURSTING THROUGH the skintight silver knickers worn by the Detroit Lions, are spread out before him. They're his men—linebacker Joe Schmidt's men—and when the Baltimore Colts' center snaps that ball, those four rumps will lurch ahead. These are Detroit's frontline troops: Darris McCord, 250 pounds; Ray Krouse, 275 pounds; Bob Millert, 255 pounds; Gil Mains, 255 pounds. If they go in low, the way they should, Joe Schmidt won't even see their heads bob up over the horizon of their backsides.

They're dug in a yard or so apart. Beyond them, through the gaps, Joe can see the Baltimore linemen crouching grimly, their upper lips tucked in against their teeth, and beyond them, the Baltimore backs. Joe hates them all with a fury that has possessed him from the moment he set foot on the field.

Joe Schmidt is built that way. Before he got into uniform he neither felt nor looked like a fanatic. When he is in street clothes, his extraordinarily broad shoulders, his size-18 neck, his kindly eyes, his blond hair and his even manner give him the appearance of a nice old Saint Bernard. But once he puts on that uniform, he becomes Mr. Hyde.

So now, as Joe sets himself for the Baltimore attack, he looks across the line where Johnny Unitas, dirty-faced, is barking signals. Unitas? Hell, he's a sand-lotter from Joe's own hometown of Pittsburgh. Unitas may be an old pal, and he may be one of the National Football League's best passers, but to Joe Schmidt right now, Unitas is just a miserable busher up from the Bloomfield Rams.

# The NFL Goes Mainstream

## ► By Michael MacCambridge

**By the second half of the fifties, pro** football had moved from the margins to the mainstream. Television helped: There were 172,000 television sets in the country in 1948, but 25 million by 1954. While the new technology hurt baseball attendance and nearly killed boxing, the NFL handled television shrewdly. Home games were blacked out in local markets, but all road games were telecast back to home cities. Meanwhile, Time, Inc.'s weekly magazine *Sports Illustrated*, launched in 1954, began documenting the pro game through the fall. The extra coverage, both electronic and print, helped fans better understand the strategy of the game and appreciate players beyond the skill positions. Linebackers like Sam Huff in New York

and Joe Schmidt in Detroit became recognized as quarterbacks of the defense. Even linemen like Cleveland's indomitable Don Colo and Baltimore's gifted behemoth Eugene "Big Daddy" Lipscomb became stars in their own right. The growing popularity could be seen from coast to coast, where the average attendance nearly doubled over the decade. In New York, the Giants' 1956 move from the Polo Grounds to Yankee Stadium changed the perception of the team. ("All of a sudden, instead of going to the dumps on the West Side, somebody would be inviting you to dinner at Toots Shor's or '21'," said Frank Gifford.) Fans waited in line overnight in Detroit for championship game tickets. In Los Angeles, the Rams played on multiple

occasions to crowds of 100,000. By 1959, Thomas Morgan, writing in *Esquire*, argued, "The best game played in America today, with the possible exception of draw poker, is professional football. Among professional spectator sports, it has no peer . . . The professionals' game is harder, faster, meaner and more acute than either the college game or the sluggish pro game of the Thirties." While the '58 title game may have seemed to some to arrive like a bolt out of the blue, pro football's rise had been coming for years.

**BRUTE FORCE**
Ferocious play by defensive linemen such as Browns guard Don Colo (70, left) and Big Daddy Lipscomb (above) made the line of scrimmage resemble a multicar crash on the freeway.

Guaranteed
to happen at most
football games....
An old-timer will turn
to a younger man and
tell him that football
has been ruined by
the new rules.
He will not specify
what rules.

**JIMMY CANNON**

► FROM *WHO STRUCK JOHN?*, 1956

CAUTION:
MERGER AHEAD!
The first Super
Bowl was between
the AFL champion
Kansas City Chiefs
and the NFL's
mighty Green Bay
Packers, in 1967.
The Packers beat the
upstarts handily.

19

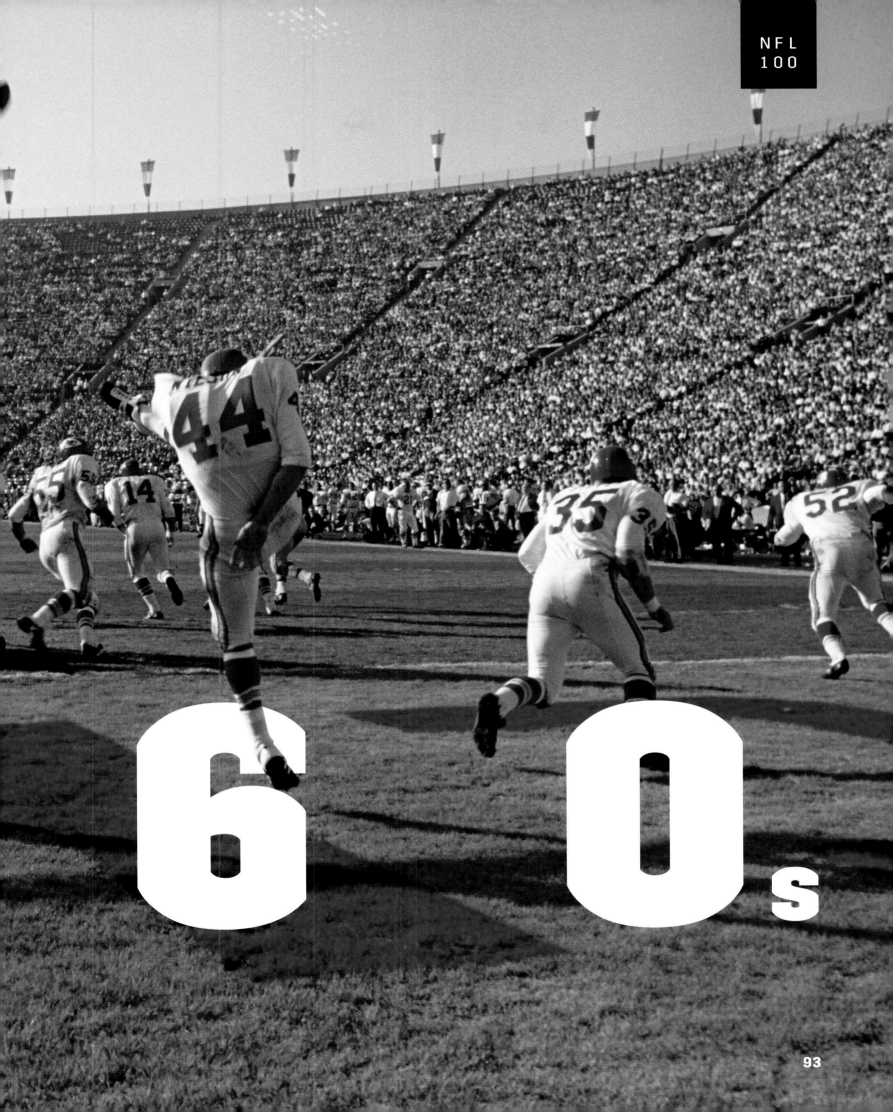

# 60s

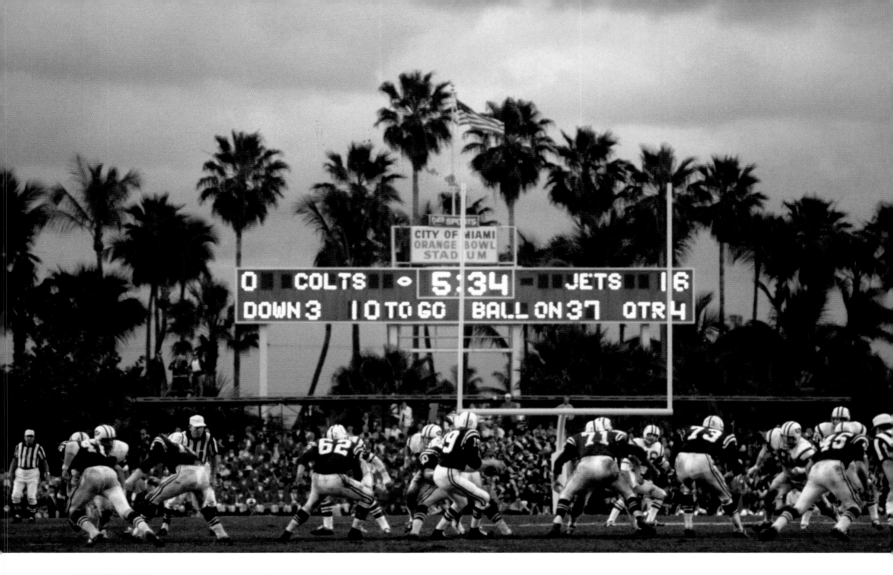

**FLATTOP FLOP** Johnny Unitas came off the Colts' bench in a futile bid to overtake Joe Namath's New York Jets in Super Bowl III.

**F**OOTBALL CHANGES IN EVERY decade, but in no other decade did it change as conclusively or convulsively as it did in the 1960s. The new decade dawned with just 12 pro teams and football still a distant second to major league baseball in popularity among American sports fans. It ended with 26 teams and pro football ascendant, having eclipsed baseball as the nation's most popular sport. During the course of ten years, two warring leagues fully merged into one, creating the necessity for a new championship game, the Super Bowl, which would become a national holiday in the civic religion of American culture.

The challenge to the established league was launched by a diffident Texan, the twenty-six-year-old Lamar Hunt, who in the summer of 1959 announced the formation of the American Football League, to begin play in September 1960. The AFL opened up the game with more passing (and a more slender, tapered football) but also provided opportunities for players, coaches, and even cities. Hunt's greatest innovation was a joint national television contract in which each team shared TV revenues equally to help ensure competitive balance.

Over in the NFL, change came just as quickly, as thirty-three-year-old commissioner Pete Rozelle (elected on the 23rd ballot, after a weeklong standoff at the NFL's annual meetings in January 1960) took over the established league. Rozelle acted swiftly, moving the league offices to midtown Manhattan to raise its profile in both the media and advertising worlds; following the AFL's lead in 1961 to push through a joint television package; and later presiding over the formation of the highly influential NFL Films and highly lucrative NFL Properties.

On the field, the dominant figure of the '60s was a coach, Vince Lombardi, under whom the Green Bay Packers became the apotheosis of American teamwork. The autocratic Lombardi preached fundamentals and execution, and his Packers perfected the power sweep while winning NFL titles in 1961, 1962, and 1965.

# There was cloak-and-dagger, high-pressure recruiting, and secret drafts. When the Cowboys' president, Tex Schramm, referred to "the war in the '60s," he wasn't talking about Vietnam.

Interrupting the Packers run were the Bears' staunch defense in 1963 and Jim Brown and the Browns, who captured the title in '64. The Houston Oilers won the first two titles in the AFL, while the Buffalo Bills, led by quarterback and future congressman Jack Kemp, won consecutive championships, in 1964 and 1965.

By the end of 1965, the bitter battle between the AFL and NFL for high-priced, high-profile rookies had become all-consuming. There were cloak-and-dagger scenes, high-pressure recruiting, and secret drafts going on in one hotel while public drafts were being staged in another. When the Cowboys' president, Tex Schramm, referred to "the war in the '60s," he wasn't talking about Vietnam. By the spring of 1966, a truce was finally reached—the merger between the two leagues was announced on June 8, 1966, after two months of furtive back-channel negotiations between Hunt and Schramm.

Lombardi's Packers kept rolling, edging the Dallas Cowboys in the 1966 NFL Championship Game, then defeating Hunt's Kansas City Chiefs in the first "AFL-NFL World Championship Game," which, even before it was played, most people were referring to as the Super Bowl, the name Hunt had coined in the summer of 1966.

Lombardi would win another Super Bowl, to cap the 1967 season, before retiring from the Packers. At the time, conventional wisdom held that it might be another decade before the AFL caught up with the NFL. But just a year later, quarterback Joe Namath guaranteed a victory for his New York Jets and delivered, slaying the NFL's heavily favored Baltimore Colts in Super Bowl III, one of the most shocking upsets in sports history.

**PETER PRINCIPLES**
Pete Rozelle, who was NFL commissioner for 29 years, is credited with making the Super Bowl the most popular sporting event in America. He also orchestrated the AFL-NFL merger and expanded the league from 12 teams to 28.

Many thought that result was a fluke until the conclusion of the 1969 season, when the AFL's Chiefs, returning for their second Super Bowl trip, trounced the heavily favored Minnesota Vikings of the NFL 23–7 in Super Bowl IV. After ten years, the AFL had finally gained parity with the older league and earned its overdue respect, at the precise moment it ceased to exist.

And, at the conclusion of the eventful decade, the larger, unified NFL had reshaped the American sports landscape—and stood at its summit. —**Michael MacCambridge**

# Leaders

| | | | | |
|---|---|---|---|---|
| **PASSING YARDS** ▲ | 1960 | Johnny Unitas | Colts | 3,099 |
| | 1961 | Sonny Jurgensen | Eagles | 3,723 |
| | 1962 | Sonny Jurgensen | Eagles | 3,261 |
| | 1963 | Johnny Unitas | Colts | 3,481 |
| | 1964 | Charley Johnson | Cardinals | 3,045 |
| | 1965 | John Brodie | 49ers | 3,112 |
| | 1966 | Sonny Jurgensen | Redskins | 3,209 |
| | 1967 | Sonny Jurgensen | Redskins | 3,747 |
| | 1968 | John Brodie | 49ers | 3,020 |
| | 1969 | Sonny Jurgensen | Redskins | 3,102 |
| **RUSHING YARDS** ▲ | 1960 | Jim Brown | Browns | 1,257 |
| | 1961 | Jim Brown | Browns | 1,408 |
| | 1962 | Jim Taylor | Packers | 1,474 |
| | 1963 | Jim Brown | Browns | 1,863 |
| | 1964 | Jim Brown | Browns | 1,446 |
| | 1965 | Jim Brown | Browns | 1,544 |
| | 1966 | Gale Sayers | Bears | 1,231 |
| | 1967 | Leroy Kelly | Browns | 1,205 |
| | 1968 | Leroy Kelly | Browns | 1,239 |
| | 1969 | Gale Sayers | Bears | 1,032 |
| **RECEIVING YARDS** ▲ | 1960 | Raymond Berry | Colts | 1,298 |
| | 1961 | Tommy McDonald | Eagles | 1,144 |
| | 1962 | Bobby Mitchell | Redskins | 1,384 |
| | 1963 | Bobby Mitchell | Redskins | 1,436 |
| | 1964 | Johnny Morris | Bears | 1,200 |
| | 1965 | Dave Parks | 49ers | 1,344 |
| | 1966 | Pat Studstill | Lions | 1,266 |
| | 1967 | Ben Hawkins | Eagles | 1,265 |
| | 1968 | Roy Jefferson | Steelers | 1,074 |
| | 1969 | Harold Jackson | Eagles | 1,116 |

## CHAMPIONS

▼

1960
**PHILADELPHIA EAGLES**
—
1961
**GREEN BAY PACKERS**
—
1962
**GREEN BAY PACKERS**
—
1963
**CHICAGO BEARS**
—
1964
**CLEVELAND BROWNS**
—
1965
**GREEN BAY PACKERS**
—
1966*
**GREEN BAY PACKERS**
—
1967
**GREEN BAY PACKERS**
—
1968
**NEW YORK JETS (AFL)**
—
1969
**KANSAS CITY CHIEFS (AFL)**

*Super Bowl era begins

# Pick Six

## 616

Games played in American Football League history. The first AFL game was played on Friday, September 9, 1960, at Nickerson Field in Boston between the Denver Broncos and Boston Patriots, with the Broncos winning 13–10. In the final game, on January 4, 1970, the Chiefs defeated the Raiders 17–7 to advance to the Super Bowl.

## 23

Ballots it took to elect 33-year-old Rams general manager Pete Rozelle to replace the late Bert Bell as NFL commissioner. The first 22 ballots were split between NFL treasurer Austin Gunsel and chief legal counsel Marshall Leahy before Rozelle was nominated as a third, compromise choice.

## 18

Consecutive games from 1963 to 1965 in which Baltimore Colts running back Lenny Moore scored at least one touchdown, an NFL record. That mark would stand for 40 years until San Diego Chargers running back LaDainian Tomlinson matched it in 2004 and 2005.

## 3,100

More fans per game who attended AFL games involving the Dallas Texans (24,500) than the NFL's Dallas Cowboys (21,400) at the Cotton Bowl, home to both new teams. The Texans outdrew the Cowboys in two of their three seasons sharing a home before the AFL's entry moved to Kansas City to become the Chiefs in 1963.

## 17

Players and executives who comprised the charter class of the Pro Football Hall of Fame in Canton, Ohio. Two of the men who were there at the very beginning, George Halas and Jim Thorpe, were among the eleven enshrined as players and six who were selected as executives.

## 60

Degrees warmer for the AFL title game between the Oilers and the Raiders in Oakland on New Year's Eve, 1967, than it was for the NFL title game the same day in Green Bay. The temperature in Oakland was 47°F, while the Packers and Cowboys battled on the –13° tundra of Lambeau Field.

# Innovations

**1960:** Pete Rozelle moves NFL offices to New York City.

**1961:** Old-guard teams Bears, Giants, and Packers adopt helmet logos.

**1962:** Grabbing the face mask is outlawed in both the NFL and the AFL.

**1968:** Oilers become the first team to regularly play indoors and on AstroTurf.

## HELLO

► The Playoff Bowl, matching conference runners-up, is established (1961).

► Al Davis joins the Oakland Raiders as head coach (1963).

► Bears draft future Hall of Famers Dick Butkus and Gale Sayers at nos. 3 and 4 overall (1965).

► Southeast expansion adds Falcons (1966) and Saints (1967) in the NFL, Dolphins in the AFL (1966).

► Chuck Noll becomes the Steelers head coach (1969).

## GOODBYE

► Segregated teams, as the Redskins sign Bobby Mitchell (1962).

► Polo Grounds hosts final pro football game (1963).

► Curly Lambeau dies at age 67 (1965).

► AFL and NFL hold separate drafts for the final time (1966).

► All-time rushing leader Jim Brown retires at 30 (1966).

# Super Bowl Touchdowns

From the first Super Bowl touchdown, a 37-yard pass from Bart Starr to Max McGee in Super Bowl I, through Sony Michel's two-yard run in Super Bowl LIII, there have been 290 total touchdowns scored by 200 players in 53 games, with each of the 28 teams that have appeared in a Super Bowl having scored at least one TD. Here's a breakdown of how those touchdowns were scored.

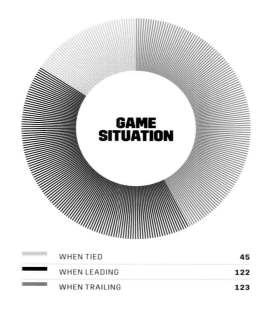

**GAME SITUATION**

| | | |
|---|---|---|
| | WHEN TIED | 45 |
| | WHEN LEADING | 122 |
| | WHEN TRAILING | 123 |

**PLAY TYPE**

| | | |
|---|---|---|
| | BLOCKED PUNT RETURN* | 2 |
| | FUMBLE RECOVERY RETURN | 7 |
| | KICKOFF RETURN | 10 |
| | INTERCEPTION RETURN | 15 |
| | RUSHING | 98 |
| | PASSING | 158 |

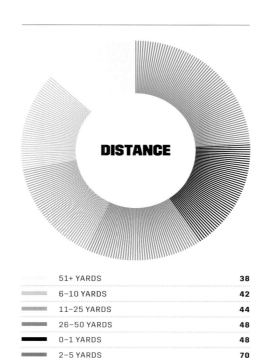

**DISTANCE**

| | | |
|---|---|---|
| | 51+ YARDS | 38 |
| | 6–10 YARDS | 42 |
| | 11–25 YARDS | 44 |
| | 26–50 YARDS | 48 |
| | 0–1 YARDS | 48 |
| | 2–5 YARDS | 70 |

**QUARTER**

| | | |
|---|---|---|
| | OT | 1 |
| | 1ST QUARTER | 47 |
| | 3RD QUARTER | 70 |
| | 2ND QUARTER | 80 |
| | 4TH QUARTER | 92 |

\* None of the 499 Super Bowl punts have been returned for a TD.

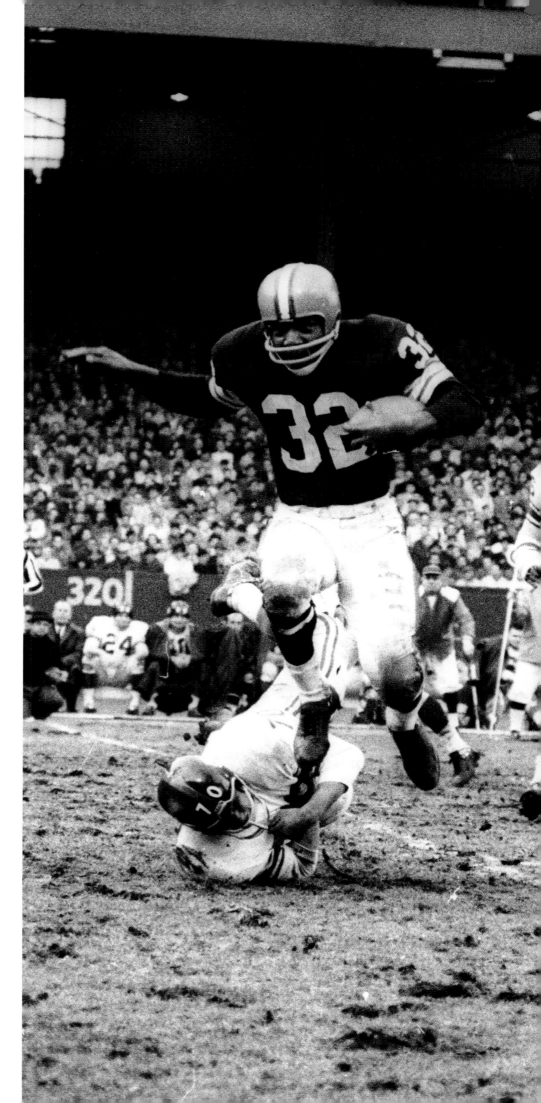

# JIM BROWN

▶ **By Jim Murray**

FROM THE *LOS ANGELES TIMES*
FEBRUARY 21, 1971

**Nobody ever ran with a football like James**
Nathaniel Brown. Not the Galloping Ghost, the
Four Horsemen, Bronko Nagurski—nobody. Jim
Brown wasn't a player, he was a Force. You didn't
tackle him, you sabotaged him—like guerrillas
swarming over a munitions train. He played nine
years and rolled up 12,312 yards rushing. Of the
top 10 scorers in pro football history, only one
of them got there without ever kicking a field
goal or a point-after-touchdown. Jim Brown.

Jim Brown didn't kick or throw the ball
into the end zone. He arrived with the ball. He
usually left a trail of nosebleeds behind him. His
126 touchdowns were all a result of Mass plus
Speed, of Time and Punishment. He really was
Jim Brawn. He is the only man I know who can
communicate menace while he's sitting down
and pecking at a lettuce salad with a purse
over his arm. For a long time, people thought he
was all Brown and no brains. He rarely smiled.
He didn't have to scowl. The conclusion was, he
was "sullen," 230 pounds of barely controlled
rage. The consensus was, you were lucky the
New York Giants and Detroit Lions had to bear
the brunt of it and not society as a whole.

Jim Brown did not need a reason to run over people. "Let's face it," said Sam Huff, his great adversary. "No linebacker in this league could stop Brown man-to-man." He was 6'2" and nearly 230 and he had a build that would make Charles Atlas gasp. In addition to his speed and power, he used his shoulder and his free arm as weapons. There was something about the way he ran, or the way he looked, that simply froze tacklers. He went through them like a blowtorch in a wax museum.

He was many things, was Jim Brown of Cleveland, but mostly he was consistent. In eight of the nine seasons he played he led the league in rushing, six times in carries and five times in touchdowns. He was as close to the perfect running back as any coach ever craved.

➤ **By Mickey Herskowitz,** FROM *THE GOLDEN AGE OF PRO FOOTBALL*, 1974

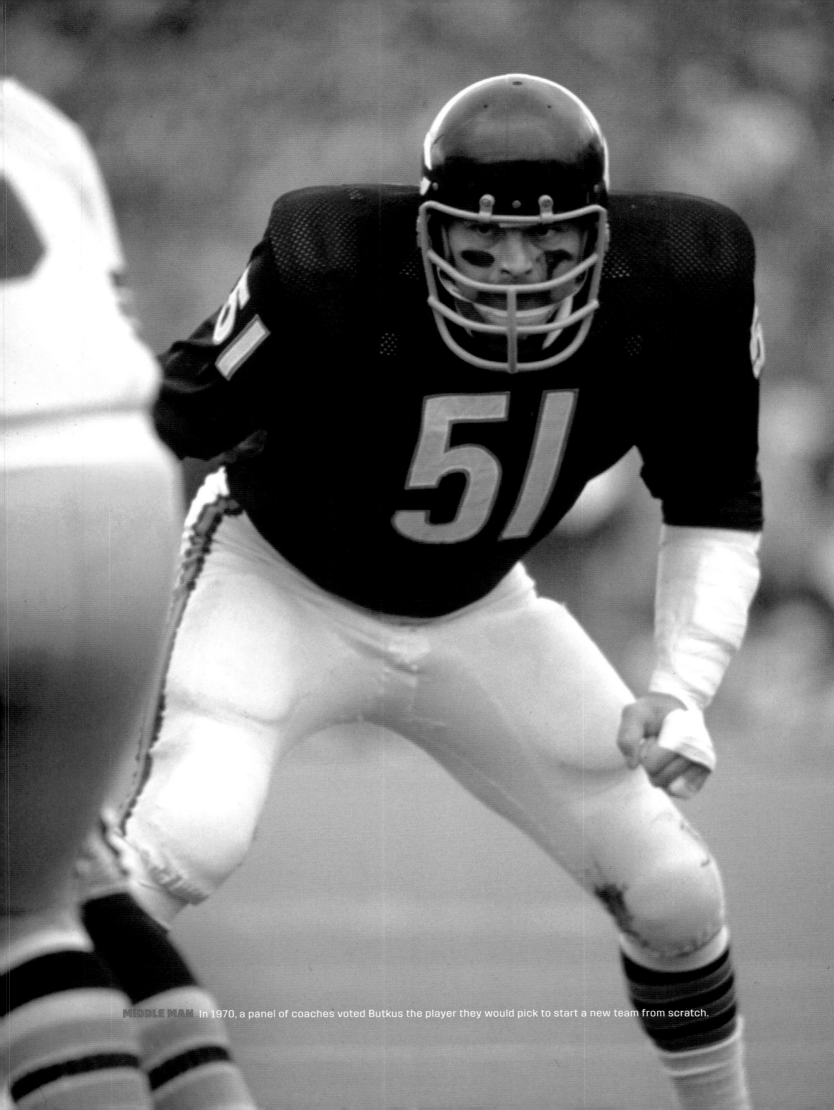

"Middle linebackers," the late Curly Lambeau used to say, "are people who start out in life tying tin cans to dogs' tails. They develop a fondness for train wrecks." Dick Butkus was a middle linebacker, for instance. So was Ray Nitschke. So, no doubt, was Genghis Khan. To play the position you have to have all the compassion of a Chinese warlord or a Mafia hit man. You play the game at a low smolder. You scowl a lot, and growl even more. It's suicidal. Other guys have "assignments." Your assignment is the ball. A middle linebacker swoops like a hawk over a chicken. And he takes no prisoners.

— **By Jim Murray,** FROM *THE JIM MURRAY COLLECTION*, 1988

# DICK BUTKUS & RAY NITSCHKE

— **By Jerry Kramer with Dick Schaap**
FROM *DISTANT REPLAY*, 1985

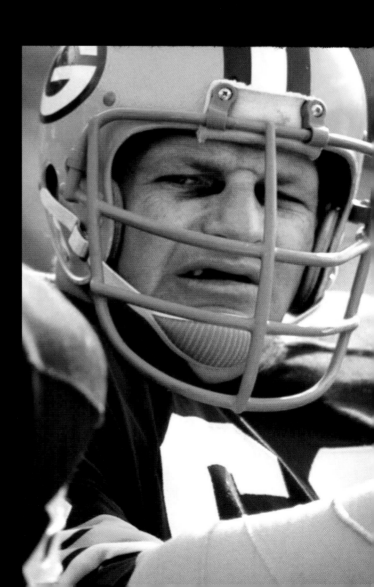

One afternoon ... Fuzzy Thurston, Bob Skoronski and ... got to discussing how good Nitschke was, and who was better, Nitsch or Dick Butkus of the Chicago Bears, another great middle linebacker who, like Ray, wound up in beer commercials. I argued that Ray was simply the best and the toughest linebacker ever.

"We double-teamed Butkus more than any other guy we ever played against," Ski pointed out.

"Butkus was the best I ever played against," Fuzzy said, diplomatically, 'but I never played against Ray."

"I think Ray was the hardest hitter the game ever had," Ski said, "but Butkus was the best defensive player."

His last eight years in the National Football League, Ray competed with Butkus. His first eight years in the NFL, Ray competed with Detroit's Joe Schmidt and Chicago's Bill George. All four of them, all middle linebackers playing in the same division, were elected to the Pro Football Hall of Fame. Ray made the Hall of Fame even though he was picked for the Pro Bowl only once, which indicates how tough the competition was at middle linebacker.

When we beat the New York Giants, 16–7 for the 1962 NFL championship, Ray was named the Most Valuable Player. I actually thought he was the second most valuable. I thought the guy who kicked the three field goals that made the difference in the game should have been the MVP. But I would have been willing to share the award with Ray

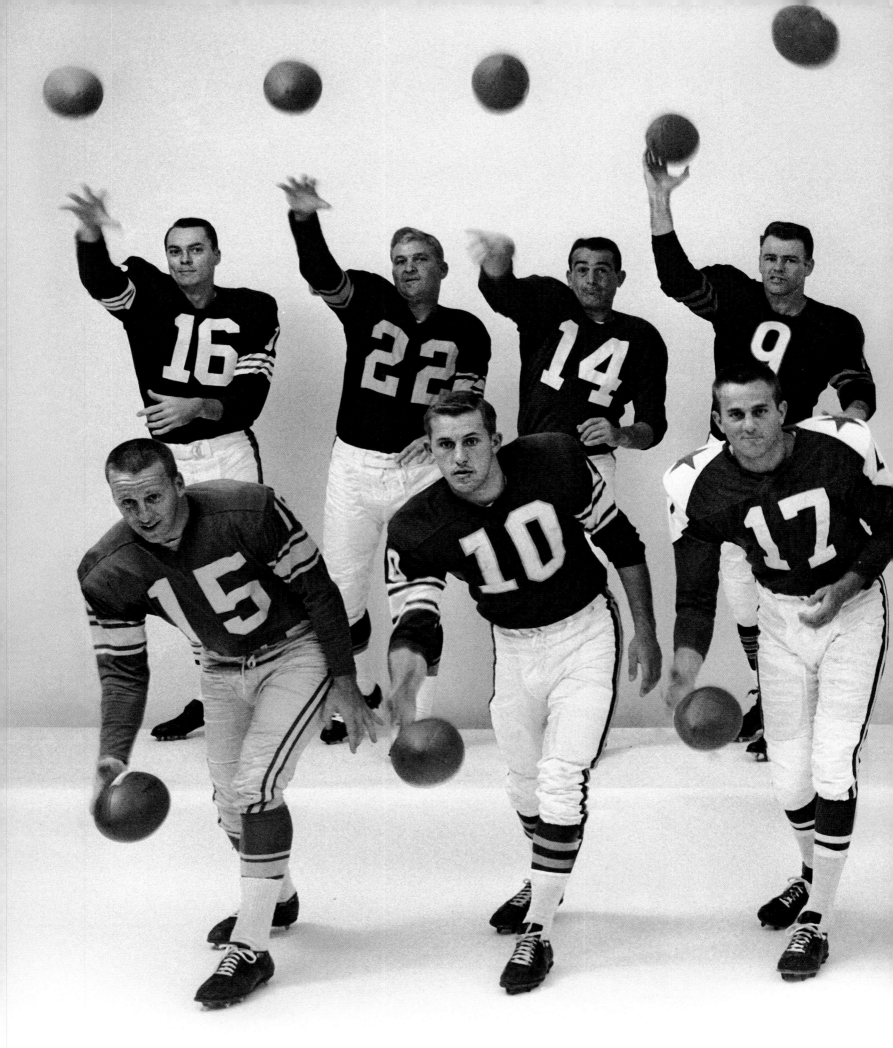

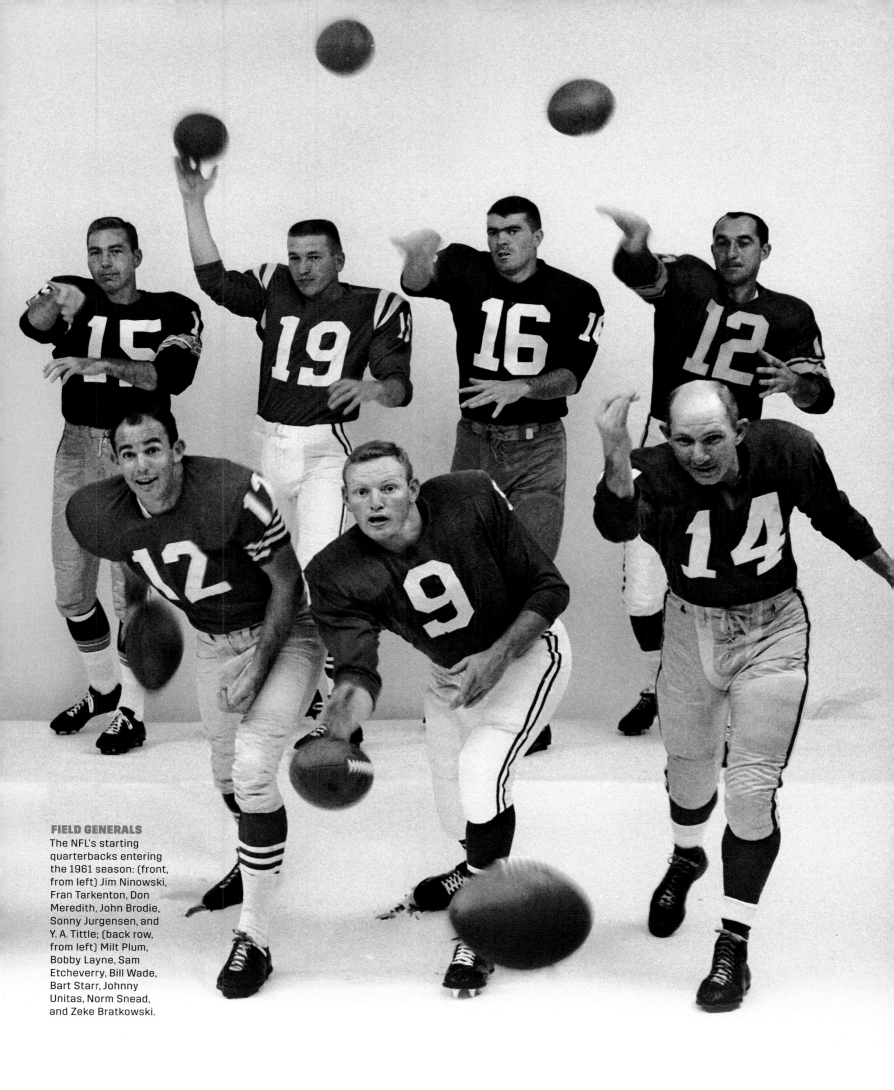

**FIELD GENERALS**
The NFL's starting quarterbacks entering the 1961 season: (front, from left) Jim Ninowski, Fran Tarkenton, Don Meredith, John Brodie, Sonny Jurgensen, and Y. A. Tittle; (back row, from left) Milt Plum, Bobby Layne, Sam Etcheverry, Bill Wade, Bart Starr, Johnny Unitas, Norm Snead, and Zeke Bratkowski.

# JOHNNY UNITAS

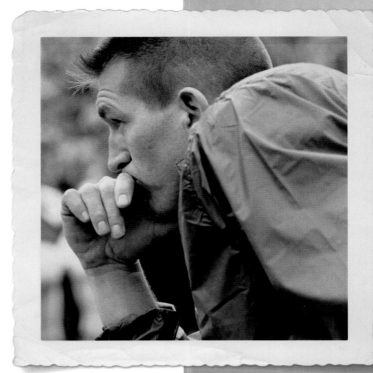

▶ **By Frank Deford**
FROM *SPORTS ILLUSTRATED*,
SEPTEMBER 23, 2002

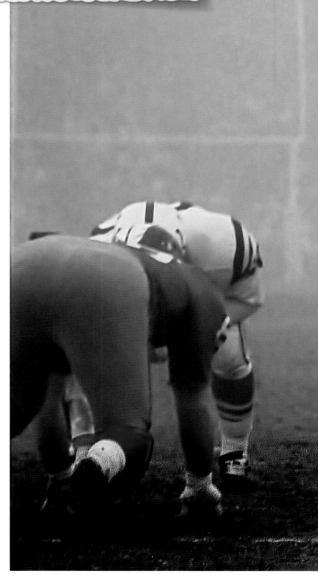

SOMETIMES, EVEN IF IT WAS ONLY YESTERDAY, OR EVEN IF IT JUST FEELS like it was only yesterday. . . . Sometimes, no matter how detailed the historical accounts, no matter how many the eyewitnesses, no matter how complete the statistics, no matter how vivid the film. . . . Sometimes, I'm sorry, but. . . . Sometimes, you just had to be there.

That was the way it was with Johnny Unitas in the prime of his life, when he played for the Baltimore Colts and changed a team and a city and a league. Johnny U was an American original, a piece of work like none other, excepting maybe Paul Bunyan and Horatio Alger.

Part of it was that he came out of nowhere, like Athena springing forth full-grown from the brow of Zeus, or like Shoeless Joe Hardy from Hannibal, Mo., magically joining the Senators, compliments of the devil. But that was myth, and that was fiction. Johnny U was real, before our eyes.

Nowadays, of course, flesh peddlers and scouting services identify the best athletes when they are still in junior high. Prospects are not allowed to sneak up on us. But back then, 1956, was a quaint time when we still could be pleasantly surprised. Unitas just surfaced there on the roster, showing up one day after a tryout. The new number 19 was identified as "YOU-ni-tass" when he first appeared in an exhibition, and only later did we learn that he had played, somewhere between obscurity and anonymity, at Louisville and then, for six bucks a game, on the dusty Pittsburgh sandlots. His was a story out of legend, if not, indeed, out of religious tradition: the unlikely savior come out of nowhere.

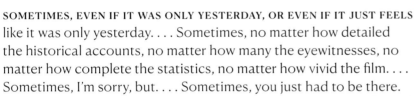

**DIVINE INTERVENTION**
Play-calling was one of Unitas's many strengths, and all of his coaches depended on it. "It's like being in a huddle with God," said Colts tight end John Mackey.

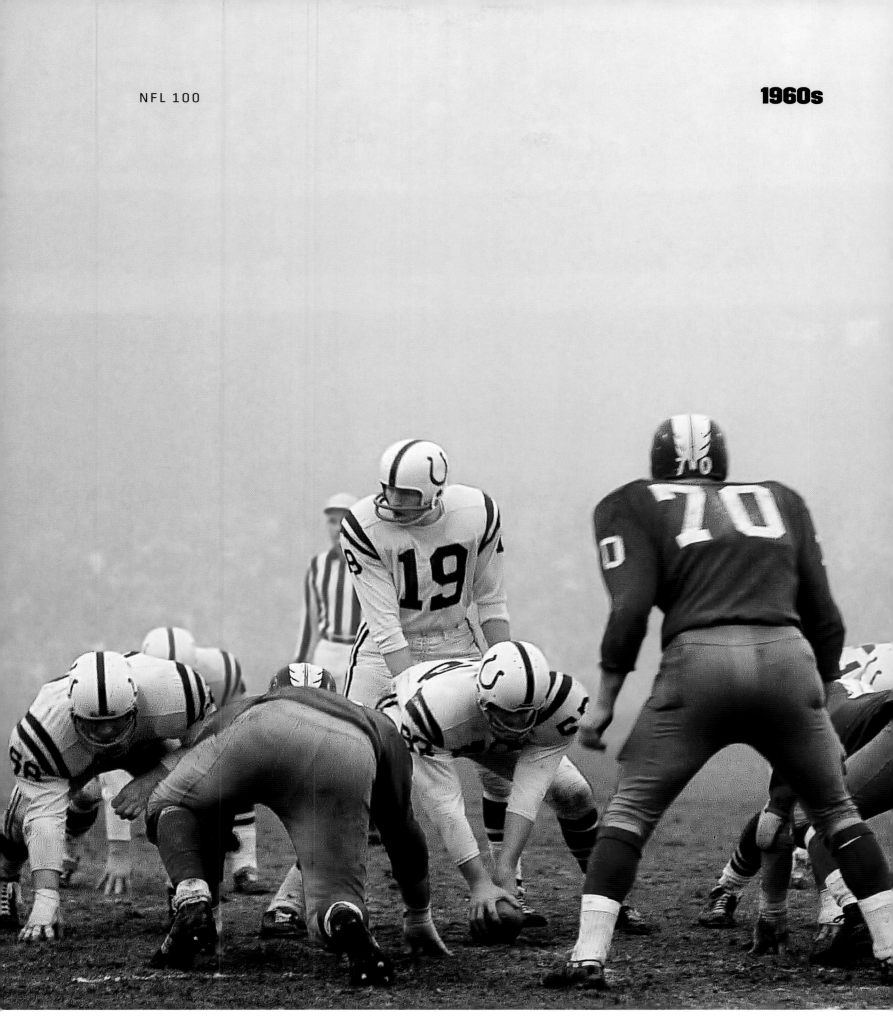

# VINCE LOMBARDI

**By Peter Bonventre**

*FROM NEIL LEIFER'S SPORTS STARS*, 1985

**Vince Lombardi was obsessed with excellence and success. The former does not** necessarily guarantee the latter, and for many years it seared Lombardi's soul. The son of an immigrant Brooklyn butcher, he was a member of Fordham's Seven Blocks of Granite line in the mid-'30s . He held a full-time job as an insurance investigator while attending law school, then coached three sports and taught physics, chemistry, algebra and Latin in a New Jersey Catholic high school. There was a stint as an assistant at West Point and later with the New York Giants, and Lombardi felt the fear of time running out. He mumbled curses and searched for answers to explain why he couldn't get a break. Was it his ethnicity? His bluntness? His lack of glamour?

Finally, at 46, Lombardi knew redemption. Hired as head coach of the lowly Green Bay Packers in 1959, he would make the most of what was given him. A year earlier the Packers had won only one game. They won seven of 12 games in Lombardi's first season and a Western Division title in his second. Then, they captured five NFL championships in seven years, as well as the first two Super Bowls.

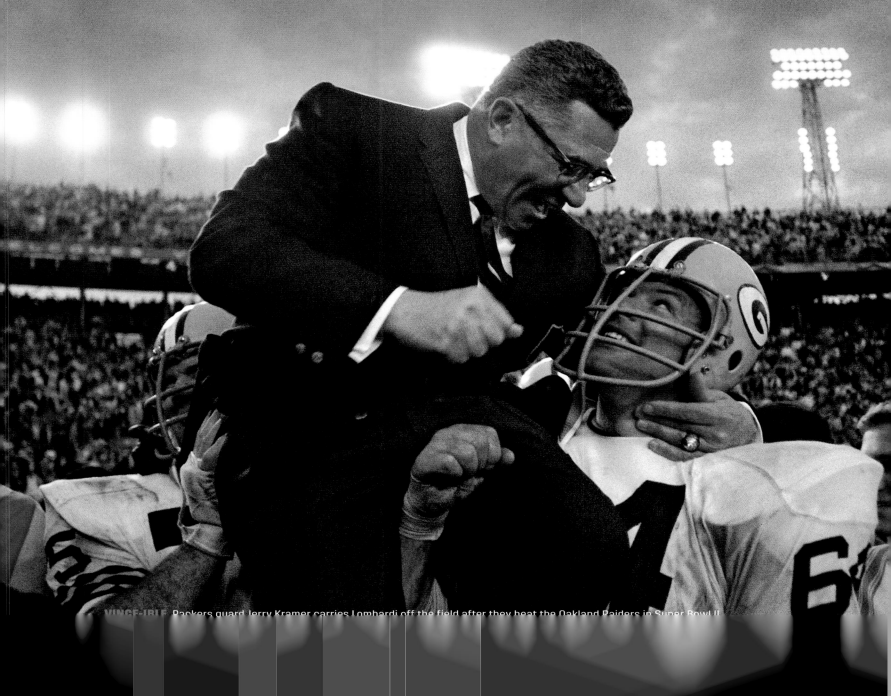

**VINCE-IBLE** Packers guard Jerry Kramer carries Lombardi off the field after they beat the Oakland Raiders in Super Bowl II.

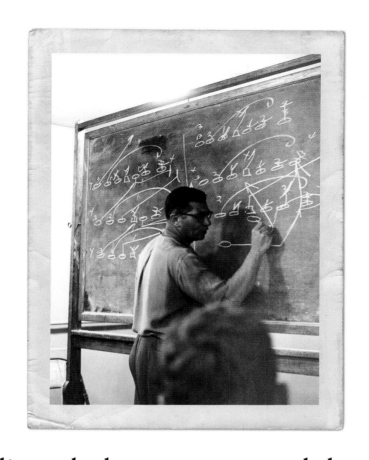

Lombardi took the unsung and the unknown and made us famous, made us stars, made us winners. He made a miracle. The year before he came to Green Bay, our lineup included 12 men who eventually played in the all-star game, the Pro Bowl, five of whom wound up in the Pro Football Hall of Fame. With that nucleus, the 1958 Packers won one game, tied one and lost 10. We lacked a leader. We lacked discipline. Lombardi provided both. He transformed a country-club picnic into the Bataan death march. We marched to nine straight winning seasons and five NFL championships.

▶ **By Jerry Kramer with Dick Schaap,** FROM *DISTANT REPLAY*, 1985

# BART STARR

➤ **By Peter Bonventre**

FROM *NEIL LEIFER'S SPORTS STARS*, 1985

IN THE '60S, WHEN THE GREEN BAY PACKERS RULED pro football with uncommon purpose, three players eclipsed all the others—and one player in particular formed the backbone of those championship seasons. In the words of the team's coach, the late, great Vince Lombardi: "There are many great quarterbacks, and I don't mean to be disparaging to any of them when I say Bart Starr is the greatest. He's smart and disciplined. He takes command. He's a leader. If we're in this game to win, then he is the best quarterback ever to play because he won the most championships. It's as simple as that."

**STARR POWER** Starr led the Packers to five league championships and is the only QB to have an NFL title three-peat.

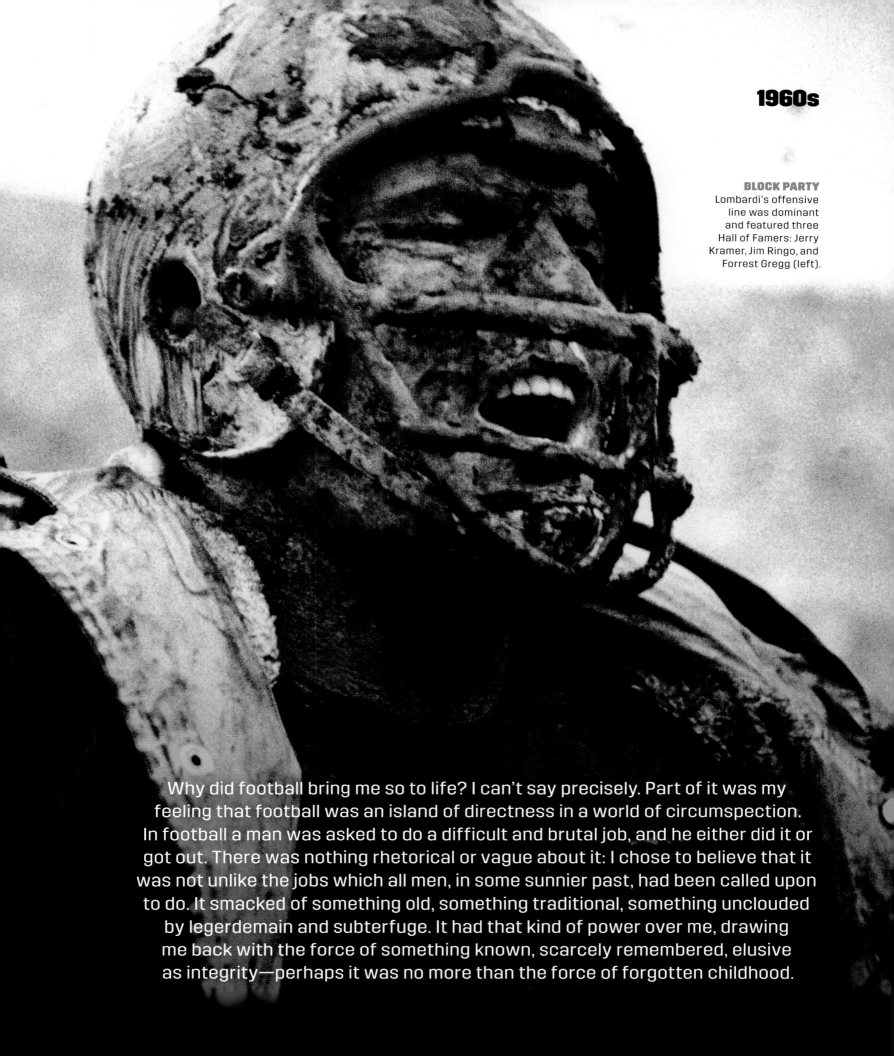

**BLOCK PARTY**
Lombardi's offensive
line was dominant
and featured three
Hall of Famers: Jerry
Kramer, Jim Ringo, and
Forrest Gregg (left).

Why did football bring me so to life? I can't say precisely. Part of it was my
feeling that football was an island of directness in a world of circumspection.
In football a man was asked to do a difficult and brutal job, and he either did it or
got out. There was nothing rhetorical or vague about it: I chose to believe that it
was not unlike the jobs which all men, in some sunnier past, had been called upon
to do. It smacked of something old, something traditional, something unclouded
by legerdemain and subterfuge. It had that kind of power over me, drawing
me back with the force of something known, scarcely remembered, elusive
as integrity—perhaps it was no more than the force of forgotten childhood.

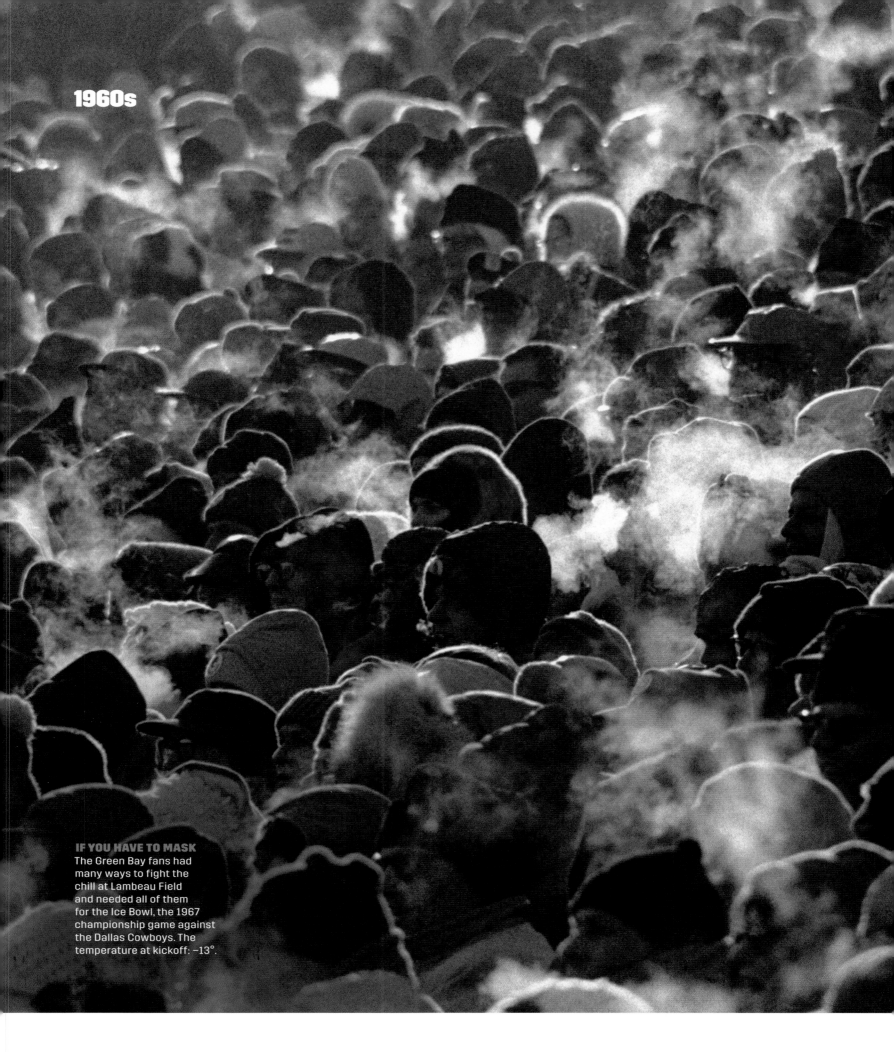

**IF YOU HAVE TO MASK**
The Green Bay fans had many ways to fight the chill at Lambeau Field and needed all of them for the Ice Bowl, the 1967 championship game against the Dallas Cowboys. The temperature at kickoff: −13°.

# Lambeau Field

**▶ By Johnette Howard**

FROM *SPORTS ILLUSTRATED*, JANUARY 13, 1997

THERE WAS A TIME WHEN THE GREEN BAY PACKERS' Lambeau Field wasn't the quaint anomaly it is today. Everyone played football on grass, and there were no Teflon roofs to shut out the midday sun, no domes to block the late-autumn wind. When mud-spattered linemen Forrest Gregg and Jerry Kramer hoisted coach Vince Lombardi on their shoulders in 1961 for his first NFL title ride, only God's gray sky hung overhead.

Franchise free agency didn't exist back then either. There was no threat of the Packers' being wooed away by some Sun Belt city offering a percentage of the revenue generated from the sale of personal seat licenses. Why, the world hadn't even heard of turf toe when Lombardi stalked Lambeau's frozen sidelines in his trademark overcoat, shrieking, "Hey! Whaddaya doin' out there?" in his best Brooklynese. "With Lombardi it was never cold here," says former All-Pro Fuzzy Thurston, who played guard for Green Bay from 1959 to '67. "Before games he'd just say something like, 'Men, it's a little blustery out there today.' Blustery, see? Then he'd say, 'It's our kind of day. Now get out there and strut around like it's the middle of July.'"

The Packers were a league power then, as they are now, and Lambeau Field was the NFL's answer to Boston Garden or Yankee Stadium—hallowed ground where dynasties were born. During Lombardi's nine-year stay the Packers won five league championships, including the first two Super Bowls. Twenty-nine winters have passed since Green Bay last had a championship team, yet within the magical space of Lambeau Field it still seems to be 1967.

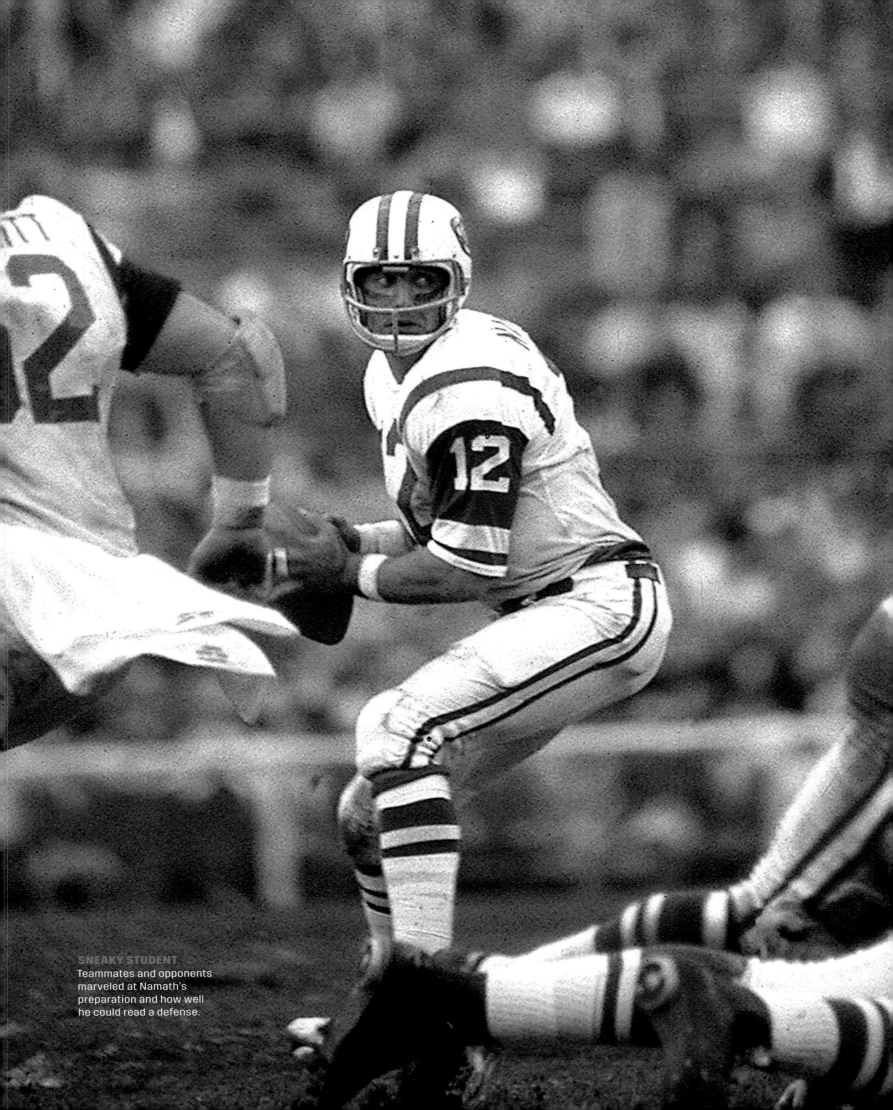

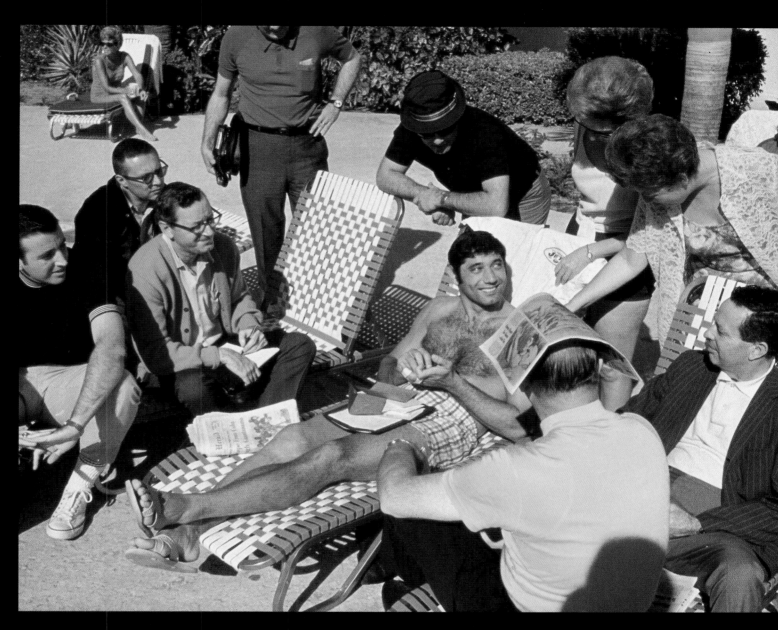

**REPORTING POOL** Namath basked in the press attention before Super Bowl III, and was as good poolside as he was during the game.

# JOE NAMATH

▶ **By Peter Bonventre**
FROM *NEIL LEIFER'S SPORTS STARS*, 1985

**At 21, Joe Namath was a star, and at 25, a legend. His stunning** moment of glory came on Jan. 12, 1969, in Super Bowl III. The New York Jets were 19-point underdogs, but Namath laughed at the odds—and guaranteed all who'd listen that he and his teammates would crush the mighty Baltimore Colts. The final score: 16–7. The winner: the Jets. The hero: Namath. As the architect of a seemingly impossible triumph, he gave instant credibility to the merger between the upstart American Football League and the haughty National Football League.

# SONNY JURGENSEN

► **By Joe McGinniss,** FROM *THE SATURDAY EVENING POST*, 1968

GIVE SONNY JURGENSEN ONE YEAR IN NEW YORK City, and the East Side bartenders would be asking Joe Namath for proof of age. But Sonny has never had that year. Eleven seasons in the provinces—most of them with losing teams. It is as if Barbra Streisand were held captive in New Haven with a road show.

He throws the ball farther, faster and more accurately—under the most intense sort of physical and psychological pressure—than anyone else who is paid to play the game. And it does no good. He throws 50 yards to the end zone, and a receiver drops the ball.

Coming from behind, he completes his seventh pass in a row—and a rookie tackle is penalized for holding. No matter how many touchdowns he manages to direct, his defense always seems to give up more.

Last year, despite all this, and with the calcium so heavy in his elbow that he needed drugs to kill the pain, Sonny Jurgensen set new National Football League records for the most yards gained by passing. He led all quarterbacks in passes thrown for touchdowns and in lowest percentage of interceptions.

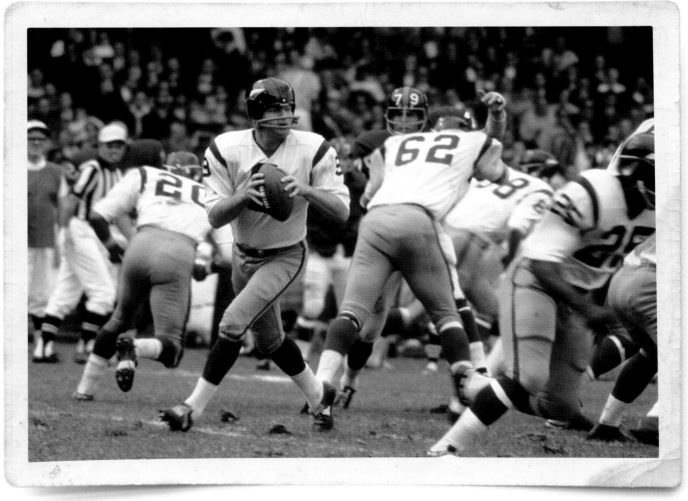

**SONNY DAY** Lombardi: "If we would have had Sonny Jurgensen in Green Bay, we'd never have lost a game."

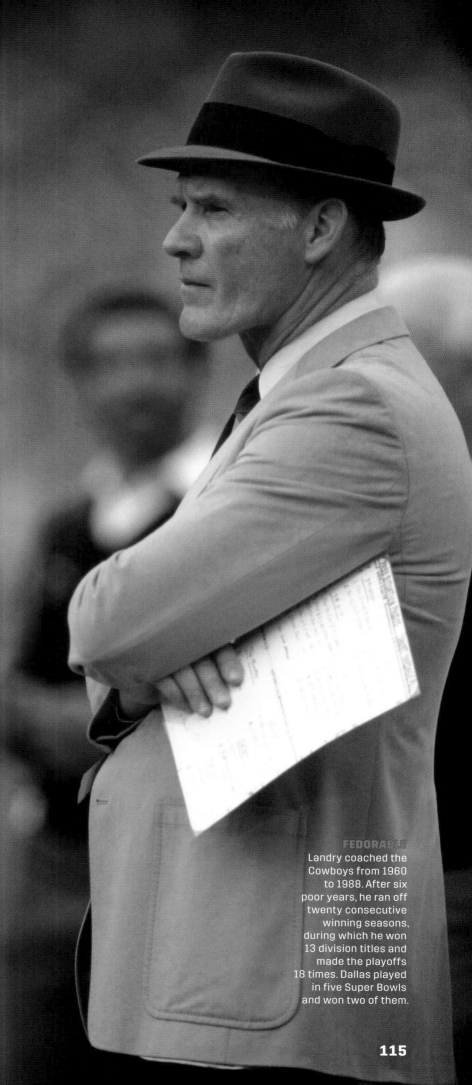

# Tom Landry

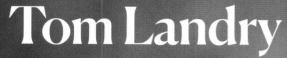

**By Paul Zimmerman**
FROM *SPORTS ILLUSTRATED*
FEBRUARY 21, 2000

**It is an enduring image: the man stoically** standing on the Dallas Cowboys sideline in his trademark hat. But ... Landry was a New York favorite before he ever put X's and O's to paper. In 1949 he played left cornerback—defensive halfback, as it was called in those days—for the Brooklyn–New York Yankees of the old All-America Conference, and he played the position with a roughneck style that the fans loved. Picture an early-day Mel Blount, and you've got Landry.

Six years later, in 1956, Landry coached the defense and Vince Lombardi oversaw the offense, giving the NFL champion Giants the most dynamic pair of assistant coaches ever to grace one staff. Landry would go on to build the Cowboys from an undermanned expansion team into an NFL power, first with a stunning array of offensive formations and maneuvers, then with a solid organizational structure. In 29 seasons under Landry, Dallas won two Super Bowls, played in three other title games and went 20 consecutive years with a winning record. He ranks [fourth] in career NFL victories, with 270. In his 40-year pro career Landry was vital in forging a brand of football that the NFL could hang its hat on.

**FEDORABLE**
Landry coached the Cowboys from 1960 to 1988. After six poor years, he ran off twenty consecutive winning seasons, during which he won 13 division titles and made the playoffs 18 times. Dallas played in five Super Bowls and won two of them.

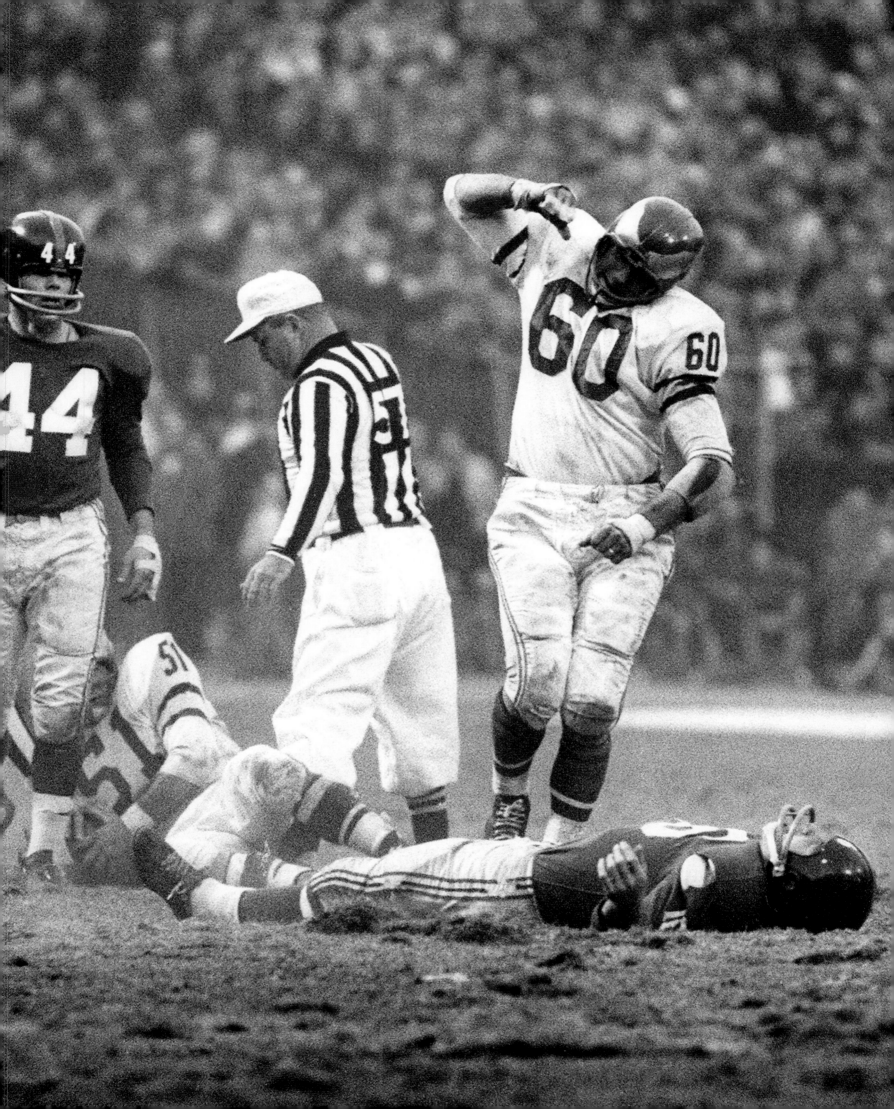

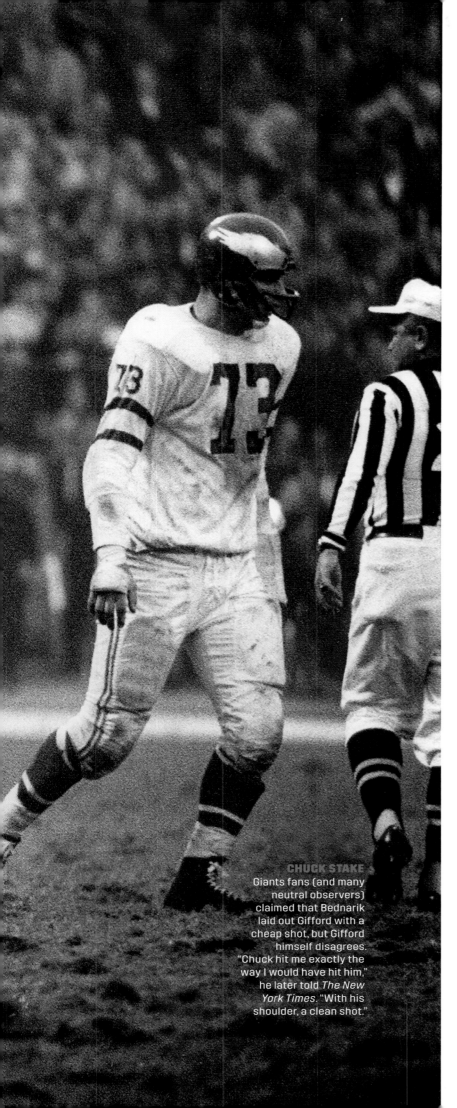

**CHUCK STAKE**
Giants fans (and many neutral observers) claimed that Bednarik laid out Gifford with a cheap shot, but Gifford himself disagrees. "Chuck hit me exactly the way I would have hit him," he later told *The New York Times*. "With his shoulder, a clean shot."

# CHUCK BEDNARIK

► **By John Schulian**
FROM *SPORTS ILLUSTRATED*, SEPTEMBER 6, 1993

THE PASS WAS BEHIND GIFFORD. IT WAS A BAD delivery under the best of circumstances, life-threatening where he was now, crossing over the middle. But Gifford was too much the pro not to reach back and grab the ball. He tucked it under his arm and turned back in the right direction, all in the same motion—and then Bednarik hit him like a lifetime supply of bad news.

Thirty-three years later there are still people reeling from The Tackle, none of them named Gifford or Bednarik. In New York somebody always seems to be coming up to old number 16 of the Giants and telling him they were there the day he got starched in the Polo Grounds (it was Yankee Stadium). Other times they say that everything could have been avoided if Charlie Conerly had thrown the ball where he was supposed to (George Shaw was the guilty Giants quarterback).

And then there was Howard Cosell, who sat beside Gifford on *Monday Night Football* for 14 years and seemed to bring up Bednarik whenever he was stuck for something to say. One week Cosell would accuse Bednarik of blindsiding Gifford, the next he would blame Bednarik for knocking Gifford out of football. Both were classic examples of telling it like it wasn't.

But it is too late to undo any of the above, for The Tackle has taken on a life of its own. So Gifford plays along by telling what sounds like an apocryphal story about one of his early dates with the woman who would become his third wife. "Kathie Lee," he told her, "one word you're going to hear a lot of around me is *Bednarik*." And Kathie Lee supposedly said, "What's that, a pasta?"

For all the laughing Gifford does when he spins that yarn, there was nothing funny about Nov. 20, 1960, the day Bednarik handed him his lunch.

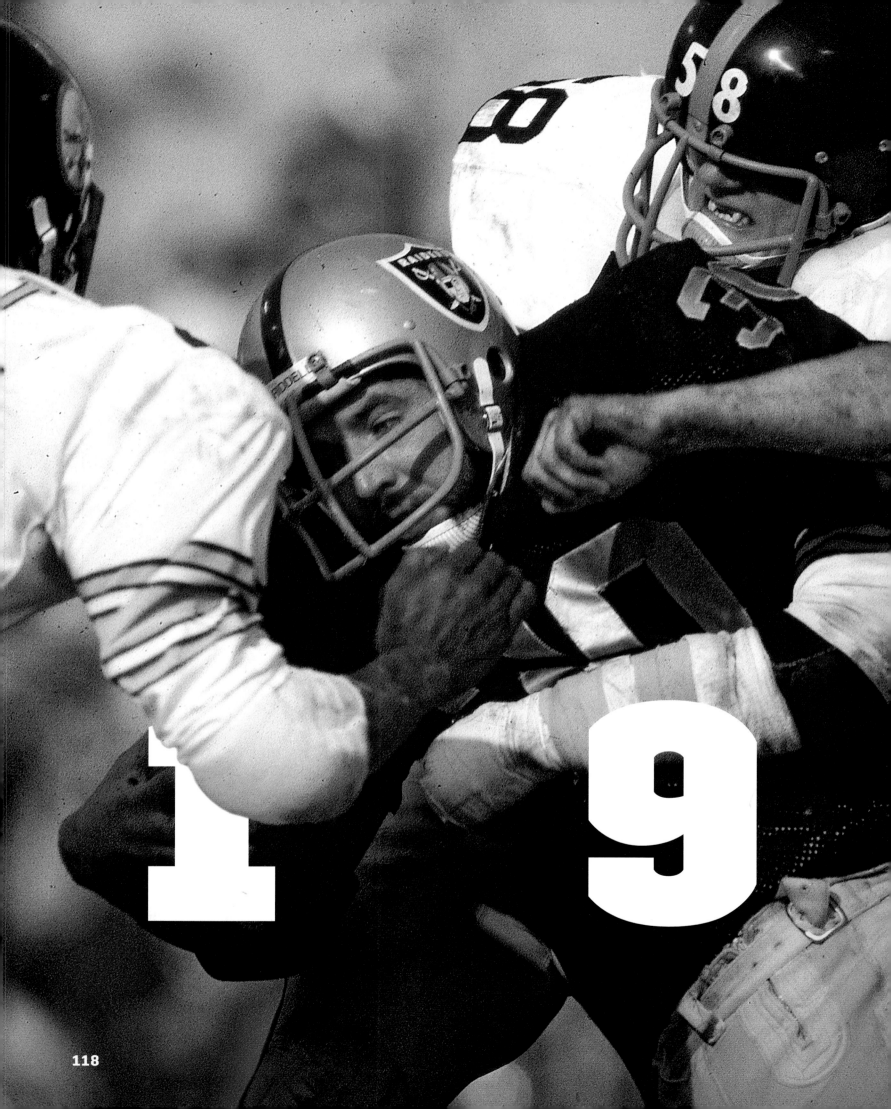

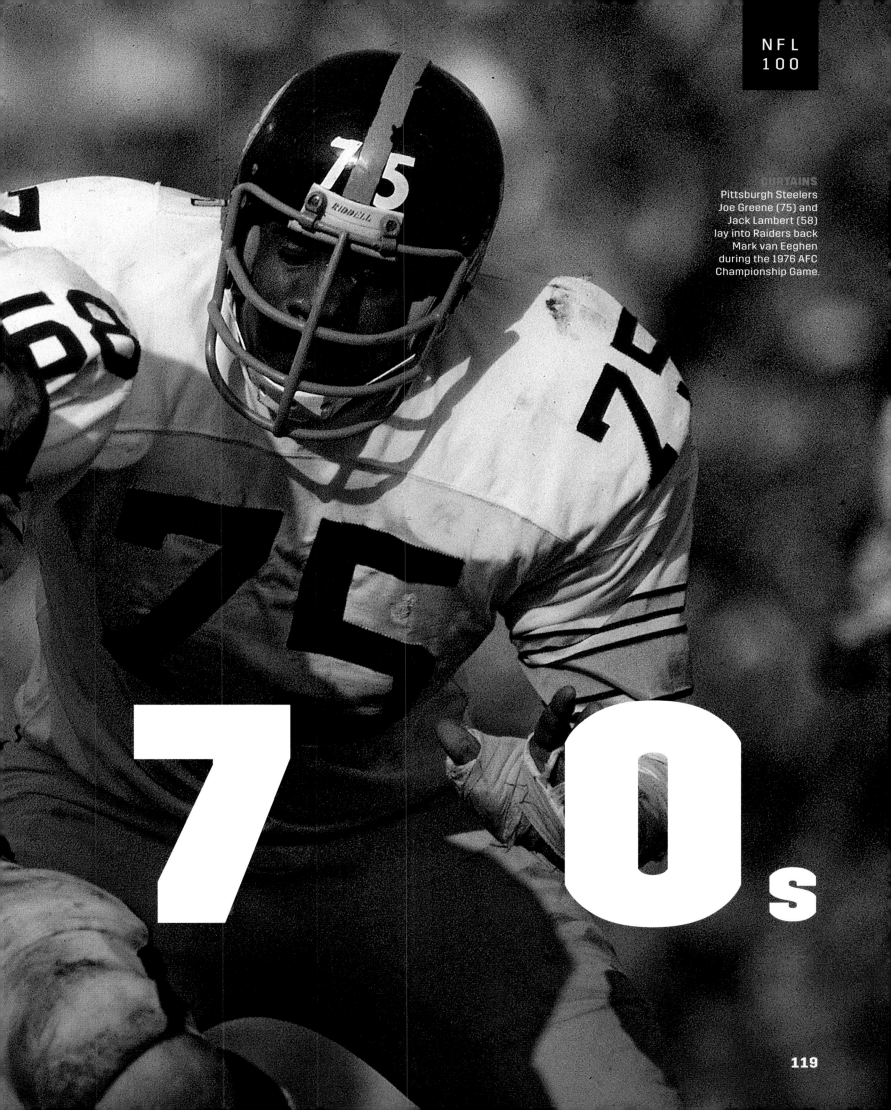

**CURTAINS**
Pittsburgh Steelers
Joe Greene (75) and
Jack Lambert (58)
lay into Raiders back
Mark van Eeghen
during the 1976 AFC
Championship Game.

# 7 0s

# The Decade

IN THE 1970S, PRO FOOTBALL EXPANDED decisively from the realm of sports into the realm of entertainment, and its championship game was transformed from a big sporting event to an American institution. "If Jesus Christ were alive today," said Norman Vincent Peale, "he'd be at the Super Bowl." As the NFL began its second half-century, commissioner Pete Rozelle raised the game's profile by moving it to prime time, where, on September 21, 1970, the Cleveland Browns beat the New York Jets in the first weekly broadcast of *Monday Night Football*. The series opened the game up to a broader audience and became a cultural phenomenon of the '70s. It was not a good decade for bowling leagues.

With the full merger of the AFL and the NFL, the mismatched 16 to 10 breakdown between the NFL and AFL was rebalanced, leaving 13 teams in each conference, with Baltimore, Cleveland, and Pittsburgh joining the 10 existing AFL teams in the American Football Conference. There were no longer separate rules for the two leagues. (The AFL's two-point conversion was eliminated, though its policy of names on the back of jerseys was instituted throughout the NFL.) It was an era of vast, circular multipurpose stadiums, with less dirt and grass, as a majority of teams moved toward artificial playing surfaces (which the players mostly hated).

This decade, more than most, was shaped by rules changes. When the hash marks were moved toward the center of the field in 1972, to make passing easier, the unintended consequence was to make the running game stronger. Ten running backs gained 1,000 yards

in 1972, and one—O. J. Simpson—became the first to break the 2,000-yard mark, rushing for 2,003 in 1973.

While the memorable moments were many—Franco Harris's Immaculate Reception, Roger Staubach's Hail Mary playoff winner to Drew Pearson, and the epic Longest Game between the Dolphins and the Chiefs on Christmas Day 1971—the decade's prevailing trends and greatest teams were defined by defense. The Vikings' defensive tackle Alan Page won the Most Valuable Player award in 1971, becoming the first defender to do so. The Dolphins, who had a perfect 17–0 season in '72, won back-to-back Super Bowls with a stifling No-Name Defense and the bulldozing running of Larry Csonka and his oft-broken nose. The defenses on Dallas's two Super Bowl champions were dubbed Doomsday and Doomsday II. The Vikings appeared in four Super Bowls with the Purple People Eaters, while the Broncos made one with their Orange Crush defense.

> ## The memorable moments were many—Franco Harris's Immaculate Reception, Roger Staubach's Hail Mary—but the decade's greatest teams were defined by defense.

But the black-and-gold standard was set by the Pittsburgh Steelers, whose intimidating defensive unit, anchored by Hall of Famer Joe Greene, was known as the Steel Curtain. "Losing has nothing to do with geography," Chuck Noll had said when he was hired by the hapless club in '69. In the coming years, as the Steelers rode to four Super Bowl wins in the '70s—an era when the steel economy in western Pennsylvania was crumbling—their intimidating style and fierce work ethic were seen as a reflection of their fans' and their region's resilience. Those first two Steelers titles were a product of their formidable pass rush, a trio of exemplary linebackers, and a bruising secondary. "We had all-stars at every position," said Andy Russell.

**COWBOY JUNCTION**
Dallas's Doomsday defense was led by Charlie Waters (41), Chuck Howley (54) and Cornell Green (34), seen here abusing the Washington Redskins in 1970.

But the Steelers' second pair of Lombardi Trophies, in the 1978 and '79 seasons, were a testament to the effectiveness of the evolving league rules. Though the Cowboys' Tex Schramm and the Bengals' Paul Brown had pushed for the changes that liberalized passing rules in part to neutralize the Steelers' cornerbacks and their suffocating bump-and-run technique, what the changes actually did was unleash the Steelers' offense, with Terry Bradshaw firing bombs to receivers Lynn Swann and John Stallworth. All three ended up in Canton, and the Steelers triumphed in 1978 and '79, outshooting the Cowboys and then the Rams in Super Bowls XIII and XIV.

Though the Steelers dominated on the field, it was instead the Cowboys—with their slick marketing and telegenic cheerleaders—who forever seemed to be on the late-afternoon national telecasts and who would be dubbed America's Team by decade's end. Though there would be eternal arguments about that title, there was no question that, by the end of the '70s, pro football had become America's Game. —**Michael MacCambridge**

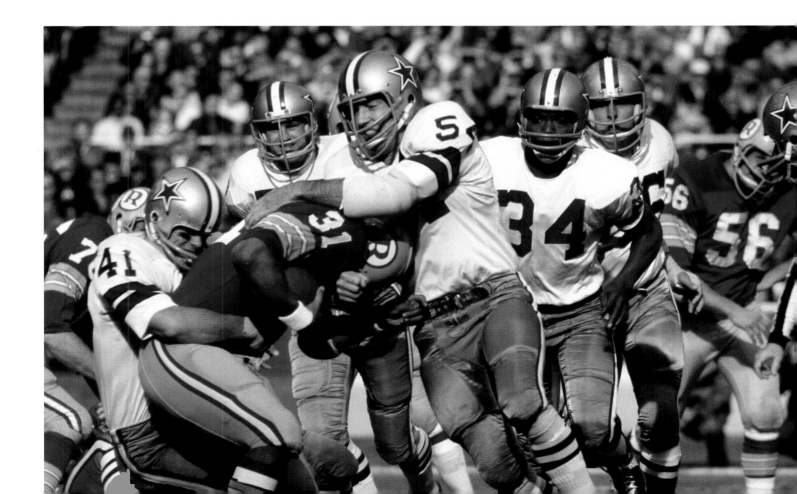

## Leaders

| | | | | |
|---|---|---|---|---|
| **PASSING YARDS** ▲ | 1970 | John Brodie | 49ers | 2,941 |
| | 1971 | John Hadl | Chargers | 3,075 |
| | 1972 | Joe Namath | Jets | 2,816 |
| | 1973 | Roman Gabriel | Eagles | 3,219 |
| | 1974 | Ken Anderson | Bengals | 2,667 |
| | 1975 | Ken Anderson | Bengals | 3,169 |
| | 1976 | Bert Jones | Colts | 3,104 |
| | 1977 | Joe Ferguson | Bills | 2,803 |
| | 1978 | Fran Tarkenton | Vikings | 3,468 |
| | 1979 | Dan Fouts | Chargers | 4,082 |
| **RUSHING YARDS** ▲ | 1970 | Larry Brown | Redskins | 1,125 |
| | 1971 | Floyd Little | Broncos | 1,133 |
| | 1972 | O.J. Simpson | Bills | 1,251 |
| | 1973 | O.J. Simpson | Bills | 2,003 |
| | 1974 | Otis Armstrong | Broncos | 1,407 |
| | 1975 | O.J. Simpson | Bills | 1,817 |
| | 1976 | O.J. Simpson | Bills | 1,503 |
| | 1977 | Walter Payton | Bears | 1,852 |
| | 1978 | Earl Campbell | Oilers | 1,450 |
| | 1979 | Earl Campbell | Oilers | 1,697 |
| **RECEIVING YARDS** ▲ | 1970 | Gene Washington | 49ers | 1,100 |
| | 1971 | Otis Taylor | Chiefs | 1,110 |
| | 1972 | Harold Jackson | Eagles | 1,048 |
| | 1973 | Harold Carmichael | Eagles | 1,116 |
| | 1974 | Cliff Branch | Raiders | 1,092 |
| | 1975 | Ken Burrough | Oilers | 1,063 |
| | 1976 | Roger Carr | Colts | 1,112 |
| | 1977 | Drew Pearson | Cowboys | 870 |
| | 1978 | Wesley Walker | Jets | 1,169 |
| | 1979 | Steve Largent | Seahawks | 1,237 |

## CHAMPIONS

▼

1970
**BALTIMORE COLTS**
—
1971
**DALLAS COWBOYS**
—
1972
**MIAMI DOLPHINS**
—
1973
**MIAMI DOLPHINS**
—
1974
**PITTSBURGH STEELERS**
—
1975
**PITTSBURGH STEELERS**
—
1976
**OAKLAND RAIDERS**
—
1977
**DALLAS COWBOYS**
—
1978
**PITTSBURGH STEELERS**
—
1979
**PITTSBURGH STEELERS**

## Pick Six

**455**

Days from the Tampa Bay Buccaneers' NFL regular-season debut until the first franchise victory. The tangerine-clad Bucs played their first game on September 12, 1976, but lost an NFL-record 26 straight games, before finally winning the last two games of December 1977.

**98**

Yards gained on a reception by Ahmad Rashad—without scoring a touchdown. On December 10, 1972, with the ball on his own one-yard line, Cardinals QB Jim Hart hit Rashad down the left sideline. Rams defenders brought him down a yard shy of the goal line for the longest nonscoring pass play in NFL history.

**1,546**

Team seasons played during the Super Bowl era. In that time, the only perfect one—or .065% of the total—was by the 1972 Miami Dolphins, who finished the regular season 14–0 and went on to win Super Bowl VII.

**82:30**

Time it took for the Miami Dolphins to defeat the Kansas City Chiefs 27–24 in their divisional round playoff game on Christmas Day 1971, the longest game in NFL history. Chiefs running back Ed Podolak gained 350 all-purpose yards, which is still the all-time postseason record.

**0**

Steelers all-time postseason victories before Franco Harris's legendary Immaculate Reception in the 1972 division playoffs against the Raiders. The Steelers, who had last appeared in the playoffs in 1947, would go on to 14 postseason wins in the 1970s, which is tied for the second most by any team in any decade.

**870**

Receiving yards by NFL leader Drew Pearson of the Cowboys in 1977, the only season since 1958 in which the league's leading receiver did not reach 900 yards. Every other season since 1960 saw at least one 1,000-yard pass catcher.

# Run-Pass Ratio

NFL offense has evolved from a game played primarily on the ground to one contested mainly through the air. Here's how the style of offense has evolved.

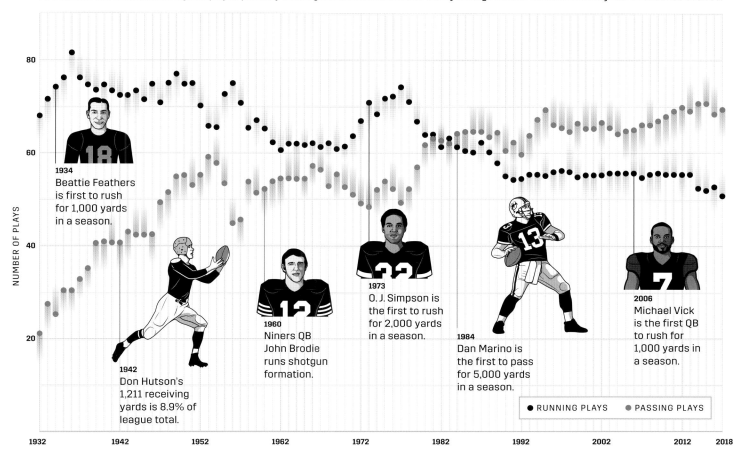

**1934**
Beattie Feathers is first to rush for 1,000 yards in a season.

**1942**
Don Hutson's 1,211 receiving yards is 8.9% of league total.

**1960**
Niners QB John Brodie runs shotgun formation.

**1973**
O. J. Simpson is the first to rush for 2,000 yards in a season.

**1984**
Dan Marino is the first to pass for 5,000 yards in a season.

**2006**
Michael Vick is the first QB to rush for 1,000 yards in a season.

● RUNNING PLAYS   ● PASSING PLAYS

NUMBER OF PLAYS

1932  1942  1952  1962  1972  1982  1992  2002  2012  2018

# Innovations

**1974:** Sudden-death overtime is added to regular-season games.

**1974:** Goalposts are moved from the goal line to the end line.

**1976:** The head slap is outlawed.

**1978:** Sixteen-game regular-season schedule is adopted.

## HELLO

► AFC and NFC formed after NFL-AFL merger (1970).

► Wild-card teams added to playoffs (1970).

► First *Monday Night Football* game (1970).

► World Football League established (1973).

► Bill Belichick hired to his first NFL job, as a Colts special assistant (1975).

► Tampa Bay Buccaneers and Seattle Seahawks founded (1976).

► 49ers hire Bill Walsh, draft Joe Montana (1979).

## GOODBYE

► Anonymity: Names on backs of jerseys made mandatory (1970).

► Patriots change name from Boston to New England (1971).

► Use of uniform numbers 0 and 00 is prohibited (1973).

► Dick Butkus and Johnny Unitas retire (1973).

► Red end zone flags are replaced by plastic pylons (1975).

► World Football League folds (1975).

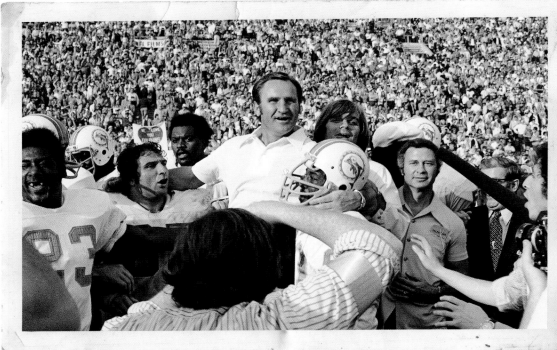

# SHULA'S SHRINE

► **By Edwin Pope,** FROM *THE EDWIN POPE COLLECTION*, 1973

**Call it Grant's Tomb. Retitle it Shula's** Shrine. Or Csonka's Causeway.

Or let 'em keep the name Rice Stadium. No matter. Henceforth this fog-bound battleground will be known as the one where the Dolphins settled themselves by any reasonable measure as football's all-time kings.

Forget Super Bowl VIII's final score of Miami 24, Minnesota 7. It was no more a reflection of Dolphins superiority than that 14–7 victory over Washington in Super Bowl VII indicated the one-sidedness there.

Do remember that both Washington then and Minnesota now were and are excellent football clubs. And that the Dolphins did much more than win by 17 this soggy Sunday.

This was murder. It made the St. Valentine's Day Massacre look like a draw. The world finally learned why Don Shula had been grinning all week. He knew what he had. Now everybody knows what he's got, which

is something nobody had before, the Kohinoor Diamond of football teams. A 32–2 record over two seasons, back-to-back Super Bowl champs.

The Dolphins buried once and for all the myth that other teams have better material. That Miami wins on unity rather than speed or muscle.

Jim Langer and Bob Kuechenberg and Larry Little and Wayne Moore and Norm Evans picked up Bud Grant's fabled Front Four from the Northland and shook them like a gang of King Kongs dangling a cluster of Fay Wrays from the Empire State Building. . . .

The Dolphins' speciously named No-Name defense pounded Viking runners into such terror that they did not get a first down rushing for a stultifying 44 minutes and 17 seconds. Bill Stanfill and Vern Den Herder came up hard on the inside. Manny Fernandez blocked the middle. Where else could a Viking runner go, except nowhere or crazy?

**MEAN TO AN END** A pro scout on Greene: "He's tough and mean and comes to hit people. He has good killer instincts. He's mobile and hostile."

# "I just play my game. You got to reckon with me I don't have to reckon with you."

—

**MEAN JOE GREENE**
PITTSBURGH STEELERS

Greene's college coach called him "a fort on foot." He was anomalously built—no definition, loosely and rather oddly jointed, a trunk that came in at the short ribs and flared back out again, a huge head and a wolfish clever face. In a film once I saw him knock down a tackle with his forearm— and then grab a guard up in one arm and the ballcarrier in the other. "There's a whole lot of things we can do on the line because he's Joe Greene," said L.C. Greenwood. "There are certain plays the offense just won't run because that's his spot. And he comes off the ball so quick. Normally you react off the snap or the man in front of you, but I don't even watch the ball. I react off Joe."

➤ **By Roy Blount Jr.,** FROM *ABOUT THREE BRICKS SHY OF A LOAD*, 1974

# CATCH AS CATCH CAN

► **By Roy Blount Jr.,** FROM *SPORTS ILLUSTRATED*, AUGUST 12, 1974

"HANDS ARE ALL IN YOUR HEAD," SAID WIDE receiver Glenn Scolnik of the concept "good hands." "A great receiver is totally relaxed from the waist up. The receiver's face is not all tight. He relaxes so his jowls hang, he eases and he takes it real soft."

Some of the receivers worked putty in their hands to keep them strong, or squeezed rubber balls, or just spent a lot of time carrying a football around and tossing it from hand to hand. "In the offseason I spend 10 minutes a day with each hand dropping the ball and catching it," said wide receiver Ron Shanklin, a great man for getting at the ball as well as for hauling it in.

That is not easy, holding a ball out in front of you in one hand, releasing it and then catching it in the same hand. Wide receiver Barry Pearson, the player you would think of first if you thought "sure-handed," said his hands weren't big enough to do that. He relied on concentration. "I watch the ball all the way in. You can't let the point hit either

of your hands; it should come between them."

"Lots of guys have good hands, and nobody knows it," said receivers coach Lionel Taylor, "because they don't have the concentration." He put the Steelers receivers through a number of drills to make them concentrate on the ball.

He would throw them knuckleballs, floaters, end-over-ends. "I learned a lot of hard-catch drills when I was playing. You'd go out for a pass, and they'd wave a towel at you, even throw weeds at you. Big handful of brush! You'd say, 'What was that!' But then in a game you're used to distractions and you don't flinch."

You never get far from contact in discussing any aspect of football. But the contact of ball on good hands is a special kind. The ball is hard and the receiver's hands are also hard. But a pass goes *snk* at the end, or even *sk* or, more softly, *ft* or *p* or *pth*—instead of *splack*—when the right touch gets ahold of it. "You don't fight the football," someone said. Iron hands in velvet gloves.

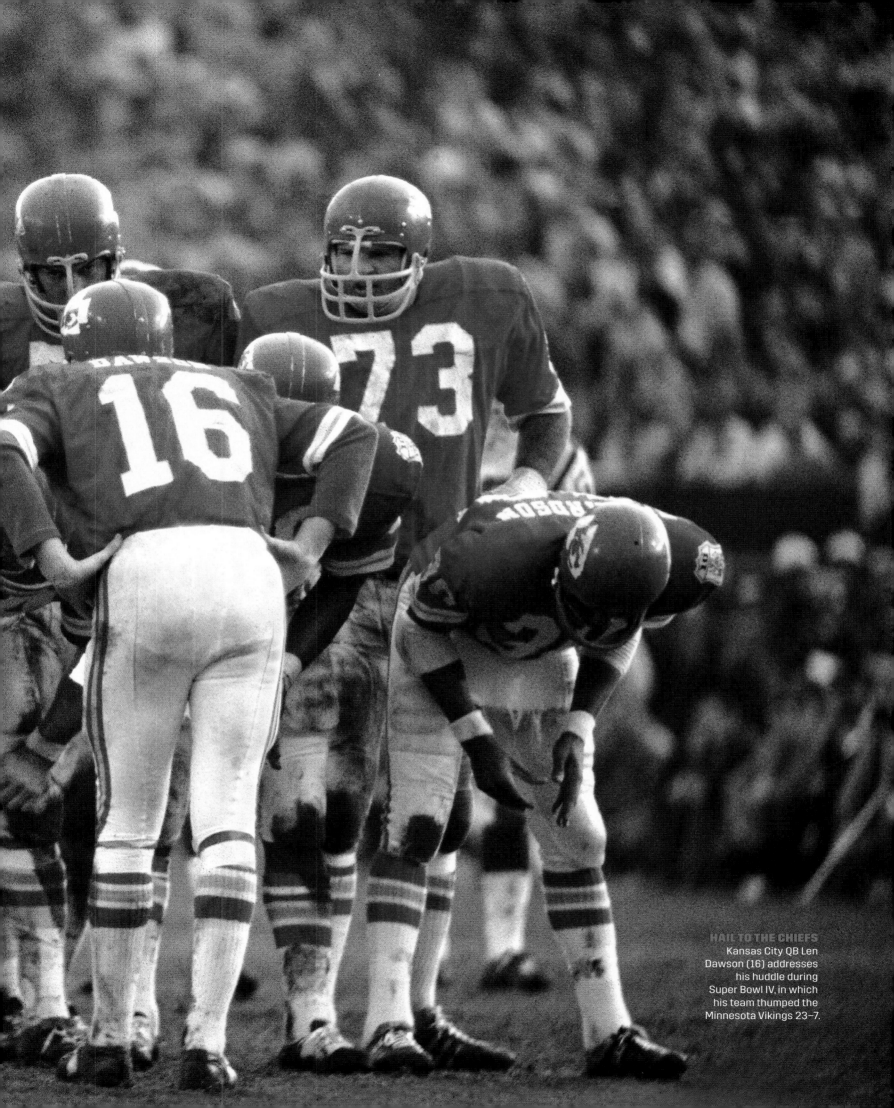

# Roger Staubach

➤ **By Jim Murray**

FROM THE *LOS ANGELES TIMES*, AUGUST 14, 1979

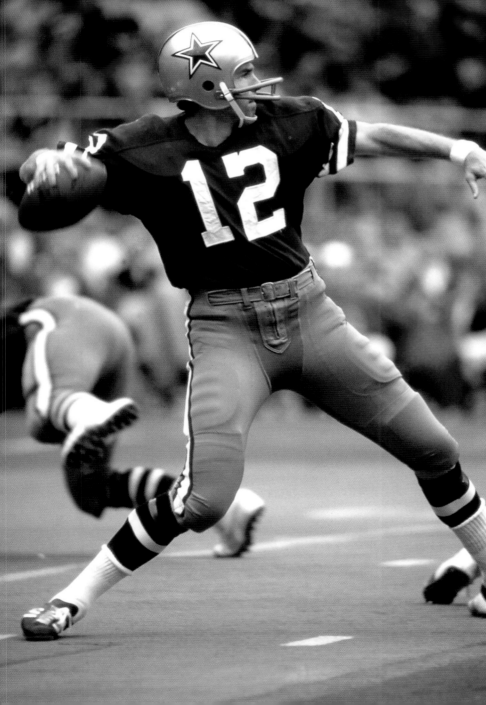

**WHEN ROGER STAUBACH WAS** named the Most Valuable Player in a Super Bowl a couple of years ago, and the sponsoring *Sport* magazine offered him a snazzy souped-up sports roadster that looked like a traveling bomb, just perfect for picking up chorus girls and speeding tickets, racing at Watkins Glen or arriving in style at the disco, Roger frowned and asked if he could have a station wagon instead.

The sports world cracked up. If Roger Staubach won two weeks at St. Tropez and the French Riviera, they said, he would ask if he could swap it for two days in Cleveland. Staubach would rather win a cow than a yacht. Roger Staubach was as square as a piece of fudge.

**OLD ROOKIE** Staubach won the Heisman while playing for Navy, then served five years, including a year in Vietnam.

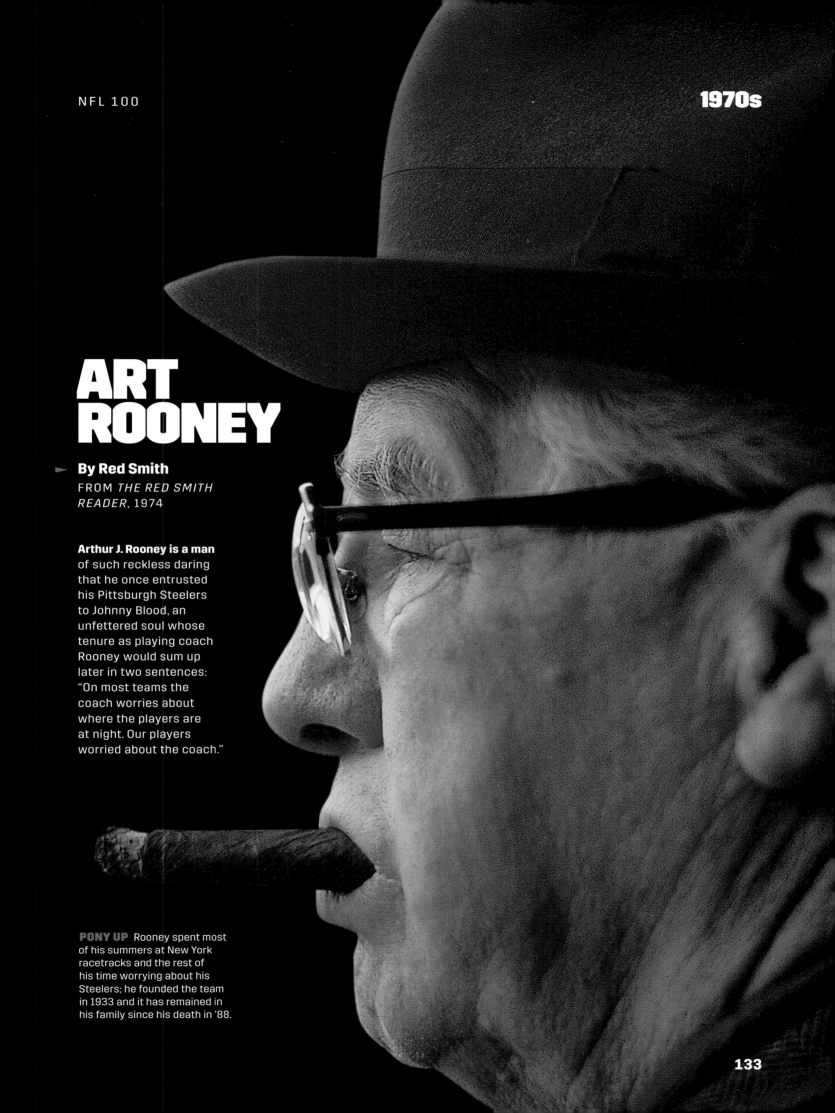

# ART ROONEY

➤ **By Red Smith**
FROM *THE RED SMITH READER*, 1974

**Arthur J. Rooney is a man** of such reckless daring that he once entrusted his Pittsburgh Steelers to Johnny Blood, an unfettered soul whose tenure as playing coach Rooney would sum up later in two sentences: "On most teams the coach worries about where the players are at night. Our players worried about the coach."

**PONY UP** Rooney spent most of his summers at New York racetracks and the rest of his time worrying about his Steelers; he founded the team in 1933 and it has remained in his family since his death in '88.

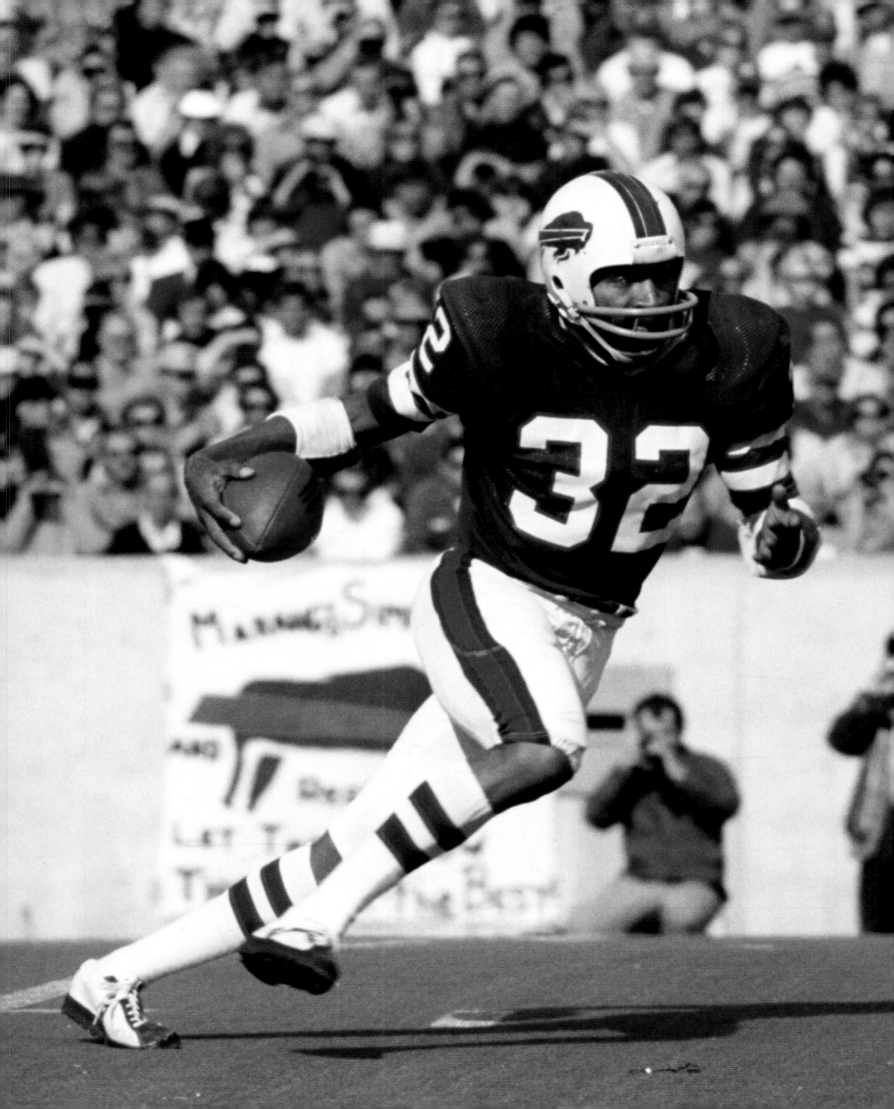

# O. J. SIMPSON

► **By Peter Bonventre**
FROM *NEIL LEIFER'S SPORTS STARS*, 1985

**He ran with the grace and balance of a great dancer,** cutting, faking and changing speeds with hints of music in every gesture, then bursting into daylight and whistling past hapless defenders. In 1973, when O. J. Simpson practiced his art with the Buffalo Bills, he took an entire pro football season and made it his own. It came down to Dec. 16 and a game against the New York Jets in Shea Stadium. Snow was falling, and O.J. glided across the field with an eerie elegance. There was 4:26 remaining in the first quarter when Simpson churned through the left side of his line for six yards—and broke Jim Brown's NFL single-season rushing record of 1,863 yards.

The referee stopped the game and ceremoniously returned the ball to O.J., who deposited it for safekeeping on the sidelines. When he got back to the huddle, his teammates chanted, "More, Juice, more. Let's get more."

There was much more. As the Bills sensed Simpson drawing close to the unthinkable distance of 2,000 yards, they paved the way with crushing blocks, and O.J. displayed his full repertory of dancing steps. Then, with 5:56 left in the game, Simpson blew over left guard for seven yards—and the Bills stormed onto the field and hoisted O.J. onto their shoulders. They carried him from the field as 47,740 shivering fans stood to applaud the season's hero. O.J. had rushed for 2,003 yards. There was no need for more.

**AROUND THE BLOCK, AGAIN**
The offensive line coach for the Buffalo Bills during Simpson's record-smashing 1973 season was Jim Ringo, a Hall of Fame center from Lombardi's Packers.

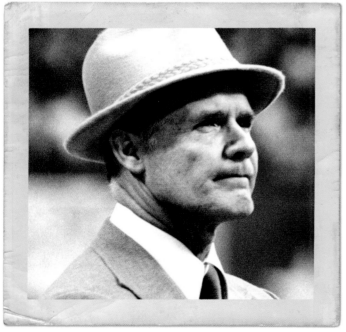

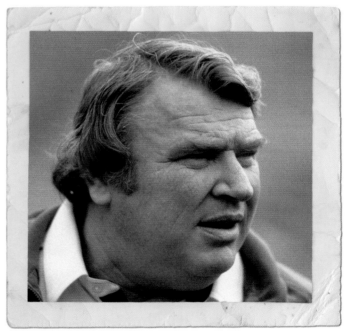

## "I've found there are three things everybody thinks they can do: star in a movie, write a book and coach a pro football team."

► **Charley Winner,** NEW YORK JETS HEAD COACH FROM
*JOE NAMATH AND THE OTHER GUYS*, BY RICK TELANDER, 1976

**X-AND-O MAESTROS**
The '70s were blessed with several Hall of Fame coaches; above, clockwise from top left: Bud Grant (Vikings), Chuck Noll (Steelers), John Madden (Raiders), and Tom Landry (Cowboys) Opposite: Don Shula (Dolphins) was hoisted up after his undefeated team beat the Washington Redskins in Super Bowl VII.

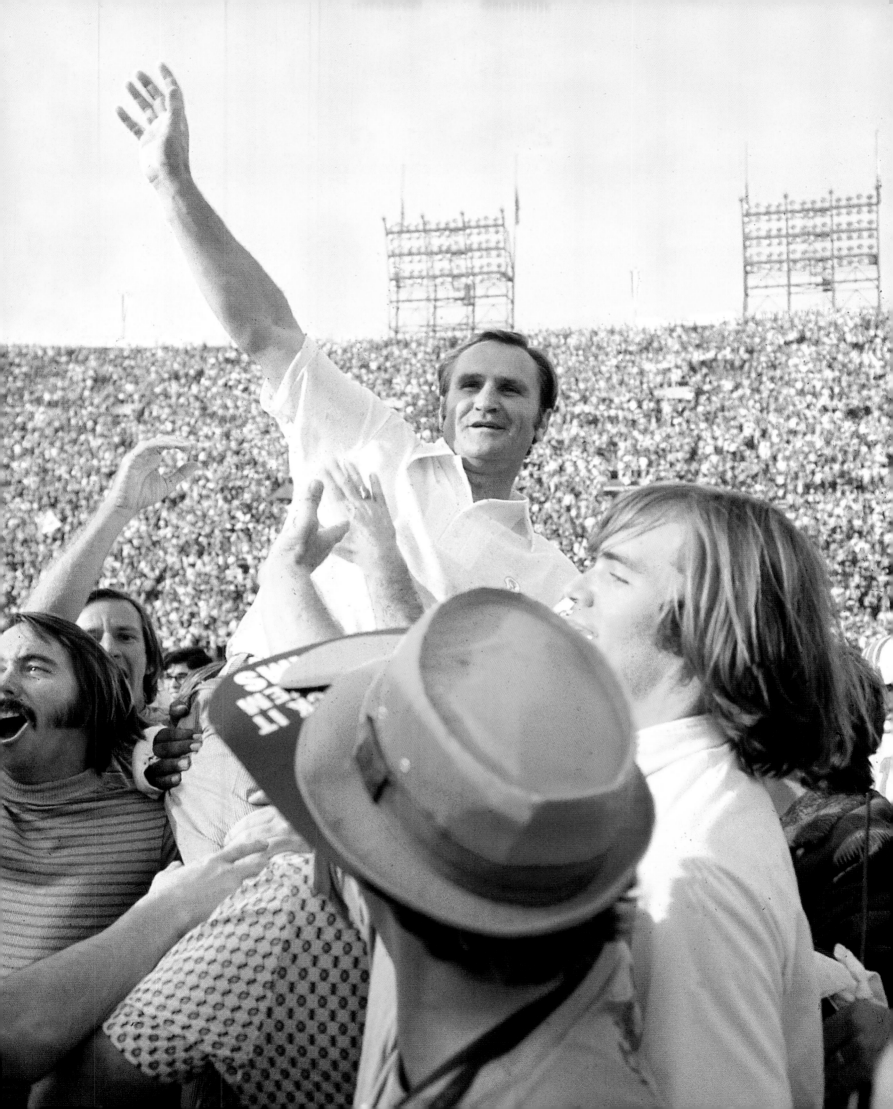

In Upshaw's Hall of Fame NFL career, 15 years of trench savagery, he never once came out of a game. [Sixty-three] was the license-plate number that linebackers and cornerbacks looked up and saw rumbling away after Upshaw—a mastodon four decades ago at 6' 5", 265—had flattened them as he led sweeps for perhaps the greatest offensive line in NFL history.

—

**GARY SMITH**

► FROM *SPORTS ILLUSTRATED*, SEPTEMBER 1, 2008

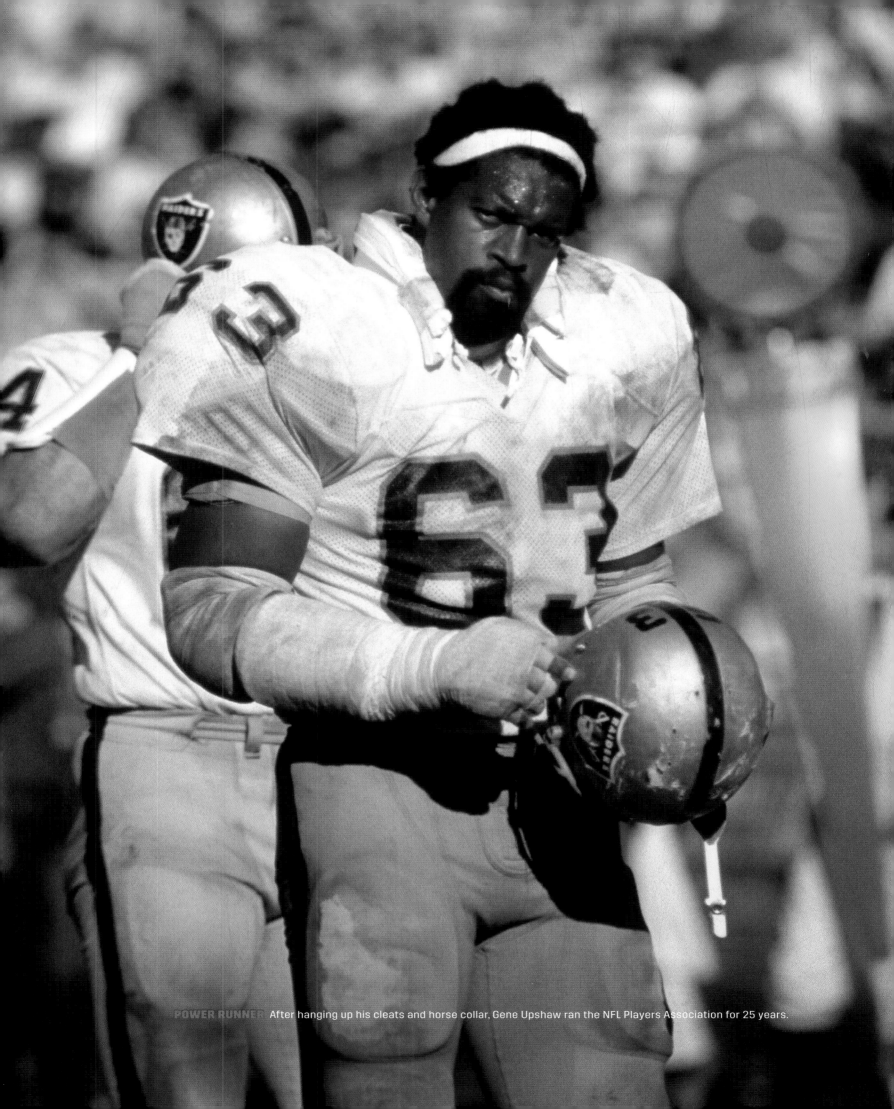

**POWER RUNNER** After hanging up his cleats and horse collar, Gene Upshaw ran the NFL Players Association for 25 years.

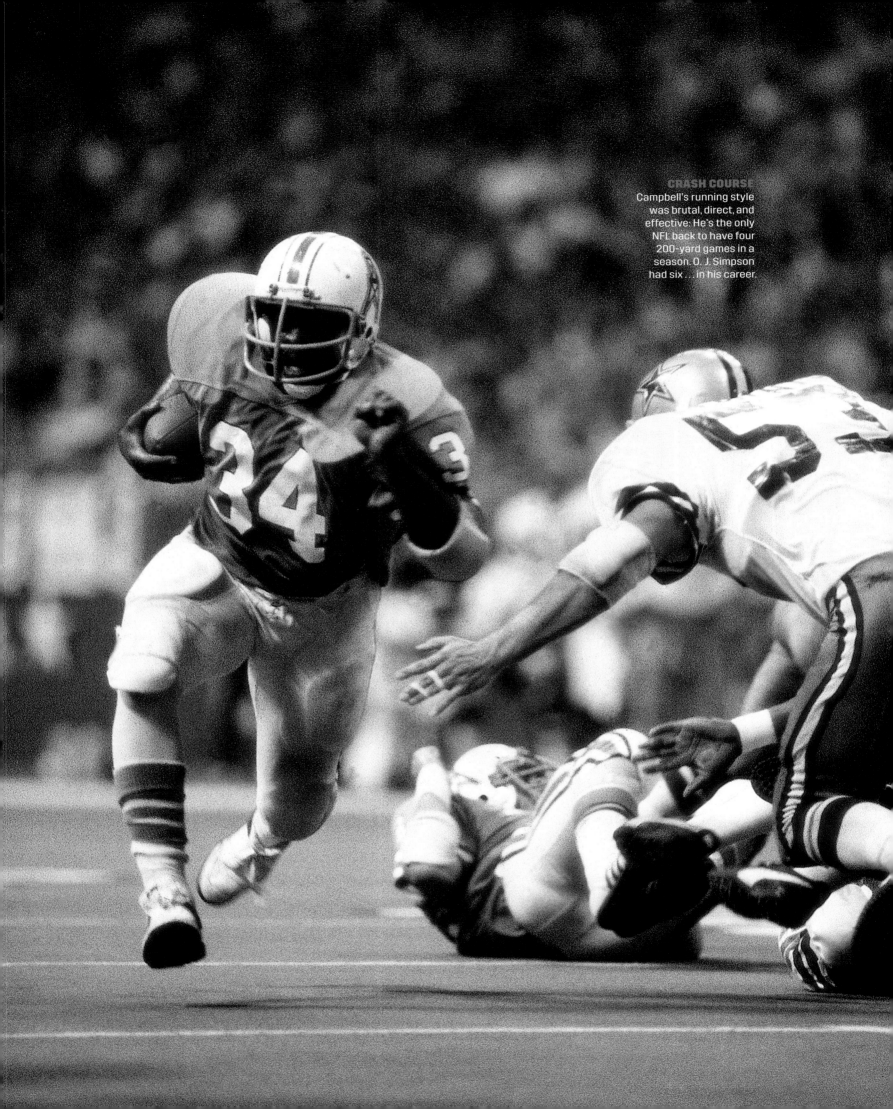

**OILER GUSHER** In 1980, Campbell (and his 36-inch thighs) came within 70 yards of breaking O. J. Simpson's single-season rushing record.

# EARL CAMPBELL

▶ **By Bruce Newman**

FROM *SPORTS ILLUSTRATED*, SEPTEMBER 3, 1979

**Here is what we know about the state of poverty:**
Its boundaries do not appear on any map; it has no flag or official song, but once you are there, it is difficult to get your zip code changed; as a character-building experience it is overrated by the rich and overpopulated by the poor; and it's a place where nobody goes for the weekend.

Earl Campbell had never given much thought to being poor, had never really realized how deprived his family had been, until—in the space of a single year—he won the Heisman Trophy, signed a contract worth $1.4 million to play for the Houston Oilers and became the hottest thing to hit the NFL since *Monday Night Football*. When the full weight of his family's privation hit him, Campbell decided to take some of his NFL greenbacks and build a spacious new house for his mother and then turn the rundown plank shack where he had grown up into a museum where other underprivileged kids could come see firsthand that the NFL was, indeed, the land of opportunity.

# THE SECOND COMING OF SAINT FRANCIS

► **By Dick Schaap,** FROM *SPORT MAGAZINE*, 1973

THE BEAUTY OF FRANCIS ASBURY TARKENTON as a quarterback, beyond his natural gifts, is his unpredictability. No quarterback, not even the ones with far stronger arms, not even the one(s) with far weaker knees, has ever done so much to drive opponents to the edge of psychoanalysis. When the Green Bay Packers were the greatest team in football, and Henry Jordan one of the greatest defensive tackles, Jordan used to have nightmares about Tarkenton. The nightmares were endless: Jordan endlessly chasing Tarkenton, endlessly trying to grab him, to punish him, endlessly failing.

When the Vikings regained Tarkenton in 1972, they brought to the drabbest offense in football the most imaginative quarterback. Tarkenton will do anything short of a felony to gain yardage. He loves the short pass; he enjoys using his backs and tight ends as receivers. He doesn't mind

**FOOTLOOSE**
Although he didn't have a cannon, Tarkenton held many passing records when he retired and had scrambled for 3,674 rushing yards.

the long pass, either; he is capable, by his own measurement, of throwing a football 61½ yards. Tarkenton's passes don't always look pretty—he fluctuates between the spiral and the lob—but they are effective, so effective that he now ranks fifth among all the passers in pro football history. Only Jurgensen, Dawson, Unitas and Starr—all of whom have put in at least 16 seasons—rate higher.

But his passing is not the quality that makes Fran Tarkenton special. It is his running, his scrambling, his logic-defying ability to avoid tackles that separates Tarkenton from other professional quarterbacks, that gives him his unique crowd appeal. Tarkenton does not have the piston-power of a Greg Landry or even of a Roger Staubach. He does not run hard; he runs slippery. He squirms, he ducks, he darts, he escapes.

A 190-pound six-footer who looks smaller, Tarkenton is about as far from a picture runner as possible. He will never be asked to pose for the Heisman Trophy, yet in at least one measurable sense, he is the greatest runner in the history of pro football. Of all the thousands who have played the game in the past half a century, Tarkenton is the only man who has averaged six yards or better per rushing attempt for more than 500 carries. And that puts Tarkenton ahead of Jimmy Brown, ahead of Gale Sayers, ahead of everybody.

If Tarkenton's rushing record is improbable, his health record is impossible. In 20 years of playing organized football—four years in high school, four in college and 12 as a pro—he has never missed a game because of injury. He has never even pulled a muscle. "That," says Tarkenton, "is because I don't have one."

JUSTICE DELAYED While terrorizing offenses for the Vikings, Page attended law school. In 1992, he became a judge in Minnesota.

# Alan Page

► **By Steve Rushin**

FROM *SPORTS ILLUSTRATED*
JULY 31, 2000

**You couldn't buy a number 88 Vikings** jersey in Minnesota in 1974. You could buy the 10 of Fran Tarkenton or the 44 of Chuck Foreman, but if you wanted the 88 of Alan Page, your parents had to find a blank purple football shirt and have the numbers ironed on. As far as I know, my parents were the only ones who ever did.

I grew up in the town in which the Vikings played their home games, in the decade in which they played in four Super Bowls. Yet even in Bloomington, Minn., in the 1970s, I was alone among my schoolmates in worshiping

Page, who was fearsome and had a reputation for brooding silence, a reputation I scarcely knew of as an eight-year-old. I knew only that Page had gone to Notre Dame, that he was genuinely great—the first defensive player to be named MVP of the NFL— and that his Afro sometimes resembled Mickey Mouse ears when he removed his helmet. Lithe and almost feline, Page went where the ballcarrier was, often pulling the runner down with one hand. He won his MVP in his fifth year. I at once loved Alan Page and knew nothing whatsoever about him

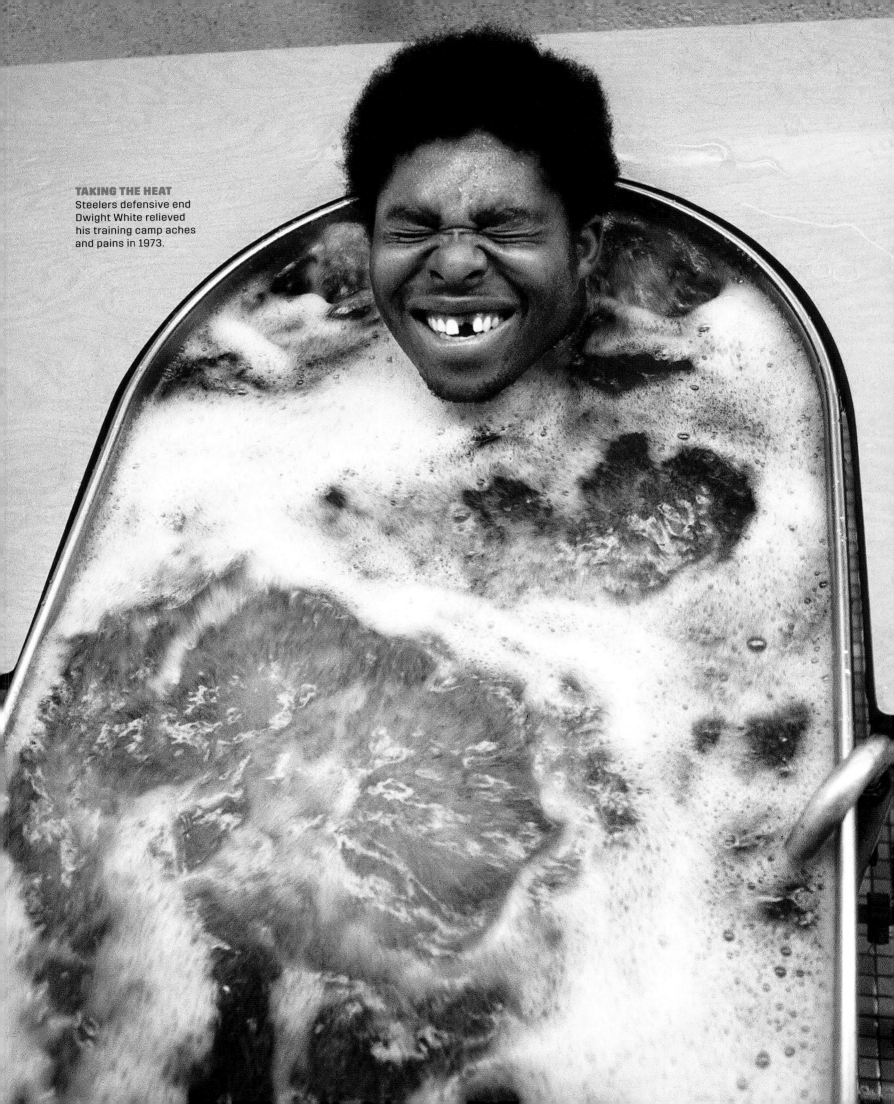

**TAKING THE HEAT**
Steelers defensive end Dwight White relieved his training camp aches and pains in 1973.

The dull roar of the whirlpools, the crackling blare of the trainer's radio, the voices straining to be heard and the constant motion of people gave the room a surreal quality. It was a room that starved some senses and overloaded others. It was a violent, tactile room full of carnal feelings.... The air literally surged with unrestrained energy.

► FROM *NORTH DALLAS FORTY*, 1973, **by Peter Gent**

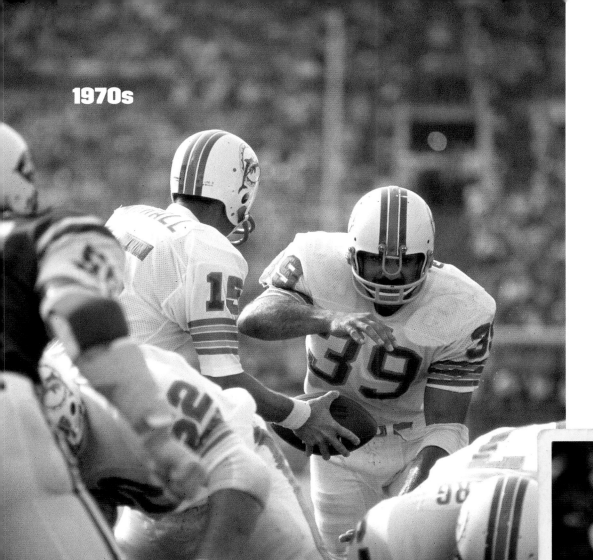

# LARRY CSONKA

► **By Edwin Pope**
FROM *THE EDWIN POPE COLLECTION*, 1988

"I'D HAVE TO SAY PAUL WARFIELD, WHO'S ALREADY IN THE Hall, is the most talented teammate I ever had. Zonk was the most inspirational—best I ever saw at turning two yards into four yards, or four into six. What a factor!

"But the image I carry of Zonk is him staggering back to the huddle, bleeding like a stuck pig, and still growling. You'd be in the line bleeding, and to see a skill player doing the same thing just made you play like hell. [Jim] Langer and I had a standing bet which side of Zonk's face his nose would be on at the end of the game." —**Bob Kuechenberg,** DOLPHINS GUARD

"There is an intensity and a danger in football—as in life generally—which keeps us alive and awake. It is a test of our awareness and ability. Like so much in life, it presents us with the choice of responding either with fear or with action and clarity."

➤ **John Brodie,** QUARTERBACK, SAN FRANCISCO 49ERS
FROM *JOE NAMATH AND THE OTHER GUYS*, BY RICK TELANDER, 1976

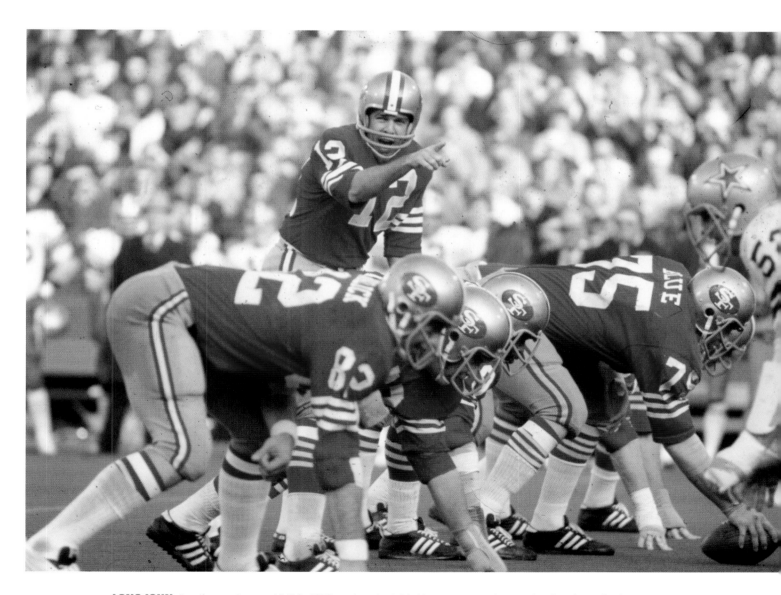

**LONG JOHN**  Brodie was league MVP in 1970, and ranked third in career passing yards when he retired.

Terry Bradshaw could throw as long and hard as you could ever ask a quarterback to do, and he was also a great threat to run. He loved contact too much, if anything—once he tried to run right over Buck Buchanan of Kansas City, who is 6'7", 270.

► **By Roy Blount Jr.,** FROM *ABOUT THREE BRICKS SHY OF A LOAD*, 1974

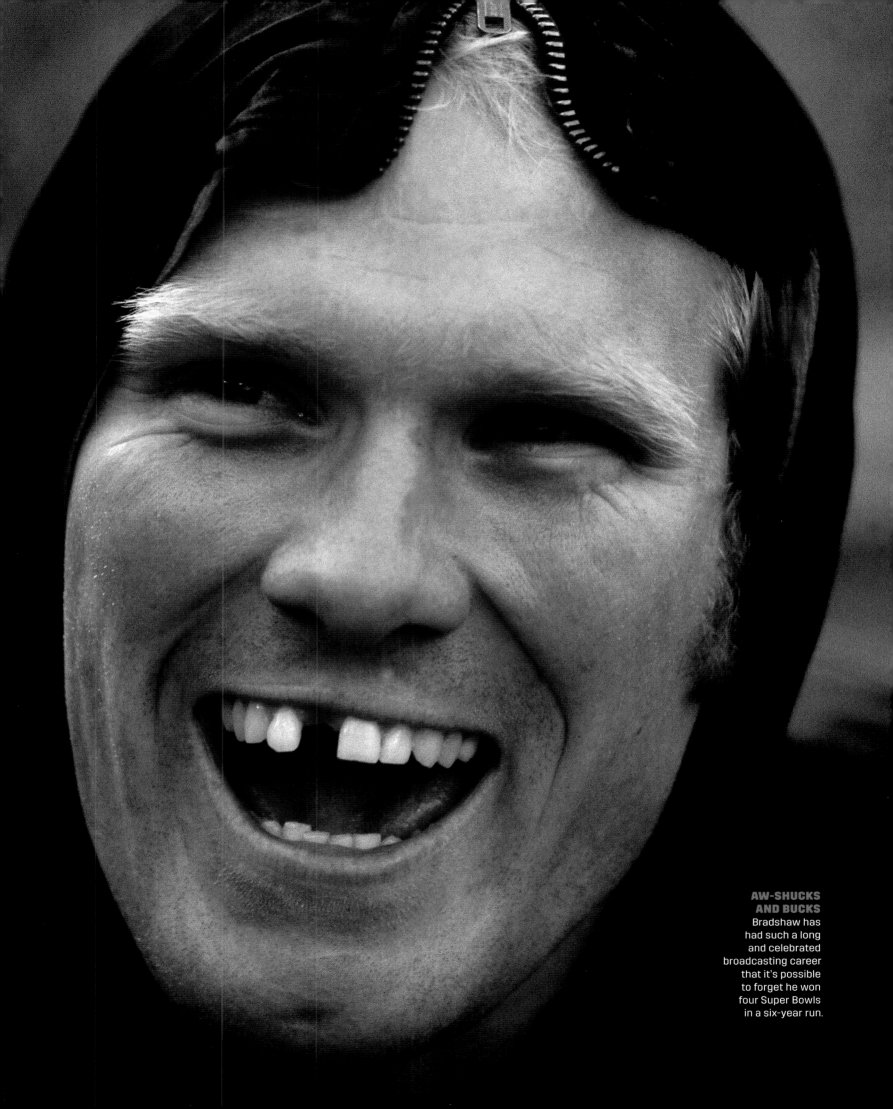

# 1 9

**N'AWLINS MAULIN'** Chicago Bears DB Reggie Phillips celebrates a pick-six against the Patriots in Super Bowl XX in 1986. It was the first Super Bowl for both franchises, but a happier event for Da Bears, who cruised to a 46–10 win.

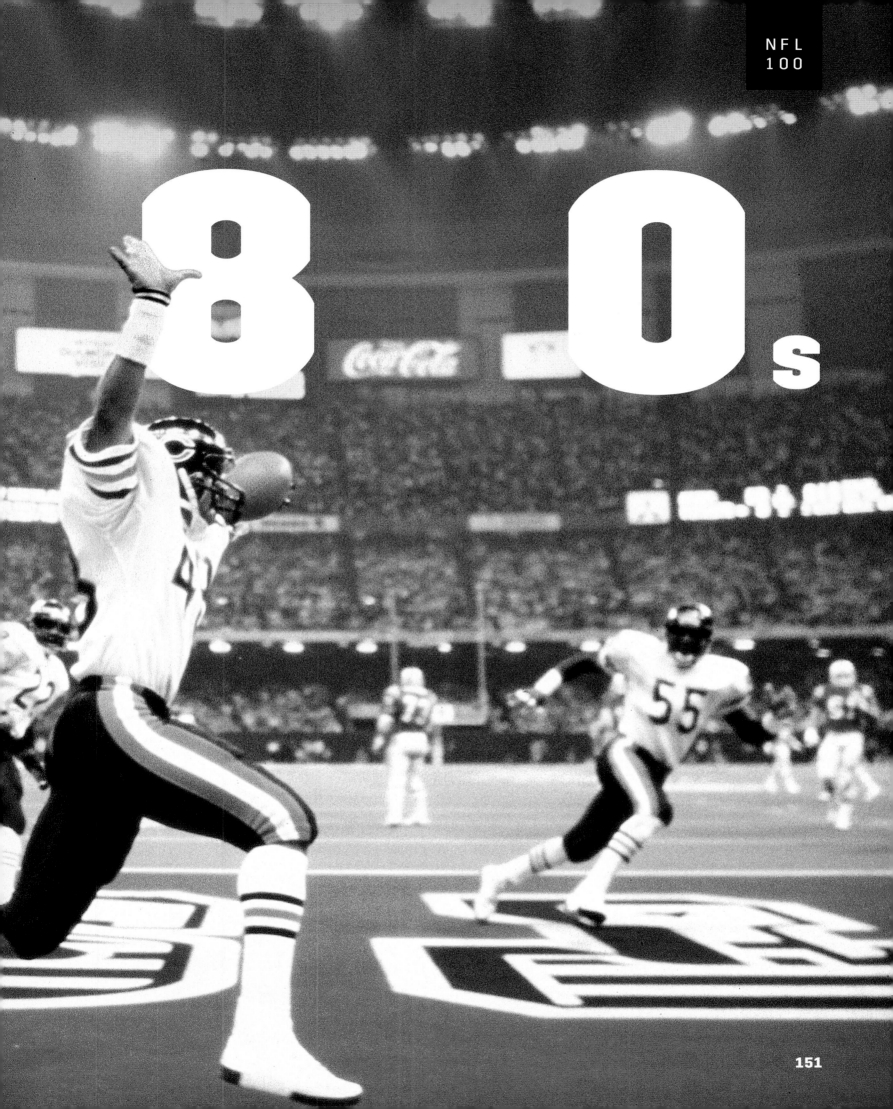

# 8 0s

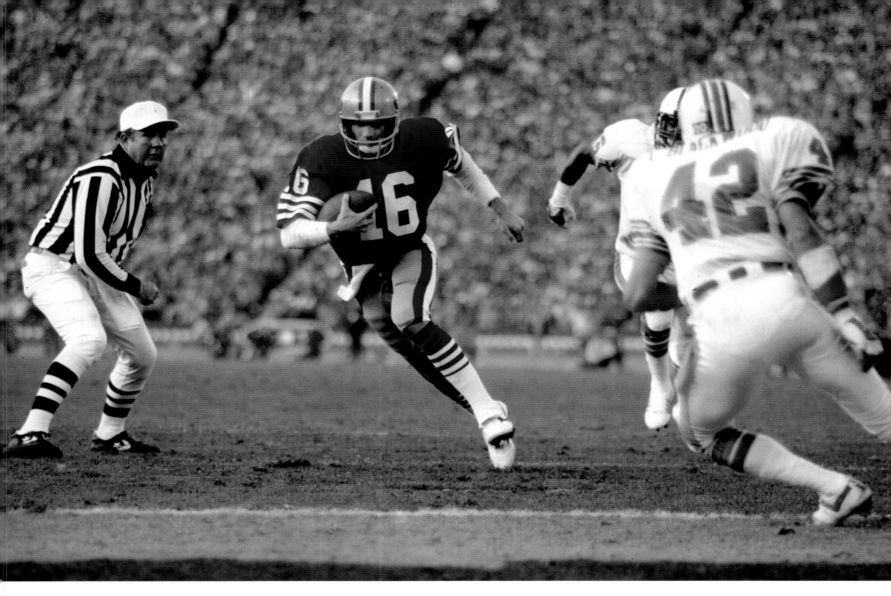

**JOE COOL** As the central character in Walsh's master plan, Montana led the 49ers to four Super Bowl wins and was the game's MVP three times.

THE COURSE OF PRO FOOTBALL IN the 1980s was set on May 3, 1979, in the third round of the NFL draft. Selecting for the Dallas Cowboys, coach Tom Landry looked at his team's master list and made the rare decision to pass up the top-rated player and instead take the one they ranked second. That's how Dallas ended up with tight end Doug Cosbie and how, six selections later, with the 82nd pick in the draft, the San Francisco 49ers took the player who had been at the top of the Cowboys' list. His name was Joe Montana.

The 49ers soon realized they had what every dynasty in pro football needs: a franchise quarterback. They also had an architect in head coach Bill Walsh, the visionary obsessive who would turn the 49ers into the Team of the Eighties while presiding over a more evolved and corporate culture. (The 49ers didn't have playbooks, they had an "inventory of plays"; they didn't have pass patterns, they had "schematics.") Walsh's West Coast Offense employed shorter drops and a more varied passing attack, but it was Montana—who possessed what his coach described as "the inherent, instinctive, genetic" aptitude for seeing receivers before they came open on a route—who was the catalyst. In his third season, Montana hit Dwight Clark in the back of the end zone for the winning touchdown in the 1981 NFC Championship Game against Dallas, on the play that became known as The Catch.

It was a decade in which football moved decisively back to real grass; offensive linemen ("the Hogs" in Washington) became celebrities; and sacks became an official statistic, just in time for the emergence of the Giants' fierce linebacker Lawrence Taylor. Mostly, it was a decade of domination. Besides San Francisco's four Lombardi Trophies,

# Niners coach and passing-offense genius Bill Walsh said Montana possessed "the inherent, instinctive, genetic" aptitude for seeing receivers before they came open.

both the Redskins and the itinerant Raiders (first in Oakland, then again in Los Angeles) won two each.

In 1985, the Bears elevated Buddy Ryan's "46" defense to new heights and defied every sporting convention by recording their music video, "The Super Bowl Shuffle," before they'd actually reached the Super Bowl. In the process, they turned William "the Refrigerator" Perry into a folk hero and finally brought Walter Payton his Super Bowl ring.

The decade featured the most celebrated draft class in NFL history, featuring six quarterbacks—led by John Elway—who went in the first round in 1983. It was the Dolphins' Dan Marino, the last of those six QBs, who blossomed first, winning the MVP award and throwing a record-breaking 48 touchdown

passes in 1984. In that same year of superlatives, Eric Dickerson eclipsed O. J. Simpson's single-season rushing mark, and Payton surpassed Jim Brown's career rushing total. But it was the 49ers who won the Super Bowl again, beginning a run of 13 straight years in which an NFC team would win the championship.

At the end of the decade, Cleveland and Denver engaged in a pair of epic AFC championship games, both won by Elway and the Broncos and each marked in infamy among Cleveland fans as The Drive and The Fumble.

There were memorable Super Bowls—John Riggins's 43-yard touchdown on fourth-and-one in the Redskins' win over Miami in Super Bowl XVII; Doug Williams's amazing second quarter in Washington's rout of the Broncos in Super Bowl XXII; and Phil Simms's 22 of 25 passing performance in the Giants' win over Denver in Super Bowl XXI. But, appropriately, the decade's most indelible Super Bowl memory was stamped by Montana, who drove the 49ers 92 yards in the last 3:10 to rally past the Bengals in Super Bowl XXIII.

For all the heroics, the '80s were a difficult decade for pro football. The Raiders sued the NFL for the right to move from Oakland to Los Angeles, and, later in the decade, the NFL weathered a legal challenge from the United States Football League. Meanwhile, labor-management bickering led to player strikes that marred the 1982 and '87 seasons.

By 1989, when Pete Rozelle announced his retirement as NFL commissioner, he often looked tired. But over three decades, he had presided over the transformation of the game, and pro football stood as America's most popular sport—a preeminent presence in American popular culture.

—**Michael MacCambridge**

**LOFTY HEIGHTS**
Raiders back Marcus Allen is the only player to win a Heisman, an NCAA title (at USC), a Super Bowl (two), and MVP honors for the NFL and the Super Bowl.

## Leaders

### PASSING YARDS

| Year | Player | Team | Yards |
|---|---|---|---|
| 1980 | Dan Fouts | Chargers | 4,715 |
| 1981 | Dan Fouts | Chargers | 4,802 |
| 1982 | Dan Fouts | Chargers | 2,883 |
| 1983 | Lynn Dickey | Packers | 4,458 |
| 1984 | Dan Marino | Dolphins | 5,084 |
| 1985 | Dan Marino | Dolphins | 4,137 |
| 1986 | Dan Marino | Dolphins | 4,746 |
| 1987 | Neil Lomax | Cardinals | 3,387 |
| 1988 | Dan Marino | Dolphins | 4,434 |
| 1989 | Don Majkowski | Packers | 4,318 |

### RUSHING YARDS

| Year | Player | Team | Yards |
|---|---|---|---|
| 1980 | Earl Campbell | Oilers | 1,934 |
| 1981 | George Rogers | Saints | 1,674 |
| 1982 | Freeman McNeil | Jets | 786 |
| 1983 | Eric Dickerson | Rams | 1,808 |
| 1984 | Eric Dickerson | Rams | 2,105 |
| 1985 | Marcus Allen | Raiders | 1,759 |
| 1986 | Eric Dickerson | Rams | 1,821 |
| 1987 | Charles White | Rams | 1,374 |
| 1988 | Eric Dickerson | Colts | 1,659 |
| 1989 | Christian Okoye | Chiefs | 1,480 |

### RECEIVING YARDS

| Year | Player | Team | Yards |
|---|---|---|---|
| 1980 | John Jefferson | Chargers | 1,340 |
| 1981 | Alfred Jenkins | Falcons | 1,358 |
| 1982 | Wes Chandler | Chargers | 1,032 |
| 1983 | Mike Quick | Eagles | 1,409 |
| 1984 | Roy Green | Cardinals | 1,555 |
| 1985 | Steve Largent | Seahawks | 1,287 |
| 1986 | Jerry Rice | 49ers | 1,570 |
| 1987 | J.T. Smith | Cardinals | 1,117 |
| 1988 | Henry Ellard | Rams | 1,414 |
| 1989 | Jerry Rice | 49ers | 1,483 |

## CHAMPIONS

1980 OAKLAND RAIDERS
1981 SAN FRANCISCO 49ERS
1982 WASHINGTON REDSKINS
1983 LOS ANGELES RAIDERS
1984 SAN FRANCISCO 49ERS
1985 CHICAGO BEARS
1986 NEW YORK GIANTS
1987 WASHINGTON REDSKINS
1988 SAN FRANCISCO 49ERS
1989 SAN FRANCISCO 49ERS

## Pick Six

**9** Super Bowls started by quarterbacks who seized Steve DeBerg's starting job. DeBerg started nine times for the 1980 49ers before being beaten out by a young Joe Montana, who'd go on to win four Super Bowls. DeBerg then started for the Broncos before being usurped in 1983 by John Elway, who'd win two of five Super Bowl appearances.

**72** Career TD passes (out of 420 total) that Dan Marino threw against the Jets in 30 meetings from 1983 to 1999. That's the most for any single QB against any franchise through the 2018 season. Tom Brady is second on the list, throwing 69 touchdown passes in 33 games against the Bills.

**5** Days elapsed between a Deion Sanders MLB home run and an NFL touchdown. His homer was on September 5, 1989, for the Yankees against the Mariners. Then in his NFL debut on September 10, he returned a Rams punt 68 yards for a Falcons score.

**85M** Dollars spent to purchase the Dallas Cowboys and Texas Stadium in 1984 by Texas businessman H. R. "Bum" Bright. After losing an estimated $1 million per month, Bright sold to Jerry Jones in 1989 for $140 million. As of 2018, *Forbes* valued the Cowboys at $4.8 billion, making it the most valuable franchise in all of sports.

**16** Teams that entered the 1982 "Super Bowl Tournament," the most to ever make the playoffs. The one-off structure was necessitated by a players' strike that reduced the regular-season schedule from sixteen to nine games. Teams were seeded 1 to 8 in each conference, regardless of division.

**3.76** Dollars ($1, plus triple damages and interest) the USFL was awarded after a U.S. District Court ruled that the NFL was in violation of antitrust laws. The USFL was seeking $567 million, claiming the NFL attempted to keep it from operating in the fall.

# Innovations

**1981:** "Lester Hayes Rule" prohibits use of slippery or sticky substances.

**1982:** Sacks become an official statistic.

**1984:** Prolonged, excessive, or premeditated celebrations prohibited.

**1985:** First limited use of instant replay to assist officials.

## HELLO

▶ The Raiders become the first Wild Card team to win a championship by defeating the Eagles in Super Bowl XV (1981).

▶ Rookie William "The Refrigerator" Perry becomes a national sensation (1985).

▶ Replacements play three weeks in place of striking players (1987).

▶ Paul Tagliabue takes over as commissioner from Pete Rozelle (1989).

▶ Raiders hire Art Shell, the first African-American head coach since Fritz Pollard in the '20s (1989).

## GOODBYE

▶ George Halas dies at age eighty-eight (1983).

▶ Colts leave Baltimore for Indianapolis (1984).

▶ Redskins quarterback Joe Theismann suffers career-ending broken leg (1985).

▶ Cardinals play final home game in St. Louis (1987).

▶ Art Rooney dies at age eighty-seven (1988).

# Mount Rush More: A History of Sacks

Today, there's as much glory in leading the NFL in sacks as there is in being the rushing leader. However, the sack didn't become an official statistic until 1982, the NFL's 63rd season. According to the Elias Sports Bureau, the league's official statisticians, the introduction was a matter of supply meeting demand—a reaction to increasingly common requests for evidence related to incentive clauses and bonuses in player contracts. Now sack stats are an integral tool for fans, fantasy football players, and actual NFL talent evaluators alike, but since their history is comparatively short, the available numbers don't tell the whole story.

DEACON JONES, LAWRENCE TAYLOR, BRUCE SMITH, REGGIE WHITE

## MOST CAREER SACKS

| 200 | 198 | 160 | 159½ | 150½ | 141½ |
|---|---|---|---|---|---|
| **Bruce Smith** (1985–2003) | **Reggie White** (1985–2000) | **Kevin Greene** (1985–1999) | **Julius Peppers** (2002–2018) | **Chris Doleman** (1985–1999) | **Michael Strahan** (1993–2007) |

## MOST SINGLE-SEASON SACKS

| 22½ | 22 | 22 | 22 | 21 | 21 |
|---|---|---|---|---|---|
| **Michael Strahan** (Giants, 2001) | **Jared Allen** (Vikings, 2011) | **Mark Gastineau** (Jets, 1984) | **Justin Houston** (Chiefs, 2014) | **Chris Doleman** (Vikings, 1989) | **Reggie White** (Eagles, 1987) |

## HONORABLE MENTION (UNOFFICIAL)

| **Deacon Jones** (1961–1974) | **Jack Youngblood** (1971–1984) | **Gino Marchetti** (1952–1966) | **Doug Atkins** (1953–1969) | **Coy Bacon** (1968–1981) | **Willie Davis** (1958–1969) |
|---|---|---|---|---|---|
| Credited with coining the word "sack" | Totaled 20 sacks in his 13th and 14th NFL seasons | Threw countless linemen out of his way en route to the QB | Bears great estimated he had multiple 25-sack seasons | 14-year career pressuring QBs ended the last season sacks weren't counted | Five-time NFL champ estimated he had 25 sacks in one season |

# THE LONGEST DAY

▶ **By Rick Reilly,** FROM *SPORTS ILLUSTRATED*, OCT. 25, 1999

**One player sat slumped on a metal bench under a cold shower,** too exhausted to take off his blood-caked uniform. Four were sprawled on the floor, IVs dripping into their arms. One of them tried to answer a reporter's questions, but no words would come out of his parched, chalky mouth. And that was the winning locker room.

On Jan. 2, 1982, a sticky, soaked-shirt South Florida night, the Miami Dolphins and the San Diego Chargers played a magnificent, horrible, gripping, preposterous NFL playoff game. For four hours and five minutes, 90 men took themselves to the limit of human endurance. They cramped. They staggered. They wilted. Then they played on, until it was no longer a game but a test of will. "People remember all kinds of details from that game," says San Diego tight end Kellen Winslow, "but they can't remember who won, because it wasn't about who won or who lost." It was about effort and failure and heroics. Each team's quarterback threw for more than 400 yards. Combined the two teams lost four fumbles and missed three easy field goals. They also scored 79 points and gained 1,036 yards. Miami coach Don Shula called it "a great game, maybe the greatest ever." San Diego coach Don Coryell said, "There has never been a game like this." Years later Miami fans voted it the greatest game in franchise history. And their team lost.

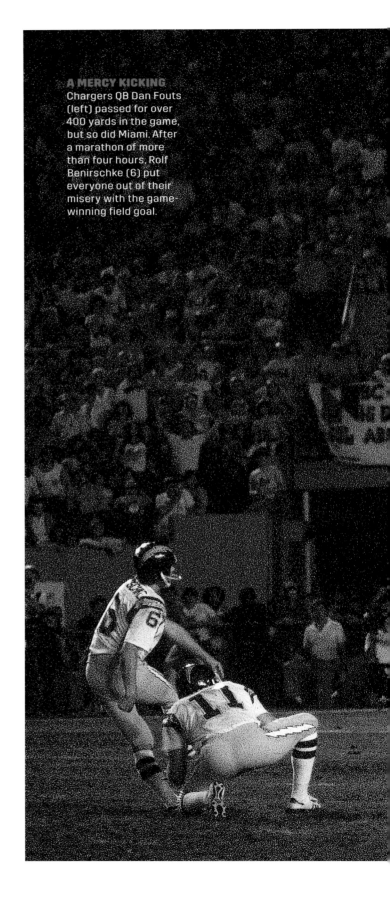

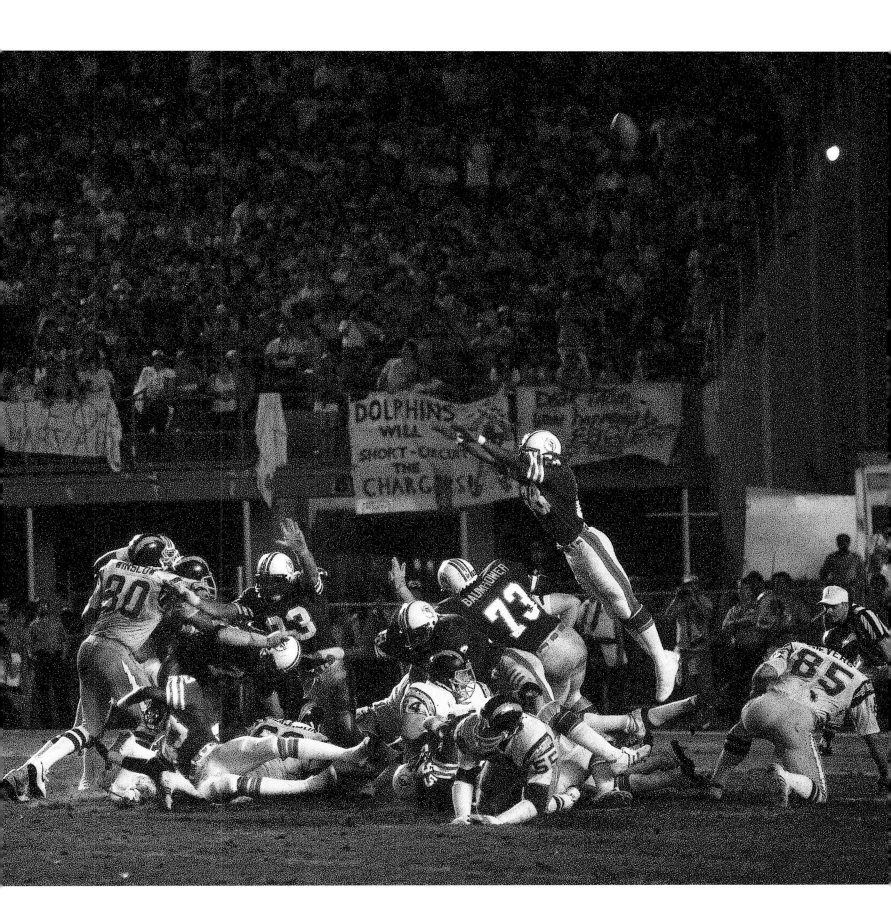

# COACHES' CORNER: THE BILLS

► **By David Halberstam,** FROM *THE EDUCATION OF A COACH*, 2005

THEIR NAMES WERE LINKED TOGETHER FOR A decade at the Giants, and then later, over a span of some two decades, with New England and the Jets: Parcells and Belichick. The Bills, they were called, and those on the outside presumed they were good friends, but they were far too different in style and manner to really be friends.

Parcells was physically bigger, and he seemed much more like what a football coach should be. He was volatile and wore his emotions close to the surface. He found that it worked for him, that he could use his emotions as an instrument of coaching. No one in that era, it seemed, was better

at challenging his players to reach for more. Starting in the mid-'80s, he became the lineal descendant of Vince Lombardi, coaching as Lombardi might have, with a great hold on the emotions of his players, and doing it in an era that was far less congenial to such techniques than when Lombardi had ruled the world.

Belichick was very different. He was driven by his brain power, and by his fascination with the challenge that professional football represented to the mind of the coach as well as the bodies of the players. Players would do what he asked not because he was their pal but because he could help them win. If Bill Parcells's strength came from being the coach who believed that everyone had a button to push, and that he was man who knew how to push each and every button, then Bill Belichick's strength was to be the coach as the ultimate rational man, surrounding himself with players who wanted to learn his system, who would buy in because his skills always prepared them so superbly.

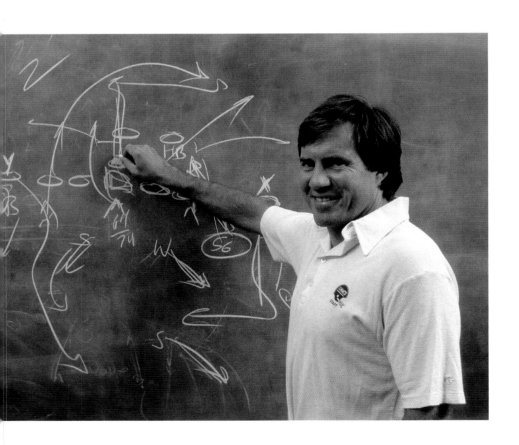

**CHALK AND AWE** Two of the NFL's greatest head coaches emerged in the 1980s. Parcells (right, in 1987) and Belichick (left, circa 1985) worked together as assistants for the Giants in '81.

"I'm a little Neanderthal," Parcells said. "I think defense is the key to any sport. That was my intent when I started coaching. That's what I wanted to coach. Not football. Football defense. It's not glamorous to those who are into what's aesthetically pleasing. But it's glamorous to me."

▶ FROM *THE BLIND SIDE*, 2006, **by Michael Lewis**

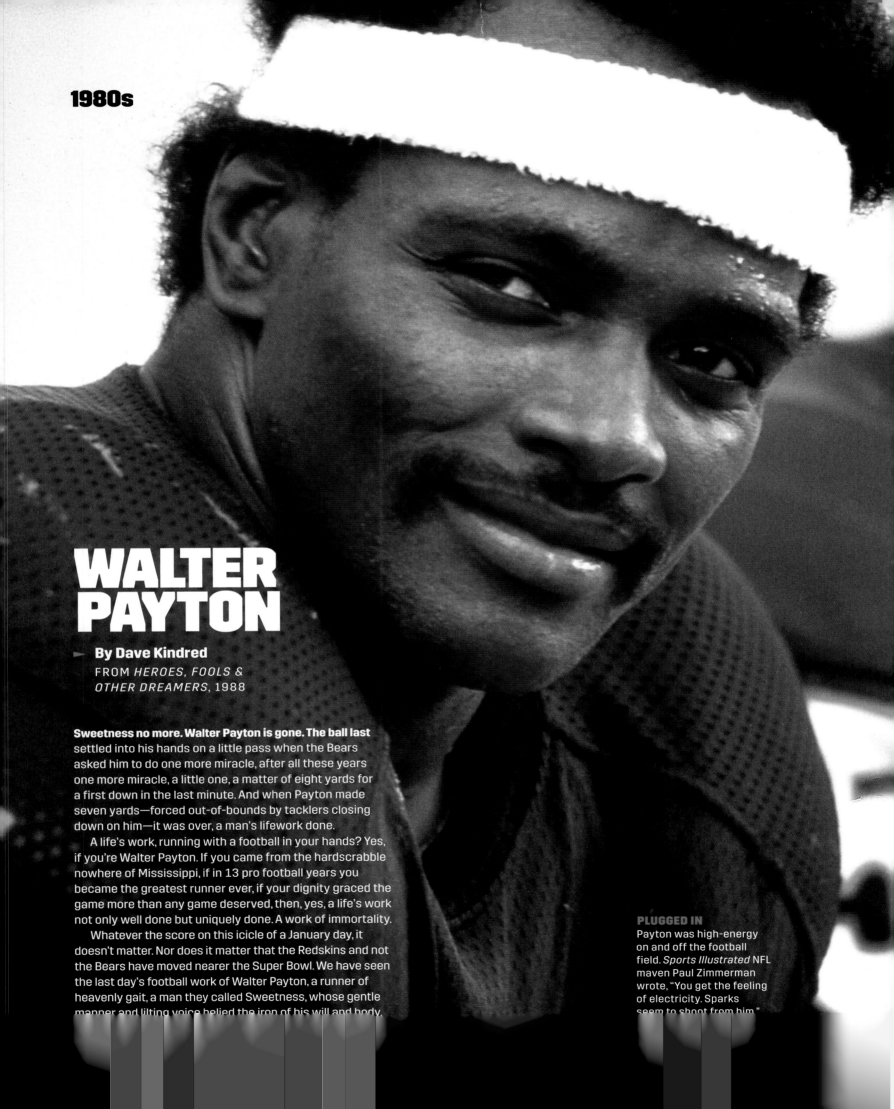

# WALTER PAYTON

**By Dave Kindred**

FROM *HEROES, FOOLS & OTHER DREAMERS*, 1988

**Sweetness no more. Walter Payton is gone. The ball last** settled into his hands on a little pass when the Bears asked him to do one more miracle, after all these years one more miracle, a little one, a matter of eight yards for a first down in the last minute. And when Payton made seven yards—forced out-of-bounds by tacklers closing down on him—it was over, a man's lifework done.

A life's work, running with a football in your hands? Yes, if you're Walter Payton. If you came from the hardscrabble nowhere of Mississippi, if in 13 pro football years you became the greatest runner ever, if your dignity graced the game more than any game deserved, then, yes, a life's work not only well done but uniquely done. A work of immortality.

Whatever the score on this icicle of a January day, it doesn't matter. Nor does it matter that the Redskins and not the Bears have moved nearer the Super Bowl. We have seen the last day's football work of Walter Payton, a runner of heavenly gait, a man they called Sweetness, whose gentle manner and lilting voice belied the iron of his will and body.

**PLUGGED IN**
Payton was high-energy on and off the football field. *Sports Illustrated* NFL maven Paul Zimmerman wrote, "You get the feeling of electricity. Sparks seem to shoot from him."

Pro football in the 1980s achieved a new dimension with the rise to prominence of a Chicago Bear named William "Refrigerator" Perry, ex-Clemson, magna cum lunchmeat. He gave every other team in the NFL a reason to go searching for a "conversation topic" to put on its roster.

► FROM *YOU CALL IT SPORTS, BUT I SAY IT'S A JUNGLE OUT THERE*, 1989, **by Dan Jenkins**

**THE INCREDIBLE BULK**
Perry was a solid defensive lineman, but when the Bears used him as an offensive battering ram near the end zone, he became a national phenom.

**YARDS SALE** Rice is the career leader in TDs (208) and in receiving yards (22,895), which puts him more than 6,000 yards ahead of the man in second place.

# JERRY RICE

➤ **By Rick Telander,** FROM *SPORTS ILLUSTRATED*, DECEMBER 26, 1994

THE BEST? HE'S HERE, IN BLUE TIGHTS AND RED windbreaker, bitchy as a diva with a headache.

The best ever?

He's right here, sitting at his locker, taking off his rain gear after practice, edgy as a cat in a sawmill.

Around him swirls the clamor of big men winding down, messing around, acting like fools. Two bare-chested linemen lock up and start to grapple, rasslin' each other and snorting like trash-talking sumos. Other players laugh, but not the best ever.

"Guys," he says irritably. "Hey, guys!" Someone could get hurt.

The two wrestlers slowly come apart, his voice bringing them to their senses. They've heard the voice before; it's their fourth-grade teacher scolding them for rolling spitballs. It's the voice of San Francisco 49er Jerry Rice, the best wide receiver ever to play football. The 6'2", tightly braided coil of nerves, fast-twitch fibers, delicate grasping skills and unadulterated want-to is setting such high standards for the position that they will probably never be approached again, and he can't stand distractions while he works.

Rice does not fool around. Ever. He works so hard at his conditioning that during the offseason he virtually exits his body and studies his physical package the way a potter studies clay. "I mess with it," he says. "I like to do different things to motivate myself. I set goals and go after them."

As a rookie in 1985 he came to the 49ers at a muscular 208 pounds, but now he weighs 196. He is so lean that you wonder if he's sick. He likes to mess with his body fat, wants it to know that he is its master. For Rice, fat is a cornerback in man coverage with no safety in sight, a minor and ultimately irrelevant nuisance. Eschewing dietary fat, he got down to 189 a year or so ago, but the weight loss was too much. His starved body

was literally eating up his muscles. His trainer ordered him to start eating things like ice cream.

"Under 4% body fat, and I don't feel good," Rice states. "I'm a health-food fanatic, but getting that low really hurt my performance. I'm at 4.8% now, and I feel good."

Well, not really good. Not the way you or I might feel good if we knew that not only were we certifiably the best receiver in the history of football but, perhaps, the greatest offensive player ever. That argument can be made. Rice already has more receiving touchdowns (130) and more total touchdowns (138) than anyone in NFL history. He has more 1,000-yard seasons (nine) than any other receiver, more touchdown catches in a Super Bowl (three) than anyone and more consecutive games with a touchdown reception (13) than anyone.

# Mauled By Bears

**▶ By Paul Zimmerman**

FROM *SPORTS ILLUSTRATED*, FEBRUARY 3, 1986

**It will be many years before we see anything approaching** the vision of hell that Chicago inflicted on the poor New England Patriots on Sunday in Super Bowl XX. It was near perfect, an exquisite mesh of talent and system, defensive football carried to its highest degree. It was a great roaring wave that swept through the playoffs, gathering force and momentum, until it finally crashed home in New Orleans's Superdome in pro football's showcase game.

The game wasn't exciting. So what? Go down to Bourbon Street if you want excitement. It wasn't competitive. The verdict on Chicago's 46–10 victory was in after two Patriots series. Don't feel cheated. Louis-Schmeling II wasn't very competitive, either. Nor was the British cavalry charge at Balaklava, but Tennyson wrote a poem about it. This game transcended the ordinary standards we use in judging football. It was historic.

The events of the next few weeks and months will determine if this is the beginning of a mighty defensive dynasty (only one of the 11 Bears defenders who started Sunday's game is older than 28) or a culmination. The forces of erosion already were at work. Buddy Ryan, the assistant coach who crafted this defense, was close to the Philadelphia head coaching job when his work was done in New Orleans. With two minutes to go, the defensive players gathered around Mike McCaskey, the Bears' president, and practically begged him to do everything he could to keep Ryan.

Such is the hold that Ryan has on his players; his is a driving spirit that causes hard-eyed veterans like middle linebacker Mike Singletary to say, "Without him we don't have much. I feel honored to have been coached by him."

**ONLY THE FINEST 1.** Defensive coordinator Buddy Ryan; **2.** Walter Payton; **3.** the infamous "Super Bowl Shuffle" video; **4.** defensive end Richard Dent; **5.** head coach Mike Ditka gets a lift after Super Bowl XX; **6.** QB Jim McMahon; **7.** Refrigerator Perry after a TD; **8.** Dent after being named Super Bowl XX MVP; **9.** defensive tackle Dan Hampton, a.k.a. Danimal.

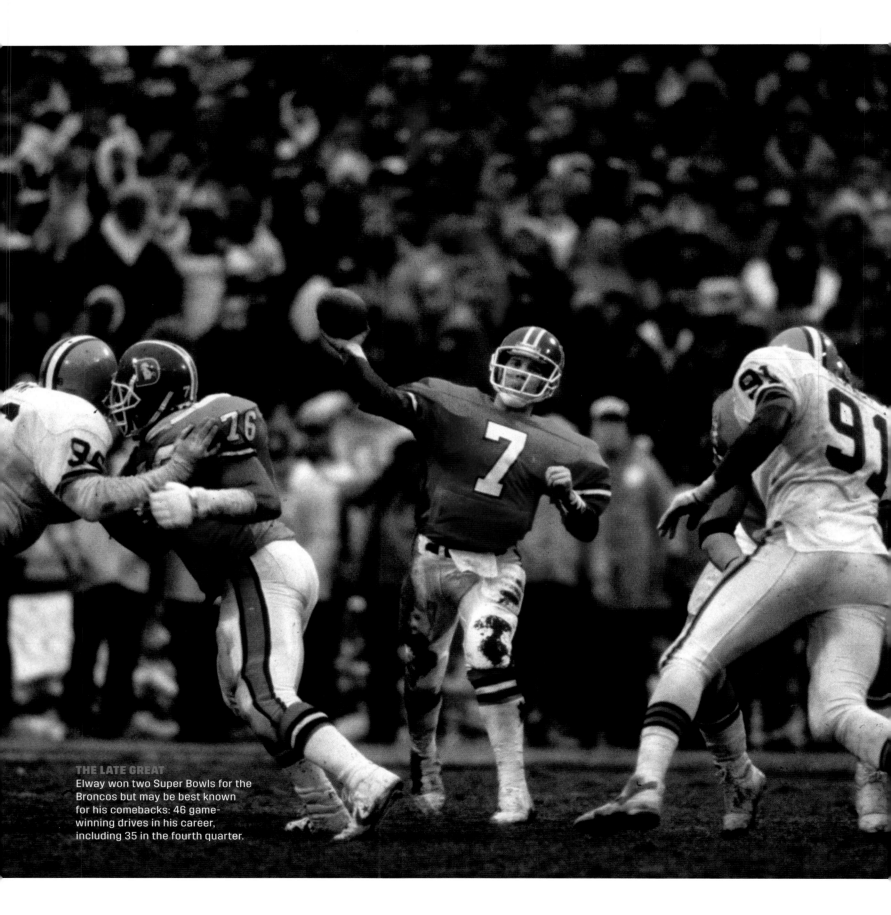

**THE LATE GREAT**
Elway won two Super Bowls for the
Broncos but may be best known
for his comebacks: 46 game-
winning drives in his career,
including 35 in the fourth quarter.

# THE DRIVE

➤ **By Rick Telander,** FROM *SPORTS ILLUSTRATED*, JANUARY 19, 1987

HAVE YOU EVER BEEN MEAN TO A NICE OLD DOG? Did you sit there with a tail-wagging mongrel at your knee and kindly offer him a meaty bone, hold it barely in front of the pooch's eager snout and at the last instant, just after his head lunged forward but before his teeth clicked shut, pull the bone away? Have you? Just for fun?

Then you've been John Elway, the Denver Broncos quarterback who yanked the bone from the mouth of the Cleveland Dawgs, er, Browns, 23–20 in overtime, for the AFC championship before 79,915 stunned fans in Cleveland Stadium on Sunday. No, let's clarify this metaphor. Elway didn't just pull victory from the Browns' mouth. He ripped the thing from halfway down their throat.

The game was over. The Browns had won and the Broncos had lost. It was that simple. But then, with 5:32 remaining and Denver trailing 20–13, Elway led his team 98 yards down the field on as dramatic a game-saving drive as you'll ever see. It was the way Elway must have dreamed it while growing up the son of a football coach, the rifle-armed youngster and his doting father talking over the breakfast table about how to pick defenses apart.

Playing on unfriendly turf, generating offense where there had been precious little before, Elway ran, passed, coaxed and exhorted his team in magnificent style. Finally, with 39 seconds left and the ball on the Browns' five-yard line, he found Mark Jackson slanting over the middle in the end zone and hit him with a touchdown bullet. After that, the overtime was a mere formality. Elway took the Broncos 60 yards this time, giving Rich Karlis field goal position at the Cleveland 15-yard line and a sweet piece of advice: "It's like practice." Karlis's 33-yard field goal, his third of the afternoon, cut through the Browns like a knife.

**BUCKING THE ODDS**
The Broncos trailed by seven when they took over on their own two-yard line late in the fourth quarter. But Elway led them down the field on a breathtaking, game-tying march that made Denver's overtime victory seem like a foregone conclusion.

# Lawrence Taylor

▶ **By Michael Lewis**

FROM *THE BLIND SIDE*, 2006

YOU DON'T THINK OF FEAR AS A FACTOR IN professional football. You assume that the sort of people who make it to the NFL are immune to the emotion. Perhaps they don't mind being hit, or maybe they just don't get scared; but the idea of pro football players sweating and shaking and staring at the ceiling at night worrying about the next day's violence seems too preposterous. The head coach of the Giants, Bill Parcells, didn't think it preposterous, however. Parcells, whose passion is the football defense, believed that fear played a big role in the game. So did his players. They'd witnessed up close the response of opposing players to their own Lawrence Taylor. . . . The feelings of those assigned to prevent Taylor from hurting quarterbacks he wanted to hurt. In Taylor's first season in the NFL, no official records were kept of quarterback sacks. In 1982, after Taylor had transformed the quarterback sack into the turning point of a football game, a new official NFL statistic was born. The record books defined the sack as tackling the quarterback behind the line of scrimmage as he attempts to pass. Taylor offered his own definition: "A sack is when you run up behind somebody who's not watching, he doesn't see you, and you really put your helmet into him. The ball goes fluttering everywhere and the coach comes out and asks the quarterback, 'Are you all right?' That's a sack."

After his first NFL season Taylor became the only rookie ever named the league's most valuable defensive player, and he published a treatise on his art. "I don't like to just wrap the quarterback," he explained. "I really try to make him see seven fingers when they hold up three. I'll drive my helmet into him, or, if I can, I'll bring my arm up over my head and try to ax the sonuvabitch in two. So long as the guy is holding the ball, I intend to hurt him. If I hit the guy right, I'll hit a nerve and he'll feel electrocuted, he'll forget for a few seconds that he's on a football field."

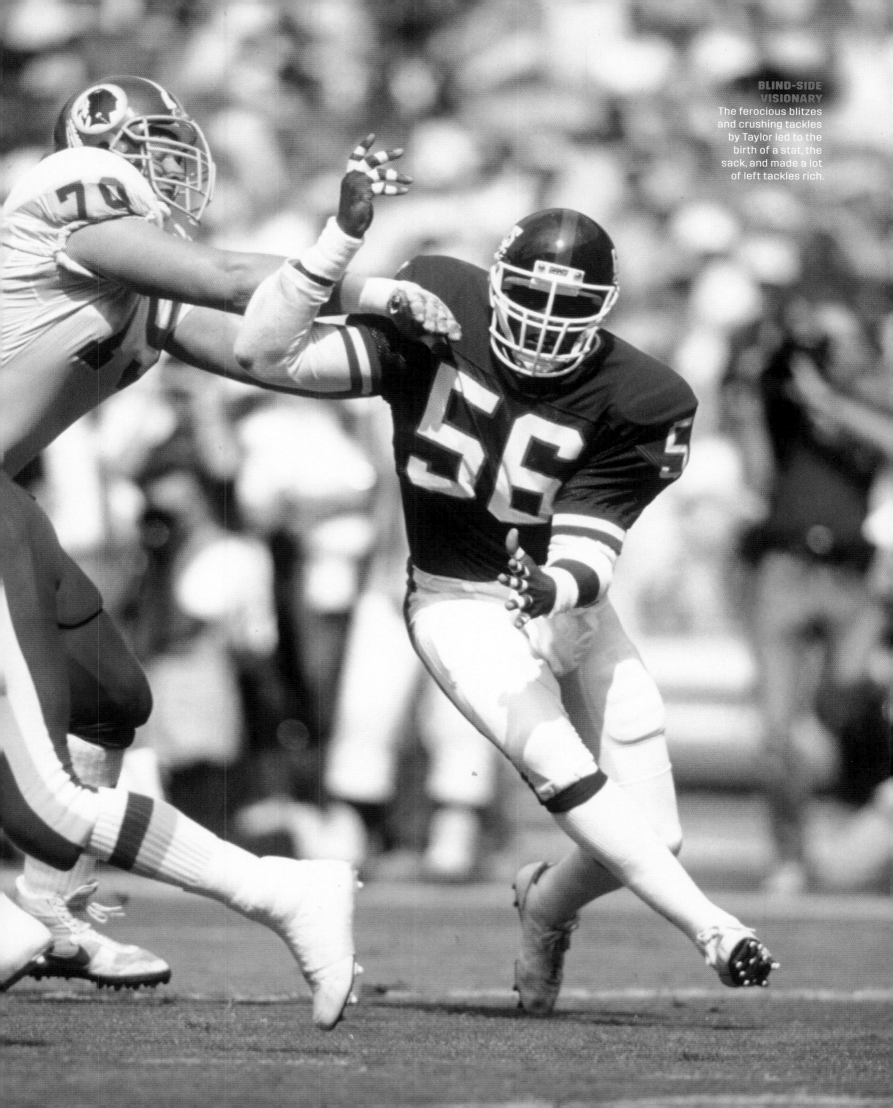

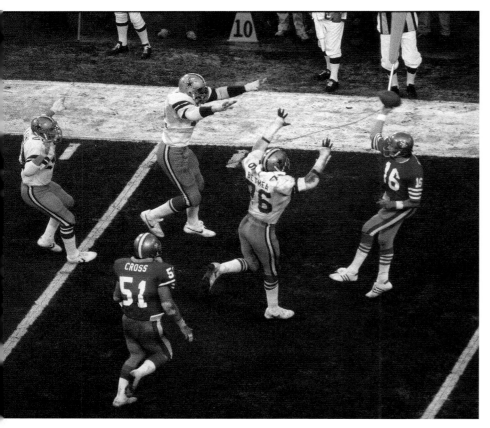

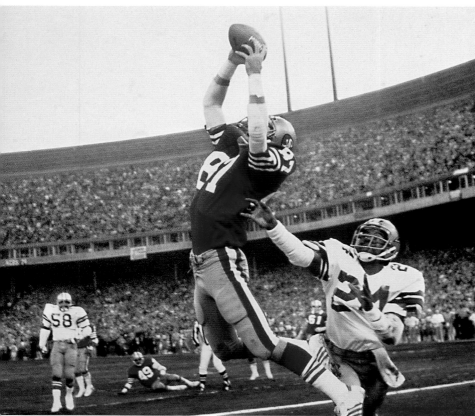

# THE CATCH

► **By Paul Zimmerman**
FROM *SPORTS ILLUSTRATED*, AUGUST 12, 1990

**When San Francisco 49ers coach Bill**
Walsh talks about offensive football,
he eventually mentions the "quick,
slashing strokes" of attack. He'll use
analogies with tennis and boxing, even
warfare, which was why he was so
taken with Joe Montana's nimble feet.
A quick, slashing attack needs a quick-
footed quarterback.... The statuesque
quarterback who can throw the ball
60 yards downfield has never been Walsh's
type. And when he refined his offense
to blend with Montana's skills, Walsh
introduced the x-factor, which was the
great escape talent of his quarterback—
elusiveness, body control, the ability to
throw while in the grasp of an opponent.

"We practiced the scrambling, off-
balance throw. It wasn't accidental when
he did it. It was a carefully practiced
thing. I'd tell him, 'Timed pattern to the
first receiver. If he's covered, move and
look for the second. Then scramble
and throw off balance, and jerk it to
the third. By the time you're reading
the third receiver, someone's got hold
of you.' And that's what we'd practice.
I'd tell him, 'I never want you to throw
to the third receiver on balance.'"

Finally it all came into focus in the '81
postseason, in one momentous play, the
last-minute touchdown pass to Clark that
buried Dallas in the NFC championship.
The play will always be known as The
Catch—Montana scrambling to his
right, with three Cowboys clutching at
him; the off-balance throw; and finally
Clark, on a breakoff route, ducking
inside, then cutting back—just the
way he and Joe had practiced on
their own so many times in camp.

**THE ARM**  The 49ers went 14–2 in '89, then outscored their playoff opponents 126–26 to win their fourth Super Bowl.

Based on the NFL quarterback rating system, Montana's '89 season was simply the best anyone has ever had—the highest rating (112.4) and third-highest completion percentage (70.2) in history. But those are just numbers. The 49ers swept through the playoffs and Super Bowl like a broom, trouncing Denver 55–10 to repeat as NFL champions. Their efficiency was frightening, and Montana was the master.

▶ **By Paul Zimmerman,** FROM *SPORTS ILLUSTRATED*, AUGUST 12, 1990

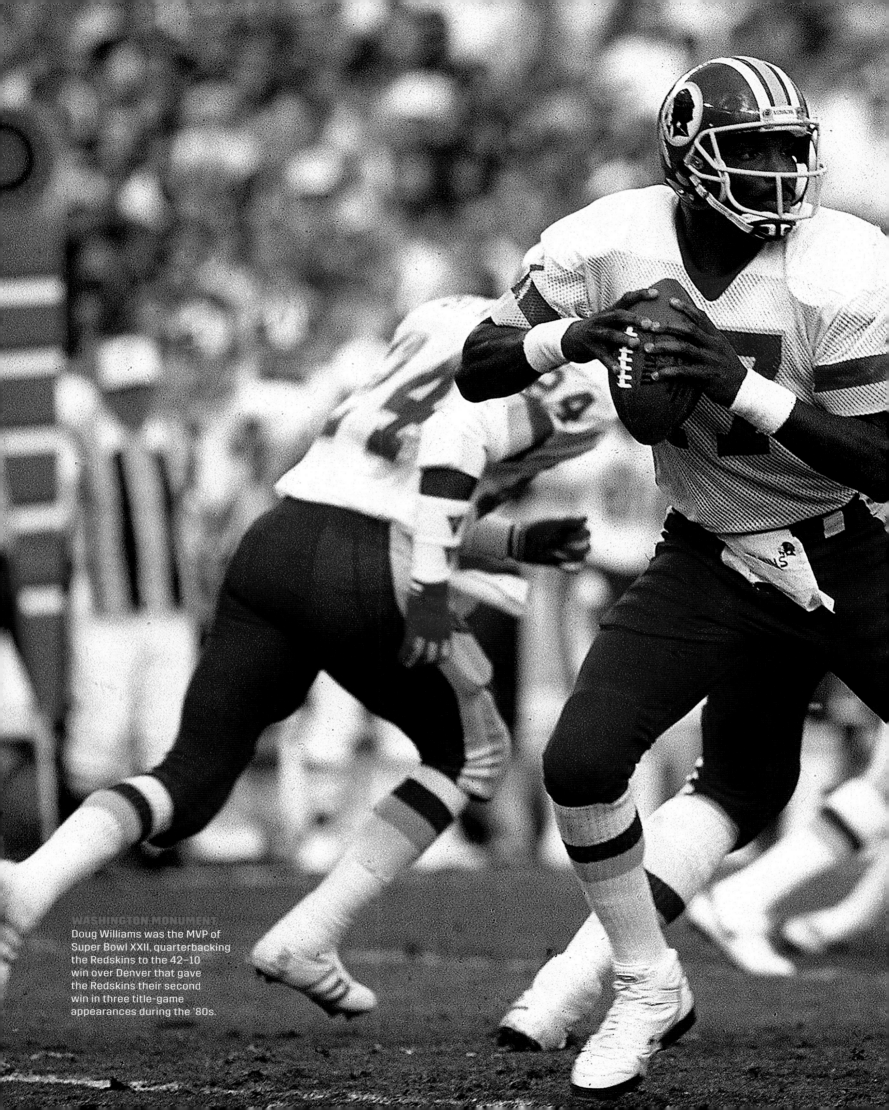

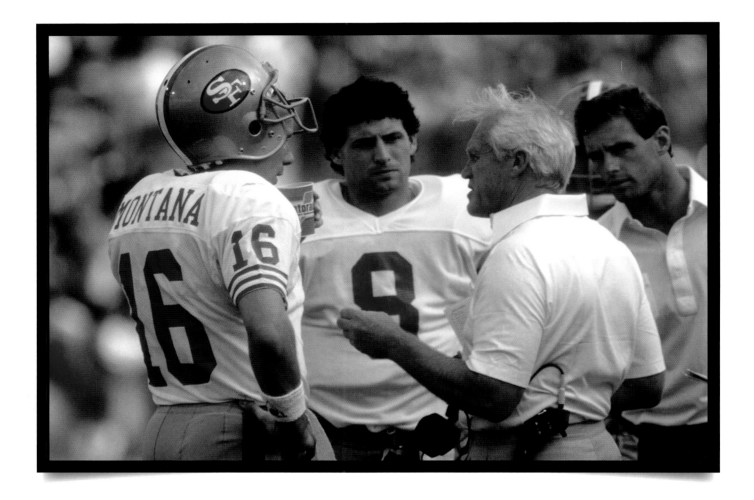

# Bill Walsh

► **By Michael Lewis**

FROM *THE BLIND SIDE*, 2006

IN A PATTERN NOW FAMILIAR IN WALSH'S OFFENSES, A QUARTERBACK who seemed to deserve a raise was instead handed a pink slip. Walsh replaced DeBerg in 1980 with a quarterback drafted in the third round who everyone said was too small and had too weak an arm to play in the NFL: Joe Montana. The next two years, Montana led the NFL in completion percentage (64.5 and 63.7) and also in avoiding interceptions. He would become, by general consensus, the finest quarterback ever to play the game. How good was he really? That's hard to know, because his coach held a magic wand, and every quarterback over whose head that wand passed instantly looked better than he'd ever been. When Joe Montana's play became sloppy during the 1987 season, Walsh replaced him, temporarily, with Steve Young—whose sensational performance caused a lot of 49ers fans to wonder, and to feel guilty for wondering, if maybe Steve Young was even better than Joe Montana.

The performance of Walsh's quarterbacks suggested a radical thought: that in the most effective passing attack in the NFL, and on one of the most successful teams in the history of pro football, the quarterbacks were fungible. The system was the star.

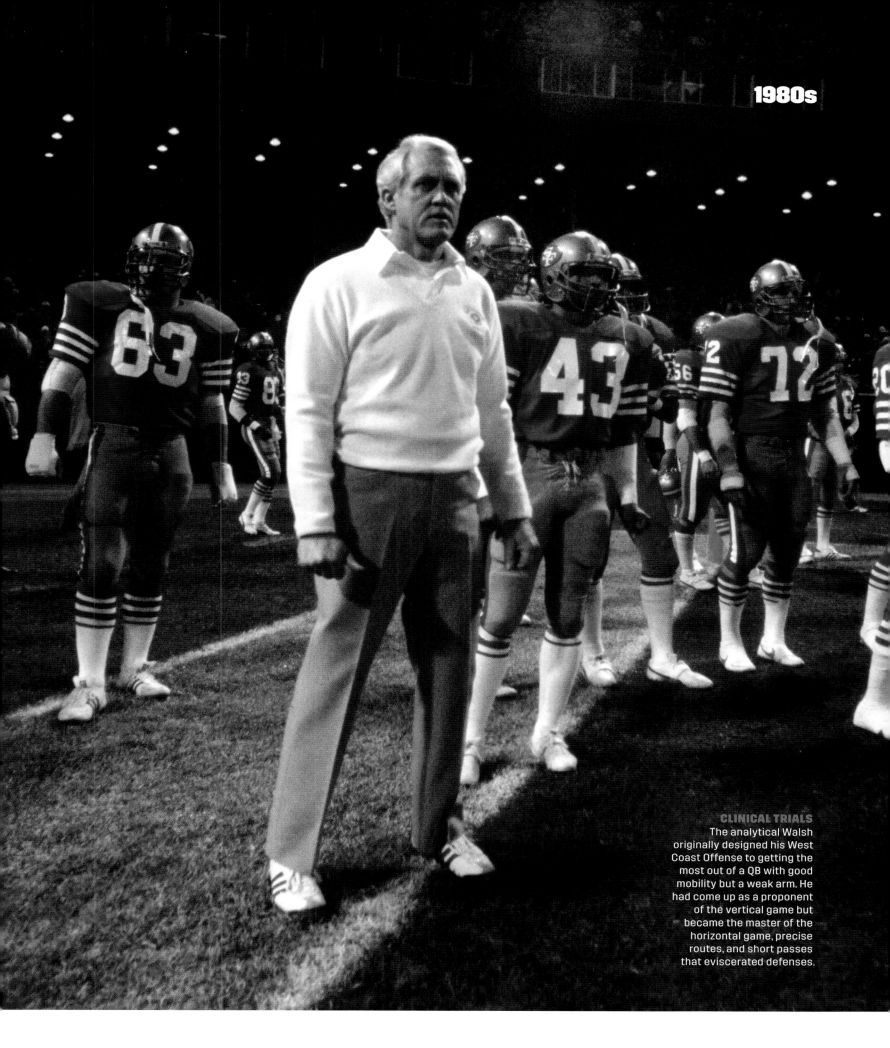

**CLINICAL TRIALS**
The analytical Walsh originally designed his West Coast Offense to getting the most out of a QB with good mobility but a weak arm. He had come up as a proponent of the vertical game but became the master of the horizontal game, precise routes, and short passes that eviscerated defenses.

# When the 1983 draft came around,

six quarterbacks were drafted in the first round. John Elway was predictably first, but four other quarterbacks were selected before Marino. With the 27th pick, Don Shula, coming off a Super Bowl loss to Washington, instantly snapped up Marino for the Dolphins. He was starting by the sixth game of his rookie season,

en route to becoming the first rookie quarterback ever to start in the Pro Bowl. The next season Marino put up the sort of mind-bending numbers that could be the standard against which quarterbacks are compared well into the next century.

► **By Michael MacCambridge**
FROM *ESPN SPORTS CENTURY*, 1999

# DAN MARINO

▶ **By Edwin Pope**

FROM *THE EDWIN POPE COLLECTION*, 1988

**Is anybody left out there with** the slightest doubt that Danny Marino's 48-touchdown-pass season is anything less than the best any quarterback ever had?

Argue with the Cowboys. Or 74,139 bug-eyed live watchers in the Orange Bowl. Or millions more who will be telling the TV tale down at the shop today, in phrases once reserved for the Sid Luckmans and John Unitases and Dan Foutses that nobody ever thought anybody would top. They won't remember the score—28–21 Dolphins.

They can't forget Marino, who stepped up into the middle of what looked like a thousand Cowboys and shot two touchdowns passes 38 and 63 yards to Mark Clayton within a minute and 40 seconds, with only 51 seconds left in the game.

In Texas, they will see this in nightmares.

"Both the same play—Texas 70," Marino said, cool as John Wayne after busting more records like kindling—first passer to throw for more than 5,000 yards (5,084), an NFL completion high (362).

The Cowboys knew he was good. That's why they paid him the biggest compliment they know. They wrenched around their whole ironclad defensive scheme to try to stop him. And found out he couldn't be stopped. Not this season. Not this Monday night. The Cowboys went with a do-or-die blitz. . . . The only thing that will stop it is firepower, and Marino brought that to bear as soon as the Cowboys starting sending linebackers and safeties through the cracks.

At the end, all the cracks were Dallas's. Ruthlessly exposed by the best quarterback any pro season ever saw.

**DROPPED PASS**
The Steelers allegedly passed up Marino in the '83 draft because they feared he'd face too much pressure as a hometown hero.

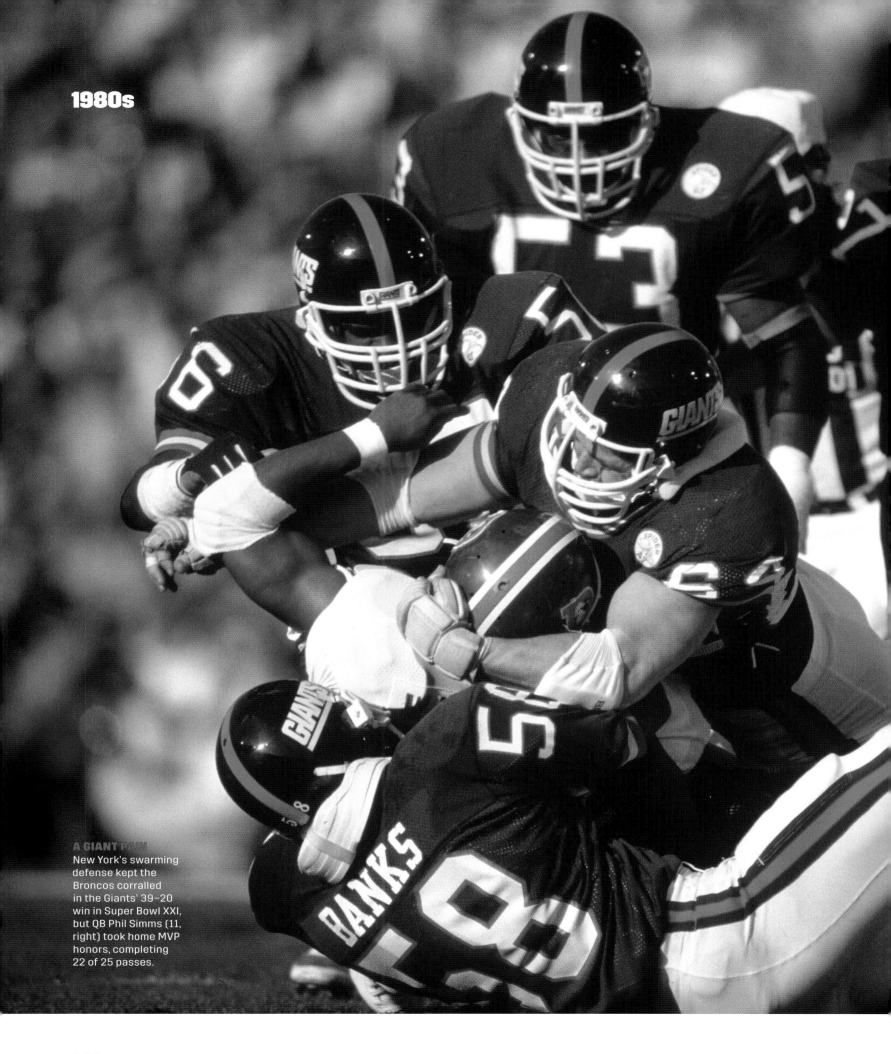

A GIANT PAIN
New York's swarming defense kept the Broncos corralled in the Giants' 39–20 win in Super Bowl XXI, but QB Phil Simms (11, right) took home MVP honors, completing 22 of 25 passes.

# GIANT STEPS

➤ **By Blackie Sherrod**

FROM *THE BLACKIE SHERROD COLLECTION*, 1988

**Super Bowl XXI was a corker for the** first 35 minutes; for the last 25, it was interesting. It was a concert by a team that was superb, on that particular day, place and situation.

Denver didn't lay down or fold up or mutilate the field with mistakes. There was but one turnover the entire game. The Broncos simply were overwhelmed by an exceptional team of that one moment, running exceptional plays with exceptional execution. New York was a textbook.

The Giants may never—probably will never—reach that plateau again, but at Sunday dusk, we were seeing a classic team. That seems somewhat of a privilege.

**BO GOES** Despite being the No. 1 pick in the 1986 NFL draft, Jackson snubbed the Buccaneers to play baseball with the Kansas City Royals.

# BO JACKSON

► **By Michael Weinreb,** FROM *BEST AMERICAN SPORTSWRITING*, 2008

His myth fully crystallized on a Monday night, on the last day of November 1987, when Bo was a rookie running back for the Los Angeles Raiders, a two-sport athlete sharing time in the backfield with a Hall of Famer named Marcus Allen. Bo took a handoff and Bo parted the entire Seattle defense and then Bo—how does one even describe this method of propulsion? Glided? Propelled? Teleported?—91 yards down the sideline, and then Bo kept on running until he disappeared into a tunnel in the bowels of Seattle's Kingdome. The *sound* of Bo running past him, former Seahawks receiver Steve Largent said, was like nothing he had ever heard before

# ERIC DICKERSON

► **By William Nack,** FROM *SPORTS ILLUSTRATED*, SEPTEMBER 4, 1985

**On Eric Dickerson's first day in** a Los Angeles Rams uniform, at a preseason minicamp in the spring of 1983, head coach John Robinson sensed for the first time the singular gift of the man around whom he sought to build his offense.

Robinson had no idea that a man so big—Dickerson was 6'3", 202 pounds at the time—could carry himself with such swift, soundless grace. Oh, they all knew he was fast. The year before, as a 17-year-old junior with little schooling in track, he had won the state championship in the 100-yard dash in 9.4. Because he was so big, they all perceived him as a power runner, a bone-jarring hoss who used his speed and power to crash through lines for daylight.

"That's the thing that surprised me. If you were blind, he could run right by you, and I don't think you'd know he was there unless you felt the wind. He's unique in that way. He is an extremely powerful runner, but he's so graceful, it's really deceiving. He's the smoothest runner I've ever seen."

At age 24, after only two seasons of professional football, Dickerson has become the most productive runner in the National Football League.

> **"Running is so natural to me. When I was running track, people used to ask me, 'When are you gonna start running hard?' The wind hits me in the face, and I feel so smooooooooth. Man, I love to run!"**
>
> ► **ERIC DICKERSON**

# 1 9

The Chiefs' Marcus Allen took the high road to the 100th rushing touchdown of his career in an October 1995 game against the Broncos.

# 90s

## The Decade

THE 1990S SAW A REVOLUTION IN the way that football teams were built, with a collective-bargaining agreement in 1993 that ushered in free agency and, a year later, a salary cap. Football lifers bemoaned the difficulty in keeping teams together, as free agency led to more player movement and higher salaries, but the game was growing, and the salary cap (and floor) preserved important components of competitive balance.

Even as the landscape was changing, one of pro football's eternal verities was underscored: The best, surest and most reliable way to build a perennial contender was through the NFL draft. In an age when you couldn't keep everyone, the draft's importance was amplified, and few teams did it better, at the beginning of the decade, than the new-look Cowboys, with owner (and de facto general manager) Jerry Jones working with energetic head coach Jimmy Johnson.

Starting with their historic haul from the 1989 trade of Herschel Walker, the Cowboys made 29 deals in the first 26 months of the new regime, building a young, fast team around franchise quarterback Troy Aikman, the redoubtable running back Emmitt Smith, and elite wide receiver Michael Irvin. But it was the sheer quantity of their draft choices and the depth they brought to the team that allowed the Cowboys to win three Super Bowls in four years (the last after Johnson left as head coach).

The salary cap would make it impossible for the 49ers to keep both the aging Joe Montana and the ascendant Steve Young, so they traded the veteran to Kansas City (where he summoned more of the Montana magic in two playoff wins at the end

**WIDE RIGHT**
The jinxed Super Bowl run of the Bills began in Super Bowl XXV, when Norwood missed a late chance to beat the Giants.

of the '93 season, and an unforgettable *Monday Night Football* duel with John Elway in '94). San Francisco coach George Seifert gave Young the keys to the car, and in the NFL's 75th anniversary season ('94), he led the 49ers to a Super Bowl triumph, over San Diego, their fifth in fourteen years.

The decade had started with the bulldozing Giants grinding out a win over the 49ers in the 1990 NFC title game (preventing a San Francisco threepeat), then upsetting the fast-breaking, no-huddle offense of the Buffalo Bills, as Scott Norwood's late 47-yard field goal attempt drifted wide right. That was the first of four consecutive Super Bowl losses for Buffalo, making it a punch line in some circles. But Marv Levy's Bills were a

# The quantity of their draft choices and the depth they brought to the team allowed the Cowboys to win three Super Bowls in four years.

remarkably talented, resilient team—never more so than when rallying from a 35–3 deficit to win their 1992 wild-card playoff game against the Houston Oilers. In 1997, it was another perpetual runner-up from the AFC, the Denver Broncos, who finally broke through, snapping the NFC's 13-game Super Bowl winning streak as thirty-seven-year-old John Elway led the way over the Packers in Super Bowl XXXII, then retired a year later, after the Broncos repeated as champs.

The league expanded again in 1995, adding the Carolina Panthers and the Jacksonville Jaguars. Unlike their expansion brethren in the '70s, these new entries were immediately competitive, and both qualified for conference championship games in their second season. "What they did in two years changed the whole landscape of the game forever and ever," said Packers GM Ron Wolf. Wolf was certainly successful in Green Bay, trading for Brett Favre, using free agency wisely (signing defensive tackle Reggie White) and then building the Packers' first world champion in 29 seasons.

The century ended with a glimpse of the future: Dick Vermeil's surprising '99 Rams—soon known as The Greatest Show on Turf—staging a series of gridiron track meets, powered by Cinderella MVP Kurt Warner (previous stops: quarterback, Arena Football League; grocery-store checker, Cedar Falls, Iowa) and the fleetest wide receiver corps in NFL history. But the Rams' tense 23–16 Super Bowl win over the Titans came by the narrowest of margins, with Mike Jones tackling Kevin Dyson on the final play just shy of the end zone. Pro football had changed drastically in the '90s—but it remained a game of inches. —**Michael MacCambridge**

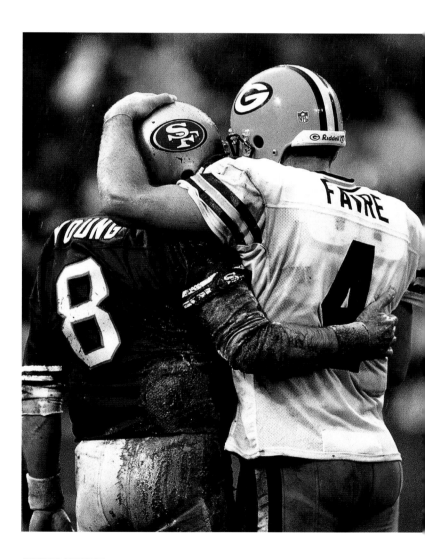

**AERIAL BALLET**
Niners QB Steve Young and Packers QB Brett Favre both led potent offenses that benefited greatly from their arms, their guts, and their scrambling.

# Leaders

## PASSING YARDS

| 1990 | Warren Moon | Oilers | 4,689 |
|------|-------------|--------|-------|
| 1991 | Warren Moon | Oilers | 4,690 |
| 1992 | Dan Marino | Dolphins | 4,116 |
| 1993 | John Elway | Broncos | 4,030 |
| 1994 | Drew Bledsoe | Patriots | 4,555 |
| 1995 | Brett Favre | Packers | 4,413 |
| 1996 | Mark Brunell | Jaguars | 4,367 |
| 1997 | Jeff George | Raiders | 3,917 |
| 1998 | Brett Favre | Packers | 4,212 |
| 1999 | Steve Beuerlein | Panthers | 4,436 |

## RUSHING YARDS

| 1990 | Barry Sanders | Lions | 1,304 |
|------|---------------|-------|-------|
| 1991 | Emmitt Smith | Cowboys | 1,563 |
| 1992 | Emmitt Smith | Cowboys | 1,713 |
| 1993 | Emmitt Smith | Cowboys | 1,486 |
| 1994 | Barry Sanders | Lions | 1,883 |
| 1995 | Emmitt Smith | Cowboys | 1,773 |
| 1996 | Barry Sanders | Lions | 1,553 |
| 1997 | Barry Sanders | Lions | 2,053 |
| 1998 | Terrell Davis | Broncos | 2,008 |
| 1999 | Edgerrin James | Colts | 1,553 |

## RECEIVING YARDS

| 1990 | Jerry Rice | 49ers | 1,502 |
|------|------------|-------|-------|
| 1991 | Michael Irvin | Cowboys | 1,523 |
| 1992 | Sterling Sharpe | Packers | 1,461 |
| 1993 | Jerry Rice | 49ers | 1,503 |
| 1994 | Jerry Rice | 49ers | 1,499 |
| 1995 | Jerry Rice | 49ers | 1,848 |
| 1996 | Isaac Bruce | Rams | 1,338 |
| 1997 | Rob Moore | Cardinals | 1,584 |
| 1998 | Antonio Freeman | Packers | 1,424 |
| 1999 | Marvin Harrison | Colts | 1,663 |

## CHAMPIONS

▼

1990
**NEW YORK GIANTS**
—
1991
**WASHINGTON REDSKINS**
—
1992
**DALLAS COWBOYS**
—
1993
**DALLAS COWBOYS**
—
1994
**SAN FRANCISCO 49ERS**
—
1995
**DALLAS COWBOYS**
—
1996
**GREEN BAY PACKERS**
—
1997
**DENVER BRONCOS**
—
1998
**DENVER BRONCOS**
—
1999
**ST. LOUIS RAMS**

# Pick Six

## 14

Consecutive 100-yard games (from Week 3 through Week 16) in the 1991 season for Lions Hall of Fame running back Barry Sanders, an NFL record. Sanders's streak began after he gained a total of 53 yards in Weeks 1 and 2 combined.

## 5.50

Dollars per hour Kurt Warner earned stocking shelves in an Iowa supermarket after being cut by the Packers in 1994. Five years later (four of them with the Iowa Barnstormers and Amsterdam Admirals), Warner would earn NFL MVP honors while quarterbacking the Rams to their first Super Bowl title.

## 45

The largest scoring differential in Super Bowl history came when the 49ers defeated the Broncos 55–10 in Super Bowl XXIV. The smallest margin came a year later in Super Bowl XXV, when Scott Norwood's game-winning field goal attempt went wide right, and the Giants edged the Bills 20–19.

## 4

Consecutive AFC titles, from 1990 to '93, for the Buffalo Bills, the only team to reach the Super Bowl in four consecutive seasons. Before the Super Bowl era, the Cleveland Browns won their league in five consecutive seasons (1946–49 in the AAFC, 1950 in the NFL).

## 32

Points deficit the Bills overcame against the Oilers in the 1992 AFC wild-card playoff game. Trailing 35–3 early in the third quarter, Buffalo, led by backup quarterback Frank Reich, scored 35 of the next 38 points to even the score by the end of regulation. The Bills then won 41–38 on a field goal in OT.

## 343

Yards from scrimmage gained in three NFL seasons by Tony Smith, the running back chosen by the Falcons with the first-round draft pick obtained from the Packers in exchange for Brett Favre on February 11, 1992. Meanwhile, Favre had 25 career games with more than 343 passing yards.

# Innovations

**1990:** Bye weeks are permanently reintroduced.

**1993:** Spiking ball after snap to stop the clock is legalized.

**1998:** ESPN debuts virtual first down line on its telecasts.

**1999:** Streamlined instant replay system is adopted.

## HELLO

► The World League of American Football debuts in the U.S., Canada, and Europe (1991).

► Carolina Panthers and Jacksonville Jaguars begin play (1995).

► NFLhome.com, the precursor to NFL.com, launches (1995).

► Ravens draft future Hall of Famers Jonathan Ogden and Ray Lewis (1996).

► NFL returns to Cleveland with the expansion Browns (1999.)

## GOODBYE

► Bo Jackson suffers a career-ending hip injury (1991).

► Chuck Noll retires after leading Steelers to four Super Bowl titles (1991).

► NFL discontinues use of pistols to mark the end of periods (1994).

► Don Shula retires with 347 wins, the most in NFL history (1995).

► Rams and Raiders both leave Los Angeles; Browns leave Cleveland (1995).

## Career Rushing Yards

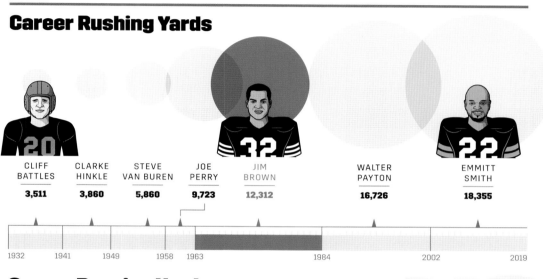

| CLIFF BATTLES | CLARKE HINKLE | STEVE VAN BUREN | JOE PERRY | JIM BROWN | WALTER PAYTON | EMMITT SMITH |
|---|---|---|---|---|---|---|
| 3,511 | 3,860 | 5,860 | 9,723 | 12,312 | 16,726 | 18,355 |

1932   1941   1949   1958   1963   1984   2002   2019

## Career Passing Yards

| ARNIE HERBER | SAMMY BAUGH | BOBBY LAYNE | Y. A. TITTLE | JOHNNY UNITAS | FRAN TARKENTON | DAN MARINO | BRETT FAVRE | PEYTON MANNING | DREW BREES |
|---|---|---|---|---|---|---|---|---|---|
| 8,041 | 21,886 | 26,768 | 33,070 | 40,239 | 47,003 | 61,361 | 71,838 | 71,940 | 73,908 |

1932   1942   1959   '64 '66   1975   1995   2007   2014 2018

## Career Receiving Yards

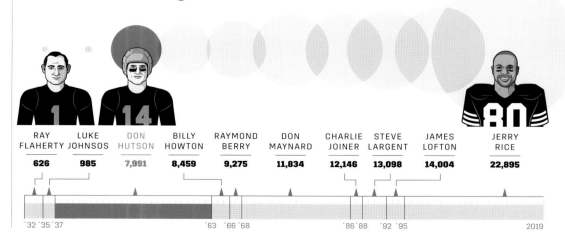

| RAY FLAHERTY | LUKE JOHNSOS | DON HUTSON | BILLY HOWTON | RAYMOND BERRY | DON MAYNARD | CHARLIE JOINER | STEVE LARGENT | JAMES LOFTON | JERRY RICE |
|---|---|---|---|---|---|---|---|---|---|
| 626 | 985 | 7,991 | 8,459 | 9,275 | 11,834 | 12,146 | 13,098 | 14,004 | 22,895 |

'32 '35 '37   '63   '66 '68   '86 '88   '92 '95   2019

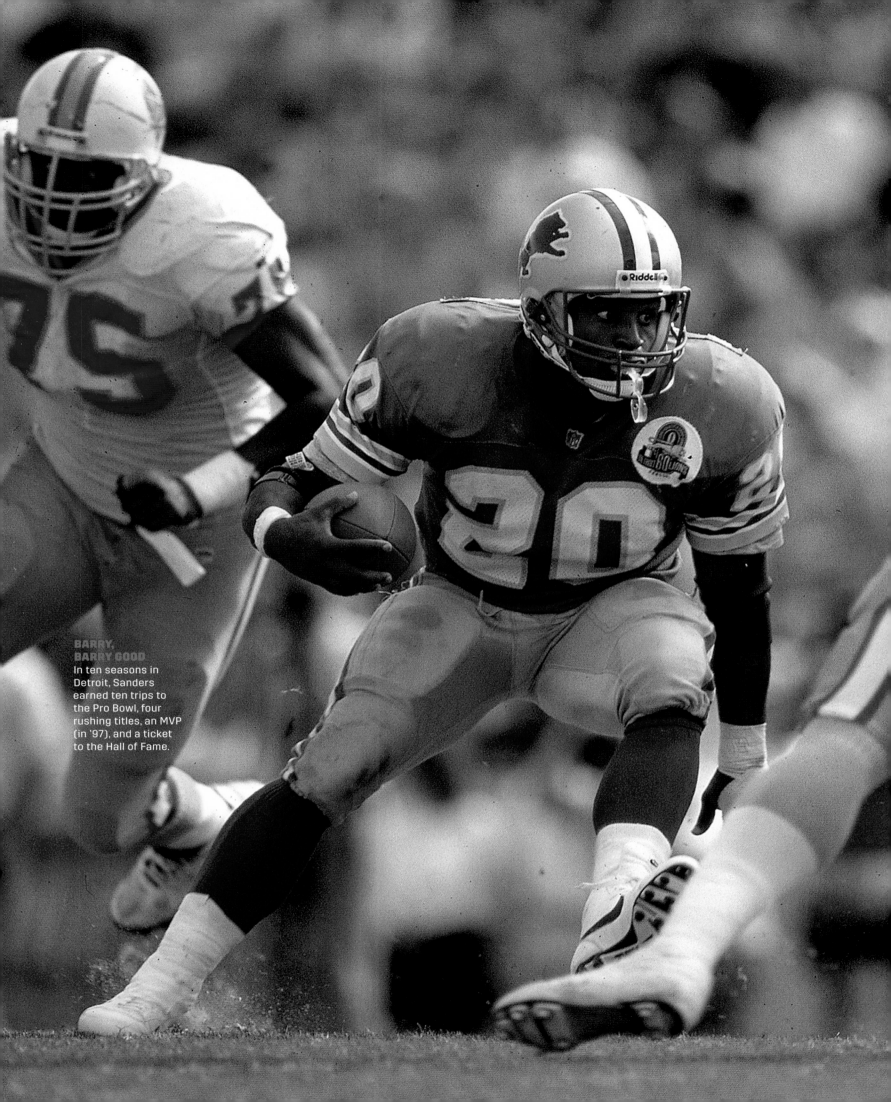

**BARRY, BARRY GOOD**

In ten seasons in Detroit, Sanders earned ten trips to the Pro Bowl, four rushing titles, an MVP (in '97), and a ticket to the Hall of Fame.

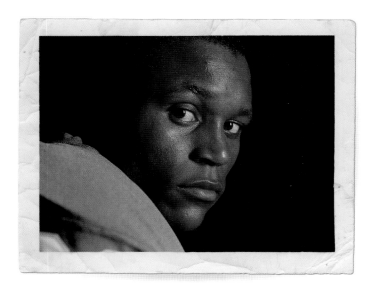

# BARRY SANDERS

➤ **By Paul Zimmerman**
FROM *SPORTS ILLUSTRATED*, DECEMBER 8, 1997

BARRY SANDERS IS WHAT PEOPLE IN THE NFL call a "freak runner." Defensive coaches can't draw up a scheme to stop him because his style follows no predictable pattern. It's all improvisation, genius, eyes that see more than other people's do, legs that seem to operate as disjointed entities, intuition, awareness of where the danger is—all performed in a churning, thrashing heartbeat.

When you look at some of the great runners of the past—Grange, Bill Dudley, Ollie Matson, Gale Sayers—that's what you see, great running through a broken field, a field in which there's space to maneuver. Sanders's finest runs often occur when he takes the handoff and, with a couple of moves, turns the line of scrimmage into a broken field. Walter Payton ran with fury and attacked tacklers. O. J. Simpson and Eric Dickerson were instinctive runners who glided into the line and sliced through it with a burst, but nobody has ever created such turmoil at the point of attack as Sanders has.

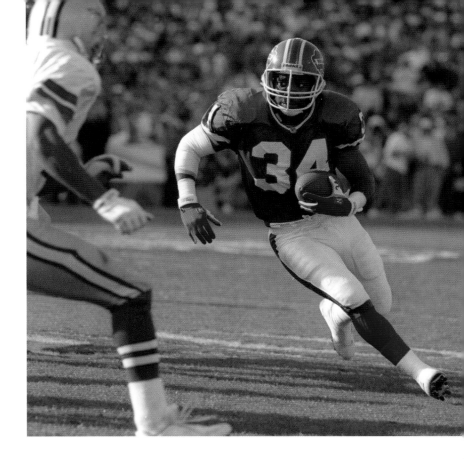

# BACKS TO BACKS

➤ **By Paul Zimmerman**

FROM *THE THINKING MAN'S GUIDE TO PRO FOOTBALL*, 1970

THEY COME INTO PRO FOOTBALL ALL INSTINCT and nerve, without the surgical scars on the knees or the knowledge of what it's like to get hit by a 240-pound linebacker. They burn brightly, and by the time they're 30 or so they might still be around, but they're different players.

Running back is a position governed by instinct, and many of the great ballcarriers were never better than they were as freshman pros. It's the most instinctive position in football, the only one in which a rookie can step in with a total lack of knowledge of everything except running the ball, and be a success.

The good runners all have the quick start and the knack of avoiding objects, and a rookie can use exactly the same skills he had in college. And if he's got the physical qualifications, he will be a good, often sensational first-year pro. He hasn't learned fear—or self-defense. The repeated hammering hasn't yet taken the zip from his legs. Everything else can be taught, the faking and blocking and pass routes, provided he has the desire to learn and the courage to executive some of the more tedious jobs.

They know how to pass-block, and they can run their pass routes without making any mistakes; they can block in front of a ballcarrier, and they run just well enough to be considered runners. They dive—and survive.

**BILLS TO PAY**
Longtime Buffalo RB Thurman Thomas (top) is the only player to lead the NFL in total yards from scrimmage for four consecutive seasons.

**BUS STRIKE**
Jerome Bettis (36) was bread-and-butter in the '90s, rushing for more than 1,000 yards six times for the Rams and the Steelers.

**BIG-GAME GAMER**
Terrell Davis (30) ran off an
NFL record seven straight
100-yard playoff games and
helped Denver win Super
Bowls in '98 (top) and '99.

**IN A HURRY**
Marshall Faulk (28)
spent five productive
years in Indianapolis and
seven more in St. Louis
on his way to Canton.

And the hands. Clad in gloves, the hands are so supple and sure that last year they snared a touchdown pass by latching onto the tail end of a fading ball. "That was not giving up on the ball," explains Rice. Sounds simple. In reality it's like grabbing the back end of a greased pig.

➤ FROM *SPORTS ILLUSTRATED*, DECEMBER 26, 1994, **by Rick Telander**

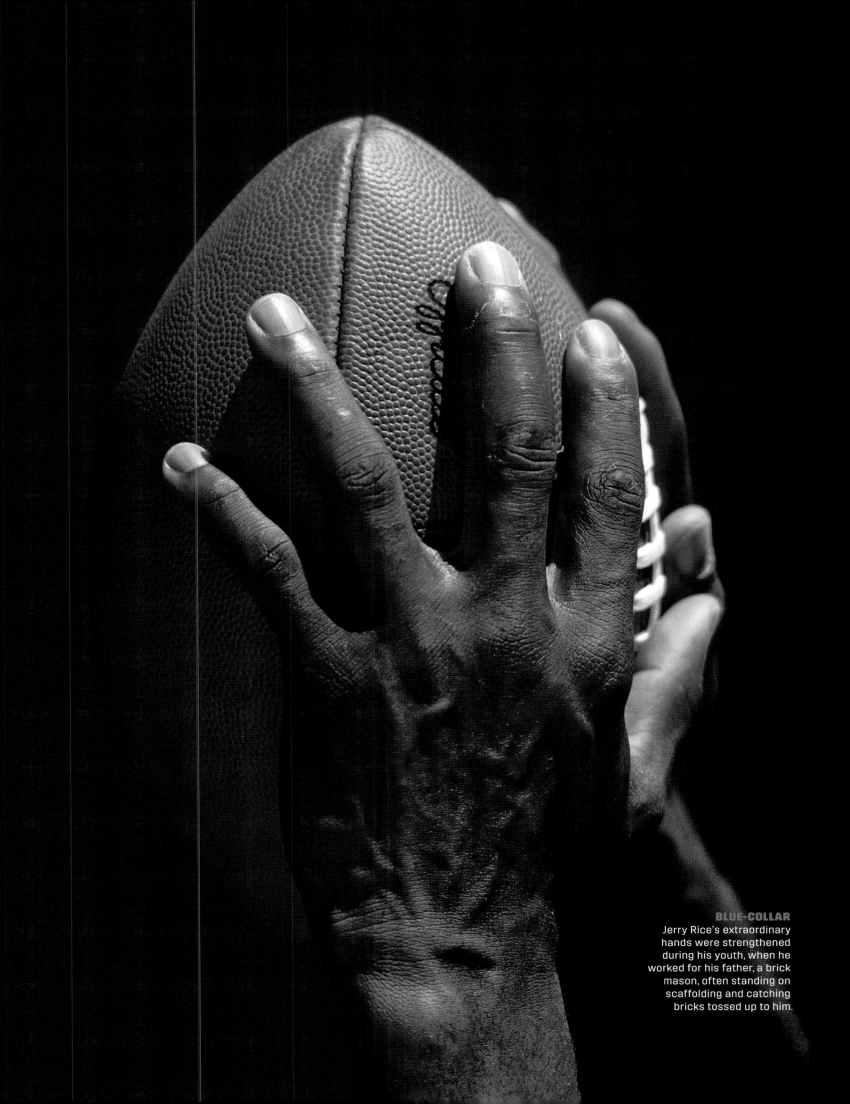

**MOON SHOTS**
Both Warren Moon (1) and
the Bills' Jim Kelly (12)
worked their way up to
the NFL, starting their
pro careers elsewhere:
Moon in the CFL and Kelly
in the short-lived USFL.

# THE TOUGHEST JOB IN SPORTS

➤ **By Peter King**
FROM *SPORTS ILLUSTRATED*, AUGUST 17, 1998

THE QUEST FOR A QUARTERBACK WHO MAY ONE
day lead a team to a Super Bowl is getting more
and more like the lottery: Take your best shot,
then cross your fingers. "The first pro football
game I ever saw was in 1953," says Ron Wolf,
executive vice president and general manager of
the Green Bay Packers. "Two good franchises,
Baltimore and Chicago. You know who the
quarterbacks were? Freddy Enke and Steve
Romanik. The point is, the more things change,
the more they stay the same. We're all still looking
for quarterbacks. Everyone wants to apply
science to this, but it's more seat-of-the-pants
than science. I don't care how sophisticated
it gets. It's still humans scouting humans."

Why is it so hard to unearth a good
quarterback? Let's start with this premise:
Quarterback is the most complex position in
sports. Comparatively, a pitcher has to be precise
in his pitch location and outwit the hitter; a point
guard must direct his teammates and adjust
on the fly to make a play work; a hockey goalie
must be athletic and fearless. A quarterback
has to be able to do and be all of those things.

"Every fall Sunday, you're the nerve center
for a city, a county, a state, a region," says
Boomer Esiason, who played quarterback
for 14 NFL seasons. "You step behind center,
and millions of people watch to see what
you'll do next. The pressure kills some guys.
There's no other job like it in sports."

**LEFT HANGING** Coming out of BYU, Steve Young signed a big deal with the short-lived USFL, was the first pick
(by the Bucs) in the 1984 NFL supplemental draft, then spent thirteen sterling seasons as a 49er.

**FAST AND FURIOUS**
Among the decade's top linebackers were **1.** Junior Seau, Chargers; **2.** Kevin Greene, Panthers; **3.** Rickey Jackson, Saints; **4.** Derrick Thomas, Chiefs.

# The Last Angry Men

► **By Rick Telander**
FROM *SPORTS ILLUSTRATED*, SEPTEMBER 6, 1993

**Linebackers rise out of the football ooze** in a curious twist on Darwin: While the primitive stayed below, groveling on all fours, the more primitive ascended to the upright position. Of course, in the beginning there were no linebackers at all in football. Because there was no forward pass, there was no need on defense for anything other than seven or eight down linemen who rooted like pigs and three or four defensive backs who could run down any ballcarrier who got past the swine. With the dawn of the pass in professional football in 1906,

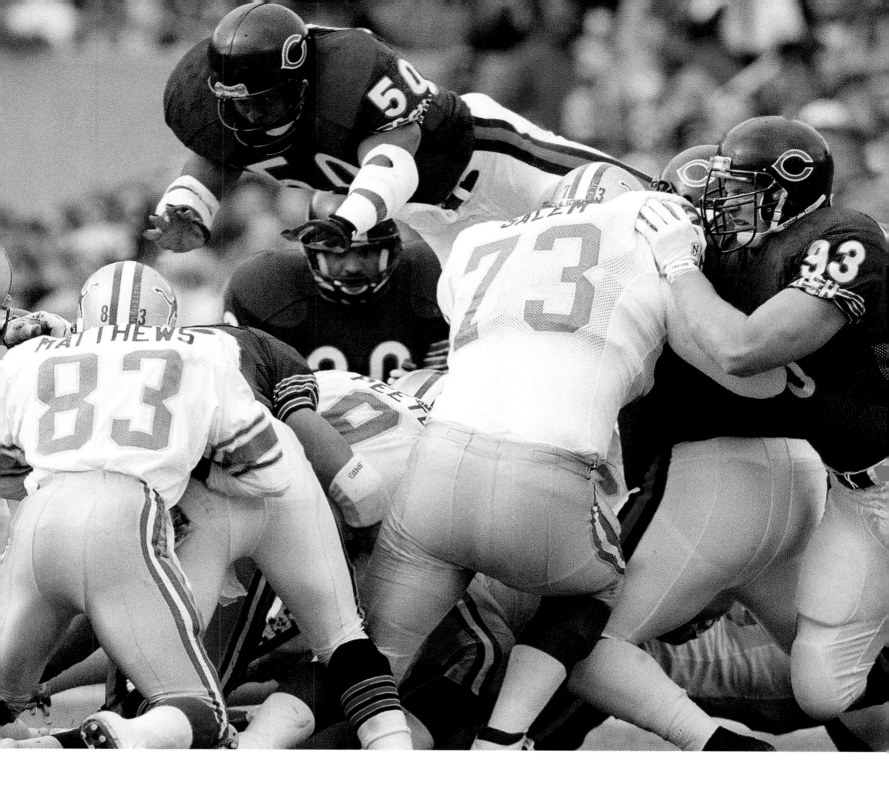

defensive principles slowly evolved. "Roving centers" started to pop up, and by 1920 something like a modern-day NFL middle linebacker had emerged.

His name was George Trafton, and he played for the Decatur Staleys, who became the Bears. There is some dispute as to whether Trafton was the first true linebacker, but he was definitely the first Butkus-like personality in the NFL. Nicknamed The Brute, Trafton was as nasty as they come, despised by rival teams and their fans.

According to Bob Carroll, the executive director of the Professional Football Researchers Association, the first outside linebacker in the NFL was 6' 4" John Alexander, who played for the Milwaukee Badgers. Normally a tackle, one day in 1922 Alexander "stood up, took a step back, two steps out and became an outside linebacker," says Carroll. "He wondered why, as tall as he was, he was always getting down on the ground where he couldn't see."

Alexander would set the evolutionary clock moving, and 60 years later it would bring us to LT himself.

# JOHN ELWAY

**By Michael MacCambridge**
FROM *AMERICA'S GAME*, 2004

What [Marty] Schottenheimer would see, across fields from Elway for more than a decade, was this unteachable, unlearnable skill on Elway's part, the ability to keep his head when all about him were losing theirs. Teams would flush Elway from the pocket, force him toward the sideline, converge toward him, and then, in an instant, watch him stop running, set his right foot, plant his left, and peg an absurdly arcing long pass across his body and across the field to a wide-open receiver streaking open 40, 50, even 60 yards down the field on the opposite sideline. It was more acrobatic, if perhaps less intellectual, than the play calling of Unitas and Namath, but the shot to the heart was just as lethal.

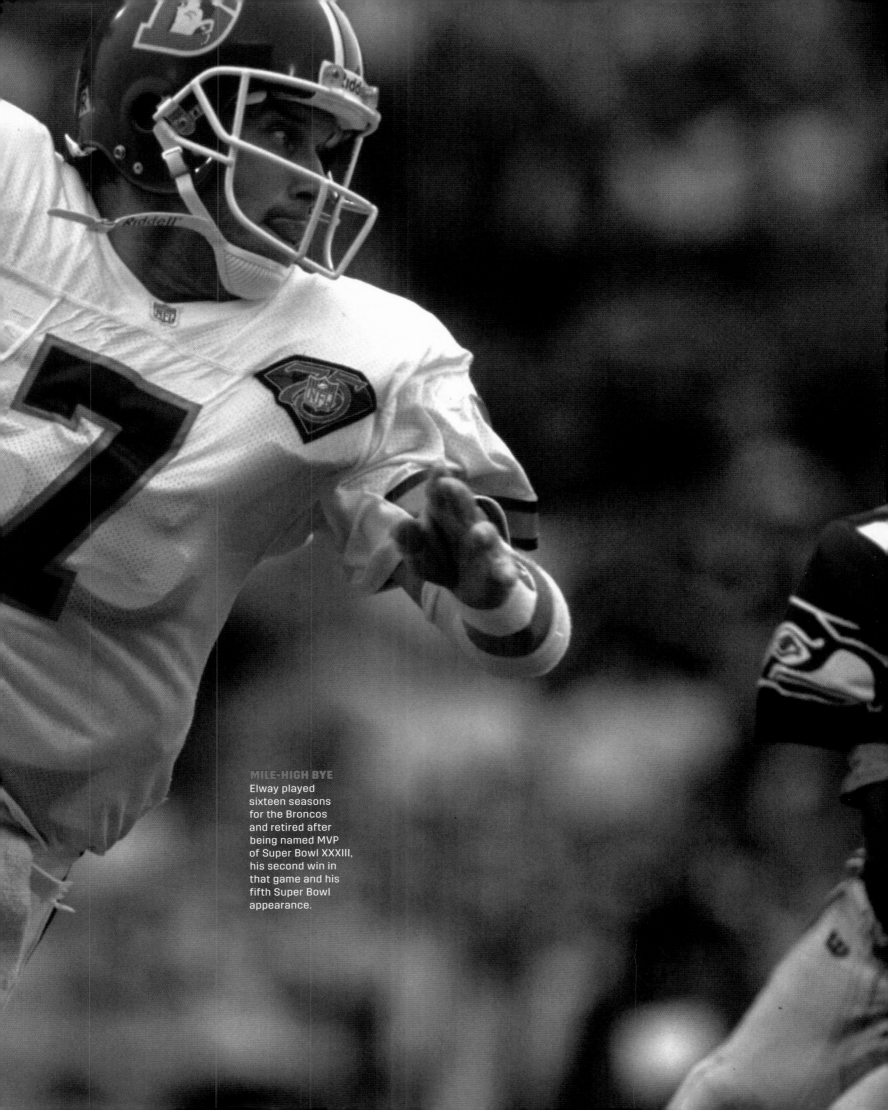

**MILE-HIGH BYE**
Elway played
sixteen seasons
for the Broncos
and retired after
being named MVP
of Super Bowl XXXIII,
his second win in
that game and his
fifth Super Bowl
appearance.

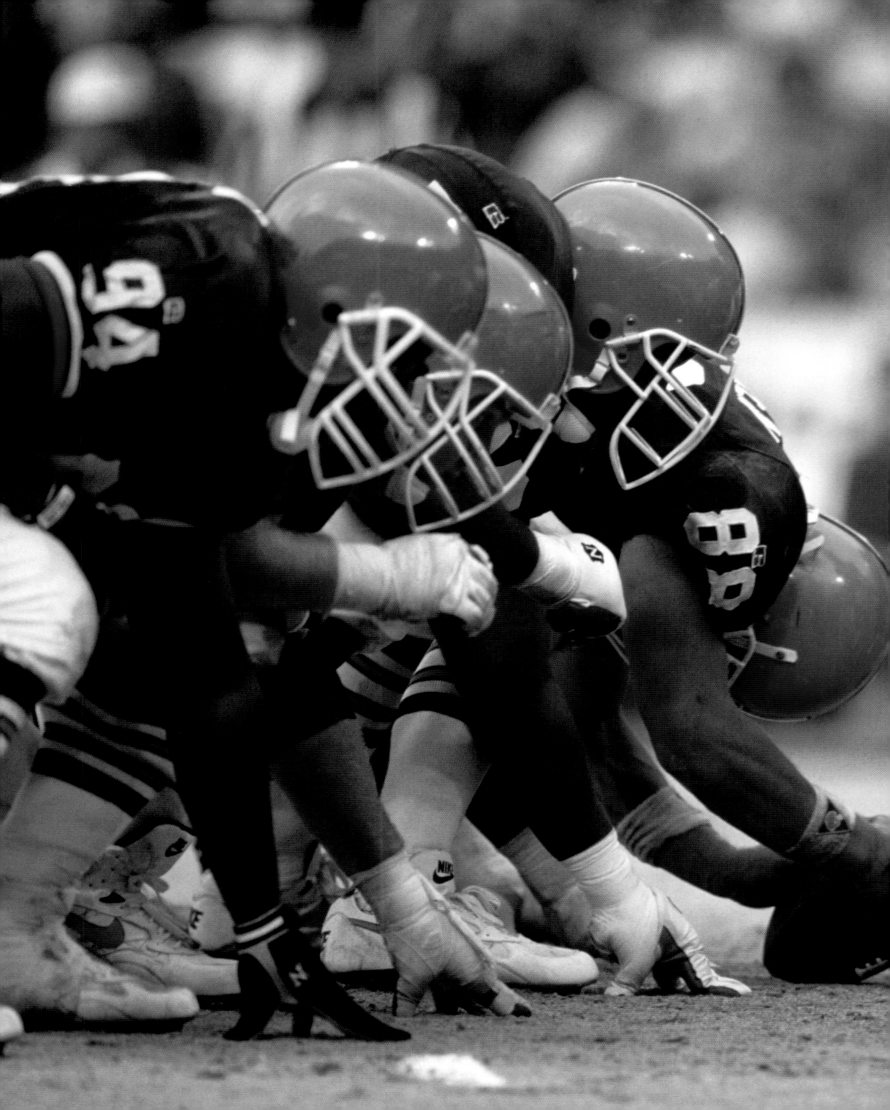

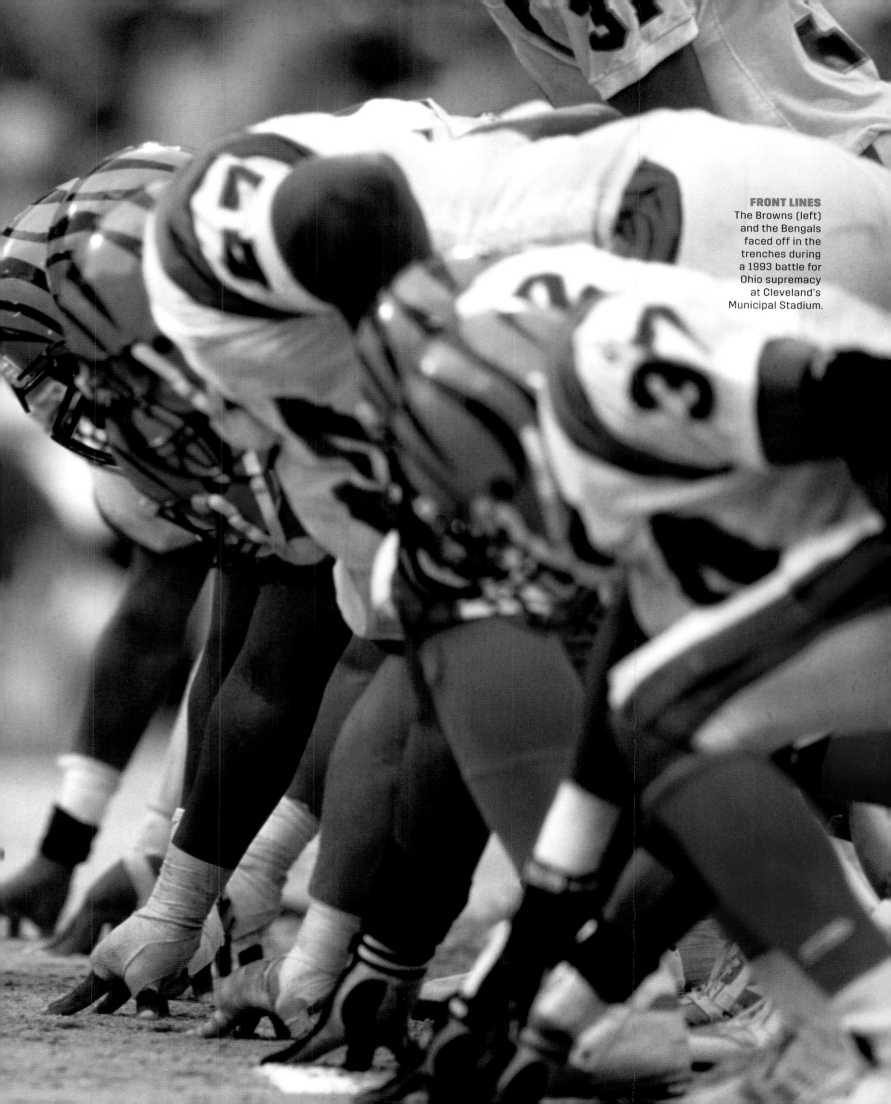

**FRONT LINES**
The Browns (left) and the Bengals faced off in the trenches during a 1993 battle for Ohio supremacy at Cleveland's Municipal Stadium.

# KEYSHAWN JOHNSON

➤ **By Jeff MacGregor,** FROM *SPORTS ILLUSTRATED*, NOVEMBER 8, 1999

**This is how he works: Under a sky** as high and hot as scalded milk, Keyshawn is running patterns on a practice field at Hofstra University, catching long, elegant passes.

He comes off the line of scrimmage like Walter Brennan. For the first three steps he's all crotchet and fuss and pistoning forearms, his big feet flapping. Then on the fourth step his feet are under him again, so he unfolds himself and he's daddy longlegs now, football fast, going, pumping—he plants one of those size-13 shoes, cutting, fakes, fakes again with a shake of the head that seems like an angry denial, pumping, going. Part of him is headed upfield now, and the other part isn't. You can see him from every angle at once, a cubist painting of a man running, and the ball is in the air, drilling an arc into those hands as big and soft as oven mitts.

During the worst of this unseasonal heat wave it feels as if you're wearing clothes made out of steel wool, but Keyshawn is running flat out up the sideline, going deep, hitch and go, over and over—fast, as if he's chasing something. Or something's chasing him.

**JET STREAM OF CONSCIOUSNESS**
Johnson was the No. 1 overall pick in 1996. He later wrote a book about his rookie season with the Jets, modestly titled *Just Give Me the Damn Ball.*

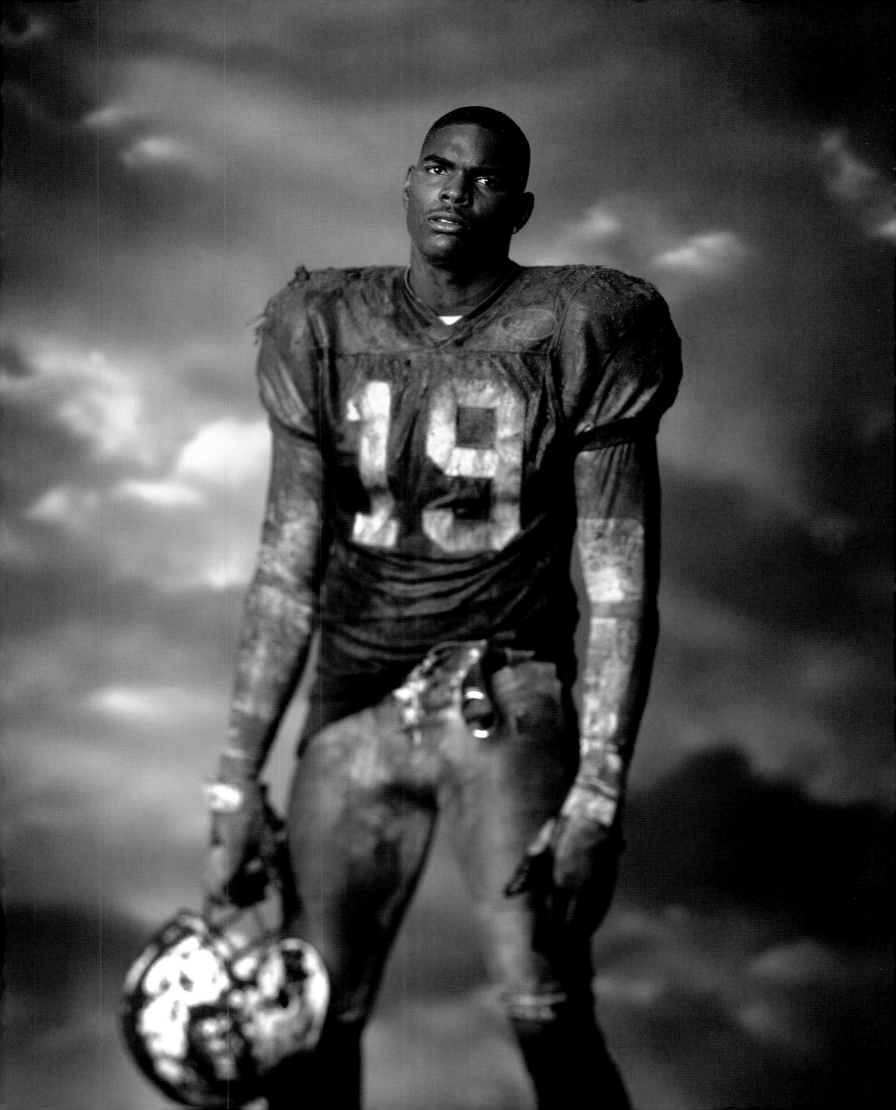

Yes, [Emmitt] Smith knows who he is, and he knows where he is. More than speed or power or balance, awareness has been his greatest asset. He's always been able to read the men shifting in front of him, anticipate where and when a hole would open, when to make that famous cutback.

► **By S. L. Price,** FROM *SPORTS ILLUSTRATED: THE FOOTBALL BOOK*, 2008

**THE LONG HAUL**
Smith is the NFL career rushing leader, with 18,355 yards. He also leads all backs in rushing touchdowns, with 164, and trails only Jerry Rice for the overall TD mark.

# BRETT FAVRE

► **By Alan Shipnuck**
FROM *SPORTS ILLUSTRATED*
DECEMBER 10, 2007

**There is no happier place than Green Bay,**
Wis., on a Sunday evening after the
Packers have won. The beer tastes better,
the girls are even prettier, and few seem
to notice the bite in the air. In a town
defined by its team, civic temperament
can be quantified on a scoreboard. A
few weeks ago, in the moments after
the Packers had defeated the Carolina
Panthers 31—17 at Lambeau Field, the
parking lot was alive with merriment.

The epicenter of Green Bay's game-
day good cheer is adjacent to Lambeau,
just across Holmgren Way, a block over
from Lombardi Avenue: Brett Favre's
Steakhouse, located at 1004 Brett Favre
Pass. The restaurant ("Where you are
the MVP!") is a 20,000-square-foot
temple to the Packers' quarterback.

The intensity of Favre's relationship
with the Packers faithful goes far beyond
mere longevity. He arrived in Green Bay
in 1992 through a trade with the Atlanta
Falcons, and in the third game of the
season came off the bench to lead a
madcap comeback against the Cincinnati
Bengals, throwing the winning touchdown
with 13 seconds left. He has refused
to leave the starting lineup ever since,
harnessing his hair-on-fire style to win an
unprecedented three MVP awards (1995,
'96, '97) and lead Green Bay to a Super Bowl
triumph following the 1996 season.

**CAGEY CAJUN**
Favre is the only
player to be voted
league MVP in three
consecutive seasons,
starting in 1995.

# The Grind Game

► **By Michael Lewis,** *FROM THE BLIND SIDE*, 2006

In 1978, NFL teams passed 42 percent of the time and ran the ball 58 percent of the time. Each year, right through until the mid-1990s, they passed more and ran less until the ratios were almost exactly reversed: In 1995, NFL teams passed 59 percent of the time and ran 41 percent of the time. It's not hard to see why the passing game was improving and the running game was stagnant. Every year NFL teams ran the ball thousands of times, and every year the league averaged between 3.9 and 4.1 yards per carry. With just the tiniest, seemingly random variations from year to year, the yield from this mill was monotonously consistent going all the way back to 1960. Some teams did a bit better, of course, and some did a bit worse. The league as a whole, however, never figured out how to make the running game yield even a fraction of a yard more than it always had. It was possible that the running game awaited some innovative coach to figure out how to make it work more efficiently.

And it could be that the steel industry is just awaiting the CEO who can find gold in its mills.

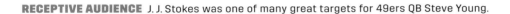

**RECEPTIVE AUDIENCE** J. J. Stokes was one of many great targets for 49ers QB Steve Young.

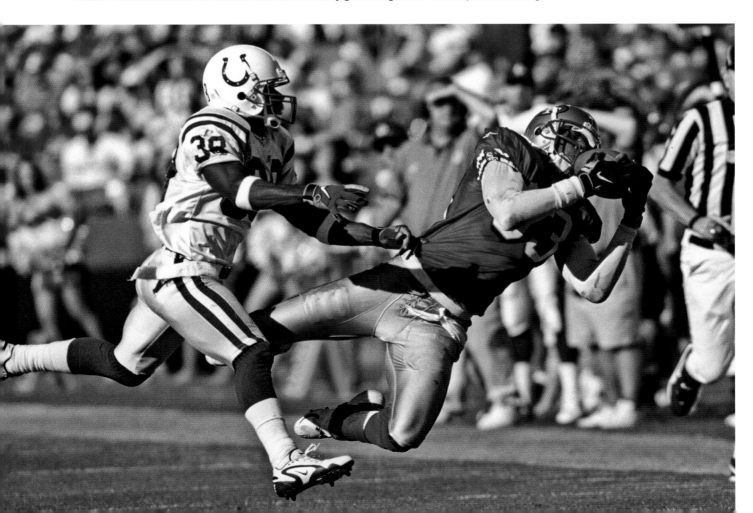

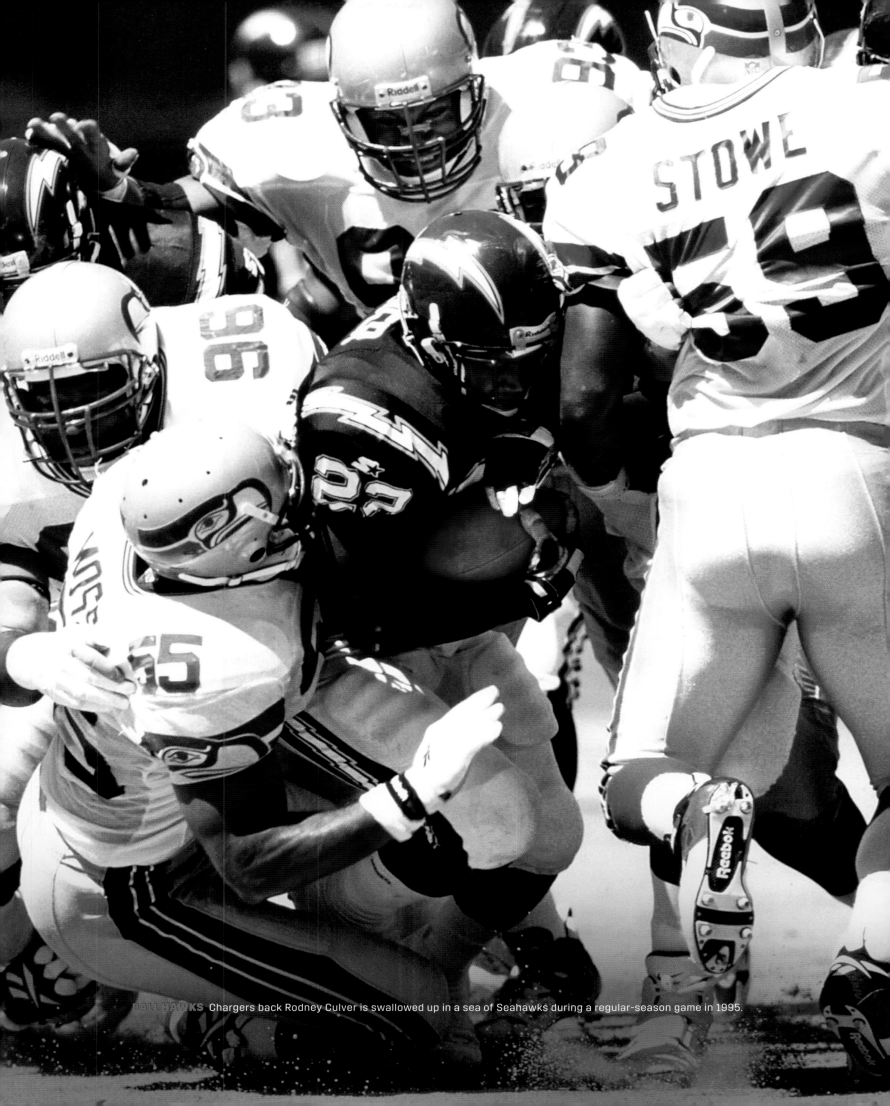

**BALL HAWKS** Chargers back Rodney Culver is swallowed up in a sea of Seahawks during a regular-season game in 1995.

**SICK PICK-SIXES**
In 1994, Sanders had two interception returns of more than 90 yards for the 49ers.

**SPLIT SHIFT** Sanders is the only athlete who's played in both a Super Bowl and a World Series.

# DEION SANDERS

► **By Michael MacCambridge**
FROM *ESPN SPORTS CENTURY*, 1999

**Sanders developed his "Prime Time"** persona at Florida State, where he showed up for his final regular-season game in a limousine, sporting a top hat and tails. What made this self-promotion tolerable was his performances—he created his own hype, then lived up to it. He was the first man to play in both a Super Bowl and a World Series, and the first to score an NFL touchdown and hit a major league homer in the same week.

On the football field he was a wonder. His quick jam move at the snap could shut down receivers instantly, and in an era of liberalized passing rules, the man who once ran a 4.2 40-yard dash

in shoulder pads was the ultimate cover cornerback, despite his dubious tackling skills. His closing speed was so otherworldly that, after a few seasons, quarterbacks rarely threw to his side, and virtually never threw his way on out patterns. By 1998, he'd given up the gold chains and become a born-again Christian, preaching the Lord's gospel and speaking out against his past transgressions. But even when he was strutting his stuff across the national stage as the most flamboyant athlete of his time, there was a sense that even Sanders didn't quite believe his own shtick.

"You can't live soft and fight hard. You have to program yourself. It doesn't just happen; it ain't a switch that you turn on and turn off as you walk through the door of the complex. I MEAN, I LIVE, READ, EAT, SLEEP FOOTBALL. That's me. That's what I do. And if you don't do that, then this game is gonna eat you up and devour you."

—

WARREN SAPP

▶ FROM *AMERICA'S GAME*, 2004, **by Michael MacCambridge**

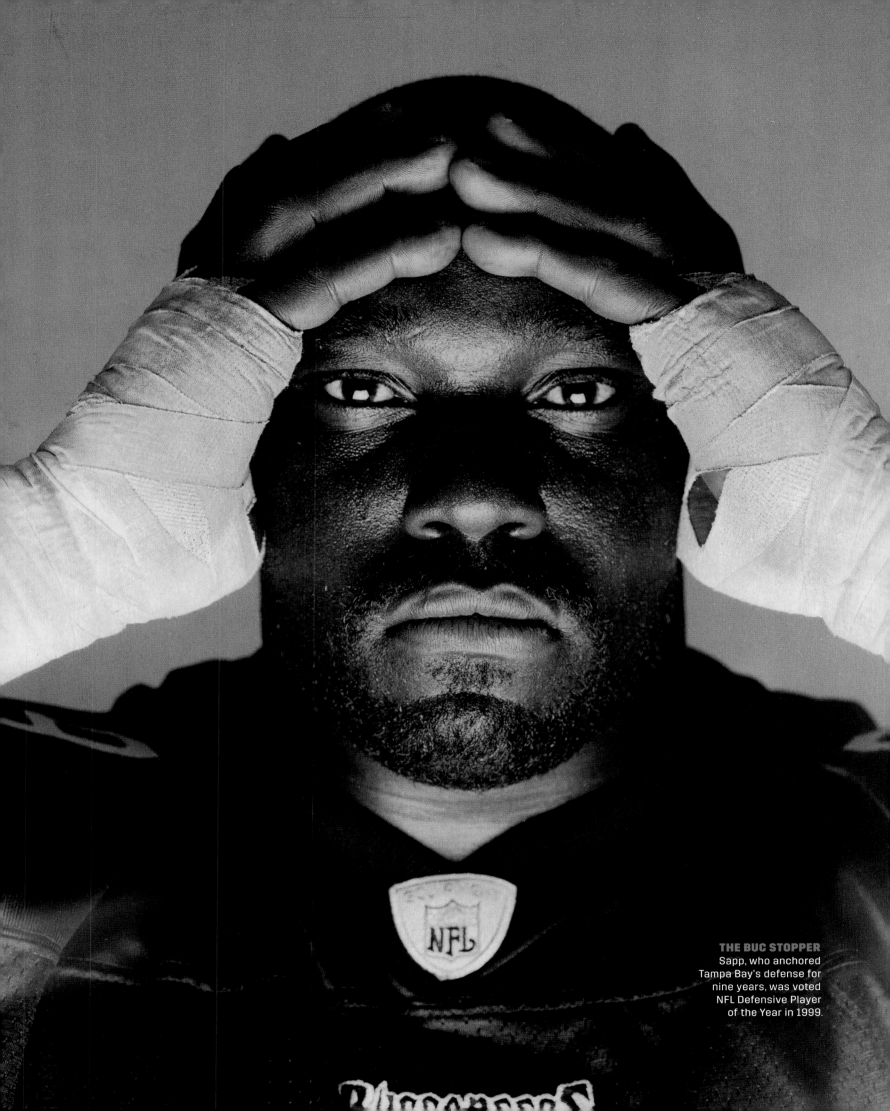

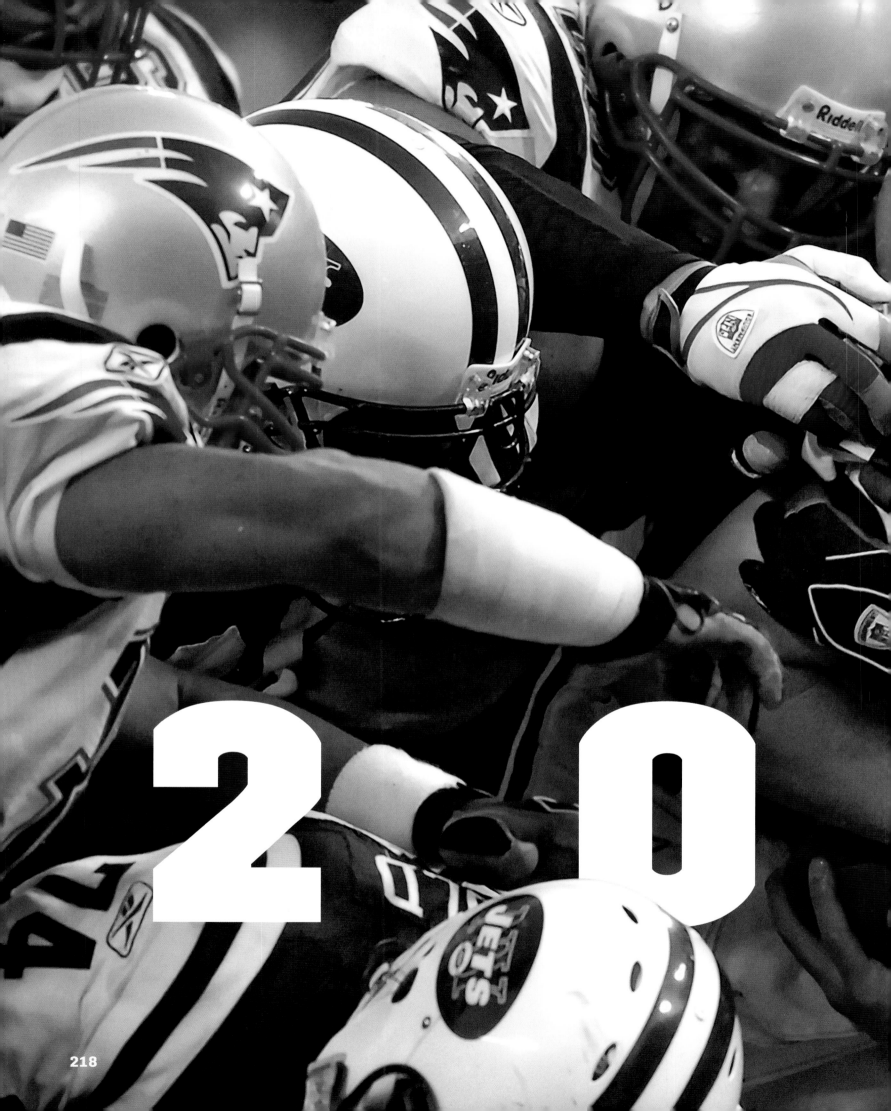

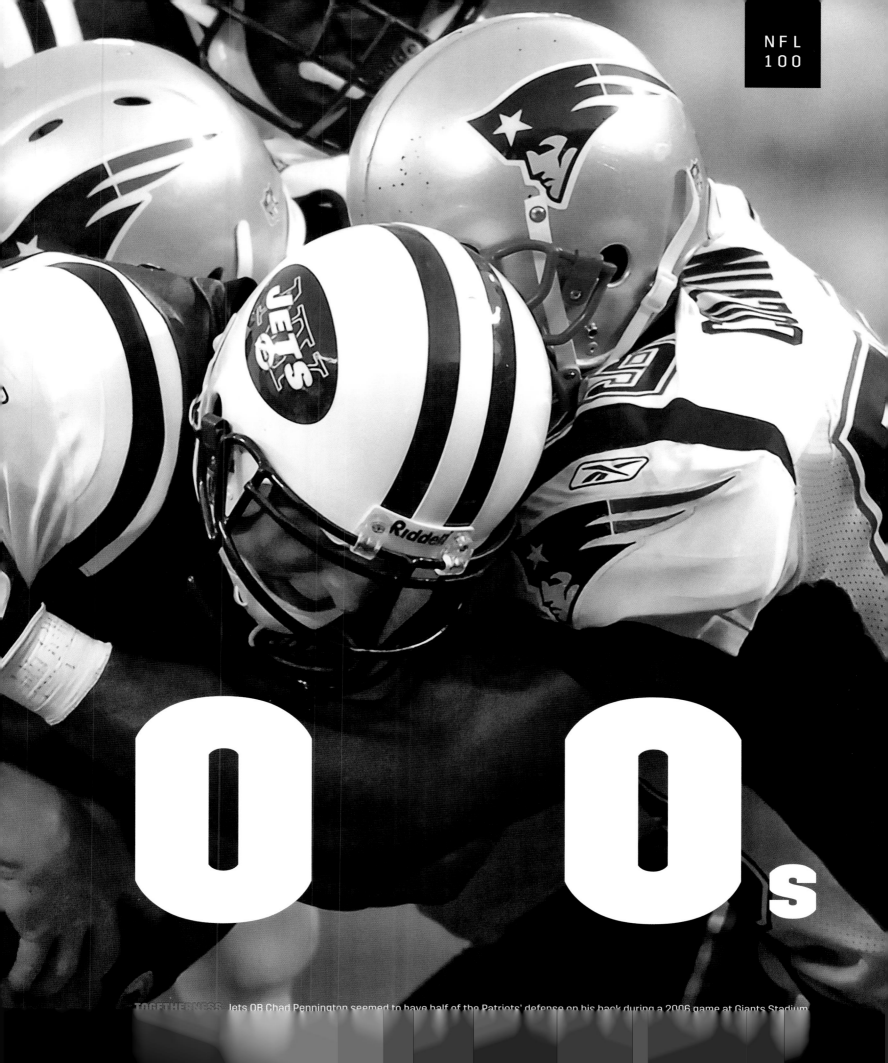

NFL
100

# 00s

INTERVIEWED IN 1969, ON THE EVE OF THE completion of the NFL-AFL merger, Pete Rozelle was asked about the long-range future of the NFL, and he predicted a 32-team league, divided into two 16-team conferences, with each of those conferences separated into four four-team divisions. In 2002, with the addition of the expansion Houston Texans, Rozelle's vision came to pass, structured precisely as he'd predicted.

At the dawn of the new century, the conventional wisdom was that the carefully calibrated elements designed to maintain competitive balance—the salary cap (and salary floor), free agency, and slotted scheduling—would make it almost impossible for teams to repeatedly dominate.

Almost.

In the NFC, parity reigned, with nine different teams winning the conference championship during the decade. But in the AFC, it was a different story as the Patriots (four AFC titles), the Steelers (three), and the Colts (two) nearly ran the table.

The Patriots had lost four players to free agency in 1999, which yielded four compensatory picks in the 2000 NFL draft. With the second of those selections, near the end of the sixth round (the 199th choice overall), the Patriots selected Michigan quarterback Tom Brady. It would eventually go down as one of the great draft steals in history and served to underscore the value of premium quarterbacks and coaches in a salary-cap league.

When the attacks on the United States occurred on September 11, 2001, commissioner Paul Tagliabue

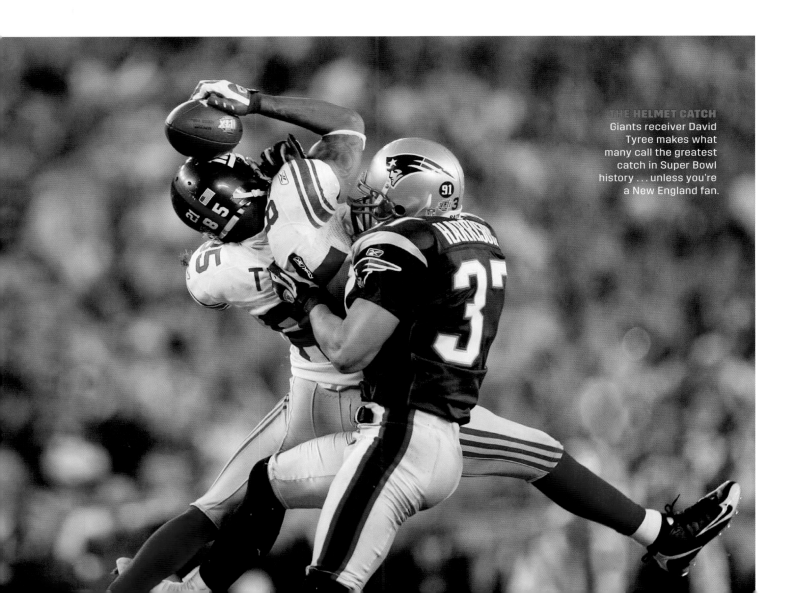

THE HELMET CATCH
Giants receiver David Tyree makes what many call the greatest catch in Super Bowl history ... unless you're a New England fan.

deliberated overnight, then decided that the league could not go on with games that weekend. After a one-week hiatus, pro football returned as a focus of unity and healing, and on September 23, Tagliabue and NFLPA executive director Gene Upshaw were at Arrowhead Stadium in Kansas City—with two of football's first families, the Maras and the Hunts—for the New York Giants' game at the Kansas City Chiefs.

That 2001 season culminated in a postseason fraught with drama, as the young, untested Brady—filling in for the injured Drew Bledsoe so capably that he kept the job even when Bledsoe healed—led the Patriots to an epic playoff win over the Oakland Raiders in a driving snowstorm (the famous Tuck Rule Game). Adam Vinatieri kicked a clutch 45-yard field goal through the snow to send the game into overtime, then won it a few minutes later. At the Super Bowl in New Orleans, Bill Belichick's Patriots—eschewing individual introductions to run out onto the field en masse—upstaged the Rams' Greatest Show on Turf and engineered a 20–17 upset win, with Vinatieri again kicking the winning field goal.

The decade was full of playoff heroics, like the Music City Miracle, the 75-yard kickoff return keyed by Frank Wycheck's cross-field lateral to Kevin Dyson that lifted the Titans over the Bills in the 2000 playoffs; and Santonio Holmes's remarkable catch in the corner of the end zone to seal the Steelers' win over the Cardinals in the last minute of Super Bowl XLIII.

But one game stood out. In the 2006 AFC Championship Game, the Colts fell behind their nemeses, the Patriots, 21–3, before Peyton Manning staged a furious rally, culminating in a long touchdown drive at the end of the game to prevail, 38–34. Two weeks later, the Colts won their first

**PATRIOT GAMES**
Packers safety Darren Sharper holding an American flag after the NFL's return to action after the 9/11 terrorist attacks.

championship in 36 years, and Tony Dungy became the first African-American coach to win a Super Bowl.

But the decade belonged to New England. The Patriots would win three Super Bowls in four seasons, then march toward what seemed another inevitable title in 2007, when they went 16–0 in the regular season. But the effort to match the perfect season of the 1972 Dolphins was derailed in the Super Bowl. Late in the game, trailing 14–10, Eli Manning led a Giants rally, evading Patriots rushers then throwing a strike to wideout David Tyree, whose astounding "helmet catch" kept the drive alive, before Manning hit Plaxico Burress in the end zone for the winning points.

Though they fell short of perfection, the Patriots remained the standard against which other teams were judged. Football fans argued about whether Belichick made Brady great, or Brady made Belichick great. It was a moot point; they were both great. And they weren't done yet. —**Michael MacCambridge**

# The decade belonged to New England, which won three Super Bowls in four seasons, then marched toward what seemed another inevitable title in 2007.

## Leaders

| | | | | |
|---|---|---|---|---|
| **PASSING YARDS** | 2000 | Peyton Manning | Colts | 4,413 |
| | 2001 | Kurt Warner | Rams | 4,830 |
| | 2002 | Rich Gannon | Raiders | 4,689 |
| | 2003 | Peyton Manning | Colts | 4,267 |
| | 2004 | Daunte Culpepper | Vikings | 4,717 |
| | 2005 | Tom Brady | Patriots | 4,110 |
| | 2006 | Drew Brees | Saints | 4,418 |
| | 2007 | Tom Brady | Patriots | 4,806 |
| | 2008 | Drew Brees | Saints | 5,069 |
| | 2009 | Matt Schaub | Texans | 4,770 |
| **RUSHING YARDS** | 2000 | Edgerrin James | Colts | 1,709 |
| | 2001 | Priest Holmes | Chiefs | 1,555 |
| | 2002 | Ricky Williams | Dolphins | 1,853 |
| | 2003 | Jamal Lewis | Ravens | 2,066 |
| | 2004 | Curtis Martin | Jets | 1,697 |
| | 2005 | Shaun Alexander | Seahawks | 1,880 |
| | 2006 | LaDainian Tomlinson | Chargers | 1,815 |
| | 2007 | LaDainian Tomlinson | Chargers | 1,474 |
| | 2008 | Adrian Peterson | Vikings | 1,760 |
| | 2009 | Chris Johnson | Titans | 2,006 |
| **RECEIVING YARDS** | 2000 | Torry Holt | Rams | 1,635 |
| | 2001 | David Boston | Cardinals | 1,598 |
| | 2002 | Marvin Harrison | Colts | 1,722 |
| | 2003 | Torry Holt | Rams | 1,696 |
| | 2004 | Muhsin Muhammad | Panthers | 1,405 |
| | 2005 | Steve Smith | Panthers | 1,563 |
| | 2006 | Chad Johnson | Bengals | 1,369 |
| | 2007 | Reggie Wayne | Colts | 1,510 |
| | 2008 | Andre Johnson | Texans | 1,575 |
| | 2009 | Andre Johnson | Texans | 1,569 |

## CHAMPIONS

▼

**2000**
**BALTIMORE RAVENS**
—
**2001**
**NEW ENGLAND PATRIOTS**
—
**2002**
**TAMPA BAY BUCCANEERS**
—
**2003**
**NEW ENGLAND PATRIOTS**
—
**2004**
**NEW ENGLAND PATRIOTS**
—
**2005**
**PITTSBURGH STEELERS**
—
**2006**
**INDIANAPOLIS COLTS**
—
**2007**
**NEW YORK GIANTS**
—
**2008**
**PITTSBURGH STEELERS**
—
**2009**
**NEW ORLEANS SAINTS**

## Pick Six

**12**

Career offensive receptions—all for touchdowns—for linebacker Mike Vrabel. Two of Vrabel's catches came in Super Bowls XXXVIII and XXXIX for the Patriots, which means that only six legendary receivers (Jerry Rice, Cliff Branch, Antonio Freeman, Rob Gronkowski, John Stallworth, and Lynn Swann) have more Super Bowl TD catches.

**3.6M**

Dollars that Cardinals veteran safety Pat Tillman, who broke the Cardinals' record for tackles in 2000, turned down for a three-year contract. Instead, he chose to enlist in the U.S. Army following the attacks of September 11, 2001. Tillman, an Army Ranger, was killed in action in Afghanistan on April 22, 2004.

**26**

Consecutive home defeats for the Lions from Nov. 11, 2007, to Nov. 21, 2010, to break Detroit's own NFL record of 24, set from 2001 to 2003. At the heart of the new streak was the Lions' 16-game winless season in 2008, the first in NFL history.

**3**

Different "home" stadiums played in by the Saints during the 2005 season in the aftermath of Hurricane Katrina. The Saints played their eight home games at Giants Stadium, the Alamodome in San Antonio, and LSU's Tiger Stadium in Baton Rouge, winning just once. No other Saints team had won fewer than two home games in a season.

**76**

Times rookie quarterback David Carr of the expansion Houston Texans was sacked in 2002, still the most any NFL quarterback has been sacked in a season. Three years later Carr was sacked 68 times, the third most in a season. By contrast, Dan Marino was sacked a total of 73 times in his first six NFL seasons with the Dolphins.

**105,121**

Fans in attendance to watch the Giants spoil the opening of Cowboys Stadium in Arlington, Texas, on September 20, 2009. The largest crowd in NFL history saw New York beat the Cowboys on a late field goal. The previous record was 103,467 held by the 2005 Cardinals and 49ers.

# Innovations

**2000:** "Bert Emanuel Rule" allows controlled ball to touch ground on a catch.

**2000:** Multiplayer celebrations deemed unsportsmanlike conduct.

**2002:** League realigns from six to eight divisions.

**2008:** One D-player allowed to have radio contact with sidelines.

## HELLO

➤ Houston Texans become NFL's 32nd team (2002).

➤ Seahawks rejoin NFC after 25 years in AFC (2002).

➤ First regular-season game played outside the U.S. (Mexico, 2005).

➤ Roger Goodell becomes NFL's eighth commissioner (2006).

➤ "The Duke," by Wilson, returns as official ball after 36-year absence (2008).

## GOODBYE

➤ Bill Belichick resigns after one day as Jets coach; joins Patriots (2000).

➤ Paul Tagliabue retires after nearly seventeen years as commissioner (2006).

➤ Lamar Hunt, Chiefs owner and AFL founder, dies at age seventy-four (2006).

➤ Nick Saban leaves Dolphins to become Alabama head coach (2007).

➤ Miami Orange Bowl, home to five Super Bowls, is demolished (2008).

# What It Cost to Build the Stadiums

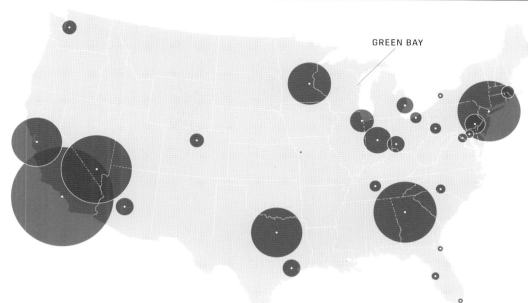

GREEN BAY

| YEAR | STADIUM | CITY | TEAM(S) | COST |
|------|---------|------|---------|------|
| 1957 | Lambeau Field | Green Bay | Packers | $960,000 |
| 1972 | Arrowhead Stadium | Kansas City | Chiefs | $43,000,000 |
| 1973 | Mercedes-Benz Superdome | New Orleans | Saints | $22,000,000 |
| 1975 | New Era Field | Orchard Park | Bills | $134,000,000 |
| 1987 | Hard Rock Stadium | Miami | Dolphins | $115,000,000 |
| 1996 | EverBank Field | Jacksonville | Jaguars | $134,000,000 |
| 1996 | Bank of America Stadium | Charlotte | Panthers | $242,000,000 |
| 1997 | FedEx Field | Landover | Redskins | $250,000,000 |
| 1998 | Raymond James Stadium | Tampa | Buccaneers | $194,000,000 |
| 1998 | M&T Bank Stadium | Baltimore | Ravens | $220,000,000 |
| 1999 | FirstEnergy Stadium | Cleveland | Browns | $290,000,000 |
| 2000 | Nissan Stadium | Nashville | Titans | $290,000,000 |
| 2000 | Paul Brown Stadium | Cincinnati | Bengals | $450,000,000 |
| 2001 | Heinz Field | Pittsburgh | Steelers | $281,000,000 |
| 2001 | Stadium at Mile High | Denver | Broncos | $364,000,000 |
| 2002 | Gillette Stadium | Foxborough | Patriots | $325,000,000 |
| 2002 | CenturyLink Field | Seattle | Seahawks | $360,000,000 |
| 2002 | Ford Field | Detroit | Lions | $430,000,000 |
| 2002 | NRG Stadium | Houston | Texans | $449,000,000 |
| 2003 | Lincoln Financial Field | Philadelphia | Eagles | $518,000,000 |
| 2003 | Soldier Field | Chicago | Bears | $600,000,000 |
| 2006 | State Farm Stadium | Glendale | Cardinals | $455,000,000 |
| 2008 | LucasOil Stadium | Indianapolis | Colts | $720,000,000 |
| 2009 | AT&T Stadium | Arlington | Cowboys | $1,300,000,000 |
| 2010 | MetLife Stadium | East Rutherford | Giants & Jets | $1,600,000,000 |
| 2014 | Levi's Stadium | Santa Clara | 49ers | $1,300,000,000 |
| 2016 | US Bank Stadium | Minneapolis | Vikings | $1,100,000,000 |
| 2017 | Mercedes-Benz Stadium | Atlanta | Falcons | $1,600,000,000 |
| 2020 | Raiders Stadium | Las Vegas | Raiders | $1,800,000,000 |
| 2020 | L.A. Stadium at Hollywood Park | Inglewood | Rams & Chargers | $2,600,000,000 |

# RANDY MOSS

By **Ian Crouch,** FROM *NEWYORKER.COM*, AUGUST 3, 2011

**In the middle of a week of frantic** postlockout personnel moves around the NFL, Randy Moss, one of the greatest wide receivers of all time, announced his retirement. He had played 13 seasons in the league. He made the announcement quietly, speaking through his agent, even though he spent most of his career as one of the game's most outsized, vocal characters. His specific mix of gifts and flaws makes fans and writers uncomfortable, and so we've tried to iron out his eccentricities and cast him, instead, in more familiar terms. Here are a few characters from which to choose:

**THE FREAK:** Randy Moss was taller, faster and smarter than nearly every defensive back in the NFL, making him nearly unguardable, and had a combination of strengths both natural and earned that merited him the nickname he chose for himself, The Freak. Moss caught 153 touchdown passes, tying him for second all-time among receivers.

**THE LOAFER:** Moss, at times, gave the impression of carelessness on the field—languidly running routes on plays where his number wasn't called—and petulance off of it. This week's retrospectives have pegged him as one of the most gifted players ever—a compliment that doubles as criticism, since it suggests that Moss was a great player but could have been even better.

**THE PERSONALITY:** We are still in the era of the "personality" wide receiver in football: the boastful and fragile Terrell Owens, the gonzo social-media self-promoter Chad Ochocinco and Moss, who always provided entertaining press conferences and had the distinction of sporting an especially fine beard and perhaps the greatest hairstyle ever worn by a football player. His smile was electric and infectious. He was a brand, not marketable to middle-America, and perhaps not suitable to being monetized in any real way, but distinct and entertaining and, in the end, completely necessary.

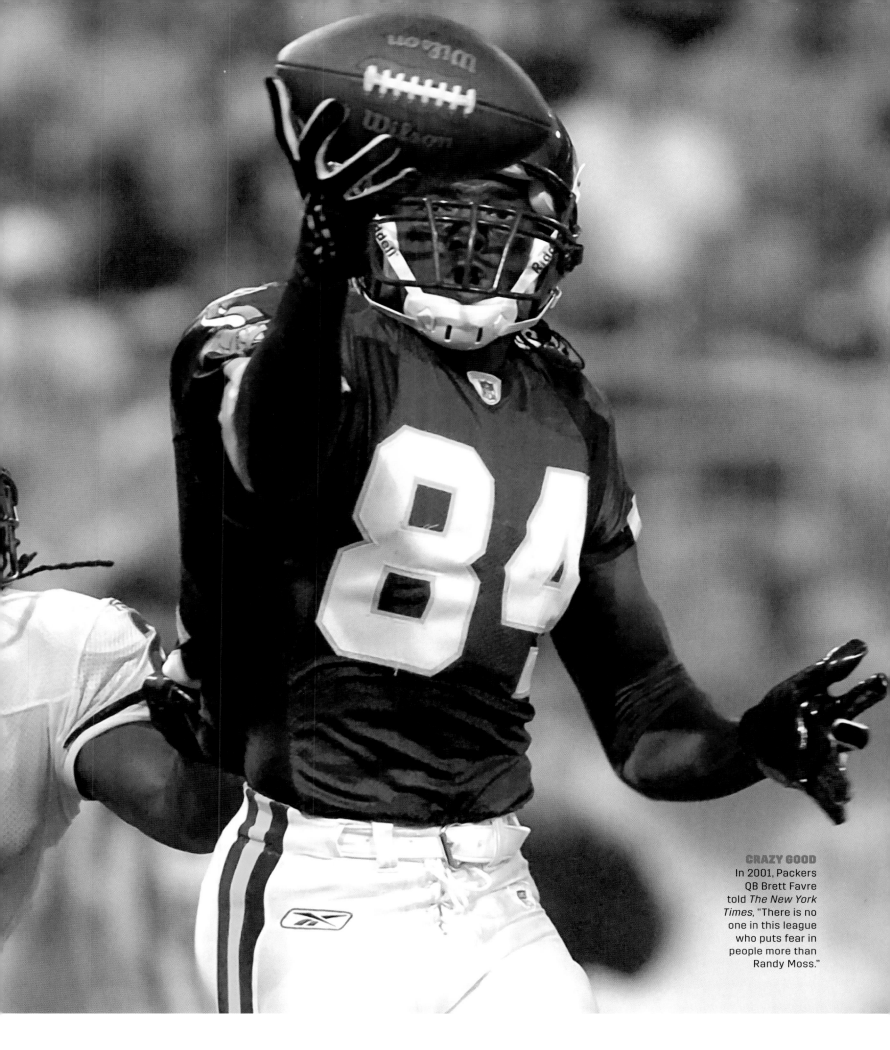

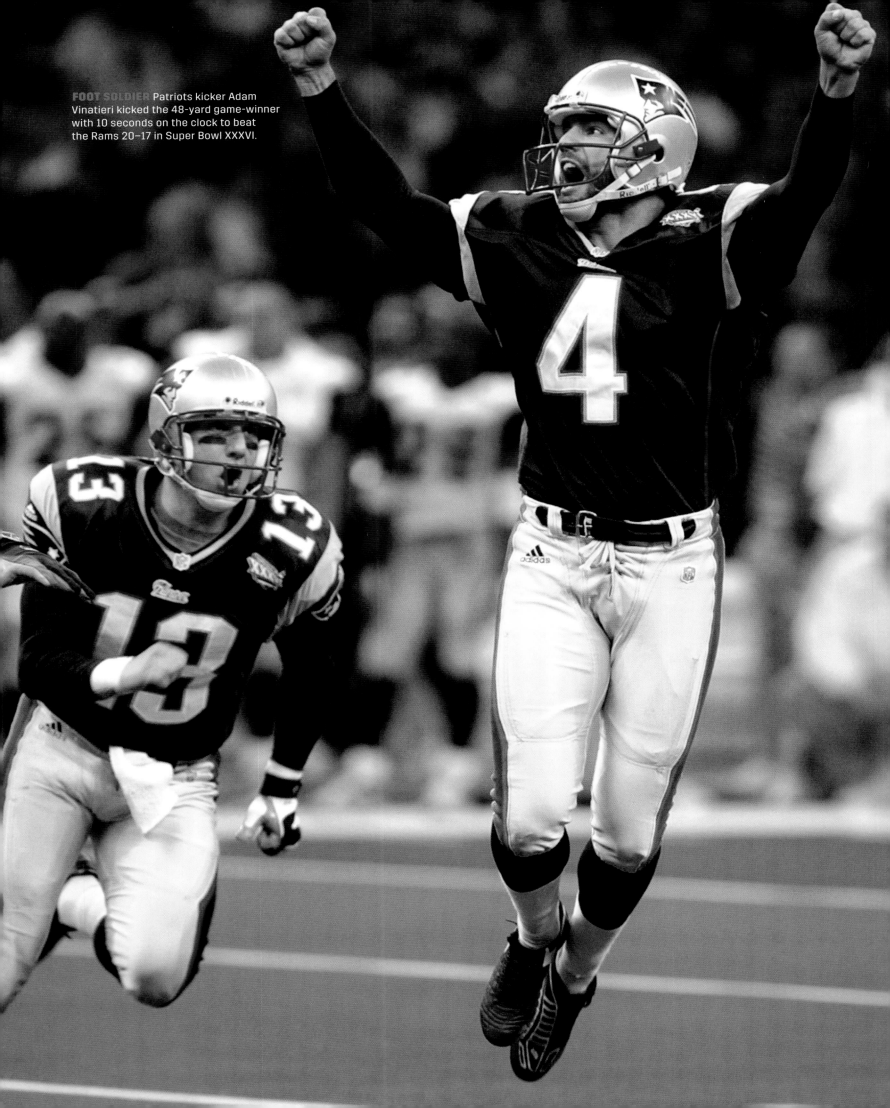

**FOOT SOLDIER** Patriots kicker Adam Vinatieri kicked the 48-yard game-winner with 10 seconds on the clock to beat the Rams 20–17 in Super Bowl XXXVI.

# PAT ANSWER

➤ **By Michael Silver**

FROM *SPORTS ILLUSTRATED*
FEBRUARY 11, 2002

**Take a knee, Bill Belichick thought.** Play it safe, kill the clock and don't put your young quarterback in a position to blow the Super Bowl. This was one option that Belichick, the cerebral coach of the New England Patriots, considered on Sunday night as the Louisiana Superdome shook with energy and the roof seemed ready to cave in on his team.

Then, with 81 seconds left and the Patriots locked in a 17–17 tie with the resurgent St. Louis Rams, Belichick's head deferred to his heart. Although his tired team had squandered a 14-point, fourth-quarter lead, Belichick decided that kneeling was for wimps. Instead, his underdog Patriots and their undaunted 24-year-old quarterback, Tom Brady, would deliver one of the most thrilling finishes the sport has known.

What Brady did as those seconds ticked off sent chills through the spines of fans from Cape Cod to Kandahar. Aside from a pair of clock-killing spikes, he completed 5 of 6 passes for 53 yards to set up Adam Vinatieri's 48-yard field goal, which sailed through the uprights for a 20–17 victory as time expired. Brady, whose statistics had been unimpressive until that final drive, was voted the MVP of what will go down as one of the greatest Super Bowls.

**BRADY BUNCH** Patriots QB Tom Brady outgunned the Rams' Greatest Show on Turf to win his first Super Bowl, and the first for his franchise.

**BRIAN'S SONG** Urlacher played his entire thirteen-year career for the Bears and went to eight Pro Bowls.

# BRIAN URLACHER

► **By David Haugh**

FROM THE *CHICAGO TRIBUNE*, 2018

**To understand the drive that made** Brian Urlacher elite, go back to 2004 when the *Sporting News* named the Bears middle linebacker the NFL's most overrated player after he had made the Pro Bowl his first four seasons.

"That pissed me off, and the next year what happened? I was NFL defensive player of the year," Urlacher recalled recently. "I think I was vindicated."

Lifetime validation came Saturday for the Bears' best player since Walter Payton when the game bestowed its highest honor on Urlacher, electing

him to the Pro Football Hall of Fame.

In 13 seasons for the Bears, from 2000 to 2012, Urlacher transformed the position by chasing down running backs with blazing speed rare for a 6' 4", 258-pound linebacker. In coach Lovie Smith's Cover Two defense, the Bears routinely counted on Urlacher's athleticism to clog running plays at the line of scrimmage and cover passes in the deep middle. Urlacher becomes the 28th Hall of Famer to enter as a Bear—more than any other NFL team—and upholds the franchise's middle-linebacker tradition he took seriously.

# Terrell Owens

► **By Karl Taro Greenfeld,** FROM *SPORTS ILLUSTRATED*, JULY 24, 2006

TERRELL OWENS SMILES, AND YOU EXPECT A mischievous upturn of the lips, but instead he flashes a broad grin full of bright white teeth and uncomplicated joy. You anticipate villainy—years of bad press have had their effect—but what Owens shows right now is only satisfaction at joining the Cowboys and giddiness at the prospect of imminent revenge. . . .

Terrell Owens might be the most universally reviled supremely talented athlete of his era (at least Barry Bonds is beloved in San Francisco), having assumed that mantle at some point during his four-month broken-field run through the sports news cycle last summer and fall. The controversial touchdown celebrations for which he became famous now seem quaint after his immolation of the Philadelphia Eagles' 2005 season. . . .

It was almost enough to make you forget what Owens had accomplished on the field, so let's review: If T.O. had left [Philadelphia] after his suspension by the Eagles in early November and never played again, you could easily make the case that he still belonged in the Hall of Fame: In 10 seasons he had 716 catches, more than 10,000 yards receiving and 101 touchdowns, fourth most in NFL history. Owens holds the single-game reception record (20, San Francisco versus Chicago, Dec. 17, 2000), was named to five straight Pro Bowls from 2000 to '04, turned in five straight 1,000-yard seasons and delivered riveting moments in big games. . . . (And as any aficionado of *Madden NFL* will tell you, there has never been a better third-and-seven receiver in the history of computer games.)

**DEEP THREAT** One of Owens's league-leading 13 TD catches in 2002 came on this 76-yard strike against the Chargers.

# XXL

► **By Linda Robertson,** FROM *THE MIAMI HERALD*, 2006

**GO BIG OR GO HOME**
McDougle, a first-round
pick by the Lions in the
1999 draft, was listed
at 335 pounds during
his seven NFL seasons.

**Stockar McDougle, son of a chef, is** the largest Miami Dolphin at 6' 4", 348 pounds. He wears size-16 cleats, size-46 pants, a size-62 jacket and a size-15 ring. He is a mountain of a man, but a mountain who can run the 40-yard dash in 5.2 seconds and bench-press 450 pounds.

McDougle's teammate, Wade Smith, majored in eating as a college senior, adding 25 pounds to impress NFL scouts. He has packed on almost 100 pounds in seven years to remake himself as a football player. He longs for the day when his wife can see him slim down from 315 to 220 because that is "the real me."

University of Miami tackle Eric Winston insists he won't bulk up as Smith did. He hopes his reputation as a master of the "pancake block" and his 312 pounds will be enough to make it in the NFL.

Teenager Kevin Perez, 275 pounds and growing, dreams of becoming a pro. Like Perez, Pace High's Javon Hill—6' 4", 330 pounds—makes his classmates look Lilliputian.

Add up these five offensive linemen and you get three-quarters of a ton of massive muscle. They are part of a trend that shows no signs of tapering. It's the boom of the bulge in football. Players have grown bigger at every position at every level, especially in the past 10 years along the line of scrimmage.

The 2005 opening day rosters of the NFL included an unprecedented 332 players who weighed 300 pounds or more. Thirty years ago there were none.

"When I played, a 300-pounder was a freak," said UM associate head coach Art Kehoe, 48, and a former Hurricanes offensive lineman. "Today, if you don't weigh 300 pounds you are a freak."

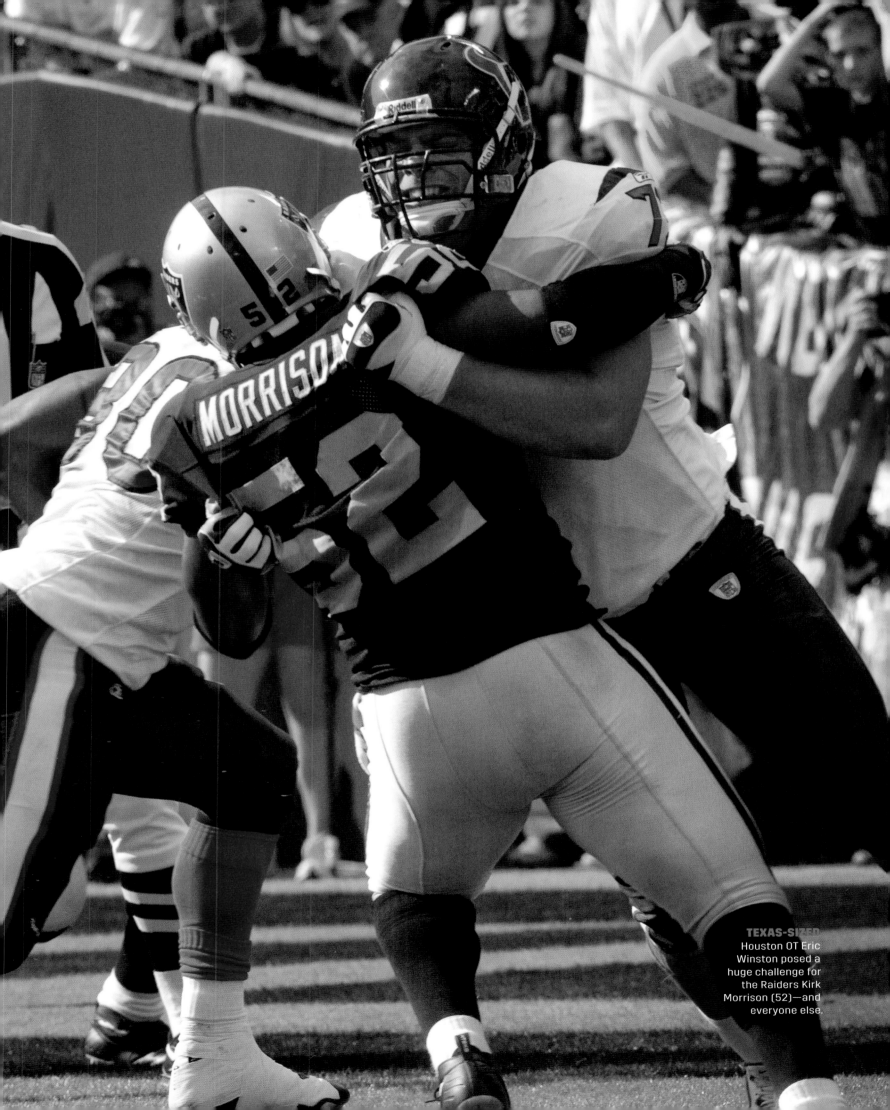

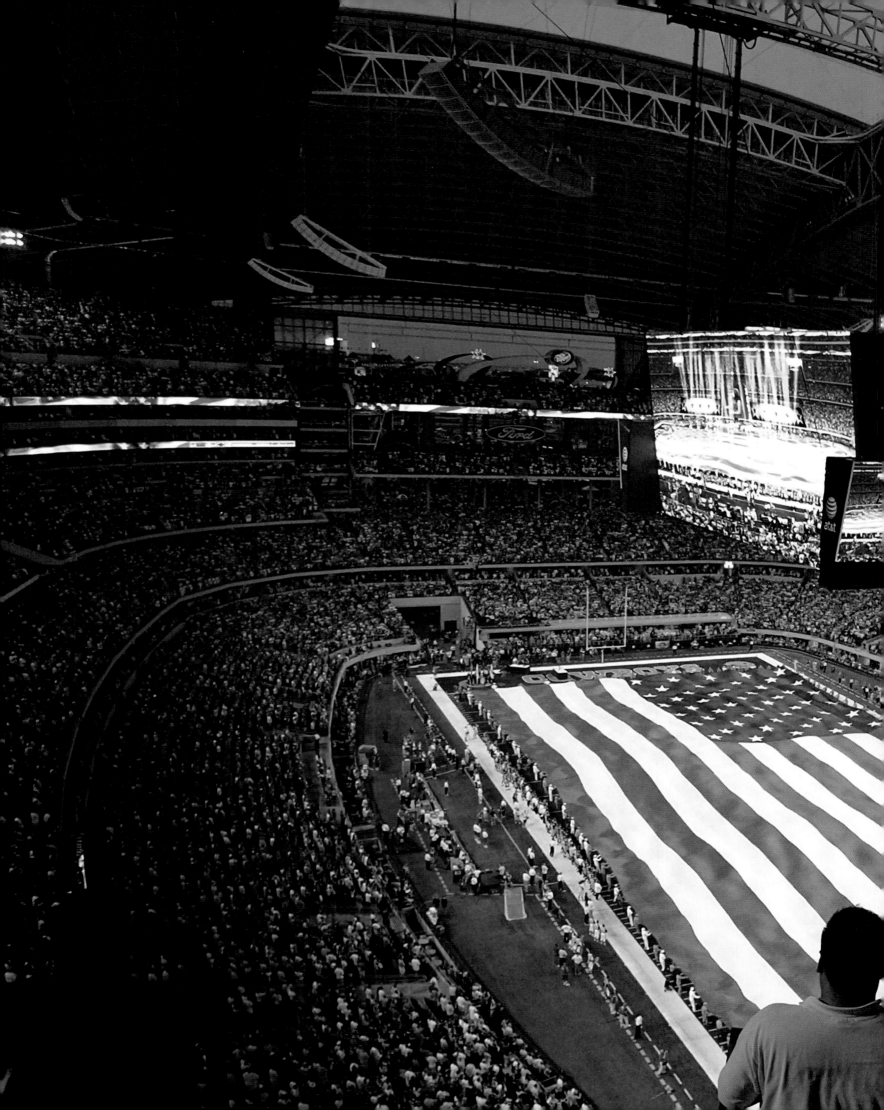

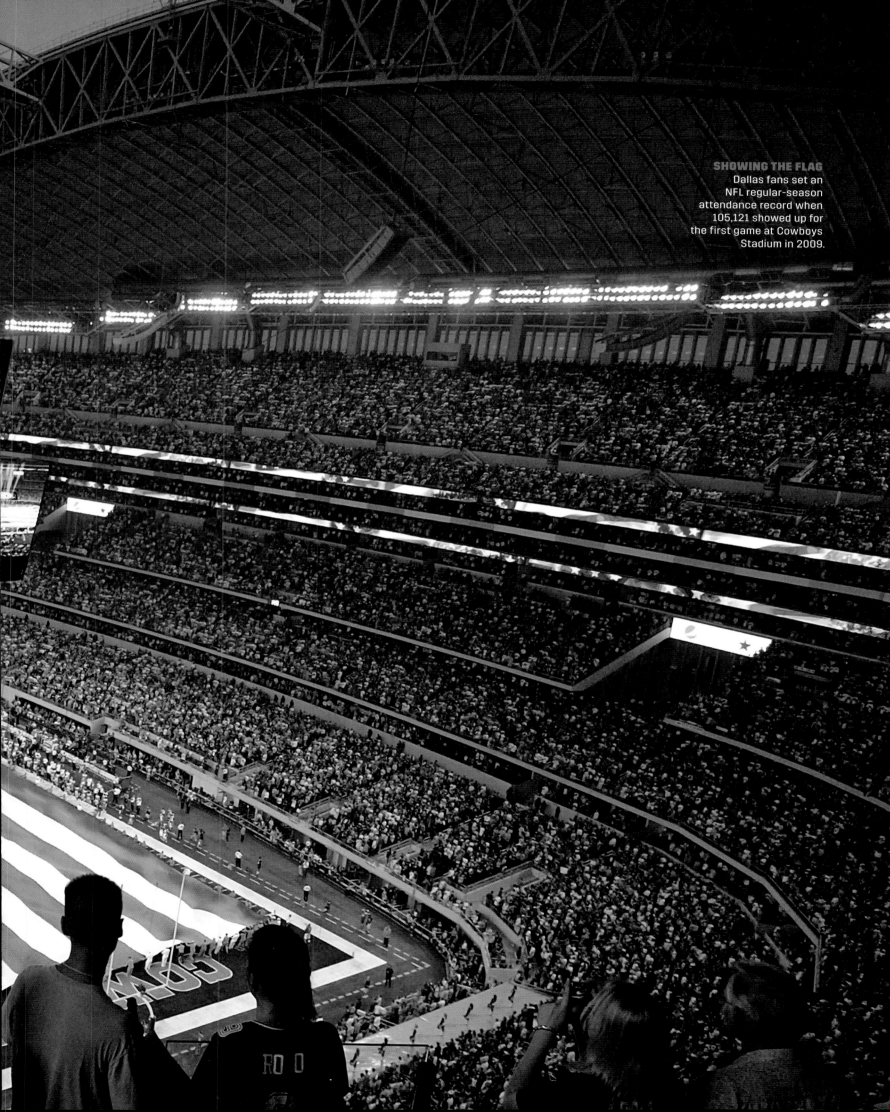

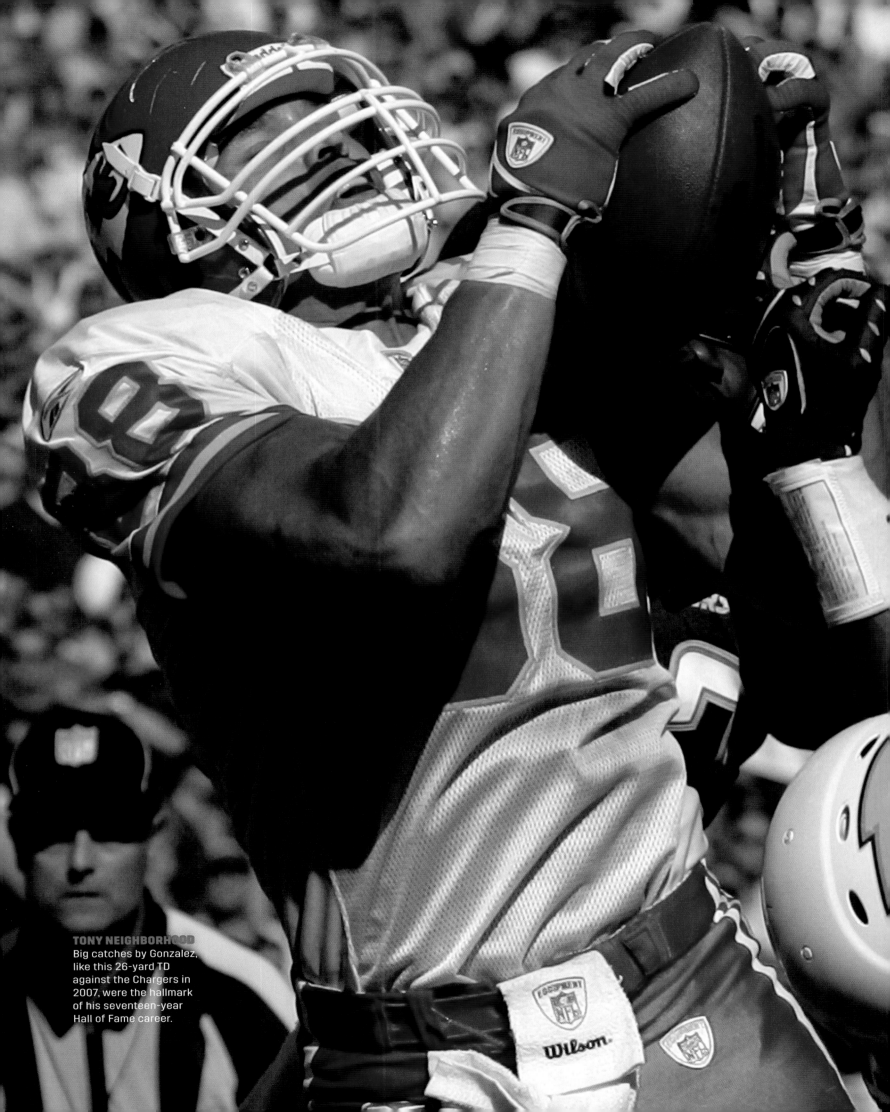

**TONY NEIGHBORHOOD**
Big catches by Gonzalez, like this 26-yard TD against the Chargers in 2007, were the hallmark of his seventeen-year Hall of Fame career.

# Tony Gonzalez

➤ **By Seth Wickersham**
FROM *ESPN THE MAGAZINE*, FEBRUARY 17, 2014

GONZALEZ'S ROUTINE HAS BEEN REFINED OVER the years and is legendary in both the Chiefs' and Falcons' buildings for its unyielding neuroticism and unparalleled results. . . . He begins every morning at exactly 7:23. He eats the same breakfast of oatmeal and a protein shake. Before every practice and every game, he runs in a five-by-five-yard square, to perfect breaking out of routes. Then he catches 500 passes a week out of these breaks, asking them to be thrown inaccurately to best replicate a game. "It becomes a trained reflex," Gonzalez says. "That way, you never have to think."

He learned much of his routine from Jerry Rice, who early in his career worried he'd be a bust too. Now they are the two top pass catchers in NFL history. To Gonzalez, it's simple: The difference between very good and future Hall of Famer is knowing how to work.

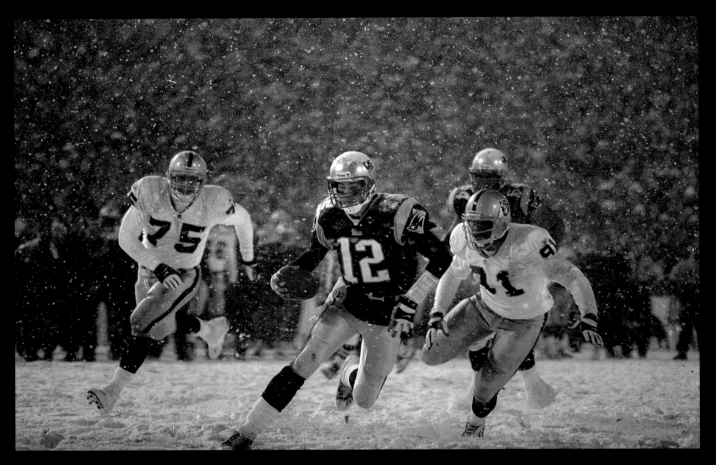

**TUCK RULE** Brady plowed his way in for a score against the Raiders in their 2001 playoff game.

# TOM BRADY

► **By David Halberstam,** FROM *THE EDUCATION OF A COACH*, 2005

On the second day of the draft, when they did the fourth, fifth and sixth rounds, [Tom Brady's] name was still on the board, and though they were already carrying three quarterbacks, including Drew Bledsoe, the team's star, they decided Brady simply represented too much value to pass up. Still, there was no sign of the greatness to come, or that a little more than a year later serious football people would be comparing him to Joe Montana.

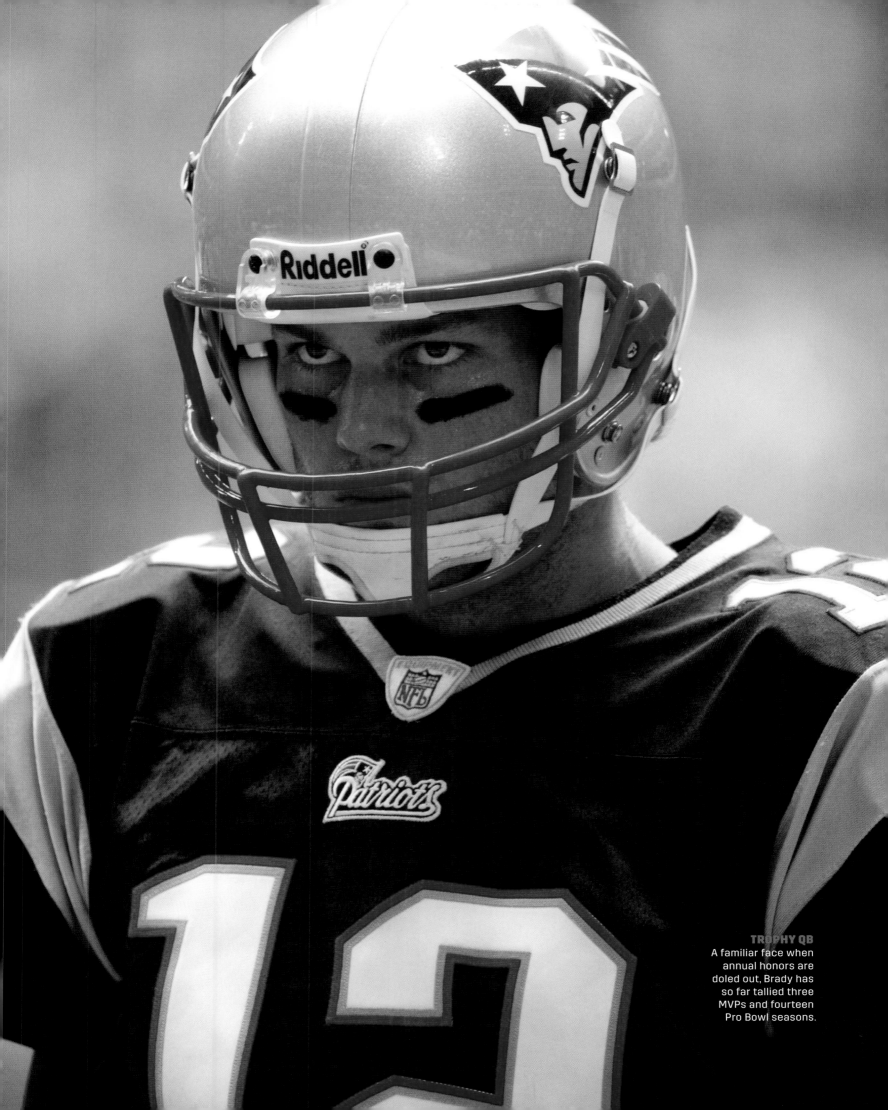

**SAVING PACE** The Rams' pass-happy offense was predicated on the stellar pass protection by Orlando Pace (76).

# The Left Tackle

► **By Michael Lewis,** FROM *THE BLIND SIDE: EVOLUTION OF A GAME*, 2016

THE IDEAL LEFT TACKLE WAS BIG, BUT A LOT OF people were big. What set him apart were his more subtle specifications. He was wide in the ass and massive in the thighs: The girth of his lower body lessened the likelihood that Lawrence Taylor, or his successors, would run right over him. He had long arms: Pass rushers tried to get in tight to the blocker's body, then spin off of it, and long arms helped to keep them at bay. He had giant hands, so that when he grabbed ahold of you, it meant something.

The left tackle position, as it had been reconceived by the modern pass-oriented offense, presented a new psychological challenge for the offensive lineman. In the old days, no one could really see what you were doing, and you usually had help from the lineman on the other side of you. That was still true at the other line positions. A mistake at guard cost a running back a few yards; a mistake at left tackle usually cost a sack, occasionally cost the team the ball, and sometimes cost the team the quarterback.

And—here was the main thing—you only needed to make one mistake at left tackle to have a bad game. The left tackle was defined by his weakest moment. He wasn't measured by the body of his work but by the outliers.

# WALTER JONES

**By Danny Kelly**
FROM *SBNATION.COM*
JULY 30, 2014

**Walter Jones is the prime football** example of a walking contradiction. A quiet, soft-spoken and humble man that just so happens to be probably the greatest left tackle to ever play the game. A guy that seemed to make it a yearly tradition of holding out of training camp because he hated it but was a consummate worker and pro that pushed Escalades (literally) as part of his training regimen during the offseason.

Makes pushing defenders 20 yards downfield seem easy.

Jones was a 320-pound behemoth with feet as quick as a wide receiver's and the balance of a ballerina. He was that guy that sprung for a 13,000-square-foot home complete with a regulation size football field in the backyard but refused to let MTV's *Cribs* come publicize its glory. "I just don't see the reason," he said.

I guess he just doesn't need to show off. Funny, coming from the guy that completely demoralized almost everyone he lined up against during his 180 career games, making him one of the easiest choices as a first-ballot Hall of Famer in recent history.

**VALET PARKING** Jones came up with his unique training regimen in high school: "We didn't have a lot of weight equipment, so I would push trucks around. . . . Once you get it going, it was almost like you were pushing a sled."

**BEAR-HEADED**
Chicago Bears defensive tackle Darwin Walker kept his head but lost his helmet during a goal-line stand against the Giants in a 2007 regular-season game. The Giants finished 10–6 and scored a major upset in the Super Bowl.

# PEYTON MANNING

▶ **By Lee Jenkins,** FROM *SPORTS ILLUSTRATED*, DECEMBER 23, 2013

WHEN MANNING WAS A ROOKIE, THE COLTS INSTALLED a no-huddle package called Lightning, which they deployed when they trailed. One day, around 2000, Moore asked Manning, "Why are we waiting to be down 10–0? Why don't we start in Lightning?" That question changed football. At first, Moore would call two plays from the sideline and let Manning pick one. Then Moore gave Manning four plays and let him switch from runs to passes. Finally he let him call entire games. "It's always been a cerebral position, but Peyton made it more cerebral," says former Broncos quarterback and current executive vice president John Elway. "He was the first one to get in the hurry-up, figure out the coverage at the line, find the right play against the coverage and call everything himself. He really started the no-huddle. Now everybody does it." From Pop Warner on, quarterbacks are asked to think faster because Manning showed what was possible. "He set the standard," says the Patriots' Tom Brady.

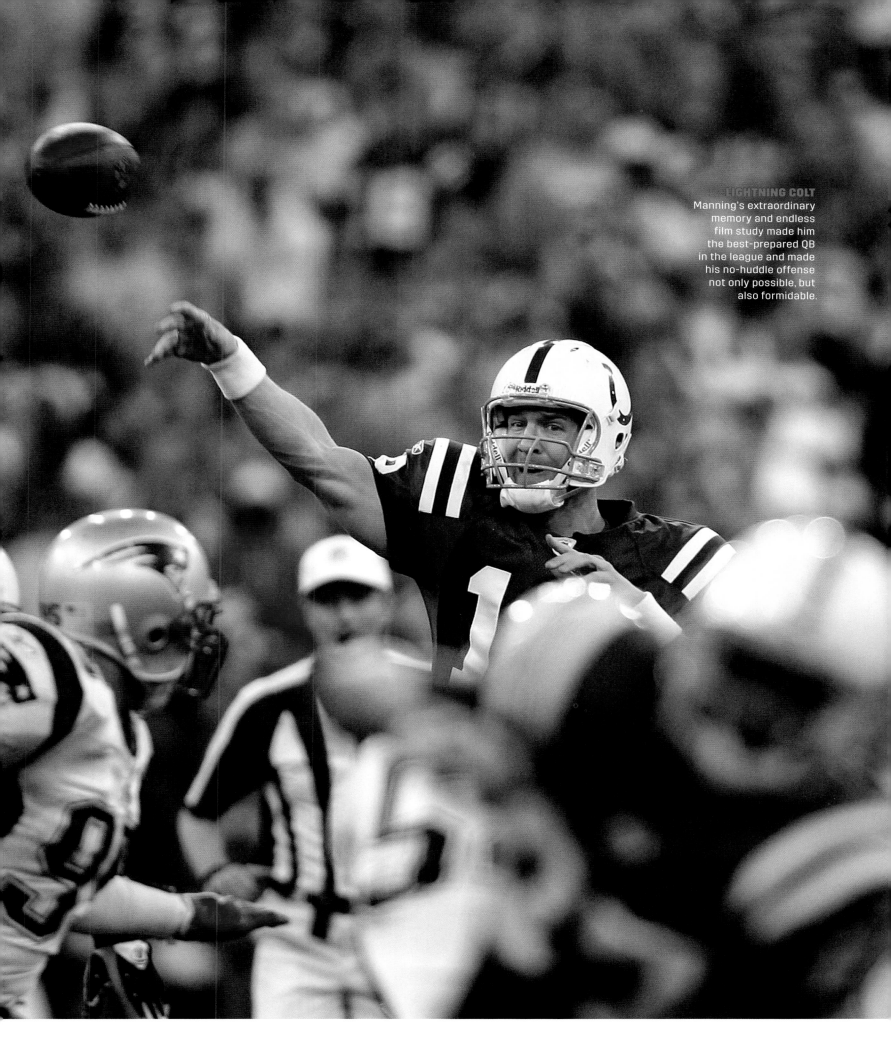

# DERRICK BROOKS

► **By Spencer Hall**

FROM *SBNATION*, AUGUST 2, 2014

**It is so hard to make playing linebacker** look like a skill position. It is a job that when done really, really well by the most talented people on the field resembles either a) a rodeo contestant successfully completing a calf-roping, or b) a runaway forklift tearing through a terrified warehouse full of workers. Linebackers traffic in blunt force and obstruction, and while that's a skill, it's not the kind you would ever confuse with the gossamer frames of wide receivers catching passes on their fingertips, or a quarterback gently floating a fade in over a cornerback's hands. It is a position with skills, but not what you could call a skill position.

Derrick Brooks, though: Derrick Brooks made linebacking look like a skill position. Part of it came from playing weakside linebacker, where he often had to cover receivers and play in space against people who should have been faster than he was. Brooks shattered that theory and was faster in space than many of his opponents were. Cutbacks by running backs were swallowed whole, and passing lanes choked off before they ever got a chance to open. Brooks was not a prototypical weakside linebacker. He was instead a redefinition.

**PIRATE BOOTY** Brooks never missed a game over fourteen seasons with the Buccaneers and was a key to one of the decade's best defenses.

**ARMED AND DANGEROUS** Kurt Warner led the explosive aerial attack that came to be known as the Greatest Show on Turf.

# Pass First

► **By Neil Paine,** FROM *FIVETHIRTYEIGHT.COM*, SEPT. 23, 2014

FIFTEEN YEARS AGO, MIKE MARTZ HAD A RADICAL notion: "Why does the run have to set up the pass?"

That, according to *Sports Illustrated*'s Peter King, was the question the new St. Louis Rams offensive coordinator posed to his head coach, Dick Vermeil, as they prepared for the coming NFL season in June 1999. It was to be Vermeil's third in St. Louis, and judging from the press clippings, probably his last if things didn't change in a hurry. Over the previous two seasons, Vermeil had coached the Rams to 23 losses and only nine wins, with an offense that ranked 23rd out of 30 NFL teams in passing efficiency and 26th in scoring.

Then came Martz. "I don't know of any assistant coach that came in, at any one time, in any one program, and made as big a contribution as Mike did at that time," Vermeil said in a recent interview. In his estimation, Martz's contribution to the Rams

was equivalent to that of a first-round pick—and that's not a hard case to make. Upon Martz's arrival, the Rams went from laughingstocks to Super Bowl champs with an explosive attack that came to be known as the Greatest Show on Turf.

It was, at the time, the third-most-potent scoring offense and the second-most-efficient passing attack the league had seen in its modern incarnation. And of even more historical significance, the Rams did it before the league became fixated on throwing the ball.

While the longtime mantra of football coaches everywhere had been to "establish the run" before passing, Martz's plan was to aggressively pass the ball until the Rams had a lead worth protecting with the run. Stocked with speed everywhere and willing to throw in any situation, the Greatest Show on Turf proved that pass-first teams could win championships, and it heralded the passing fireworks we see in the NFL today.

# MARVIN HARRISON

**By Zak Keefer**

FROM *INDYSTAR.COM*, FEB. 5, 2016

**He hid in plain sight for 13 years, cloaked** behind a carefully constructed firewall of privacy, an enigma to coaches, teammates and the NFL circus around him. Marvin Harrison worked and then he went home. "Never heard him coming, never heard him going," says former coach Tony Dungy.

He left his gloves on the sideline during practice. Why? Because gloves made catching the football easy. He told coaches he wanted a starting cornerback across from him during training camp. Why? Because he had no use for backups or practice-squad players. Marvin Harrison was trying to get better, dammit. Late in his career, when his position coach begged him to trim his snaps on Fridays—common practice for a veteran— Harrison shook his head. No way.

Of course, it didn't take long for the Indianapolis Colts' inscrutable wide receiver to develop an almost telepathic rapport with his young quarterback. They forged a language based on glances, nods and gestures. They refined it through years of preparation. In practices they'd blitz though their route tree without ever saying a word. Hours, weeks, even months would pass without the football ever touching the ground.

That was Harrison's secret all along. Practice. Nothing more. He poured himself into the work, day after day, year after year, and that young quarterback—a player who'd soon become known for his own level of manic preparation—could certainly respect that. Off the field, the star QB and the spotlight-shunning receiver could not be more dissimilar; on it, it was as if they shared a brain. Each matched boundless talent with bottomless work ethic.

In Marvin Harrison, Peyton Manning found his football equal.

**THAT'S DEBATABLE** Some say D-linemen are prone to bending rules, like this (uncalled and perhaps unintentional) infraction by San Diego's Igor Olshansky on K.C.'s Priest Holmes in '05.

"Players become their positions. It's like what somebody said about the President—the office makes the man. Hell, these guys have been programmed for half their lives. You take offensive linemen—they have to learn plays and assignments— they're rules obeyers. Defensive linemen are rules breakers. Look out there in the parking lot, in the no-parking zone. I'll bet, I know, that four out of five cars there belong to defensive players."

—

RICHARD NEAL, N.Y. JETS

➤ FROM *JOE NAMATH AND THE OTHER GUYS*, 1976, **by Rick Telander**

# Jonathan Ogden

➤ **By Gene Wang,**
FROM *THE WASHINGTON POST*
FEBRUARY 1, 2013

**Long before Jonathan Ogden retired** as perhaps the most skilled left tackle in the history of professional football, he was simply "Oggie." That's what friends, teammates and coaches affectionately called him when he played at St. Albans School in the District.

More than 20 years later, the Baltimore Ravens' 11-time Pro Bowl selection and six-time All-Pro is one of 15 finalists for induction into the Pro Football Hall of Fame. The 6' 9", 340-pound starter on Baltimore's Super Bowl XXXV championship team is by all accounts a virtual certainty to join this year's class in Canton, which is set to be unveiled Saturday afternoon roughly 24 hours before the Ravens

play the 49ers in Super Bowl XLVII.

When Ogden was at UCLA, he somewhat reluctantly moved from right to left tackle. The adjustment was so smooth that he allowed two sacks over 23 games as a junior and senior, won the Outland Trophy as the country's best offensive lineman and became one of seven Bruins whose numbers were retired by the school.

The Ravens made Ogden the first pick in franchise history in 1996 at No. 4 overall and constructed much of the offense around him. In 2003, he helped Jamal Lewis rush for 2,066 yards and went on to be voted to the 2000 all-decade team. Four months after he announced his retirement in 2008, the Ravens inducted Ogden into their Ring of Honor.

**TOWER OF POWER** The Ravens' offensive line was built around Ogden, a Pro Bowler eleven times in his twelve-year Hall of Fame career.

2 0

# 1 0 s

**SOMETHING IN THE AIR**
Carolina Panthers DT Greg
Hardy takes the high road
to pressure New Orleans
QB Drew Brees in a 2013
game in Charlotte.

251

**O**VER THE FIRST CENTURY OF THE National Football League, the eternal battle between offense and defense veered back and forth across the gridiron, adhering throughout to Newton's Third Law of Physics, which states that every action will prompt an equal and opposite reaction. The constant one-upmanship of innovation and tactics has been biased in favor of the offense in the modern game, yet each time observers were prepared to declare victory in the Hundred-Year,

Hundred-Yard War, the defense has reasserted itself.

And so it was in the 2010s, when so many factors—more use of spread formations and four-wideout sets, an increased penchant for no-huddle attacks, option routes, and run-pass options—seemed to tip the scales overwhelmingly in favor of the offense.

In the face of all this, the NFL's best defenses repeatedly responded with more size, more speed, and more ingenuity. In 2013, when Peyton Manning became the first quarterback to throw for 5,000 yards and 50 touchdowns in the same season, he and the Broncos seemed an unstoppable force. But in the Super Bowl, they ran into the "long corners" of Seattle's Legion of Boom and were soundly thrashed 43–8.

Two years later, when Cam Newton and the Panthers seemed set to redefine the offensive possibilities of a pro attack directed by a big, mobile quarterback, they were stymied in the Super Bowl by Von Miller and the Broncos' gang of rushers, sending Peyton Manning into retirement with his second Super Bowl ring.

The one constant in the decade was the Patriots—the team of the '10s just as surely as they were the team of the '00s—and their five Super Bowl appearances. New England won two more Super Bowls on cliffhanger finishes—Malcolm Butler's end zone interception of Russell Wilson that preserved New England's 28–24 win over Seattle in Super Bowl XLIX, and the epic comeback from a 28–3 second-half deficit to beat the Falcons 34–28 in overtime, in Super Bowl LI.

But a year later, a resourceful, gutsy series of calls from the Philadelphia Eagles—including, on fourth-and-goal, the superbly executed Philly Special, with quarterback Nick Foles on the receiving end of Trey Burton's touchdown throw—gave the Eagles a 41–33 Super Bowl upset over the Patriots.

Offenses kept rolling in 2018, as teams averaged an all-time high of 5.6 yards

**PHILLY SPECIAL**
In addition to scoring with this catch, QB Nick Foles threw for 373 yards and three TDs as the Eagles upset the Patriots in Super Bowl LII.

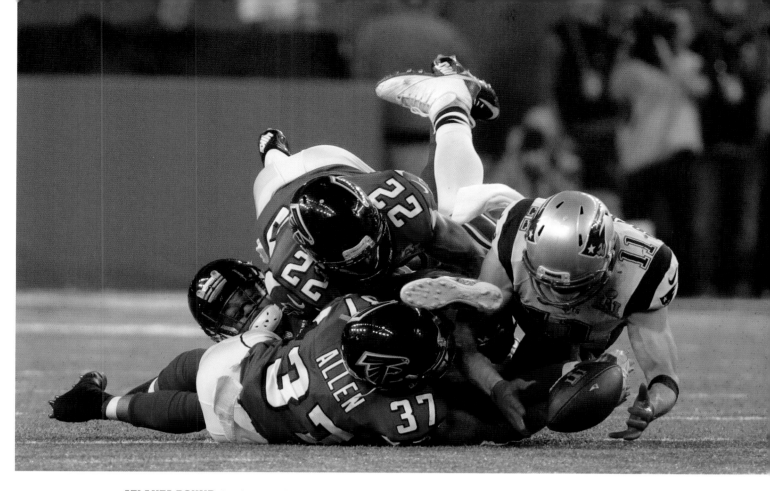

per play. In New Orleans, Drew Brees had an astoundingly accurate season, completing 74.4% of his passes and breaking Peyton Manning's all-time passing yardage record. Meanwhile, in Kansas City, under the keen eye of offensive mastermind Andy Reid, first-year starter Patrick Mahomes won the MVP award, becoming only the second quarterback to reach the 5,000-yard, 50-touchdown milestones in the same season.

On a Monday night in November of the NFL's 99th season, the Los Angeles Rams played the Kansas City Chiefs in the Los Angeles Coliseum, the very stadium where Red Grange had run in front of 75,000 for the Chicago Bears in 1926. Ninety-two years after Grange, the Rams and Chiefs staged a 54–51 thriller, an instant classic that many described as a pure glimpse into pro football's fast-break future.

But by the end of that same season, the rest of the pro football world was reminded again that Bill Belichick remained not just one of the great defensive minds in football history but also one of the most supremely resourceful coaching strategists. In the 2018 playoffs, the Patriots emphasized the importance of the eternal verities—a solid, punishing ground game that could control the ball and the clock; an aggressive, sound defense that forced more mistakes than it made—on the way to their sixth Lombardi Trophy and third in five years. Just a year after Philadelphia and New England played the second-highest-scoring Super Bowl ever, the Patriots and Rams played the lowest-scoring one, with Belichick and Tom Brady winning their sixth Lombardi Trophy together.

From one generation to the next—Brady and Brees to Mahomes and Baker Mayfield—the game of football continued to be a compelling spectacle. And in a land increasingly divided by narrowcasting and niche marketing, the National Football League reached its centennial as the nation's biggest civic tent, perhaps our last genuinely mass entertainment. —**Michael MacCambridge**

**In Super Bowl LIII, the world was reminded again that Bill Belichick remained not just one of the great defensive minds but also one of the most supremely resourceful strategists in football history.**

# Leaders

## Pick Six

**PASSING YARDS**

| | | | |
|---|---|---|---|
| 2010 | Philip Rivers | Chargers | 4,710 |
| 2011 | Drew Brees | Saints | 5,476 |
| 2012 | Drew Brees | Saints | 5,177 |
| 2013 | Peyton Manning | Broncos | 5,477 |
| 2014 | Ben Roethlisberger | Steelers | 4,952 |
| | Drew Brees | Saints | 4,952 |
| 2015 | Drew Brees | Saints | 4,870 |
| 2016 | Drew Brees | Saints | 5,208 |
| 2017 | Tom Brady | Patriots | 4,577 |
| 2018 | Ben Roethlisberger | Steelers | 5,129 |

**RUSHING YARDS**

| | | | |
|---|---|---|---|
| 2010 | Arian Foster | Texans | 1,616 |
| 2011 | Maurice Jones-Drew | Jaguars | 1,606 |
| 2012 | Adrian Peterson | Vikings | 2,097 |
| 2013 | LeSean McCoy | Eagles | 1,607 |
| 2014 | DeMarco Murray | Cowboys | 1,845 |
| 2015 | Adrian Peterson | Vikings | 1,485 |
| 2016 | Ezekiel Elliott | Cowboys | 1,631 |
| 2017 | Kareem Hunt | Chiefs | 1,327 |
| 2018 | Ezekiel Elliott | Cowboys | 1,434 |

**RECEIVING YARDS**

| | | | |
|---|---|---|---|
| 2010 | Brandon Lloyd | Broncos | 1,448 |
| 2011 | Calvin Johnson | Lions | 1,681 |
| 2012 | Calvin Johnson | Lions | 1,964 |
| 2013 | Josh Gordon | Browns | 1,646 |
| 2014 | Antonio Brown | Steelers | 1,698 |
| 2015 | Julio Jones | Falcons | 1,871 |
| 2016 | T. Y. Hilton | Colts | 1,448 |
| 2017 | Antonio Brown | Steelers | 1,533 |
| 2018 | Julio Jones | Falcons | 1,677 |

## CHAMPIONS

2010
**GREEN BAY PACKERS**
—
2011
**NEW YORK GIANTS**
—
2012
**BALTIMORE RAVENS**
—
2013
**SEATTLE SEAHAWKS**
—
2014
**NEW ENGLAND PATRIOTS**
—
2015
**DENVER BRONCOS**
—
2016
**NEW ENGLAND PATRIOTS**
—
2017
**PHILADELPHIA EAGLES**
—
2018
**NEW ENGLAND PATRIOTS**

## Pick Six

# 108

Receptions in 2018 for Christian McCaffrey of the Panthers, the most in a season for any running back in NFL history. Nineteen years earlier, Christian's father, wide receiver Ed McCaffrey, caught 101 passes for the Broncos, which makes the McCaffreys the NFL's only 100-catch father-son duo.

# 13M

Instagram followers for Browns Pro Bowl receiver Odell Beckham Jr., more than twice as many as any other NFL athlete has. On Twitter it's Russell Wilson and J. J. Watt running neck-and-neck in popularity, with each pulling in just over 5.4 million followers.

# 67

Yards in the touchdown run dubbed Beast Quake by Seahawks running back Marshawn Lynch in the 2010 Wild Card game against the Saints. The tackle-breaking run provided the winning margin, making Seattle NFC West champion but just 7–9 in the regular season, the first sub-.500 team with a postseason victory.

# 13%

The increase in water consumption, according to the New York City Department of Environmental Protection, immediately after the Giants defeated the Patriots in Super Bowl XLVI. The mass flushing caused water levels in one Yonkers, N.Y., reservoir to drop by two inches.

# 127

Diamonds on the Eagles' Super Bowl LII rings, a nod to the sum of the uniform numbers of the players involved in the Philly Special. On that play Corey Clement (30) took the snap and reversed it to Trey Burton (88), who threw it into the end zone to Nick Foles (9), who had suggested the play.

# 3,300

The combined weight, in pounds, of the Kansas City Chiefs' 11 offensive players on a touchdown pass from Pro Bowl defensive tackle Dontari Poe to tight end Demetrius Harris against the Broncos on Christmas Day, 2016. At 346 pounds, Poe was the heaviest player to ever throw an NFL touchdown pass, by a staggering 81 pounds.

# Innovations | Next Gen Stats

**2014:** League provides all teams with tablets to view hi-res photos on the sideline.

**2016:** Chips embedded in players' pads allow for precise digital tracking.

**2017:** Overtime periods reduced from 15 minutes to 10 in regular season.

**2018:** Players are penalized for lowering their head to initiate a hit.

## HELLO

► Shad Khan buys Jaguars, becoming the NFL's first ethnic-minority owner (2011).

► Ray Guy becomes the first punter inducted into the Hall of Fame (2014).

► Dr. Jen Welter becomes the first female NFL coach during Cardinals preseason (2015).

► Los Angeles is back in the NFL when the Rams (2016) and Chargers (2017) return.

## GOODBYE

► Brett Favre's NFL-record 297 consecutive game streak ends (2010).

► Owners Ralph Wilson (Bills) and William Clay Ford (Lions) die in Grosse Pointe Shores, MIchigan, within sixteen days of each other (2014).

Recent technological advances have enabled teams and fans alike to learn more than ever about the action on the field. Data collected through this technology are translated into next generation, or Next Gen, stats, which show the spatial relationships among all the players on the field on any play. Now we know in the blink of an eye the distance each player travels, exactly how fast a player runs, how far thrown balls travel in the air, and how much space receivers create between themselves and defenders.

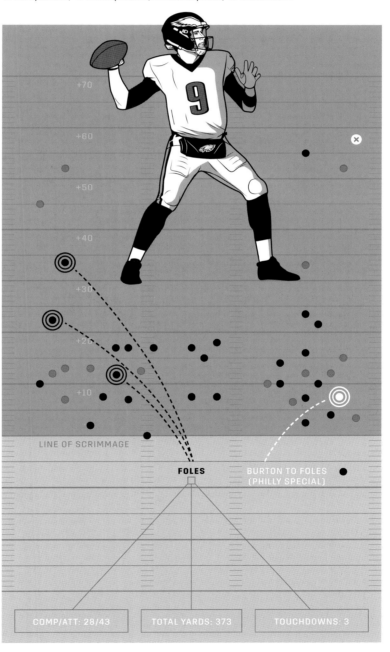

**NICK FOLES, SUPER BOWL LII**

● Completion / ● Incompletion / ✕ Interception / ◎ Touchdown

COMP/ATT: 28/43 — TOTAL YARDS: 373 — TOUCHDOWNS: 3

## NEXT GEN BEST

**Longest Distance Traveled, Ballcarrier**

**157.5** YARDS

**Dwayne Harris** / RAIDERS
Kickoff return in Week 16 of 2018 vs. Broncos

**Fastest Runner**

**23.24** MPH

**Tyreek Hill** / CHIEFS
On reception in Week 2 of 2016 vs. Texans

**Fastest Sack**

**1.4** SECONDS

**Marcus Williams** / SAINTS
Week 12 of 2018 vs. Vikings

**Longest Distance Traveled, Tackler**

**131.7** YARDS

**Cortland Sutton** / BRONCOS
On interception in Week 5 of 2018 vs. Jets

255

# AARON RODGERS

► **By Jim Wyatt**
FROM *THE TENNESSEAN*
FEBRUARY 8, 2011

**Aaron Rodgers was overlooked** coming out of high school, forced to go the junior college route because Division I schools thought he was too small to play quarterback. It lit a fire under him.

At the NFL draft in 2005, he was humbled again, forced to watch for hours until the Packers finally picked him 24th overall. Rodgers made it a point to remember the teams that passed on him. It added more fuel to his motivational fire.

Sitting behind a legend, Brett Favre, for three long seasons pushed Rodgers even further to succeed.

After winning the Most Valuable Player award by leading the Packers to a 31–25 win Sunday over the Steelers in Super Bowl XLV, the chip on his shoulder is officially gone. If not, it should be. Rodgers never will be considered an underdog again. It's his newest challenge.

**Green Bay's quarterback isn't just trying to scramble and avoid large men who want to violently slam him to the ground, he's trying to outrun the opponent who never dies: the nostalgic memory of another player in the same uniform at the same position.**

► **By Mike Wise,** *THE WASHINGTON POST*, FEBRUARY 6, 2011

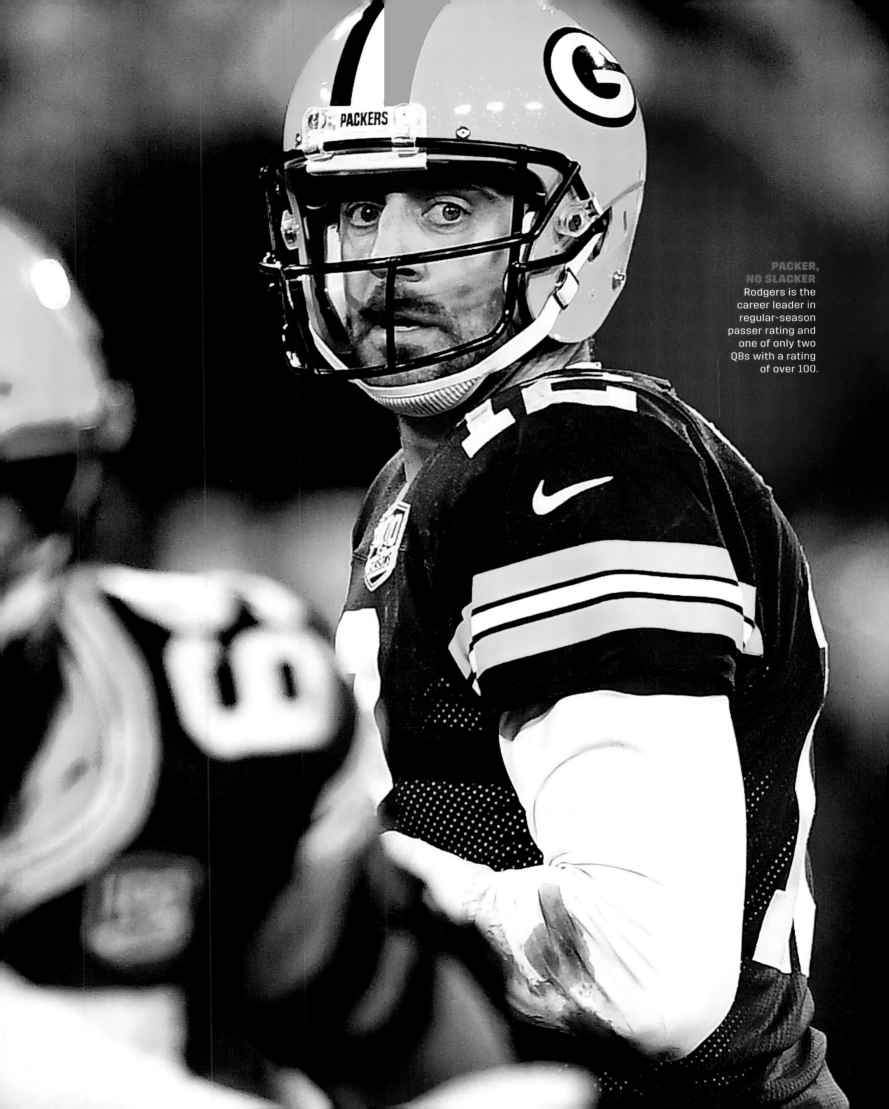

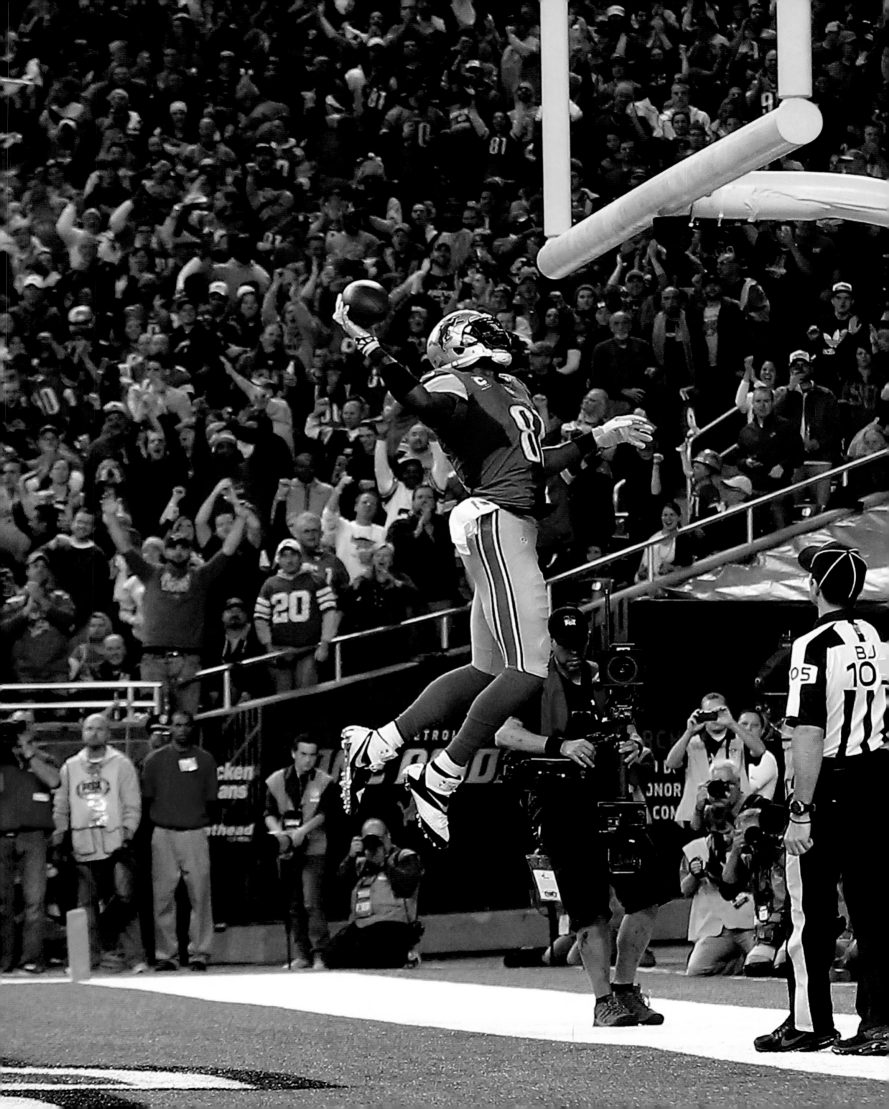

# CALVIN JOHNSON

▶ **By Gerry Dulac**

EXCERPTED FROM *THE PITTSBURGH POST-GAZETTE*, NOVEMBER 17, 2013

MEGATRON: THE NICKNAME WAS GIVEN TO him by former teammate and receiver Roy Williams, and it couldn't be more appropriate.

On the field, Johnson looks like the gigantic Transformers character, an unstoppable sentient robot capable of inflicting harm and damage on the mere mortals who try to stop him. Off the field, though, he is anything but the villainous creature—a modest, humble superstar who doesn't like to talk about his wondrous achievements, of which there are many.

There are any number of talented players who come to Heinz Field to play the Steelers. And there have been more than several who have put on performances that have been impressively memorable. But it isn't often when a player of Johnson's magnitude—his skill set, his physical gifts, his achievements—comes to town and is accorded the respect, wonderment and downright awe as the Lions' seventh-year receiver. He is not only the best wide receiver in the National Football League, he could, quite possibly, be the best to ever play the game.

# ED REED

► **By Ken Murray**

FROM *THE BALTIMORE SUN*
JANUARY 7, 2011

**His offseason started last winter** with a hint of retirement. By summer, he was diplomatically campaigning on radio for a pay raise. In the spring, he underwent hip surgery.

Staying ahead of Ed Reed is a difficult proposition at any time, but during the past year, it has been impossible to predict what the Ravens' Pro Bowl safety would do next. In his first game back after missing six weeks because of the surgery, he had two interceptions and caused a fumble. In the last two regular-season games, he picked off four passes and knocked down five. The fact that he led the league with eight interceptions while playing only 10 games is just another line on his Hall of Fame résumé.

For nine seasons, Reed, 32, has been one of the NFL's biggest playmakers and game-changers, a player with the exquisite ability to turn a game completely around and make it his with one acrobatic interception or one thunderous hit. In the mind of Ravens general manager Ozzie Newsome, that pantheon of game-changers includes Ronnie Lott, Reggie White, Michael Haynes, Deion Sanders, Rod Woodson and, from today's game, Charles Woodson. What, Newsome was asked, is the common denominator among those players?

"Instinct," Newsome said. "They just have a sense of getting themselves in a position to make the play—and then making the play. Anytime there was a game-changing play that needed to be made, Ed Reed made it."

**NEVERMORE...**
...Quoth the Ravens Hall of Fame safety Ed Reed to quarterbacks foolish enough to throw in his area.

**HE WAS EVERY-WARE** Ware went out on top, retiring after his five tackles and two sacks in the Broncos' defeat of the Panthers in Super Bowl 50.

# DEMARCUS WARE could have kept playing. He was
working out, and he was over neck and back ailments that wrecked his 2016 season in
Denver. Ware is 34, and he had a $9 million offer on the table for 2017, and he felt he could
have had the kind of reborn season that would satisfy the football devotee inside of him.

"You go through so much as a player to keep playing—for me lately, the neck injury, the back
injury—and then you correct those things," Ware said a day after he finalized his decision to
retire from football. In nine seasons with Dallas, then three with Denver, Ware was one of the
very small handful of premier edge rushers of the new century. He is eighth on the all-time sack
list with 138½, one behind 2017 Hall of Fame enshrinee Jason Taylor and three behind 2014 Hall
of Fame enshrinee Michael Strahan. Taylor and Strahan played 15 seasons. Ware played 12.

"When you're playing," Ware says, "you think the NFL's forever. You think it's never going to end."

Ware had a terrific second act in Denver. Manning led the offense. Ware led the defense.
In fact, on the night before Denver's Super Bowl 50 victory over Carolina 13 months ago,
it was Manning and Ware who were picked to speak emotionally to the Denver players.
Both veterans' voices cracked as they spoke that night. And the next day Ware had the
last big game of his career, sacking Cam Newton twice in Denver's 24–10 victory.

► **By Peter King,** FROM *THE MMQB*, MARCH 14, 2017

# Eli Manning

► **By Michael Lewis**

FROM *THE BEST AMERICAN SPORTS WRITING,* 2005

**"There is no other position in team sports** as important as the quarterback," [Ernie Accorsi] says. "A great quarterback, unlike a great running back, cannot be stopped. And if you have a great one, you're never out of it. He walks on the bus and the whole team sees him and thinks, We have a chance." The problem, from Accorsi's point of view, is finding the great quarterback.

The game itself, up close, is a mess. The formations, the elegant strategy, the athleticism—when you're right next to it, it's all chaos. The ball goes up in the air any distance at all, and the only way you can deduce what has become of it is by the reaction of the crowd. When Eli Manning drops back to pass, if you're standing a few yards away on the sidelines, you have no sense of him doing something so considered as making a decision. The monsters charging at him from every direction are in his face so quickly that you flinch and stifle the urge to scream, "Watch out!" There is no way, you think, that he can possibly evaluate which of these beasts is most likely to get to him first, and so which of them he should take the trouble to evade. At that moment any sensible person in Manning's shoes would flee. Or, perhaps, collapse to the ground and beg for mercy. Yet he is expected to wait . . . wait . . . wait . . . until the microsecond before he is crushed. He's like a man who has pulled the pin from a grenade and is refusing to throw it.

**Even when he did the improbable and led the Giants to an upset of the unbeaten Patriots in Super Bowl XLII, Eli Manning was still the little brother. He was the game's MVP and holding a Vince Lombardi Trophy, but he still wasn't considered the best quarterback in his own family. As long as Peyton Manning was healthy and the Colts starting quarterback, Eli Manning was living in a shadow, even if it never seemed to bother him. That shadow is gone now.**

► **By George Willis,** FROM THE *NEW YORK POST*, JANUARY 6, 2012

# RAY LEWIS

**By Mike Preston,** FROM *THE BALTIMORE SUN*, FEBRUARY 17, 2013

Often in sports we use the word "great," but that should be reserved for players who transcend the game and reinvent their position.

That was Ray Lewis, No. 52.

There have been other great ones, such as the Chicago Bears' Dick Butkus and Mike Singletary, but none was the complete package like Lewis.

It didn't seem as though Lewis would make this incredible Hall of Fame journey when he arrived in Baltimore 17 years ago. Since then, he has been selected to 13 Pro Bowls, won a Super Bowl, been named Super Bowl Most Valuable Player and received two NFL Defensive Player of the Year awards. Lewis is just the sixth player in NFL history to win Player of the Year more than once, and the only middle linebacker other than Singletary.

And here's something else that separates Lewis from the others: He played 17 years. Few of the great ones come close to his longevity.

**BALTIMORE CHOPS**
Lewis plied his trade for the Ravens, and only the Ravens, during an extraordinary career that spanned three decades (from 1996 to 2012) and earned him a place in the Hall of Fame.

# ODELL BECKHAM JR.

## ► By Mike Vaccaro

FROM THE *NEW YORK POST*
DECEMBER 2, 2015

**Cris Collinsworth caught 417 regular-** season passes in the NFL. He had another 21 in the playoffs.... It is not easy to impress a guy like that. Yet this is what Cris Collinsworth—37 touchdowns receiving in his career—had to say on the evening of Nov. 23, 2014, in real time, after watching Odell Beckham Jr. make the catch that, ever after, has been known as The Catch II:

"That may be the greatest catch I've ever seen in my life."

Moose Johnston caught 294 balls during 11 years in the NFL, and another 37 during the playoffs, and while memory is a fickle witness, it does seem that about 291 of them were done the hard way, avoiding defenders and tacklers and grinding his way to another first down.

Hard to impress a guy like that, too.

Yet this is what Moose Johnston had to say last Sunday, in real time, after watching Beckham make The Catch II:

"The ball's in a spot that only Odell Beckham Jr. can make the catch. And I do mean ONLY Odell Beckham Jr. can make that catch."

So this isn't just me—who last caught a football in a pool at a Marriott somewhere (while managing not to spill my daiquiri)—telling you how otherworldly Odell Beckham Jr. is. These are guys who know what they see.

So yes: Let the hype and the hyperbole run free and unchecked, because there isn't another thing in our immediate sporting landscape that approaches the moments when a football leaves Eli Manning's hands, when it traces its parabolic path across the sky and is tumbling somewhere in the vicinity of Odell Beckham Jr.

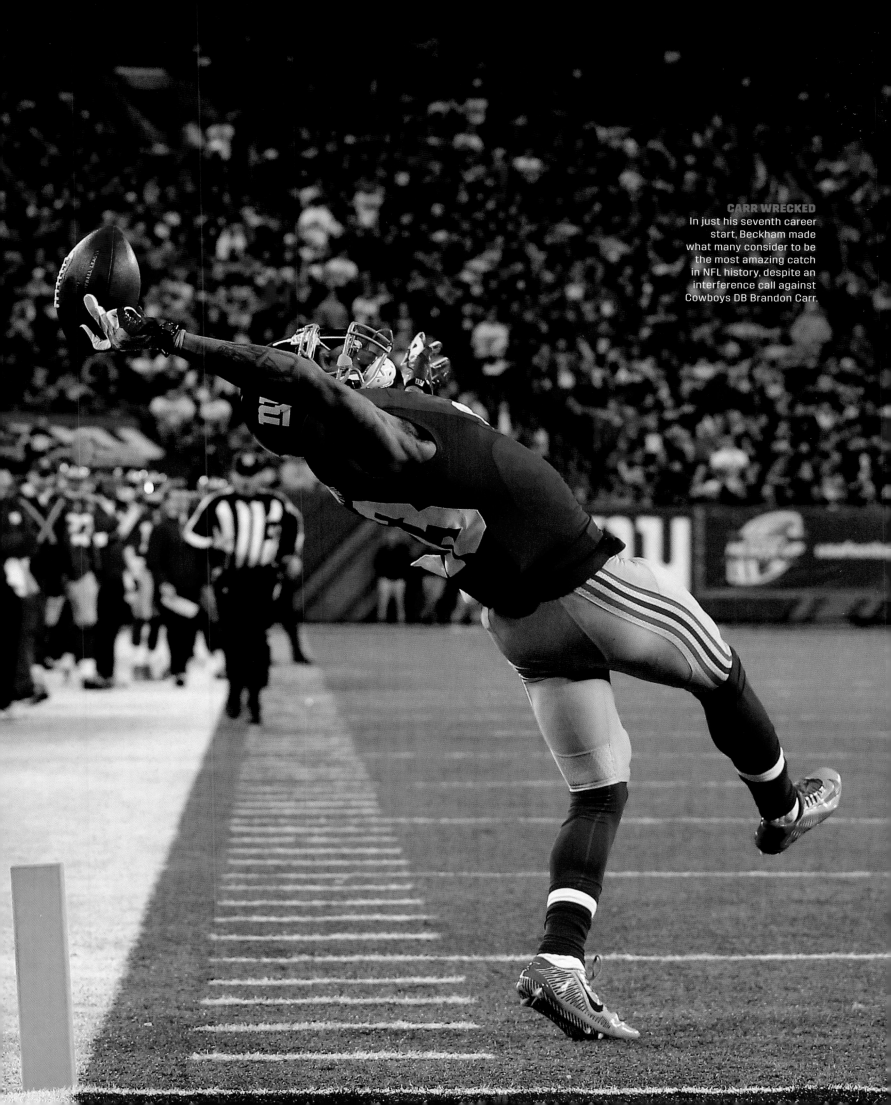

# J. J. Watt

▶ **By Dan Solomon,** FROM *TEXASMONTHLY.COM*, DECEMBER 23, 2014

J. J. WATT HASN'T THROWN A SINGLE TOUCHDOWN pass this year. That's almost 40 fewer than Peyton Manning, Andrew Luck or Aaron Rodgers. All of those players—quarterbacks for playoff-bound teams—also have at least 4,000 passing yards more than Watt, the standout Houston Texans defensive end whose passing yardage total is, likewise, a big ol' goose egg.

When it comes to rushing yards, Watt doesn't fare much better. He's got zero on the year, compared to a whopping 1,745 (with 12 touchdowns!) from DeMarco Murray, or 1,341 (and eight touchdowns) for Steelers tailback Le'Veon Bell. Both running backs will, presumably, continue their successful seasons into the playoffs.

In other words: Watt doesn't throw passes, and Watt doesn't run the ball. He's not the centerpiece of a high-powered, playoff-bound offense. That is, ultimately, the gist of the argument against J.J. Watt earning his first NFL MVP award this season.

What does Watt do? Basically everything else.

He's certainly the centerpiece of one of the NFL's best defenses. He has more sacks, with 17½, than any defensive lineman in the NFL; he has more tackles than anyone else at his position; he's tied for third at his position in fumbles forced and is first in fumbles recovered; he's tied for second in interceptions and leads defensive ends with 11 passes defensed. He's tied for first place in the number of defensive touchdowns, and he's also got three additional TDs on offense, where he occasionally lines up at tight end.

Everything J. J. Watt attempts on a football field he succeeds at in ways that make him a once-in-a-generation talent. But Watt probably won't be the NFL MVP when the award is voted on at the end of the season. Those stats up there about passing and rushing yards, touchdown passes and playoff appearances? They tend to matter a lot more than simply being the best player in football, which anyone paying attention to the game can pretty clearly see that Watt is.

**SMART MOVE** A tight end early in his college days, Watt converted to defense and has been on a rampage ever since as one of the NFL's premier defensive ends.

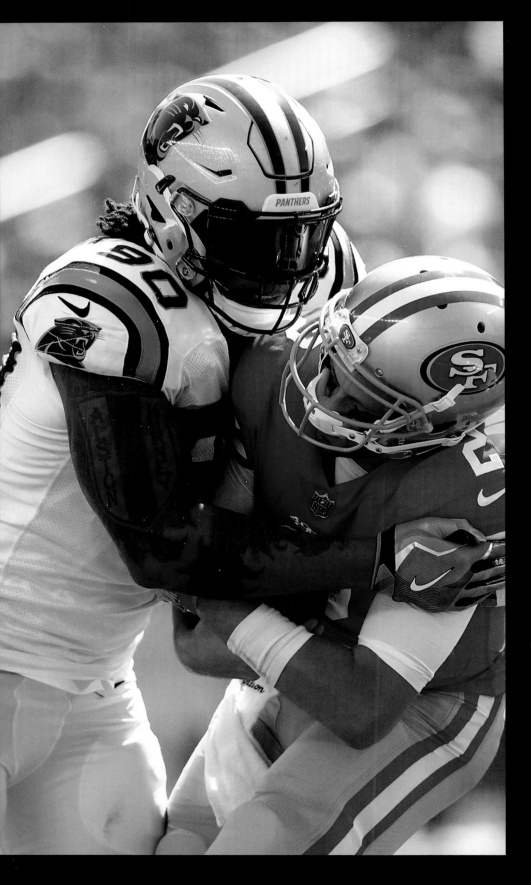

# "JULIUS PEPPERS

was just one of the biggest, best athletes I ever saw on a football field. The combination of his size and athleticism was unbelievable. I would watch him on film and think, Man, this guy is a great athlete. Then, every time I saw him on the field, I remember thinking, He's a giant, too. How do you have that combination? He was one of those guys that you had to attack in a completely different way than every other defender. I know we play a game where everyone is a great athlete, but some guys are just rare. He was one of them."

▶ **KURT WARNER, RAMS QB**
FROM *NFL.COM*, 2019
**by Brooke Cersosimo**

**COURT SIDE**
Before he launched his seventeen-year NFL career (including ten seasons in Carolina), Peppers played college basketball for a couple of years at UNC.

**NO MAN'S LAND** Quarterbacks so rarely dared throw in Revis's direction that receivers he covered were said to be stranded on Revis Island.

# DARRELLE REVIS

► **By Greg Logan**

FROM *NEWSDAY*, JANUARY 23, 2011

**It was just a random moment in the** middle of a game that Aliquippa (Pa.) High's football team was dominating on its way to a 12–0 record this past season. Coach Mike Zmijanac turned to look behind him and saw a group of about a dozen younger kids who had lost interest in the game on the field and were busy playing their own game.

Turning to an assistant, Zmijanac said, "That's why we win."

One of those little kids not so long ago was Darrelle Revis. He's big-time now at 25, an All-Pro cornerback with the Jets with a $46 million contract who is returning to his home area today to play the region's beloved Steelers for the AFC championship at Pittsburgh's Heinz Field.

But growing up in Aliquippa, Revis was just one of many gifted athletes the area has spawned. Some of them you've heard of, going all the way back to Mike Ditka in the '50s, "Pistol Pete" Maravich in the '60s, Sean Gilbert in the '80s and Ty Law in the early '90s. But more of them never made it out of a former steel mill town that has fallen on hard economic times as the population has dwindled to about 11,000 folks, who cling to athletics as a source of local pride.

"Athletics have kept this town together," Zmijanac said. "It's a tough place. I call it a suburban inner city. In places like this, athletics mean everything. It's a way to keep kids off the streets. It's the centerpiece of the community.

"We lose kids to the streets, but hopefully we can save some."

Revis turned out to be one of the kids who got it right.

Across the room was Revis, angled slightly forward in his seat, just as he stood on the field. Even at rest, the great player had something that claimed the eye. He seemed to gleam with posture and intent. He looked carved from a tree. He looked like an Egyptian king.

► FROM *COLLISION LOW CROSSERS*, 2013, **by Nicholas Dawidoff**

# Larry Fitzgerald

► **By Bob McManaman,** FROM *THE ARIZONA REPUBLIC*, DECEMBER 8, 2017

LARRY FITZGERALD CAN REMEMBER ALMOST EVERY catch he's made, even dating back to high school in Minnesota. Or so he says. So last Sunday, after catching his 1,200th career pass, why did he casually flip the football to the referee and start to jog off the field? "I was in the moment," Fitzgerald said Thursday. "I said to myself, I probably should keep that one, so I went back and grabbed it."

This Sunday, Fitzgerald has another milestone on the menu. With 26 receiving yards against the Titans at University of Phoenix Stadium, he will pass his childhood idol, Randy Moss (15,292), for third on the NFL's all-time receiving yardage list. Moss, who turns 41 in February, played 14 seasons in the NFL and ranks among the best

ever to play wide receiver. His 156 receiving touchdowns rank second behind only Jerry Rice (197), and that's a number that even Fitzgerald is not going to reach.

Fitzgerald was a ball boy for the Vikings when Moss played for Minnesota, and the two were always close.

"Well, I love Randy. He taught me this game. I grew up immortalizing him, watching him, and trying to emulate what he was doing every single day," Fitzgerald said. "Him supporting me, coming to my practices and giving me cleats and gloves. He let me come to the house and play basketball. He's always been over-the-top kind to me, and anytime that you can have your name mentioned in the same sentence as Randy Moss, you've got to be happy."

**CARDINAL RULES** Fitzgerald was still making spectacular TD catches at age thirty-five in 2018, his 16th NFL season.

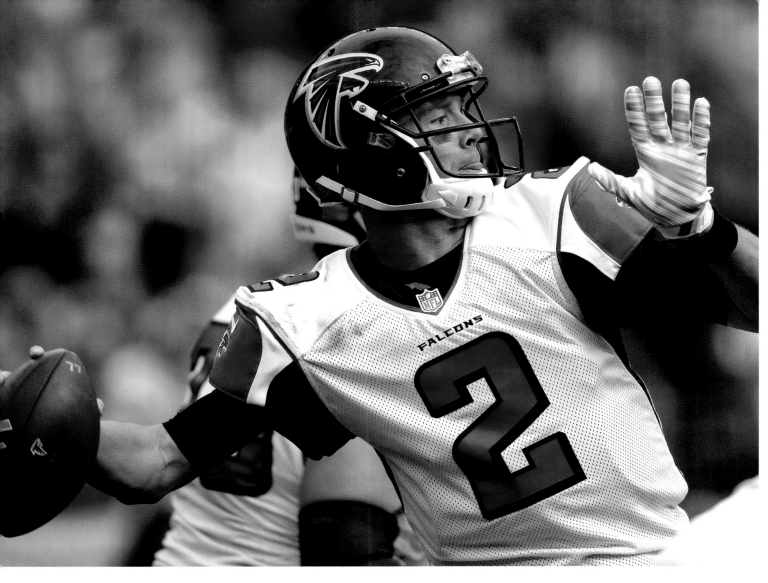

**RYAN AIR** The Falcons' starting QB as a rookie in 2008, Ryan still held the job—and was the NFL's MVP—nine years later.

# MATT RYAN

➤ **By Steve Hummer,** FROM *THE ATLANTA JOURNAL-CONSTITUTION*, FEBRUARY 5, 2017

HE MOST LIKELY WILL ENTER THE SUPER BOWL arena with the initials MVP appended to his name—having claimed that award in absentia the night before. He will be at the controls of an offense that ravaged the league for the 11th-most points ever. He will measure himself against the most proficient quarterback of his time, the Patriots' Tom Brady.

Prior to this season Ryan had done none of the postseason work necessary to join the top one percenters at quarterback. He was 1–4 in the postseason. He was the master of the red-zone interception (four last season). In the four prior seasons he was good for an average of an interception a game.

But at the age of 31, in his ninth NFL campaign,

Ryan gave true greatness a whirl. Well into the back nine of his professional life, he put up all new career bests across the board. Most passing yards (4,944). Most passing touchdowns (38). Fewest interceptions (7). And his first foray to the Super Bowl.

"He's made a huge step," Kyle Shanahan, the Falcons' offensive coordinator, said, "and it's tough to make a huge step when you've had the kind of career that he has."

"Matt has put the work in. He started working on this year in January last year. It showed the first time I saw him in OTAs [offseason training]. He attacked this year as hard as I've ever seen anyone attack a year. It's really cool when you see someone put that much in and you get the results."

# TERRELL SUGGS

► **By Mike Preston**

FROM *THE BALTIMORE SUN*
SEPTEMBER 13, 2011

**On Sunday, Pro Bowl outside linebacker** Terrell Suggs surpassed Peter Boulware as the Ravens' all-time sacks leader. The passing of another torch to Suggs may not be too far behind.

With inside linebacker Ray Lewis in his 16th season, it's only a matter of time before the Ravens find another defensive leader. Suggs holds Lewis in high regard, and there is no desire to force him out soon, but Suggs is the heir apparent.

Ravens coach John Harbaugh has pointed to Suggs as Lewis's successor and gave him another endorsement after Suggs collected three sacks to bring his career total to 71½ in the Ravens' 35–7 beatdown of Pittsburgh.

"You're talking about some great sack artists that have been here,"

Harbaugh said. "Terrell Suggs is one of the best players in the NFL. He's one of the premier defensive players that everybody game-plans around. He gets blocked every different kind of way a guy can get blocked, from one game to the next. He still finds a way to make plays.

"Plus, he's one of the best leaders I've been around," Harbaugh said. "He's part of the heart and soul of our team and our defense."

When a coach starts using words like those to describe a player, he has become more than just a player, he's part of the organization's inner fiber. Jonathan Ogden was like that, and so is Lewis. Suggs is nearing that status too, but he is willing to wait his time.

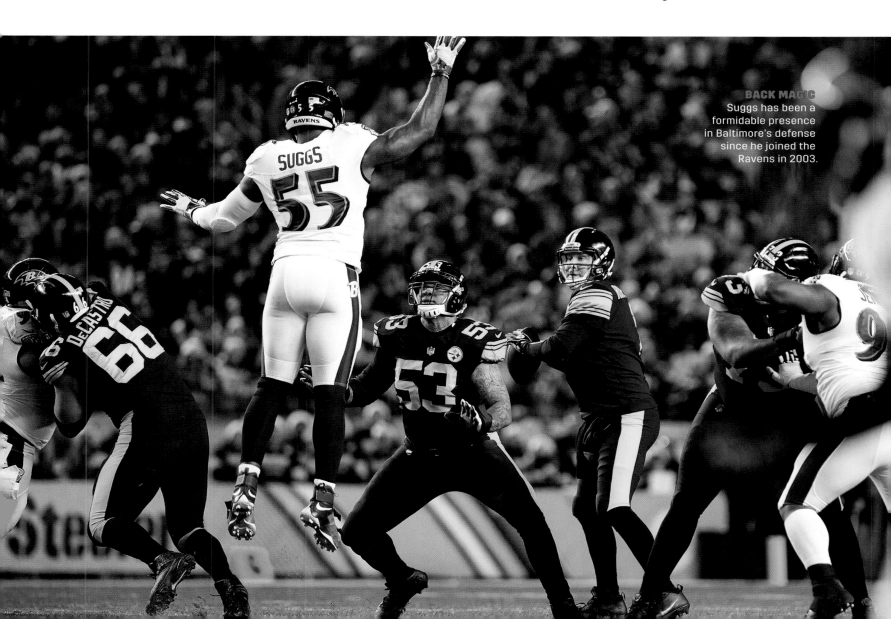

**BACK MAGIC**
Suggs has been a formidable presence in Baltimore's defense since he joined the Ravens in 2003.

2010s

# ANTONIO BROWN

➤ **By Ray Fittipaldo,** EXCERPTED FROM
*THE PITTSBURGH POST-GAZETTE*, SEPTEMBER 6, 2018

**Antonio Brown makes the difficult** seem routine. The highlight reel catches grab your attention, but Brown also spoils with his consistency. He has accumulated three 1,500-yard seasons in the past four years. Jerry Rice, who is widely regarded as the best receiver in the history of the NFL, had four 1,500-yard seasons during his 21-year career.

Brown is just 90 yards shy of 10,000 for his career as he enters his ninth NFL season. The prolific start to his career has Brown on pace to rank among the NFL's all-time leading receivers and perhaps challenge Rice's records for yards and receptions, which for years have been considered unbreakable.

If Brown has 90 receiving yards against the Browns in the season opener, he'll reach the 10,000-yard milestone in 116 games. Only one player in the history of the NFL reached that milestone sooner. Calvin Johnson recorded 10,000 yards in 115 games. Brown would match former Rams receiver Torrey Holt at 116 games. Hall of Famers Lance Alworth did it in 120 games and Rice in 121 games.

Now here's the kicker: Johnson, Holt and Alworth all were out of the NFL a few years after hitting the 10,000-yard milestone. Rice played for another 12 years and set every meaningful record for receivers. His 22,895 yards are nearly 7,000 more than his closest competitor, Terrell Owens.

Rice mastered the art of staying in top shape into his early 40s while Johnson, Holt and Alworth retired by the time they hit 33. Brown turned 30 in July, and he has no plans to pull a Calvin Johnson and retire in his prime. In fact, Brown is well aware of his potential place in history.

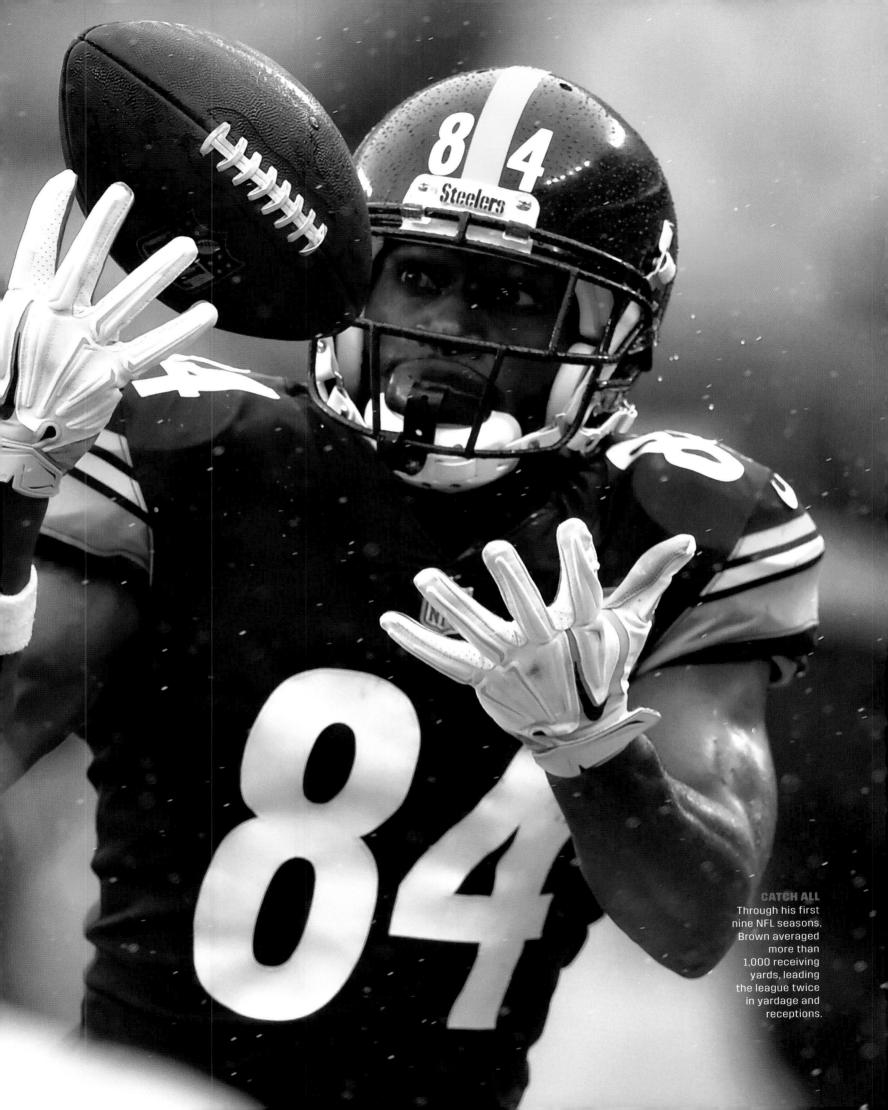

# Todd Gurley

► **By Jerry Brewer**

FROM *THE WASHINGTON POST*
JANUARY 19, 2019

**Todd Gurley wears his braided hair in a** high ponytail and peers through blue-tinted sunglasses. He cocks his head to the left, takes a few hard chews and sighs. He couldn't be more bored.

He is soft-spoken and circumspect and too cool for elaboration, but mostly, he's bored. Gurley, a Los Angeles Rams running back, can be animated when talking about his team, but when it comes to himself, he is just a couple of notches above Marshawn Lynch on the indifferent scale.

Gurley may be the most dynamic offensive weapon in football, and over the past two seasons, he has emerged as the standard of the versatile NFL running back. The league is now brimming with young and intriguing ballcarriers who can catch, block and test offenses with their power and their speed. But Gurley so consistently drops jaws—hurdling defenders, making one-handed snags, standing up pass rushers, zipping past other speedy players with ease—that even his teammates are nonchalant about his play.

Just a few years ago, the accepted belief was that tailbacks possessed diminished value in this evolving, pass-centric game. The lead back was becoming a specialist, an opening act to the supposed third-down back, whose popularity had risen because of his multipurpose talents in up-tempo, spread-out offenses. But now, there is a generation of running backs who have done it their entire lives, and they are leading a renaissance for the position.

Gurley is at the top of that list.

**RAM SMOOTH** In his first four seasons, Gurley established himself as one of the league's most potent and versatile weapons.

**COMMANDER IN CHIEFS** In 2018, Mahomes became the second NFL QB (after Peyton Manning) with 5,000 yards and 50 TDs in a season.

# PATRICK MAHOMES

Sure, it would be great for Mahomes to become the first MVP in franchise history. That cosmetic point, though, is trivial compared to Mahomes's cosmic impact on a team animated by his arrival and a community fevered by his presence. He's transformed the Chiefs from a contender to a favorite, the demons of recent playoffs notwithstanding, by altering the very dimensions of the possible. His nuclear arm, fascinating escape artistry, arsenal of release angles and astounding poise mean the Chiefs simply never can be counted out with him playing.

▶ **By Vahe Gregorian,** FROM *THE KANSAS CITY STAR,* DECEMBER 30, 2018

**A.D. DO**
Since an explosive rookie year in 2007, Peterson has averaged more than 1,000 yards per season and led the league in rushing three times.

# Adrian Peterson

► **By Ron Borges**, FROM *PRO FOOTBALL WEEKLY*, DECEMBER 30, 2012

**Not only were the words themselves** shocking, but the source of those words made them even more so because of the weight of Curtis Martin's own staggering accomplishments.

"To me, as far as God-given ability, Adrian Peterson has more than anyone I've ever seen play running back," Jim Brown's chess partner and the fourth leading rusher in NFL history said recently during a visit to his old stomping grounds (literally) at Gillette Stadium in Foxborough.

To hear anyone's name in the same sentence as Jim Brown's when the subject is running the football is difficult for those of us who watched Brown dominate the NFL for nine remarkable seasons in which he averaged 104.3 yards per game and never missed one of them. What he did toting a football became and remains the gold standard by which all future running backs must be measured.

"I'm talking in the history of the NFL, not just in this era," Martin said of Peterson. "I believe he's that guy. I don't know any other back with his elusiveness combined with his speed, his power, with his durability. He may not have the best career of any running back, but I think he's probably the most talented there is."

# Long Live the Quarterback

► **By Kevin Clark**

FROM *THE RINGER*, JANUARY 17, 2019

"NICE AND OLD," TOM BRADY DEADPANNED LAST week after being told that he and Philip Rivers, at a combined age of 78 years, would be the oldest quarterback pairing in playoff history. This record will be shattered by three years if Brady and Drew Brees face each other in the Super Bowl. In the meantime, during Sunday's AFC championship game, Brady will help break the record for the biggest disparity in age between quarterbacks in a playoff game when the Patriots play the Chiefs and Patrick Mahomes II.

These are not just fun facts; they are indicative of how much the NFL is changing. A generation of quarterbacks is performing at such a high level into their late 30s and, in some cases, early 40s, that they're challenging our notions about longevity and team-building. We cannot say they are better than previous generations at their ages, because no

is getting smarter, as every other generation has, but they have shielded themselves from the physical deterioration that playing the position incurs due to how the modern game operates."

Modern medicine has contributed to increased longevity. Brady recovered from a torn anterior cruciate ligament, Manning from spinal-fusion surgery, and Brees from a full 360-degree tear of the rotator cuff. All three won Super Bowls after their surgeries.

Then, too, there are vast changes in the way quarterbacks approach their conditioning. In the '70s, Ken Stabler's offseason regimen consisted largely of beer in the morning and scotch in the evenings. For Brady, it's pliability exercises, vibrating foam rollers, and a diet heavy on carrots, dandelion greens, and—when he's in the mood to

break training—avocado ice cream for dessert.

Otto Graham retired after ten punishing seasons in the pros and Bobby Layne after twelve. But their workouts probably didn't incorporate the multidirectional ab rollouts favored by Brees, the Swiss ball hyperextension that's crucial to Ben Roethlisberger's core workouts, or the kickboxing that Philip Rivers put into his offseason training regimen.

Some things haven't changed. The one necessity for all great quarterbacks across the generations is an obsessive, single-minded dedication. Sammy Baugh used to spend hours in his backyard every day, throwing 10-, 15- and 20-yard passes into a moving tire swing. Imagine how good he could have been with a personal trainer, a hyperbaric chamber, and a nutritionist.

**STAYING POWER** Invaluable veterans such as (from left) Brees, Rivers, Roethlisberger, and Brady challenge long-held assumptions about the career span of quarterbacks.

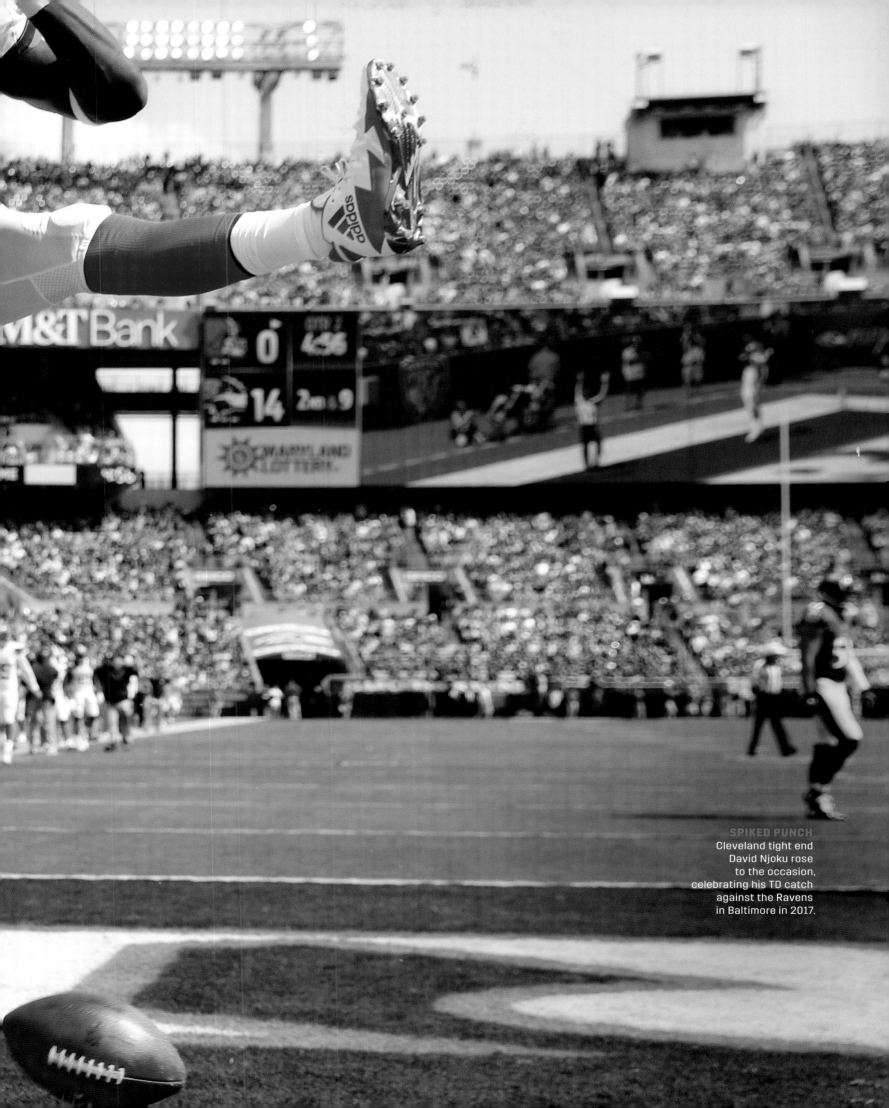

**SPIKED PUNCH**
Cleveland tight end
David Njoku rose
to the occasion,
celebrating his TD catch
against the Ravens
in Baltimore in 2017.

# Acknowledgments

This book would not have been possible without the extraordinary efforts of a talented and dedicated editorial team, who were in the lineup from opening whistle to final gun: Dot McMahon, Michael Goesele, Mark Rykoff, and Carolyn Davis, and, of course, our writer-not-in-residence, Michael MacCambridge, and stat master, David Sabino. Thank you to Peyton Manning for his time and words. Many others worked behind the scenes, which is all the more reason to highlight here their essential role and vital support in making this book possible. Chief among them were Pete Abitante and Alvaro Saralegui at the NFL; Garrett McGrath, Deb Wood, and Peggy Garry at Abrams; Ben Liebenberg and Alix Kane at NFL Photo; Kevin O'Sullivan at AP Images; Gesine Stross at Getty Images; and Saleem Choudhry at the Pro Football Hall of Fame; Todd Detwiler for his artful design of the infographics; cover photographer Michael Kraus; Bob Roe for his supersonic sweep through the literature of pro football; Carolyn Fleder for her tireless transcription of that vast opus; and Jill Jaroff for her usual sharp-eyed copyediting.

## Text

**1920s** **28–29** Michael MacCambridge; **32–33** © Dan Jenkins, used with permission (2); **35** © W. C. Heinz; **36** © 1979 by Walter W. Smith, from THE RED SMITH READER, edited by Dave Anderson, used with permission of Penguin Random House; **37** © Myron Cope, used with permission; **39** Courtesy Gary Waleik, NPR's *Only A Game*—WBUR, Boston

**1930s** **42–43** Michael MacCambridge; **46** Oliver E. Kuechle/*The Milwaukee Journal*; **47** ©Myron Cope, used with permission; **49** ©Charles P. Pierce; **50** Gerald Holland/*Sports Illustrated*; **51** ©Myron Cope, used with permission; **52** Peter King/*Sports Illustrated*

**1940s** **56–57** Michael MacCambridge; **60** ©George Ratterman and Robert G. Deindorfer; **61** Robert W. Peterson/Oxford University Press; **63** ©National Football League Properties Inc.; **65** Courtesy Michael MacCambridge; **66** ©Dan Jenkins, used with permission; **67** ©National Football League Properties Inc.; **68** ©Myron Cope, used with permission; **69** ©National Football League Properties Inc.

**1950s** **72–73** Michael MacCambridge;

**76** Tex Maule/*Sports Illustrated*; **77** ©Bob Carroll, used with permission; **78** Excerpt(s) from . . . AND EVERY DAY YOU TAKE ANOTHER BITE ©1971 Larry Merchant, used with permission of Doubleday/Penguin Random House; **78** ©George Ratterman and Robert G. Deindorfer; **80–81** ©National Football League Properties Inc. (3); **84** Courtesy Peter Bonventre; **85** ©Myron Cope, used with permission; **86–88** ©National Football League Properties Inc. (3); **89** ©Myron Cope, used with permission; **90** Michael MacCambridge

**1960s** **94–95** Michael MacCambridge; **98** Jim Murray/*Los Angeles Times*, used with permission; **99** ©National Football League Properties Inc.; **101** (top) Jim Murray/*Los Angeles Times*, used with permission; (bottom) ©1985 The Word Business Inc.; **104** Frank Deford/*Sports Illustrated*; **106** Courtesy Peter Bonventre; **107** ©1985 The Word Business Inc.; **108** Courtesy Peter Bonventre; **109** Excerpt(s) from A FAN'S NOTES ©1968 Frederick Exley, used with permission of Penguin Random House; **111** Johnette Howard/*Sports Illustrated*; **113** Courtesy Peter Bonventre; **114** Joe McGinniss/*The Saturday Evening Post*; **115** Paul Zimmerman/*Sports Illustrated*; **117** Courtesy John Schulian

**1970s** **120–121** Michael MacCambridge; **124** Edwin Pope/*The Miami Herald*; **127–128** Courtesy Roy Blount Jr. (2); **132** Jim Murray/*The Los Angeles*

*Times*, used with permission; **133** ©1979 by Walter W. Smith, from *The Red Smith Reader*, edited by Dave Anderson, used with permission of Penguin Random House; **135** Courtesy Peter Bonventre; **136** Courtesy Rick Telander; **138** Gary Smith/*Sports Illustrated*; **141** Bruce Newman/*Sports Illustrated*; **142** Courtesy Dick Schaap Estate; **143** Steve Rushin/*Sports Illustrated*. **145** ©Peter Gent; **146** Edwin Pope/*The Miami Herald*; **147** Courtesy Rick Telander; **148** Courtesy Roy Blount Jr.

**1980s** **152–153** Michael MacCambridge; **156** Rick Reily/*Sports Illustrated*; **158** From THE EDUCATION OF A COACH by David Halberstam, ©2005, used with permission of Hyperion/Hachette Book Group; **159** Courtesy Michael Lewis; **160** Courtesy Dave Kindred; **162** ©Dan Jenkins, used with permission; **185** Rick Telander/*Sports Illustrated*; **166** Paul Zimmerman/*Sports Illustrated*; **169** Rick Telander/*Sports Illustrated*; **170** Courtesy Michael Lewis; **172–173** Paul Zimmerman/*Sports Illustrated* (2); **176** Courtesy Michael Lewis; **178** Courtesy Michael MacCambridge; **179** Edwin Pope/*The Miami Herald*; **181** Blackie Sherrod/*The Dallas Morning News*, used with permission; **182** Courtesy Michael Weinreb; **183** William Nack/*Sports Illustrated*

**1990s** **186–187** Michael MacCambridge; **191** Paul Zimmerman/*Sports Illustrated*; **192** ©Paul Zimmerman; **194** Rick Telander/*Sports Illustrated*; **196** Peter King/*Sports Illustrated*; **200–201** Rick Telander/*Sports Illustrated*; **202** Courtesy Michael MacCambridge; **206** Jeff MacGregor/*Sports Illustrated*; **208** S.L.Price/*Sports Illustrated*; **211** Alan Shipnuck/*Sports Illustrated*; **212** Courtesy Michael Lewis; **215–216** Courtesy Michael MacCambridge (2)

**2000s** **220–221** Michael MacCambridge; **224** Ian Crouch/*The New Yorker*; **227** Michael Silver/*Sports Illustrated*; **228** David Haugh/*The Chicago Tribune*; **229** Karl Taro Greenfeld/*Sports Illustrated*; **230** Linda Robertson/*The Miami Herald*; **235** Seth Wickersham/*ESPN The Magazine*; **236** From THE EDUCATION OF A COACH by David Halberstam, ©2005, used with permission of Hyperion/Hachette Book Group, Inc.;

**238** Courtesy Michael Lewis; **239** Danny Kelly/Sbnation.com; **242** Lee Jenkins/*Sports Illustrated*; **244** Spencer Hall/Sbnation.com; **245** Neil Paine/FiveThirtyEight.com; **247** Zak Keefer/*The Indianapolis Star*; **248** Courtesy Rick Telander; **249** Gene Wang/*The Washington Post*

**2010s** **252–253** Michael MacCambridge; **256** Jim Wyatt/*The Tennessean*; **256** Mike Wise/*The Washington Post*; **259** Gerry Dulac/Excerpted from *The Pittsburgh Post-Gazette* ©2019; **260** Ken Murray/*The Baltimore Sun*; **261** Peter King/The MMBQ/*Sports Illustrated*; **262** (top) Courtesy Michael Lewis; (bottom) George Willis, *New York Post*; **265** Mike Preston/*The Baltimore Sun*; **266** Mike Vaccaro/*The New York Post*; **269** Dan Solomon/ Texasmonthly.com; **271** Greg Logan/*Newsday*; **273** Bob McManaman/*The Arizona Republic*; **274** Steve Hummer/*The Atlanta Journal-Constitution*; **275** Mike Preston/*The Baltimore Sun*; **276** Ray Fittipaldo/ Excerpted from *The Pittsburgh Post-Gazette* ©2019; **278** Jerry Brewer/*The Washington Post*; **279** Vahe Gregorian/The *Kansas City Star*; **281** Ron Borges, used with permission from *Pro Football Weekly* and ProFootballWeekly.com; **282–283** Michael MacCambridge

## Photo

**COVER** Photograph by Michael Kraus, **2–3** Hy Peskin/*Sports Illustrated*/Getty Images; **4–5** Walter Iooss Jr./*Sports Illustrated*/Getty Images; **6–7** Heinz Kluetmeier/*Sports Illustrated*/Getty Images; **8–9** Patrick Smith/Getty Images; **10–11** Neil Leifer/*Sports Illustrated*/Getty Images; **13** Paul Drinkwater/NBC/Getty Images; **14** Gregory Heisler/*Sports Illustrated*/Contour/Getty Images; **16–17** Peter Read Miller/*Sports Illustrated*/Getty Images; **18-19** Walter Iooss Jr./*Sports Illustrated*/Getty Images; **20–21** Christian Petersen/Getty Images; **22–23** Walter Iooss Jr./*Sports Illustrated*/Getty Images; **24–25** Greg Trott/AP Images

**1920s** **26-28** Pro Football Hall of Fame (2); **29** Pro Football Hall of Fame/AP

Images; **32-33** Pro Football Hall of Fame (2); **34** Library of Congress; **36** From top: NFL Photos/AP Images (2); Pro Football Hall of Fame; **37** Georgia Tech; **39** Pro Football Hall of Fame/AP Images

**1930s** **40-42** AP Images (2); **43** Pro Football Hall of Fame; **46** Pro Football Hall of Fame; **47** AP Images; **48-51** Pro Football Hall of Fame (4); **52** Robert Walsh/AP Images; **53** Bettmann Archive/Getty Images

**1940s** **54-57** Pro Football Hall of Fame (3); **60** Pro Football Hall of Fame; **61** From left: Pro Football Hall of Fame; AP Images; **62** Pro Football Hall of Fame; **63** Harry Hall/AP Images; **64-65** Pro Football Hall of Fame; **66** AP Images **67** From top: Vic Stein/Getty Images; Allan Grant/The LIFE Images Collection/Getty Images; **68** AP Images; **69** Bettmann Archive/Getty Images

**1950s** **70-71** Sam Myers/AP Images; **72** Bettmann Archive/Getty Images; **73** Hy Peskin/*Sports Illustrated*/Getty Images; **76** Robert Riger/Getty Images; **77** From top: AP Images; Hy Peskin/*Sports Illustrated*/Getty Images; **78-79** Bettmann Archive/Getty Images (2); **80** Robert Riger/Getty Images; **81** David Durochik/AP Images; **82-83** Harold P. Matosian/AP Images; **84** Hy Peskin/*Sports Illustrated*/Getty Images; **85** NFL Photos/AP Images; **86** Kidwiler Collection/Diamond Images/Getty Images; **87** Marvin E. Newman/*Sports Illustrated*/Getty Images; **88-89** Bettmann Archive/Getty Images (2); **90** From left: Hy Peskin/*Sports Illustrated*/Getty Images; Pro Football Hall of Fame

**1960s** **92-94** Neil Leifer/*Sports Illustrated*/Getty Images (2); **95** Donald Uhrbrock/The LIFE Images Collection/Getty Images; **98** Neil Leifer/*Sports Illustrated*/Getty Images; **99** Tony Tomsic/AP Images; **100** Tony Tomsic/Getty Images; **101** Ross Lewis/Getty Images; **102-103** Ralph Morse/The LIFE Picture Collection/Getty Images; **104** NFL Photos/AP Images; **104-106** Neil Leifer/*Sports Illustrated*/Getty Images (2); **107** Robert Riger/Getty Images; **108** James Flores/Getty Images; **109** Robert Riger/

Getty Images; **110-111** Bettmann Archive/Getty Images; **112-113** Walter Iooss Jr./*Sports Illustrated*/Getty Images (2); **114** Focus on Sport/Getty Images; **115** Andrew D. Bernstein/Getty Images; **116-117** John G. Zimmerman/*Sports Illustrated*/Getty Images

**1970s** **118-119** Neil Leifer/*Sports Illustrated*/Getty Images; **120** ABC Photo Archives/Getty Images; **121** Tony Tomsic/AP Images; **124** AP Images; **125-126** Walter Iooss Jr./*Sports Illustrated*/Getty Images (2); **129** Manny Millan/*Sports Illustrated*/Getty Images; **130-131** Neil Leifer/*Sports Illustrated*/Getty Images; **132** From left: Tony Tomsic/AP Images; Pete Leabo/AP Images; **133** Walter Iooss Jr./*Sports Illustrated*/Getty Images; **134-135** Tony Tomsic/Getty Images; **136** Clockwise from top left: NFL Photos/AP Photos; George Gojkovich/Getty Images; Focus on Sport/Getty Images; AP Images; **137** Walter Iooss Jr./*Sports Illustrated*/Getty Images; **139** Focus on Sport/Getty Images; **140** Heinz Kluetmeier/*Sports Illustrated*/Getty Images; **141** Shelly Katz/*Sports Illustrated*/Getty Images; **142** NFL Photos/AP Images; **143** Neil Leifer/*Sports Illustrated*/Getty Images; **144** Walter Iooss Jr./*Sports Illustrated*/Getty Images; **146** From left: Neil Leifer/*Sports Illustrated*/Getty Images; Focus on Sport/Getty Images; **147** James Flores/Getty Images; **149** Neil Leifer/*Sports Illustrated*/Getty Images

**1980s** **150-151** Walter Iooss Jr./*Sports Illustrated*/Getty Images; **152** Greg Trott/AP Images; **153** Walter Iooss Jr./*Sports Illustrated*/Getty Images; **156** Al Messerschmidt/AP Images; **156-157** Heinz Kluetmeier/*Sports Illustrated*/Getty Images; **158** Focus on Sport/Getty Images; **159** Eric Risberg/AP Images; **160** Michael Minardi/Getty Images; **161** Al Messerschmidt/AP Images; **163** Bettmann Archive/Getty Images; **164** George Rose/Getty Images; **165** Greg Trott/AP Images; **166** From top: Jonathan Daniel/Getty Images; Richard Mackson/*Sports Illustrated*/Getty Images; Focus on Sport/Getty Images; **167** Clockwise from top left: Ronald C. Modra/Sports Imagery/Getty Images; Paul Natkin/Getty Images; Al Messerschmidt/AP Images (2); Bettmann Archive/Getty Images; Phil Sandlin/AP Images; **168** John Biever/*Sports Illustrated*/Getty

Images; **169** George Gojkovich/Getty Images; **170-171** Mike Powell/Allsport/Getty Images; **172** From top: Carl Iwasaki/*Sports Illustrated*/Getty Images; Walter Iooss Jr./*Sports Illustrated*/Getty Images; **173** Michael Zagaris; **174-175** John Biever/*Sports Illustrated*/Getty Images; **176** Focus on Sport/Getty Images; **177** Michael Zagaris/Getty Images; **178** Tom DiPace/AP Images; **179** Bettmann Archive/Getty Images; **180-181** Focus on Sport/Getty Images; **181** Focus on Sport/Getty Images; **182** Richard Mackson/*Sports Illustrated*/Getty Images; **183** Lennox Mclendon/AP Images

**1990s** **184-185** Tim DeFrisco/*Sports Illustrated*/Getty Images; **186** Al Messerschmidt/AP Images; **187** Mickey Pfleger/Getty Images; **190-191** John Biever/*Sports Illustrated*/Getty Images; **191** Ronald C. Modra/*Sports Illustrated*/Getty Images; **192** From top: Mike Powell/Getty Images; Ezra Shaw/Getty Images; **193** From top: Don Emmert/AFP/Getty Images; Al Tielemans/*Sports Illustrated*/Getty Images; **194** Greg Trott/AP Images; **195** Mickey Pfleger/*Sports Illustrated*/Getty Images; **196** From top: Al Messerschmidt/AP Images; Doug Mills/AP Images; **197-199** Al Golub/AP Images (2); **200** Clockwise from top left: Greg Trott/AP Images; Al Messerschmidt/AP Images; Mitchell Layton/Getty Images; Chuck Solomon/AP Images; **201** AP Images; **202-203** Richard Mackson/*Sports Illustrated*/Getty Images; **204-205** Tony Tomsic/Getty Images; **206** Greg Crisp/Getty Images; **207** Walter Iooss Jr./*Sports Illustrated*/Getty Images; **208** Walter Iooss Jr.; **209** Tim Sharp/AP Images; **210** John W. McDonough/*Sports Illustrated*/Getty Images; **211** John Biever/*Sports Illustrated*/Getty Images; **212** Al Golub/AP Images; **213** Allen Kee/AP Images; **214** Tom DiPace/AP Images; **215** Heinz Kluetmeier/*Sports Illustrated*/Getty Images; **217** Walter Iooss Jr./*Sports Illustrated*/Getty Images

**2000s** **218-219** Bill Kostroun/AP Images; **220** Damian Strohmeyer/*Sports Illustrated*/Getty Images; **221** Morry Gash/AP Images; **224-225** Tom Olmscheid/AP Images; **226** Amy Sancetta/AP Images; **227** Ezra Shaw/Getty Images; **228** Al Messerschmidt/Getty Images; **229** Denis Poroy/AP Images;

**230** Brian Bahr/Getty Images; **231** Al Golub/Icon Sportswire/Corbis/Getty Images; **232-233** James D. Smith/AP Images; **234-235** Lenny Ignelzi/AP Images; **235** Greg Trott/AP Images; **236** David Bergman/*Sports Illustrated*/Getty Images; **237** Bob Rosato/*Sports Illustrated*/Getty Images; **238** Greg Trott/Getty Images; **239** From top: Otto Greule Jr./Getty Images; Bill Frakes/*Sports Illustrated*/Getty Images; **240-241** John Biever/*Sports Illustrated*/Getty Images; **242** Tom Mihalek/AFP/Getty Images; **242-243** Doug Benc/Getty Images; **244** John Biever/*Sports Illustrated*/Getty Images; **245** Elsa/Allsport/Getty Images; **246-247** Andy Lyons/Getty Images; **248** Denis Poroy/AP Images; **249** Greg Trott/AP Images

**2010s** **250-251** Streeter Lecka/Getty Images; **252** Christian Petersen/Getty Images; **253** Patrick Semansky/AP Images; **256-257** Stacy Revere/Getty Images; **258-259** Leon Halip/Getty Images; **259** Matt Rourke/AP Images; **260** Patrick Semansky/AP Images; **261** Maddie Meyer/Getty Images; **262** David J. Phillip/AP Images; **263** Sam Riche/MCT/Getty Images; **264** Patrick Smith/Getty Images; **266-267** Al Bello/Getty Images; **268** Bob Levey/Getty Images; **270** Ezra Shaw/Getty Images; **271** Rich Graessle/Icon Sportswire/Corbis/Getty Images; **272** Christian Petersen/Getty Images; **273** Gene Lower/AP Images; **274** Jack Dempsey/AP Images; **275** Shelley Lipton/Icon Sportswire/Getty Images; **276-277** David Richard/AP Images; **278** Marcio Jose Sanchez/AP Images; **279** David Richard/AP Images; **280-281** Hannah Foslien/Getty Images; **282** From left: Mark LoMoglio/AP Images; Rob Tringali/Sportschrome/Getty Images; **283** From left: Mike Roemer/AP Images; Charles Krupa/AP Images; **284-285** Rob Carr/Getty Images; **288** Walter Iooss Jr./*Sports Illustrated*/Getty Images ●

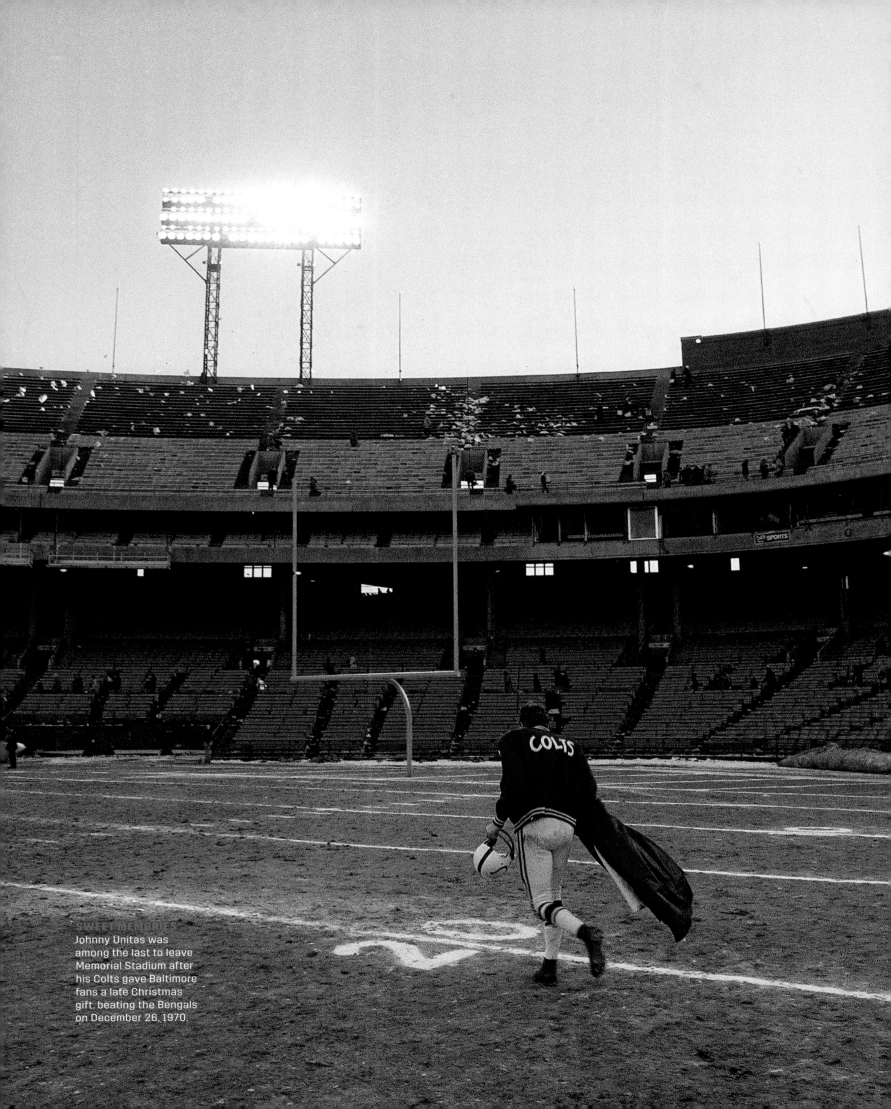

SWEET MEMORIES

**SWEET MEMORIES**
Johnny Unitas was
among the last to leave
Memorial Stadium after
his Colts gave Baltimore
fans a late Christmas
gift, beating the Bengals
on December 26, 1970.